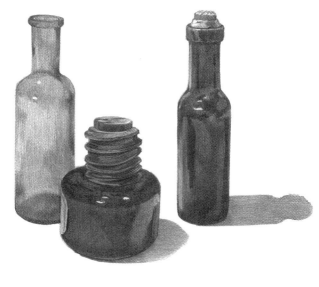

DRAWING

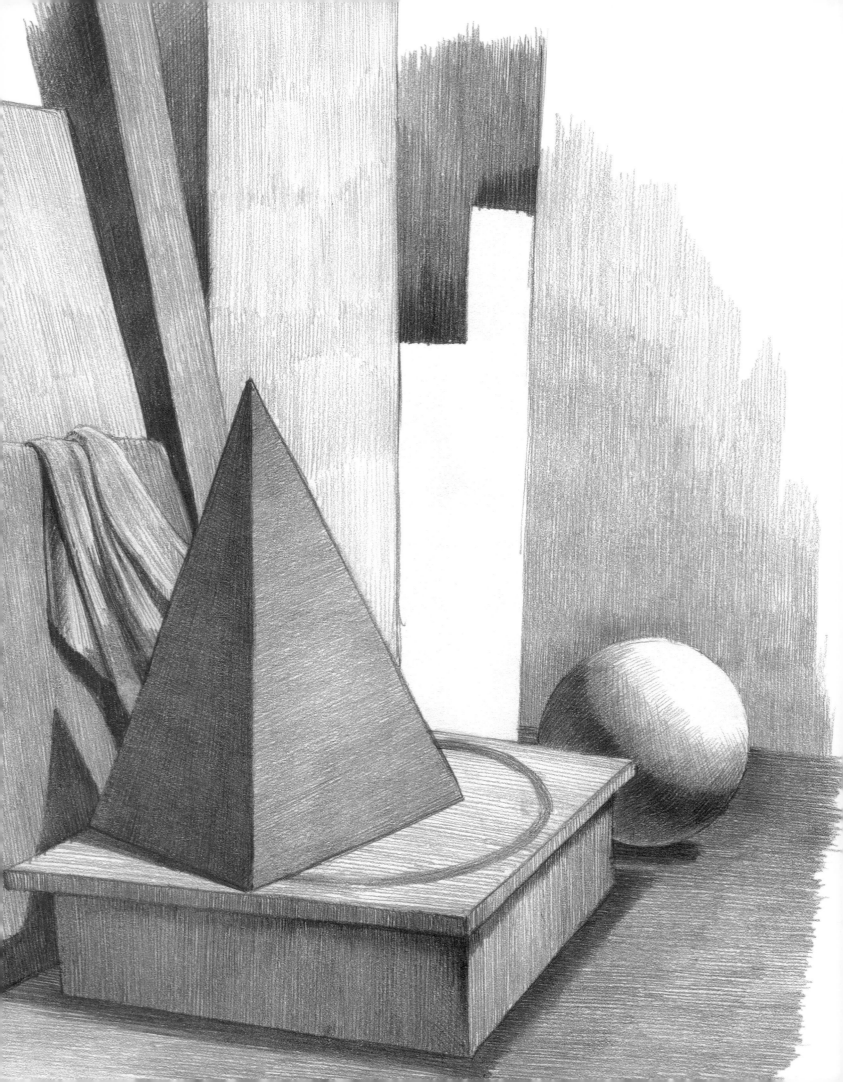

The Big Book of
DRAWING

András Szunyoghy

h.f.ullmann

© h.f.ullmann publishing GmbH
Original title: *Zeichnen. Die große Schule*
ISBN 978-3-8480-0248-1

Art director: Jolanta Szuba
Editor: Nikolett Hollósi
Layout, typography, reproduction: György Filakowszky
Project coordination: Daniel Fischer, Anke Moritz

© András Szunyoghy
© Kossuth Publishing

© for the English edition: h.f.ullmann publishing GmbH

Project coordination for h.f.ullmann: Lars Pietzschmann

Translated by Maisie Fitzpatrick in association with First Edition Translations Ltd, Cambridge.
Edited by Lin Thomas in association with First Edition Translations Ltd, Cambridge.
Typeset by The Write Idea in association with First Edition Translations Ltd, Cambridge.

Overall responsibility for production: h.f.ullmann publishing GmbH, Potsdam, Germany

Printed in China, 2014

ISBN 978-3-8480-0249-8

10 9 8 7 6 5 4 3 2
X IX VIII VII VI V IV III II I

www.ullmann-publishing.com

newsletter@ullmann-publishing.com

facebook.com/ullmann.social

Other drawing books:

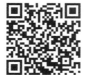

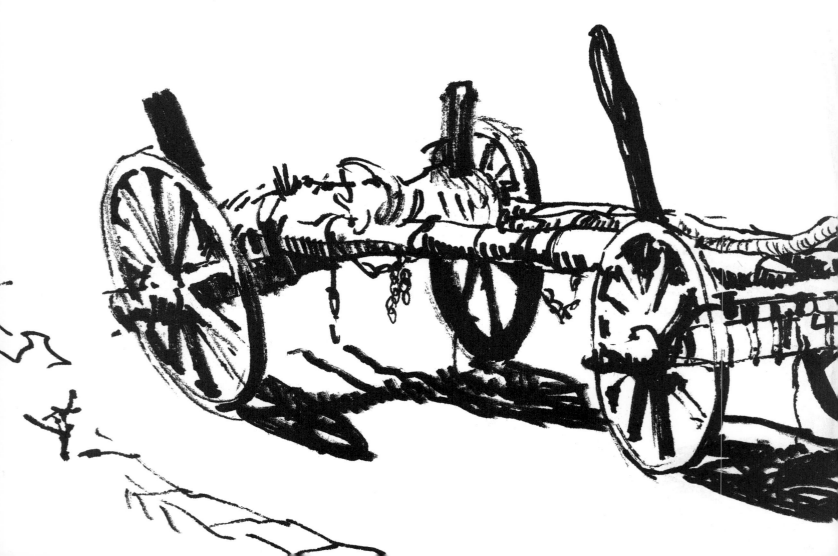

Contents

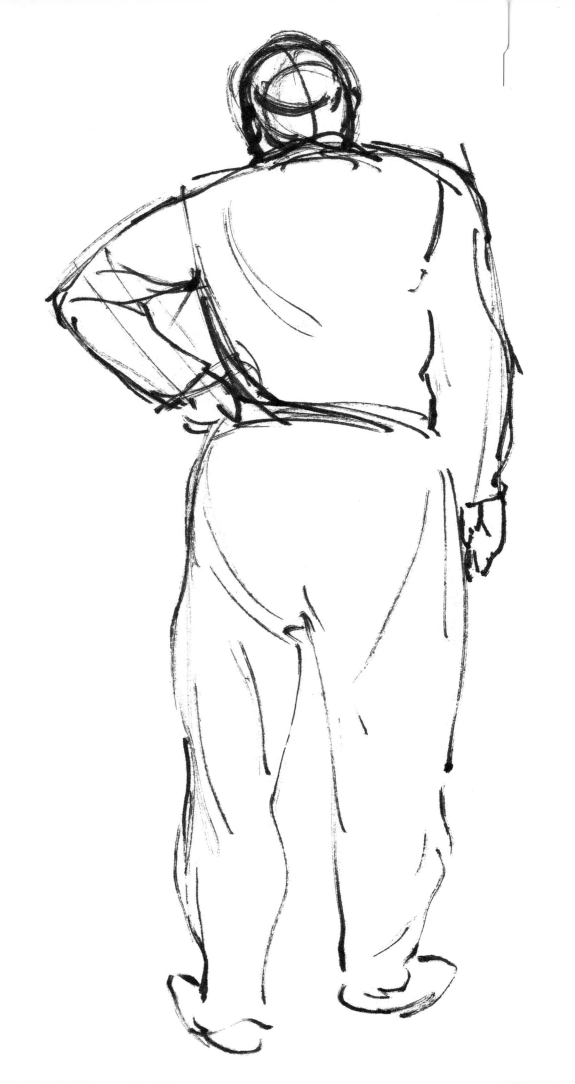

Introduction

Drawing is one of humanity's greatest accomplishments. It is like playing music, where something very special is created out of the interplay between hearing, hand movements, the mind, and something else—the element that some call soul or heart, and others talent. The mysterious magic of visual art requires the same ingredients, with the difference that hearing is replaced by seeing. Drawings and paintings are real miracles: you can conjure up whole worlds and the illusion of three-dimensionality on a blank sheet of paper, using only a pencil or paintbrush.

As the famous cave paintings prove, even prehistoric people drew. Evidence of visual art from earlier times shows that drawing has always been present throughout human history. The murals in the Egyptian tomb chambers and the frescoes in Roman palaces were purely decorative, but with Leonardo da Vinci, Dürer, Rembrandt, and Goya drawing took a new life as the beginnings of graphic art.

Of course, aside from the great masters of painting there were also many creatively-minded people who were not deemed artists. People are not always aware in just how many professions the ability to draw is essential. These include the people who design our clothes, furniture, and houses, but it also goes for a vast array of other jobs.

This book is aimed at everyone who would like to learn how to draw: taking the reader by the hand and encouraging them to think about and see things in a universal way.

Learning to draw takes time. You have to get used to a range of laws and rules in order to develop your skills. Some musicians practice eight hours a day in order to master their instrument perfectly. Visual artists are no different; only by really dedicating yourself to your craft and practicing it often will you be able to train your eye to notice all the details and enable your hand to render soft shapes. Even my tutor at art college would still shut himself away in his studio every day and spend an hour doing nothing but drawing.

The time needed in order to hone and develop this skill is different for everyone. Yet being able to draw does not make you an artist; art requires an extra element, and everyone must discover that for themselves. After all, art is the expression of thoughts, feelings, and passion within a picture or a sculpture—the creation of an individual visual language. Drawing is one of the components of this language.

Drawing has the power to delight. The guidance and advice given in this book are intended to ease the process of acquiring the skills that you will need. I have put it together in order to encourage and help people to draw.

András Szunyoghy

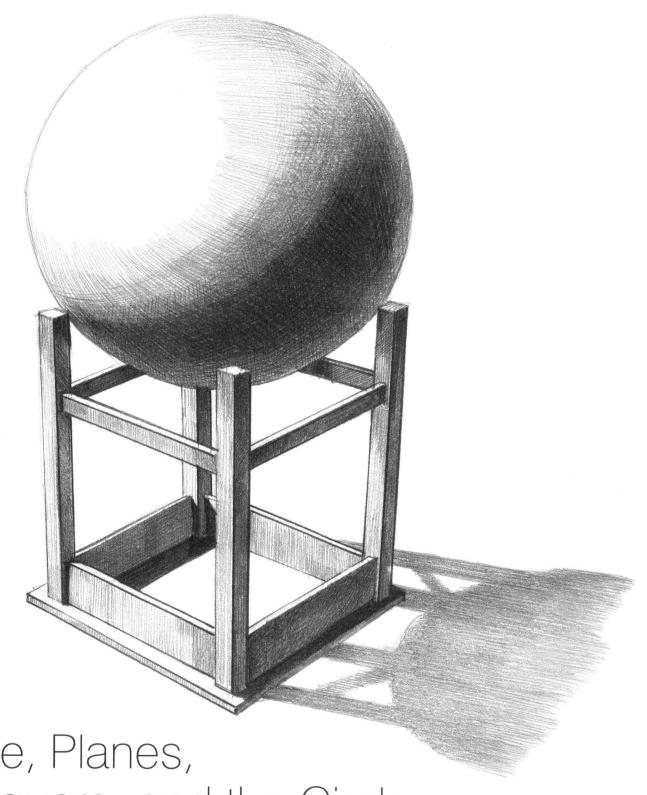

Space, Planes,
the Square, and the Circle

We are surrounded by boundless **space**. Everything that we draw exists in that space, and it is not easy to represent the special and unique position of the subject in space, and thus render its three-dimensionality on paper. When drawing, we therefore use the horizontal and vertical planes as an aid. No matter where we look, our eyes create imaginary planes. When we are drawing, however, we make use of only the horizontal plane running parallel to the earth's surface.

On a plain, we can see far into the distance, and we call the line where the earth and the sky "meet" the horizon. In the same way, we call the imaginary plane that our eyes perceive as running parallel to the earth's surface and ending at the horizon the horizontal plane. Anything that we want to draw appears either on, underneath, or above this plane. We see objects above the plane from a bottom view, and objects underneath the plane from a top view. Objects that lie directly on the horizontal plane demand a special depiction; a piece of paper, for instance, would appear as a single line. On the following pages, the horizontal plane is shown as a pair of eyes on a horizontal line.

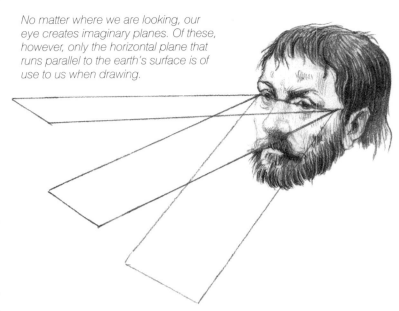

No matter where we are looking, our eye creates imaginary planes. Of these, however, only the horizontal plane that runs parallel to the earth's surface is of use to us when drawing.

On the following pages, the horizontal plane is shown as a pair of eyes on a horizontal line.

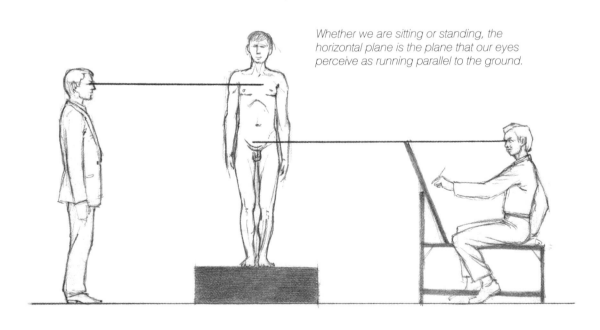

Whether we are sitting or standing, the horizontal plane is the plane that our eyes perceive as running parallel to the ground.

The horizontal plane that our eyes perceive intersects the plane of the earth at infinity.

The vertical plane is perpendicular to the horizontal plane. Both planes bisect the space, and together they divide it into four sections. If you were to draw a line each to represent the two planes, intersecting at right angles, you would have an imaginary cross dividing the space.

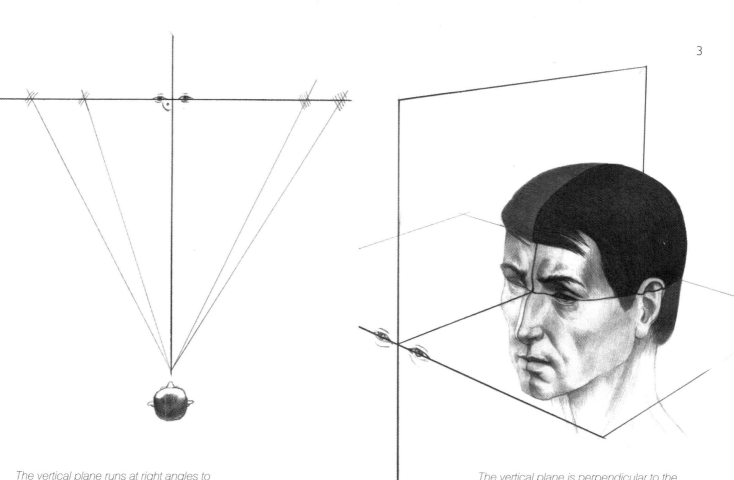

The vertical plane runs at right angles to the horizontal plane. When we look at something, our eyes also perceive imaginary vertical planes. In drawing, however, only the plane that runs at right angles to the horizontal plane is of use to us.

The vertical plane is perpendicular to the horizontal plane. Together they divide the space into four sections. If you were to draw a line to represent each of the two planes, intersecting at right angles, you would have an imaginary cross dividing the space.

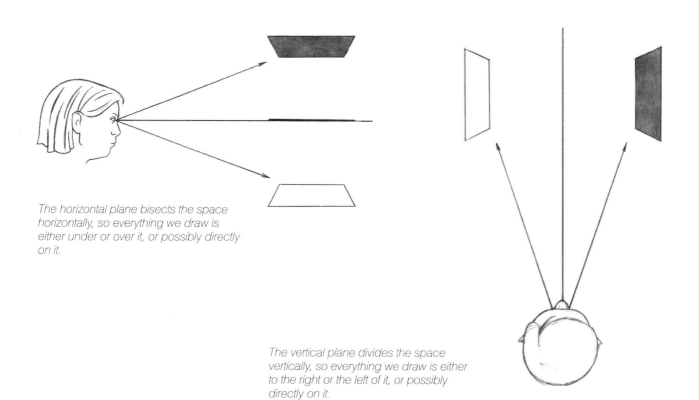

The horizontal plane bisects the space horizontally, so everything we draw is either under or over it, or possibly directly on it.

The vertical plane divides the space vertically, so everything we draw is either to the right or the left of it, or possibly directly on it.

Understanding and being able to use the rules of **perspective** is useful when drawing objects and living beings.

Perspective means the angle of vision. In visual arts, the word refers to the representation of the position of objects, shapes, and bodies in three-dimensional space, in relation to any other "actors" in the picture, or the artist, as the case may be. Perspective has two important rules:

Parallels intersect at infinity, including parallel lines and planes. Just think of two rails or the sides of a road that run exactly parallel: the two rails and the sides of the road appear to be running toward one another.

The other important rule is that an object that is closer to the viewer appears bigger than an object that is of the same size, but that is farther away. Electricity pylons are a good example of this.

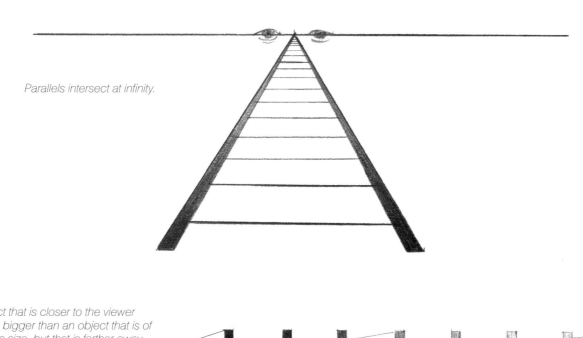

Parallels intersect at infinity.

An object that is closer to the viewer appears bigger than an object that is of the same size, but that is farther away.

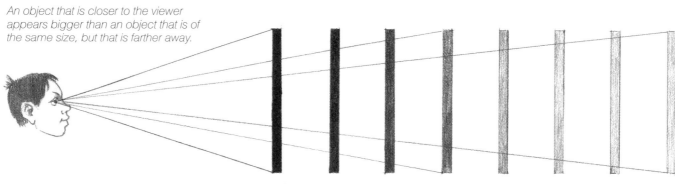

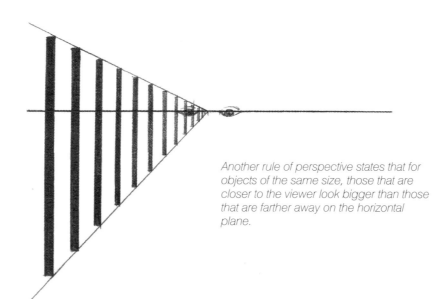

Another rule of perspective states that for objects of the same size, those that are closer to the viewer look bigger than those that are farther away on the horizontal plane.

A square with the horizontal and vertical planes bisecting its sides exactly.

A **square** has four sides of equal length. Adjacent sides form right-angles and opposite sides are parallel to one another. Here is a square with the horizontal and vertical planes bisecting its sides exactly.

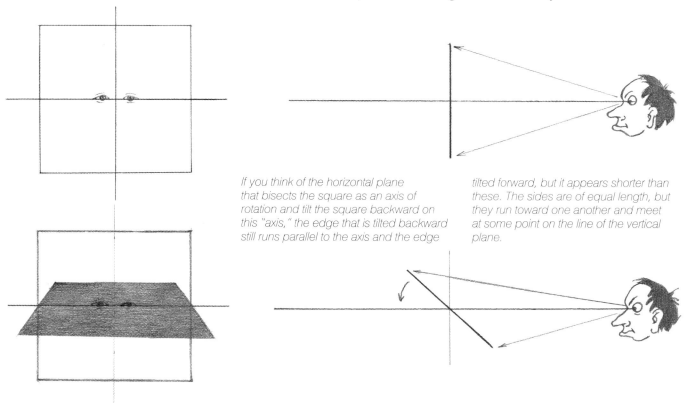

If you think of the horizontal plane that bisects the square as an axis of rotation and tilt the square backward on this "axis," the edge that is tilted backward still runs parallel to the axis and the edge

tilted forward, but it appears shorter than these. The sides are of equal length, but they run toward one another and meet at some point on the line of the vertical plane.

The farther the square is from the viewer on the vertical plane, the more of it is seen in the top view or the bottom view, and the larger it appears.

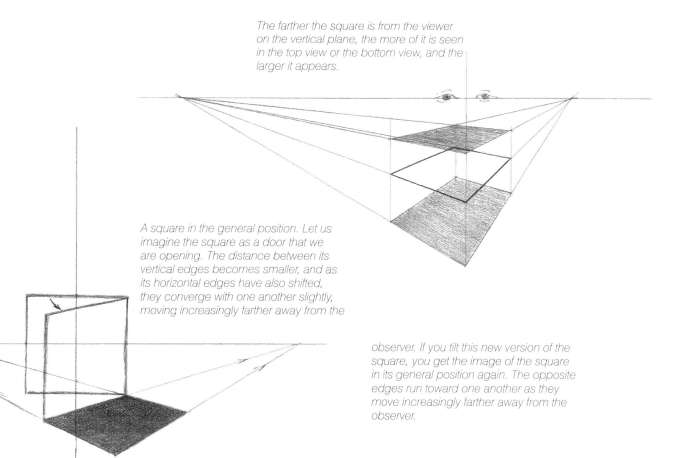

A square in the general position. Let us imagine the square as a door that we are opening. The distance between its vertical edges becomes smaller, and as its horizontal edges have also shifted, they converge with one another slightly, moving increasingly farther away from the

observer. If you tilt this new version of the square, you get the image of the square in its general position again. The opposite edges run toward one another as they move increasingly farther away from the observer.

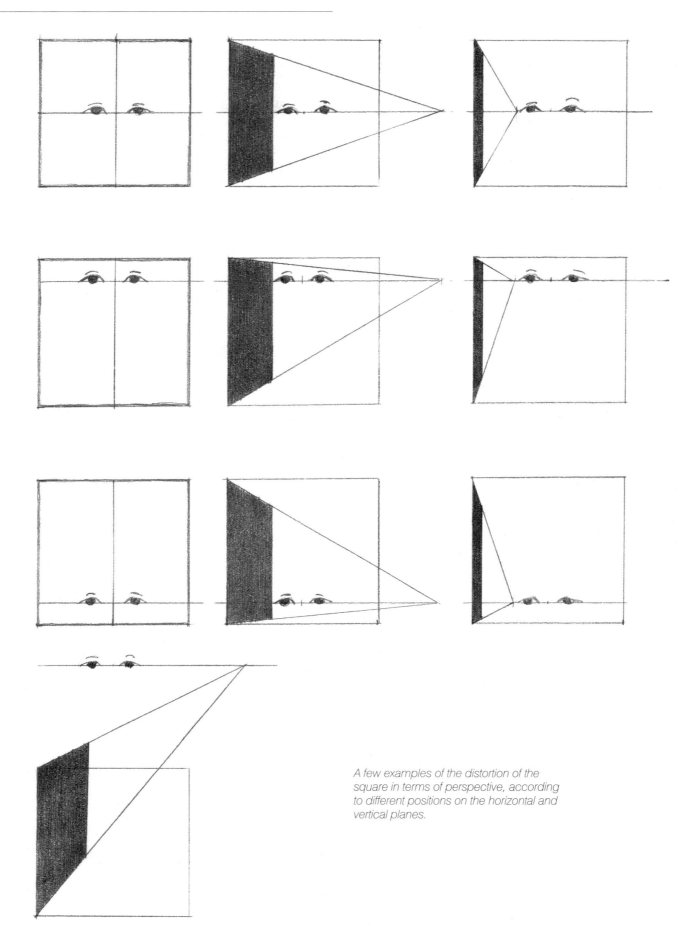

A few examples of the distortion of the square in terms of perspective, according to different positions on the horizontal and vertical planes.

The step-by-step drawing of a square in the general position.

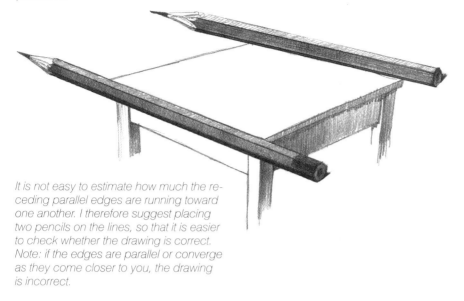

It is not easy to estimate how much the receding parallel edges are running toward one another. I therefore suggest placing two pencils on the lines, so that it is easier to check whether the drawing is correct. Note: if the edges are parallel or converge as they come closer to you, the drawing is incorrect.

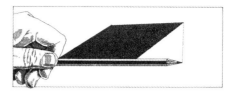

The length of the square in the general position is measured by holding one end of a measuring stick horizontally at the far corner of the square, and marking the other end with your thumbnail.

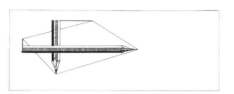

The width of the square in the general position is measured with a vertically held measuring stick in the same way.

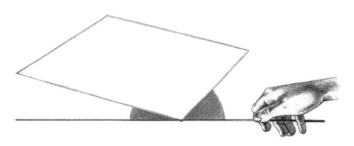

The angles between the edge and the horizontal and vertical planes, and the direction of the respective sides, can be found by holding the measuring stick horizontally or vertically at the corners of the square. The most common mistake in botched drawings is edges that run in the wrong direction.

With a little skill and a firm hold, the measuring stick can be laid on one edge of the square, used as a gauge to carry out the drawing.

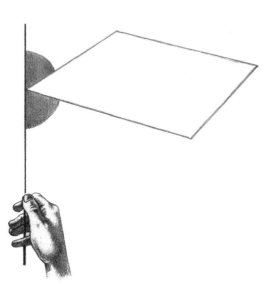

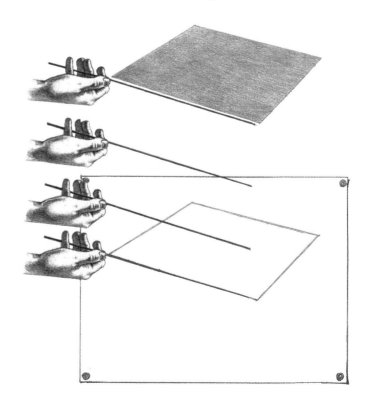

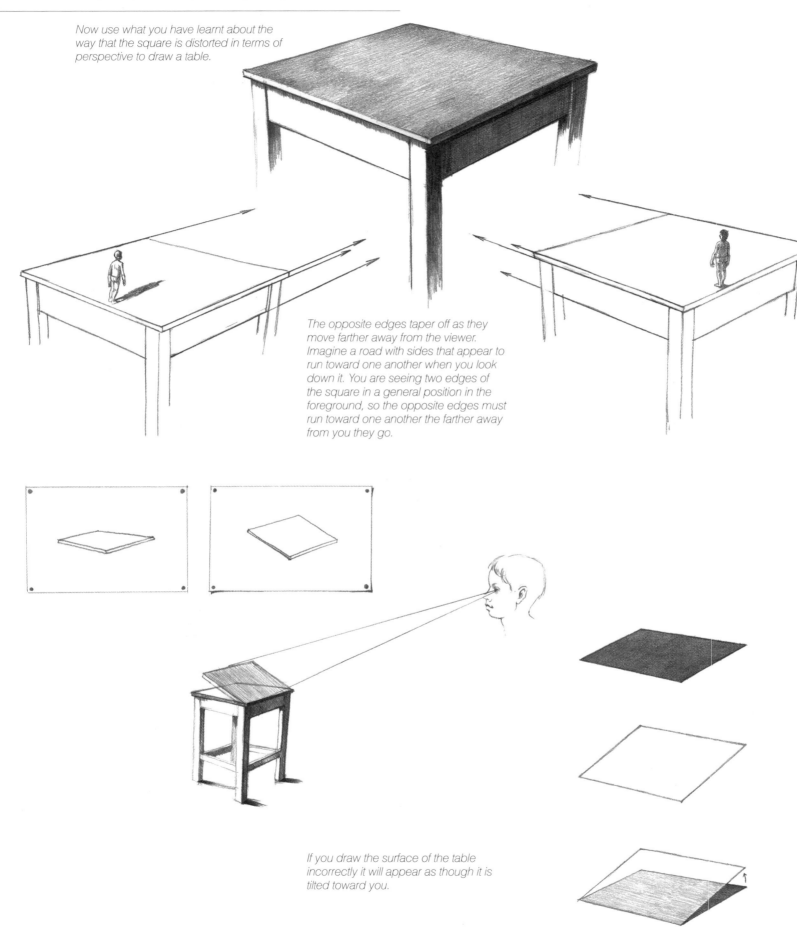

Now use what you have learnt about the way that the square is distorted in terms of perspective to draw a table.

The opposite edges taper off as they move farther away from the viewer. Imagine a road with sides that appear to run toward one another when you look down it. You are seeing two edges of the square in a general position in the foreground, so the opposite edges must run toward one another the farther away from you they go.

If you draw the surface of the table incorrectly it will appear as though it is tilted toward you.

The special thing about the **circle** is that every point on its circumference is equidistant from its centre. This distance is the radius (r). You can draw a circle within a square, touching the midpoints of the edges. This is worth noting, as what you have learnt about the square will help with understanding the way that the circle changes from different perspectives.

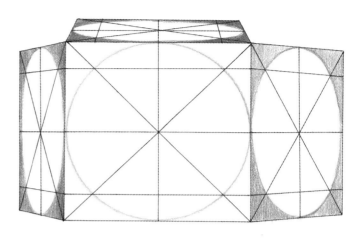

In the general position the circle appears as an ellipse. The illustration shows four sides of a cube which is drawn according to the rules of perspective. The ellipses are sketched in using the midpoints of these sides. In this way you can see how the circle changes according to perspective.

Also note the way in which the drawing of the ellipse changes as it moves farther away on the vertical plane in the top view or the bottom view.

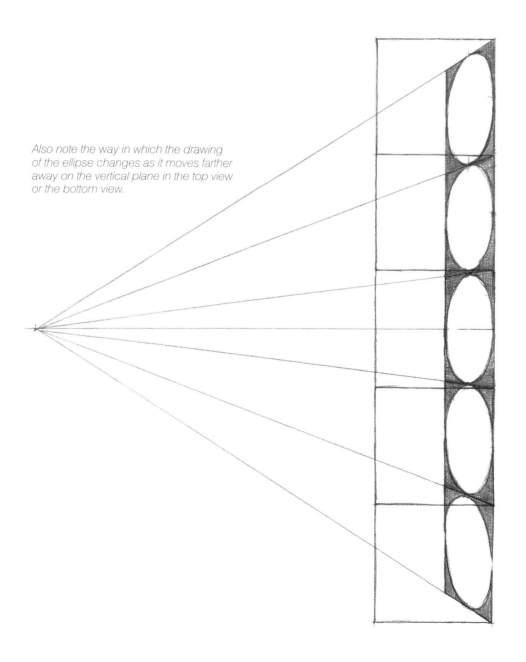

If you bisect the circle drawn inside the square and tilt it, the rules of perspective dictate that the section that is farther away from the viewer will appear smaller than the section that is closer.

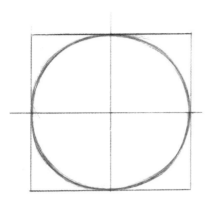

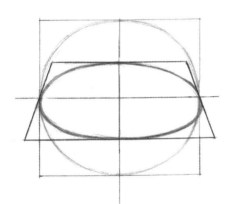

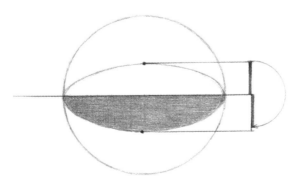

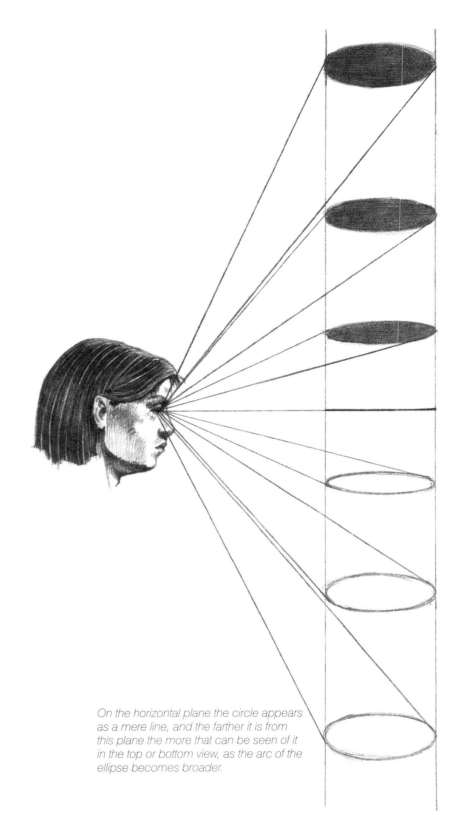

On the horizontal plane the circle appears as a mere line, and the farther it is from this plane the more that can be seen of it in the top or bottom view, as the arc of the ellipse becomes broader.

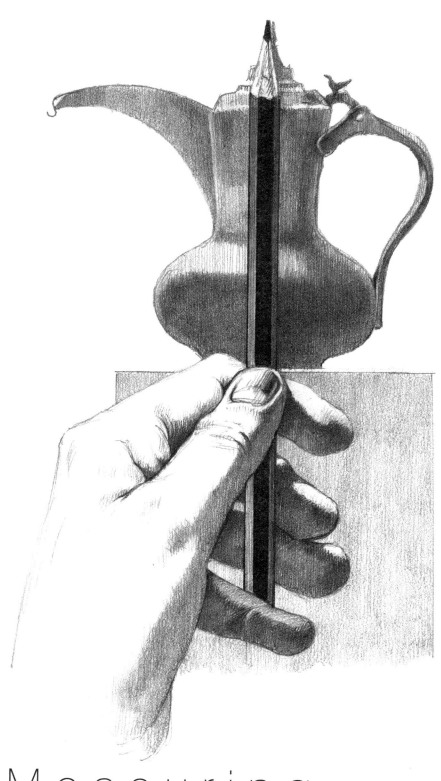

Measuring

When you first begin to draw it is difficult to estimate which of two dimensions of the subject is larger, and by how much. Dimensions can be precisely determined and compared using a tool, namely a measuring stick. A pencil, paintbrush, stick, knitting needle, or many other items make ideal measuring sticks. Learning how to measure is vital, as drawings will be incorrect as long as you do not have a feel for or fail to spot the differences between dimensions.

There are strict rules for using a measuring stick, as illustrated in the following sketches.

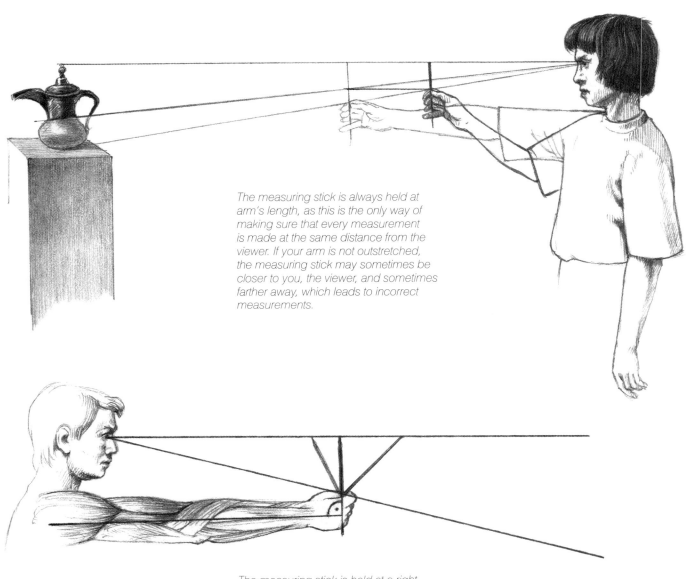

The measuring stick is always held at arm's length, as this is the only way of making sure that every measurement is made at the same distance from the viewer. If your arm is not outstretched, the measuring stick may sometimes be closer to you, the viewer, and sometimes farther away, which leads to incorrect measurements.

The measuring stick is held at a right angle to your outstretched arm; otherwise the same posture cannot be ensured for different measurements, leading to errors.

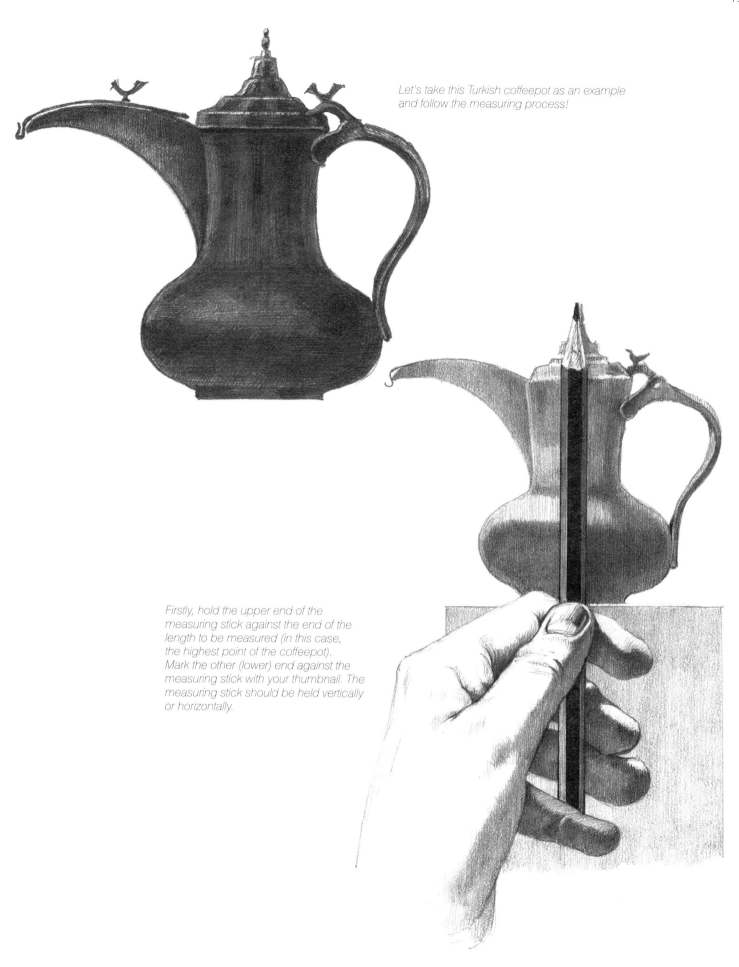

Let's take this Turkish coffeepot as an example and follow the measuring process!

Firstly, hold the upper end of the measuring stick against the end of the length to be measured (in this case, the highest point of the coffeepot). Mark the other (lower) end against the measuring stick with your thumbnail. The measuring stick should be held vertically or horizontally.

When you are sure that you have mastered measuring, you can tackle the trickier task of transferring the dimensions onto paper. In other words, you have to put what you have measured onto the page.

When you begin a drawing you are faced with a great white sheet of paper like a field of virgin snow, with no known dimensions on it. It is up to the artist whether the drawing is tiny...

... or enormous.

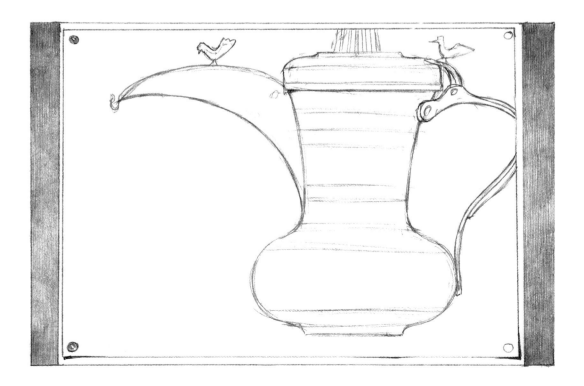

Plan the ideal size of the drawing in a small sketch, and then draw in the dimensions accordingly.

The first dimension is drawn freely. Mark the end points of one measurement on the paper, usually the height.

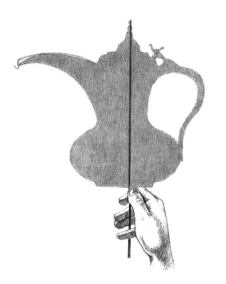

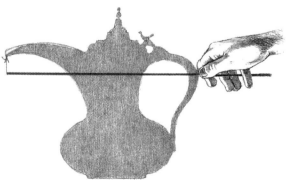

Subsequent dimensions are always compared with this first dimension, first against the subject itself and then on the drawing.

For the coffeepot I will now show how many measure-ments are needed in order to create a precise and faultless drawing.

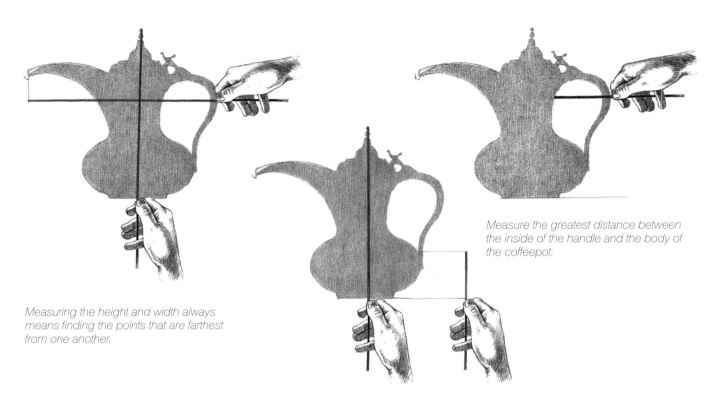

Measure the greatest distance between the inside of the handle and the body of the coffeepot.

Measuring the height and width always means finding the points that are farthest from one another.

After determining the height and width you should find out how high the lower part of the handle is in relation to the height of the coffeepot.

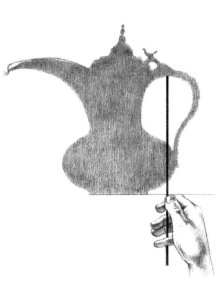

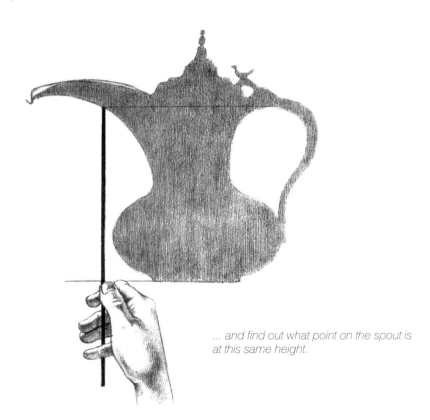

In order to draw the inner curve of the handle you also need to know how high its highest point is...

... and find out what point on the spout is at this same height.

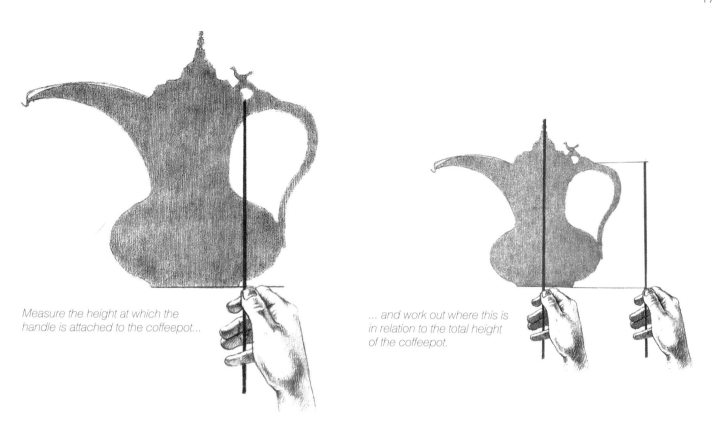

Measure the height at which the handle is attached to the coffeepot...

... and work out where this is in relation to the total height of the coffeepot.

In order to maintain the proportions, compare the distance of the lowest and highest points of the handle with the total height of the coffeepot.

Measure the distance to the point on the outer surface of the handle that is farthest from the body of the coffeepot, and compare this with the total height.

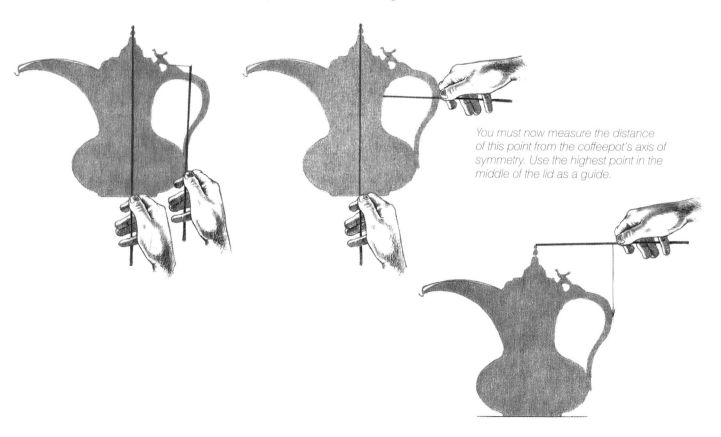

You must now measure the distance of this point from the coffeepot's axis of symmetry. Use the highest point in the middle of the lid as a guide.

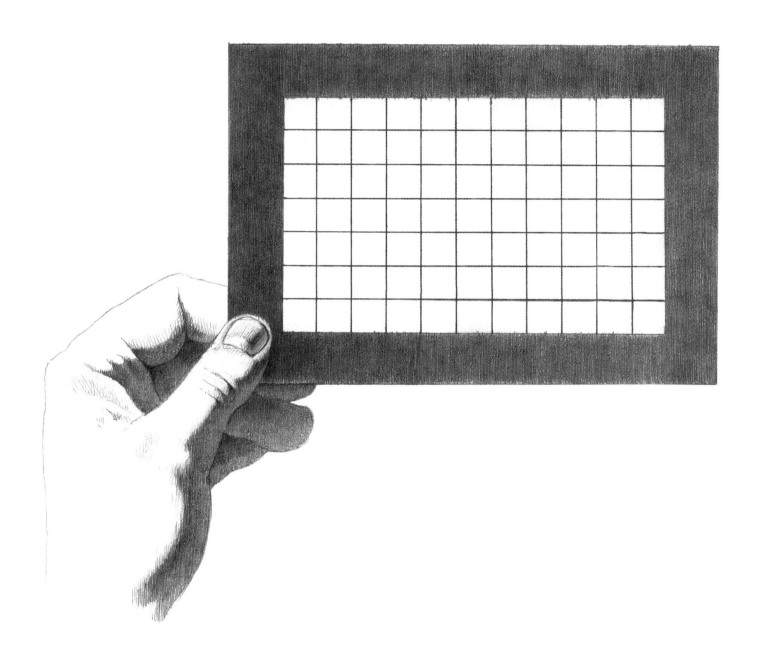

Plotting Grids

Artists have always striven to make their work easier and simpler. Today moments from the past are usually captured with a camera. For almost a hundred years photography has served as a tool for visual artists, especially at the sketching stage.

A woodcut by Albrecht Dürer

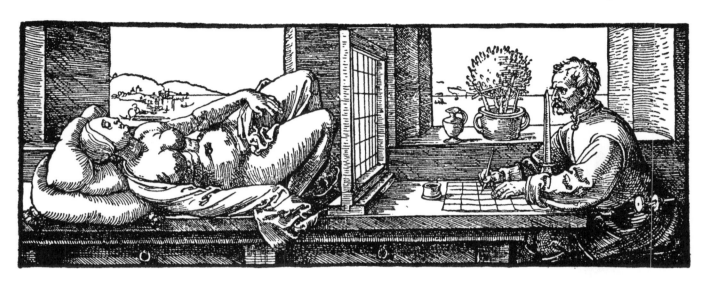

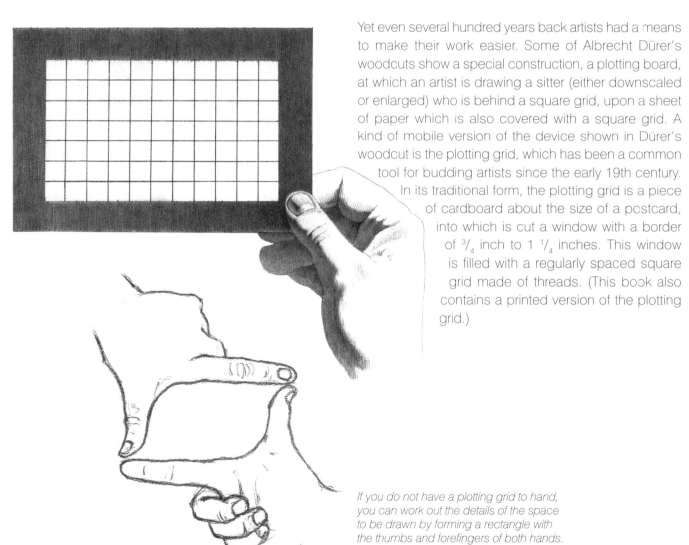

Yet even several hundred years back artists had a means to make their work easier. Some of Albrecht Dürer's woodcuts show a special construction, a plotting board, at which an artist is drawing a sitter (either downscaled or enlarged) who is behind a square grid, upon a sheet of paper which is also covered with a square grid. A kind of mobile version of the device shown in Dürer's woodcut is the plotting grid, which has been a common tool for budding artists since the early 19th century. In its traditional form, the plotting grid is a piece of cardboard about the size of a postcard, into which is cut a window with a border of $3/_4$ inch to $1 \, 1/_4$ inches. This window is filled with a regularly spaced square grid made of threads. (This book also contains a printed version of the plotting grid.)

If you do not have a plotting grid to hand, you can work out the details of the space to be drawn by forming a rectangle with the thumbs and forefingers of both hands.

The plotting grid can be used in different ways. It can be used to determine what space is to be drawn, or "cut out," as it were. If the plotting grid is close to the eyes of the viewer a larger section of the space will be seen; if it is farther away a smaller section will be seen.

Before you begin, it is vital to determine the picture area that allows for the best drawing of the subject. Move the plotting grid around in front of your eyes until you have found the ideal picture area.

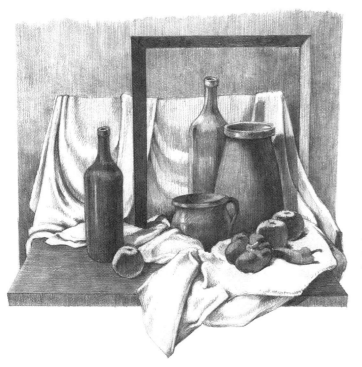

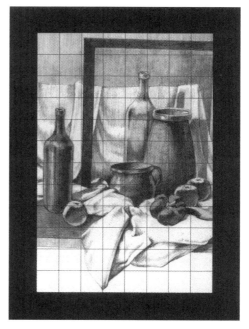

You can find the best picture area by moving the plotting grid away from or toward your eyes, seeing a smaller or larger section of the space respectively. Work out which is the better version!

Different sections of a still life.

This image section is awkward because the composition is distorted and some important details are missing.

A good image section restores important details and the beauty of the still life for the viewer.

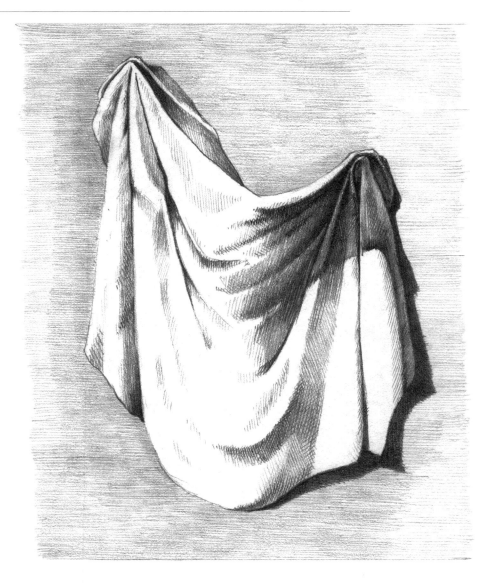

A good image section is also important when drawing drapery. Have a try—see how far away you have to hold the plotting grid in order to get the best drawing.

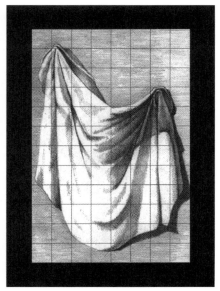

Every detail can be seen with a good image section. The distance of the drapery from the edge of the picture is just as important as the balance and harmony of the drawing.

If you hold the plotting grid too far away from you, large swathes of the cloth will be missing from the drawing.

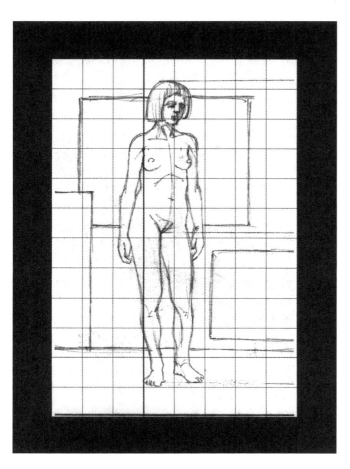

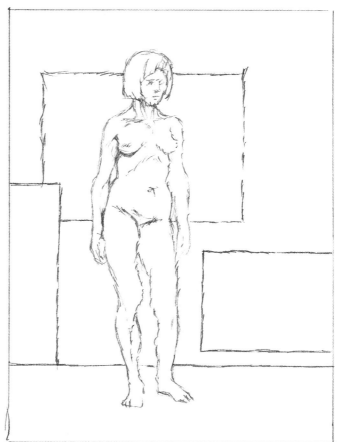

The plotting grid is also a versatile tool when drawing nudes; for instance, it makes it easier to assess the composition, discern the proportions and determine the direction of the limbs.

Another use of the plotting grid is discerning the differences between the various dimensions. This helps, as it means that you do not have to flounder about with sizes.
The plotting grid also helps to determine the axes, the direction of the edges of objects and their angle against the horizontal or vertical planes, and thus against the chosen reference line of the plotting grid.

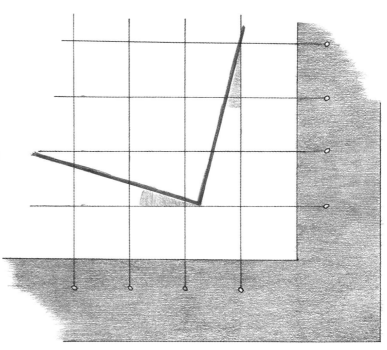

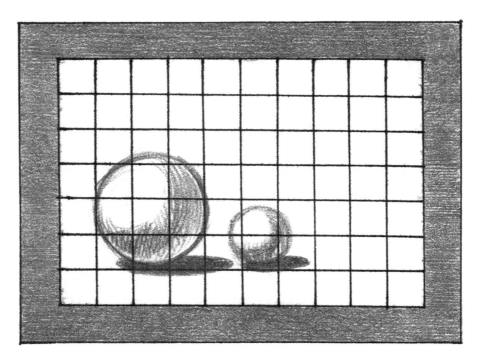

The squares of the plotting grid make finding measurements easier.

The angles of sides against the vertical and horizontal planes can easily be found with the help of a plotting grid.

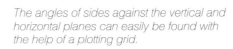

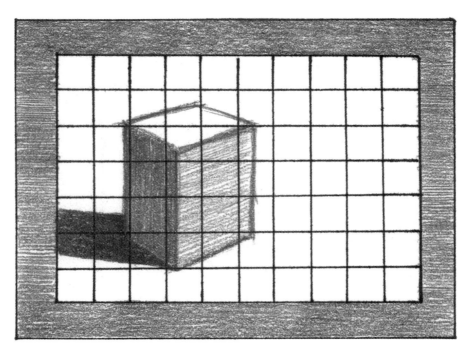

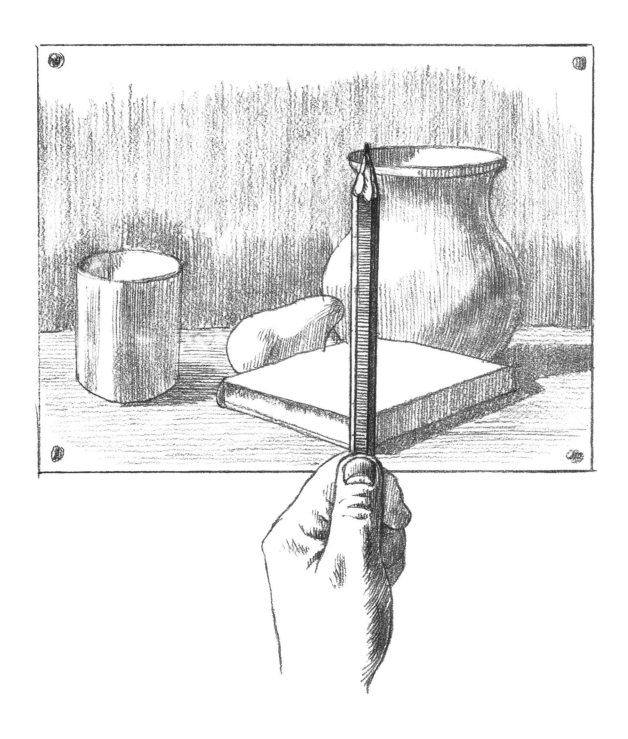

Drawing Techniques

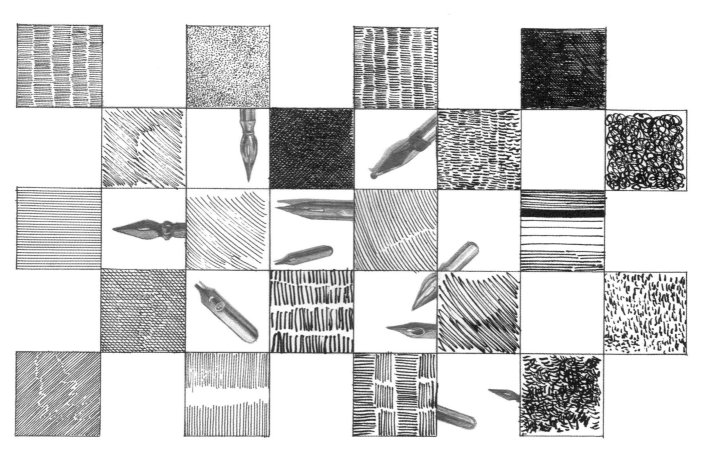

People have been using **drawing ink** for millennia, as is proven by sources dating back from as early as 2550BC. It was popular in both China and ancient Egypt. Drawing ink is color dissolved in water. It comes in many different shades, but the classic hue is black ink. The liquid can be applied to paper using a drawing pen or a paintbrush. In the past these instruments were made from goose feathers, reeds, or even bamboo. Drawing pens are suitable for many drawing techniques and allow a wide variety of visual effects.

The nib of the pen is used for drawing dots and lines. These days nibs used for writing and drawing come in myriad forms, from italic nibs for calligraphy to fine pen nibs for drawing. For centuries artists used dip pens for drawing and sketching.

Today reed pens are very popular, as you can work with them for a long time.

And one last important point: the title of ink drawings and the name of the artist are always written in ink.

Different nibs allow you to make very different marks on paper, such as patterns of parallel lines where the shading effect is determined by the frequency of the gaps between the lines.

Differences in shading can also be achieved by two or more layers of lines, dots, or playful, irregular short lines. Which technique you apply depends on the type of drawing.

Dotting is often used as a decorative technique, and is familiar to us from copper engraving. Its defining characteristic is that the differences in shading are achieved by denser or more widely spaced juxtaposed dots: if the dots are more widely set the picture appears lighter, if they are more densely packed the picture appears darker. The dots can be ordered according to a particular system, in lines, or placed completely at random. This is a rather labor-intensive technique, but it does result in great-looking drawings.

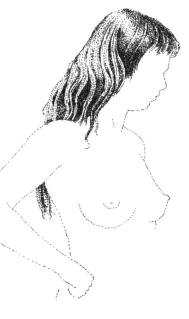

If the dots are widely spaced the picture appears lighter; if the dots are densely packed it appears darker.

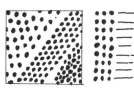

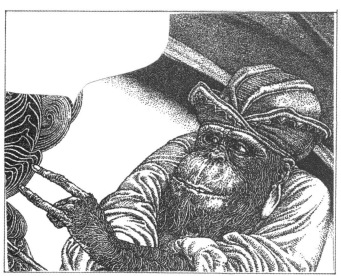

Instruments suitable for dotting

Illustration by Tamás Kovács

Pen drawing. The other method of drawing with a pen is sketching lines alongside one another. The frequency of the lines and thus the size of the space between them determine the shade of gray. More widely spaced lines create a lighter overall impression, while more densely spaced lines produce a darker effect. This can be enhanced by thickening the lines. The nib alone determines the thickness of the lines. The fifth or sixth layer of lines should be applied a little later once the effect of the previous layers has been assessed.

The nib determines the thickness of the lines.

Two or more layers of lines create stronger shading. This works best if the lines cross at a 45-degree angle.

Single-layer cross-hatching also offers a number of different effects. Broken lines produce a new, negative line that disrupts the image, where required.

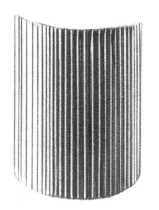

Lines that run in the same (vertical) direction allow the surface of objects to be rendered almost perfectly. You can draw a cylinder simply using a mix of thinner and thicker lines. Horizontal lines create an even background.

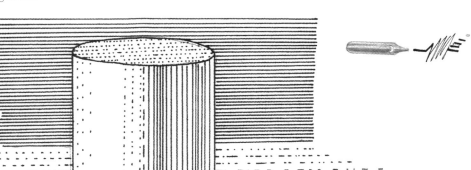

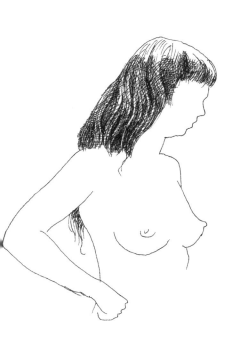

A popular version of this technique is cross-hatching two or more layers of lines. The lines should form a 45-degree angle. If there is a more acute angle between the two layers of lines they will form diamond shapes, which create an unpleasant, vibrating effect.

This results in what is known as a moiré surface, which means that the little diamonds take on a life of their own, unintentionally creating a chainlike effect. Vertical cross-hatching is also a commonly used technique.

Two or more layers of lines are needed in order to render the intensity of dark hair.

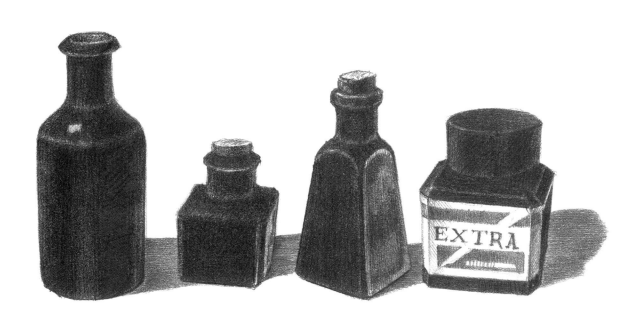

Washed ink is perhaps the most beautiful and varied drawing method. A paintbrush is generally used, giving you a foretaste of painting. As the ink has to be thinned with water, it is recommended that you use a sheet of paper as a palette for mixing the ink with water; this way the intensity of the different shades of gray can be seen immediately. When doing this you must be aware that the blended color loses some of its intensity after drying. The paper is drenched with water for the ink wash and stuck to the drawing board with adhesive tape. Once the paper dries it tightens up. If it is not stretched it will become wrinkled after being painted. If this happens, you should moisten the blank reverse side of the paper with a sponge, making sure that no water gets onto the painted side. The moistened paper—with the drawing facing downward—is stuck to the drawing board with adhesive tape. It is removed using a cutter and a ruler.

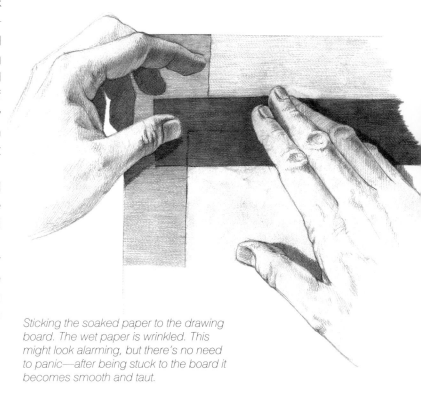

Sticking the soaked paper to the drawing board. The wet paper is wrinkled. This might look alarming, but there's no need to panic—after being stuck to the board it becomes smooth and taut.

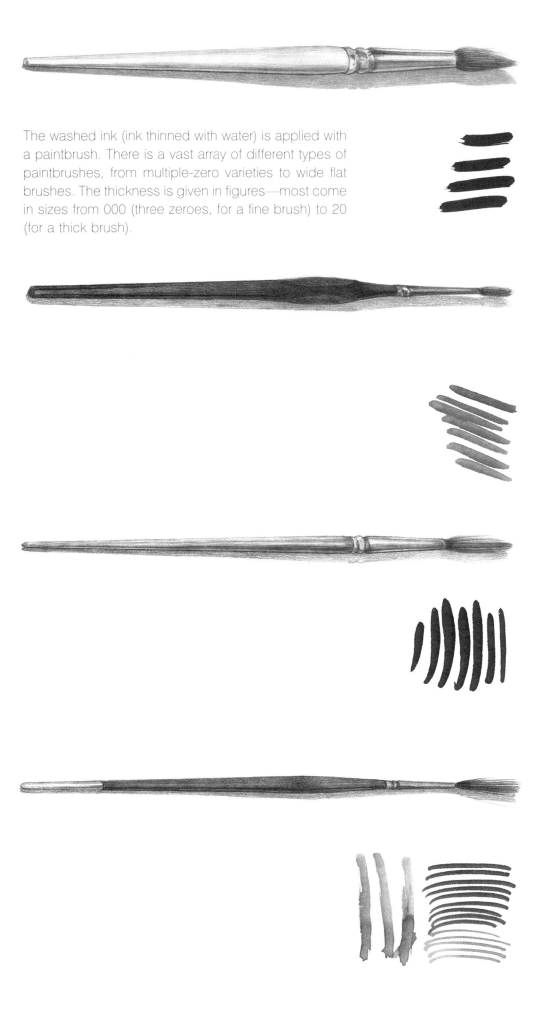

The washed ink (ink thinned with water) is applied with a paintbrush. There is a vast array of different types of paintbrushes, from multiple-zero varieties to wide flat brushes. The thickness is given in figures—most come in sizes from 000 (three zeroes, for a fine brush) to 20 (for a thick brush).

The scene that you wish to paint can be sketched out lightly in pencil and then painted. The sequence is reversed in this technique; the lightest parts are painted first, before proceeding step-by-step to the darkest. (Incidentally, this applies to all painted work.) As there is no way of completely correcting work done in paint, mistakes can only be covered over with darker areas. Drawings that are already dark cannot be corrected. When painting it is vital to render the shading that you see as precisely as possible. The piece of paper used as a palette helps with this, as it shows the intensity of the color.

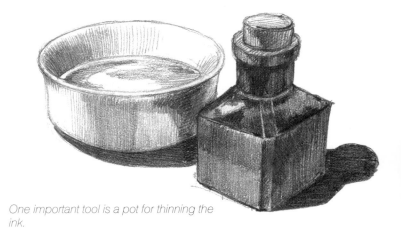

One important tool is a pot for thinning the ink.

"Chinese" paintbrushes are also popular, as their very pointed end and thick body allow for both thinner and thicker lines and areas when painting.

Size 000 paintbrushes are used for very fine lines.

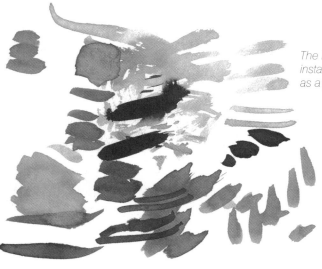

The blended shade of gray can be seen instantly on the piece of paper that is used as a palette.

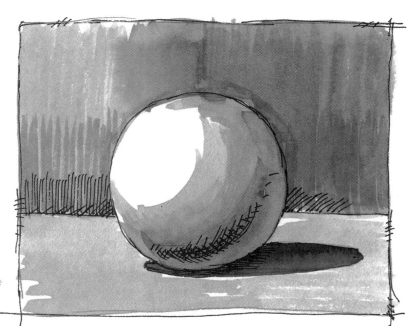

At the final stage you can draw a strong line in with a pen to enhance the impression of three-dimensionality.

Reed drawing. You can also use a reed pen for ink paintings, as it is equally suitable for thick and thin lines. Special shading effects can be achieved by twisting the reed to the side. You can also draw with a stick or a twig that you have carved through yourself; the specific tool you use will, of course, have a bearing on the type of drawing that will be produced.

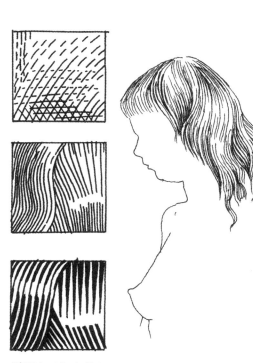

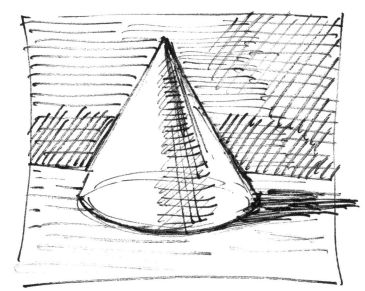

Lines can be drawn using extremely diverse techniques. Small, dot-like dashes can be inserted into the cross-hatching to render the transition to lighter shading. Parallel, curved lines also offer interesting possibilities; they are ideal for decoration and bring a sense of movement to the picture. Applying this technique with tapered, thick lines can make the surface look rounded. Thick lines result in a special texture that can be amplified by drawing fine lines in the gaps between the lines.

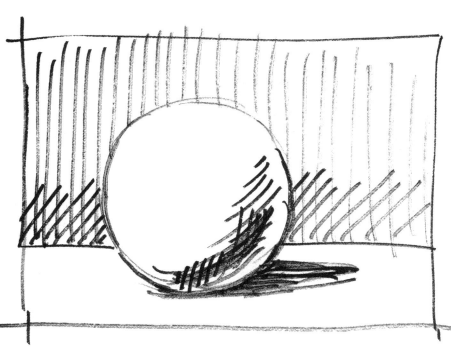

Reed pens can also create random, unintended surfaces. The lines are rough, making this technique great for sketching and croquis (quick, sketch-like drawings).

Charcoal is one of the most popular drawing materials. It allows you to work very quickly, and the end result looks great. It is used for larger drawings, but is not suitable for small sketches. Charcoal is formed from wood that has been transformed into a coal-like substance by burning without air. Ideal types of wood are willow, elder, and grapevine and fruit tree wood. It can be bought in thinner and thicker chunks, and the color of the lines that can be drawn with it range from brown to black.

A drawing is normally done with a type of charcoal. It is used differently from the pencil, as it can be blurred with a finger, hand, the side of the hand, with a rag, or with a piece of felt. Any method can be used to achieve good shading. I would recommend drawing large areas with the broader side of the charcoal, and composing the drawing out of these. You should be careful, however, as charcoal is easy to smudge and can also fall off the paper.

Different types of paper have different properties. Charcoal will slide over smooth paper, for instance, and you will not be able to get a rich black if you use this, so it is not recommended. If you use very rough paper there will be white specks between the lines drawn in charcoal, creating a distracting vibration-like effect. This can be avoided by using a darker base color for the paper. You do this by rubbing the charcoal into the surface of the paper, and only then beginning with the drawing. If you rub the charcoal with a piece of felt you will get a fine, even surface. You can make corrections to charcoal drawings with breadcrumbs or putty erasers, although caution is advised, as these can easily become stuck to the surface.

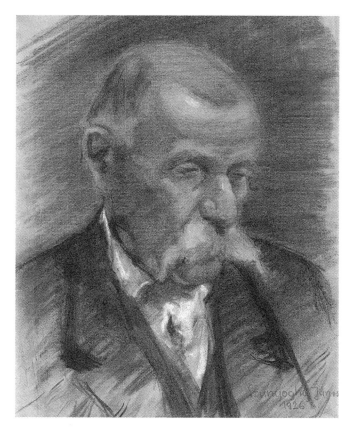

Drawing by János Szunyoghy

Paper also wears away—with successive changes the upper layer is demolished and you will not be able to apply any more black shading as the paper cannot absorb any more charcoal. If this happens it must be "fixed." When the fixing varnish is dried the little pieces that have flaked off due to rubbing stick to the paper once again, and it can continue to be used. The finished charcoal drawing must be fixed in any case, as it is very delicate. It is signed with charcoal or a pencil.

Károly Ferenczy: Daphnis and Chloe

The **pencil** is the most important drawing tool, as it is what you use when learning the basics of drawing. Once you have learnt how to wield it you can conjure up fantastic three-dimensional effects on paper.

Pencils consist of graphite, which is carbon with a crystal structure. Large graphite deposits were discovered in England in the 18th century. In Leonardo da Vinci's time the forerunners of the pencil were lead, tin, and silver pencils, yet their intensity of color was far from that of today's pencils with graphite leads. The hardness of the pencil is indicated by a number and a letter. The maximum hardness is 9H; the medium is HB, with B indicating a soft and 9B a very soft pencil. The softness of a pencil also corresponds to its blackness. A 4H-hardness pencil leaves almost no trace on the paper, while an 8B pencil gives a deep black. Personally, I prefer to use B, 2B, 6B and F (for "fine point") pencil. The pencil best suited to general work is the 2B, as it can also give rich shades of black.

The material from which the pencil is made and the ease with which the drawing can be done means that this technique is best suited to works of size 20 x 30cm or smaller. When you are drawing your hand rests on the paper. You can also "reach into" this space, and thus avoid smudging it with your hand. For drawings covering larger areas it is best to lay a piece of paper under your hand. An eraser or breadcrumb is ideal for making amendments.

Neighboring areas of shading can only be separated from one another by lines, so the different direction of the lines is of little use here. In this instance it is best to strengthen the shading in one of the areas, so that it stands out against the other.

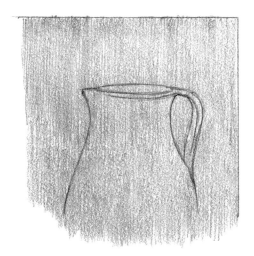

The shading of the drawn object and its background are identical, and can only be separated from one another by lines. However, this drawing is incorrect, as the jug is a rotational solid, so it is more strongly lit and thus lighter on one side than the other.

Shading can be achieved by either smooth parallel lines or random, overlapping lines. Regular horizontal or vertical lines render a smooth surface. It is best to draw lines by pulling your hand toward you at an angle of 45 degrees. When distorted, this results in curved lines, which can also convey the three-dimensionality of a surface. Lines drawn at an angle of 45 degrees can give the impression of rounded surfaces such as a barrel or a hillside.

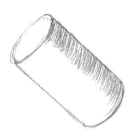

The pencil is especially versatile—you can get darker lines by applying greater pressure, and fine gray lines by pressing down less firmly. Yet this is only one way of rendering shading. Another method is to strengthen the shade of gray by drawing more closely spaced lines or several superimposed layers of lines. If there are two layers of lines on top of one another (cross-hatching), the lines should intersect at a 45-degree angle; the alternative, whereby the lines form acute-angled diamonds, appears to vibrate unpleasantly. This often inadvertently results in a moiré surface. Diamonds with 45- to 90-degree angles are also awkward-looking, albeit less so. Surfaces made up of vertically superimposed lines do not look great, but they are acceptable.

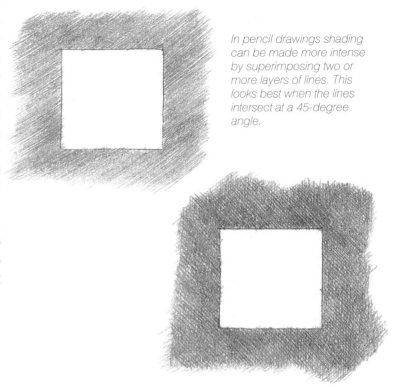

In pencil drawings shading can be made more intense by superimposing two or more layers of lines. This looks best when the lines intersect at a 45-degree angle.

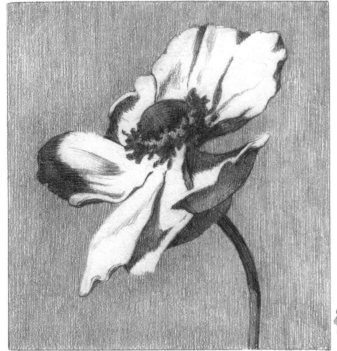

Adjacent areas of shading should be arranged in such a way that one is darker and the other lighter. Areas beside one another may also have almost identical levels of shading. If this happens one of the areas is made more intense so that it stands out.

You can create a smooth surface by drawing parallel vertical or horizontal lines.

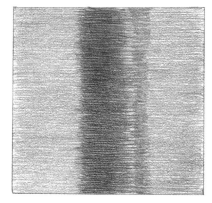

Closely spaced lines running in the same direction can be given different levels of shading by applying varying amounts of pressure.

The boundary between dark and light surfaces can be given a more three-dimensional appearance by making a strip on the shaded side darker.

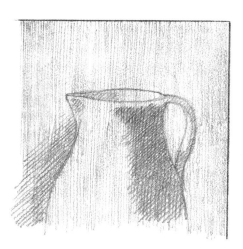

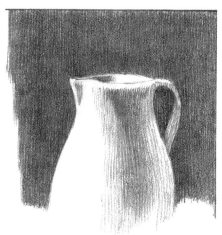

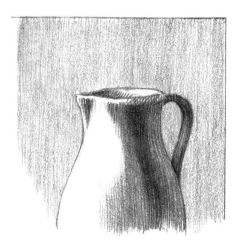

If the shading of the background and the jug are almost identical, the shade of gray for both can be intensified by adding a layer of cross-hatching at a 45-degree angle.

The shading of the background affects the shading of the objects in the drawing. It may also be a bland gray. However, the object will stand out better, the drawing will have greater contrast, and the object will appear lighter if the background is dark.

If the jug is dark the gray of the background may weaken the impact of the dark shading.

For everything else you draw there will be different levels of shading alongside one another. In order to produce really good drawings, you will need to practice discerning different levels of shading. The grayscale (left) will help you to recognize levels of shading and compare their intensity when checking your drawings. You should always look at the ten shadings on the grayscale with narrowed eyes.

The stag beetle's dark color means that its shape must be conveyed by its darkest areas. The dark (black) shading certainly contrasts sharply with the white paper.

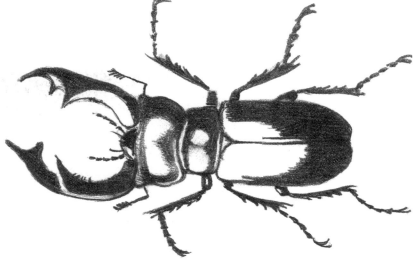

It is worth practicing the transition between different levels of shading. Whether you are drawing a sphere or an armored beetle it is vital to aim at creating smooth surfaces.

The sharp contrast between black and white can be alleviated by subtler shades of gray.

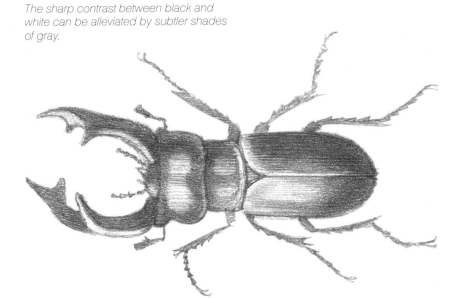

Even the lighter surfaces of objects with a darker base color are darker than white. The exception is shiny surfaces, where white conveys the shine, as with the stag beetle.

Alongside the darker shading the black appears lighter than it would against a different background.

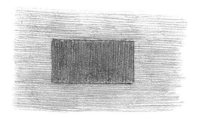

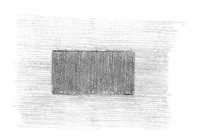

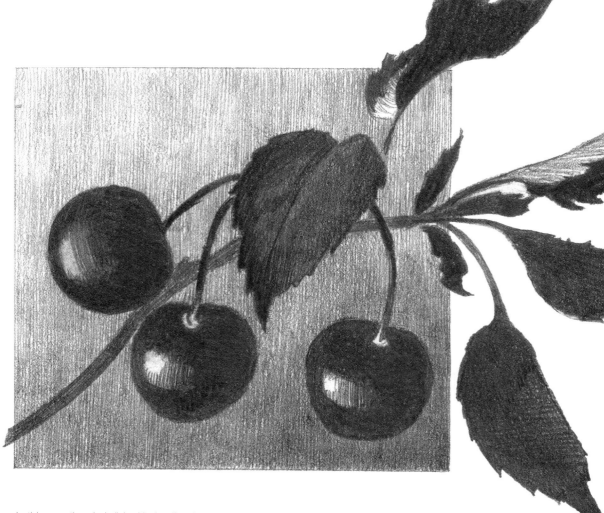

In this way the dark (black) shading is softened by the shading added around it.

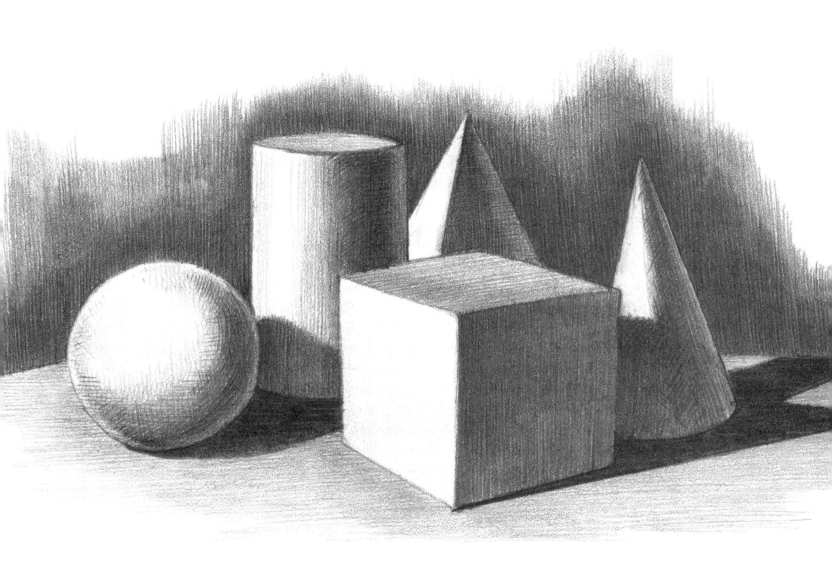

Simple Shapes

Chapter 5

One of the foundations of drawing is the illustration of simple shapes, mastering the simplest geometrical bodies and their laws. These shapes are the cube, the cylinder, the cone, the pyramid, and the sphere.

These shapes might appear simple to draw, but this is far from the case. You must check the details that you have drawn over and over again and adjust the dimensions, as initially your eye will not perceive the subtleties of the subject and your hand will not yet be adept enough at rendering them exactly. A pocket mirror is very useful for looking at the reflection of the drawing; doing this will allow you to spot any errors sooner. Another tried-and-tested method for detecting errors is to turn the drawing around; if you turn it upside down any errors will leap out at you.

One of the most common causes of error is focusing only on the detail that you are drawing at a given moment, and forgetting to check how this relates to other details and to the whole picture.

The **cube** consists of six square surfaces of equal sides that are arranged so that adjacent surfaces form a right angle with one another. The picture of the cube in perspective differs from the "spatial structure" created by the horizontal and vertical planes, depending on its position.

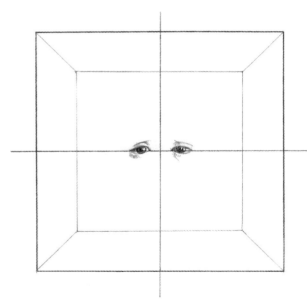

One exception is if only a single side of the cube is visible. In this case the cross made by the planes is exactly in the middle of the visible surface. The cube appears as a square, and the rules for the square apply when drawing it.

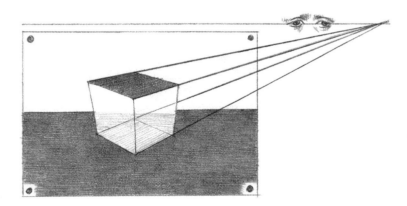

The cube is in the "general" position if three of its sides are visible. In this view the cube is below the horizontal plane.

It is also rare to see only two sides of the solid. Here the vertical lines are parallel to one another, and the horizontal edges run in two different directions toward one another.

Both the
edges and the
opposite sides of
the cube are parallel,
so there are three parallel
pairs of sides, and each pair of
sides has four edges that run in the
same direction. When drawing the cube
you must therefore make sure that its edges
run together in three different directions, so that
it has three vanishing points. The term "vanishing
point" comes from descriptive geometry. The
vanishing points of the cube in the space cannot
be generalized.

If the cube is lying on the ground or parallel to it, for example on a table or a shelf, two of the vanishing points for its lines lie on the horizontal plane, and the third is on the vertical plane.

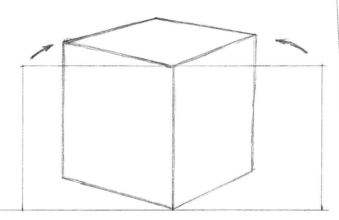

As the sides of the cube are squares, you must understand and apply the rules of the square to every individual drawing.

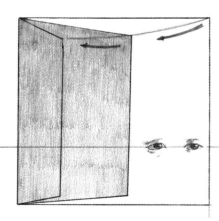

The cube consists of six squares. In the general position the sides of the cube are distorted squares, like an open window: the distance between the two parallel vertical sides becomes shorter, and the top and bottom edges run toward one another.

In the following drawings I will demonstrate the commonest mistakes made when drawing cubes.

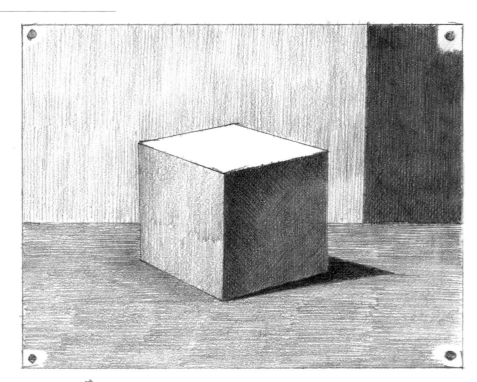

If a side is drawn incorrectly, the cube will appear to have a prism-like shape. You should always pay attention to the direction of the sides.

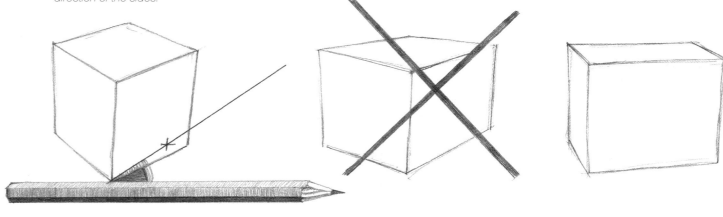

Although you may be well aware that the horizontal sides of the cube should converge into the distance, there is often a tendency to draw them the other way around.

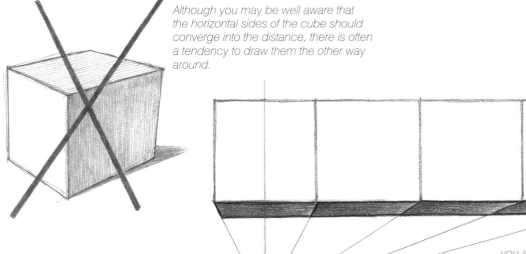

An exception to this is if you are looking at the cube from below. Here the most common error is not noticing that the bottom side is parallel to the ground.

Now we come to the different steps for drawing a cube.

Firstly, decide upon the ideal size of the cube on the paper. It is best to leave enough room around it—not too much and not too little.

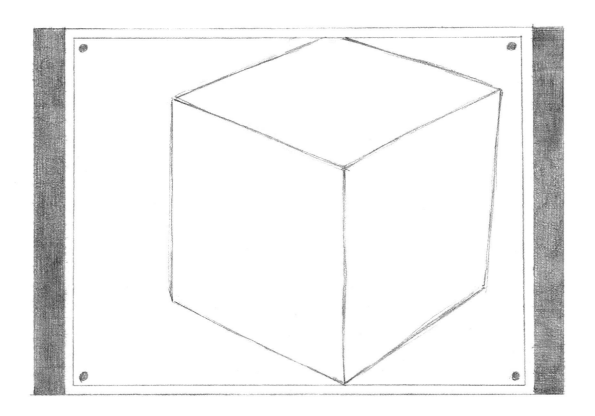

In order to do a practice drawing you have to learn how to place the cube on the page.

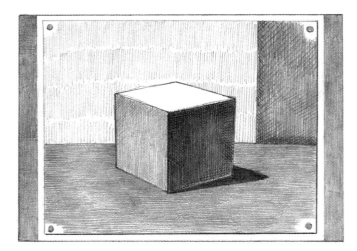

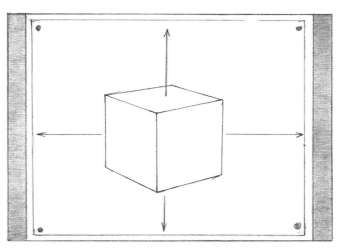

I recommend leaving more room above the cube than under it. Work out which of the two visible side surfaces is the largest and leave a little more "air" for this in the drawing.

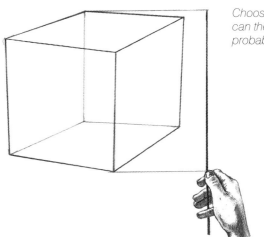

Choose one dimension, so that you can then fit the others around it. This will probably be the total height of the cube.

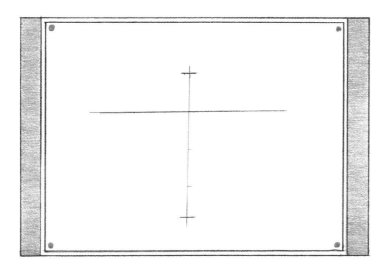

Mark out the height of the top surface in relation to the total height of the cube, and measure how many times it fits into the length of the edge that is closest to you.

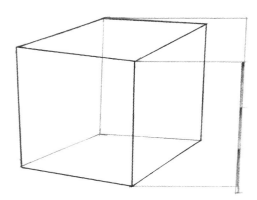

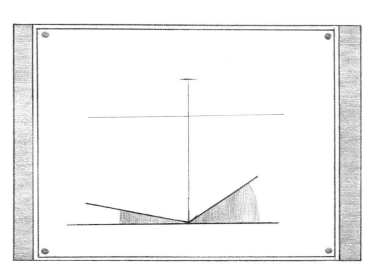

Using a pencil laid horizontally at the lower corner of the cube, establish the direction of both its lower edges, and the angle that they make with the pencil.

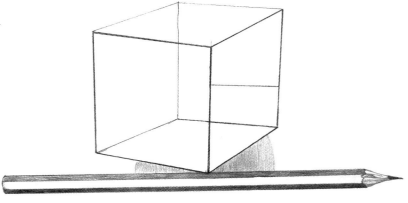

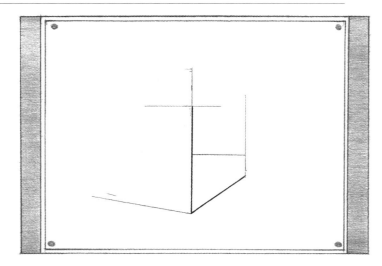

The height of the top surface, the length of the nearest edge, and the direction of the lower edges are now all marked on the drawing. Now measure the width of the right-hand side surface in relation to the closest vertical edge in order to find the position of the right-hand vertical edge.

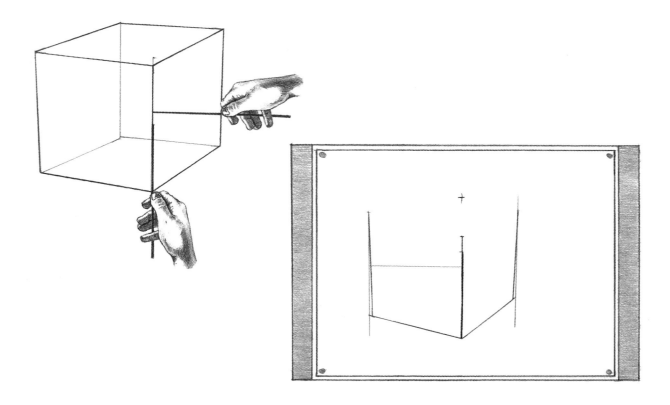

Comparing the dimensions reveals that the width of the left-hand side surface is smaller than the length of the vertical edge that is closest to you. The reason for this is that the surface of the left-hand side is not a regular square, but rather a perspective distortion of such a square, where the vertical edges are shorter the farther they are from you. The horizontal edges are no longer parallel, but run toward one another.

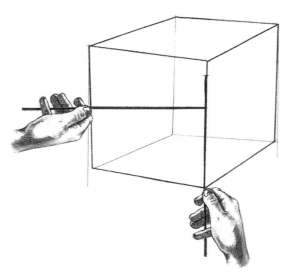

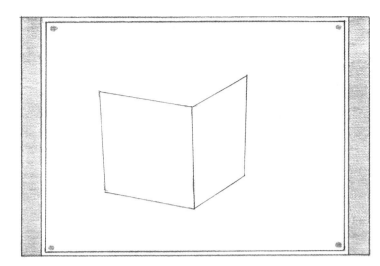

Compare the measurement of the closest vertical side of the cube with the length of the left-hand vertical side. The latter is shorter as it is farther from you.

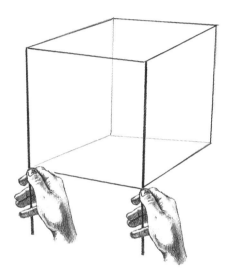

Now you know all of the cube's measurements apart from the exact dimensions of the upper surface. You have already marked the two lower edges and the three corners that they form, but the fourth corner still needs to be found. This is measured by a vertical line from the left-hand corner of the top surface in relation to the length of the nearest vertical edge, and marked on.

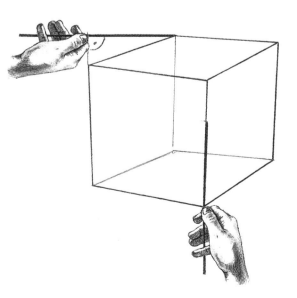

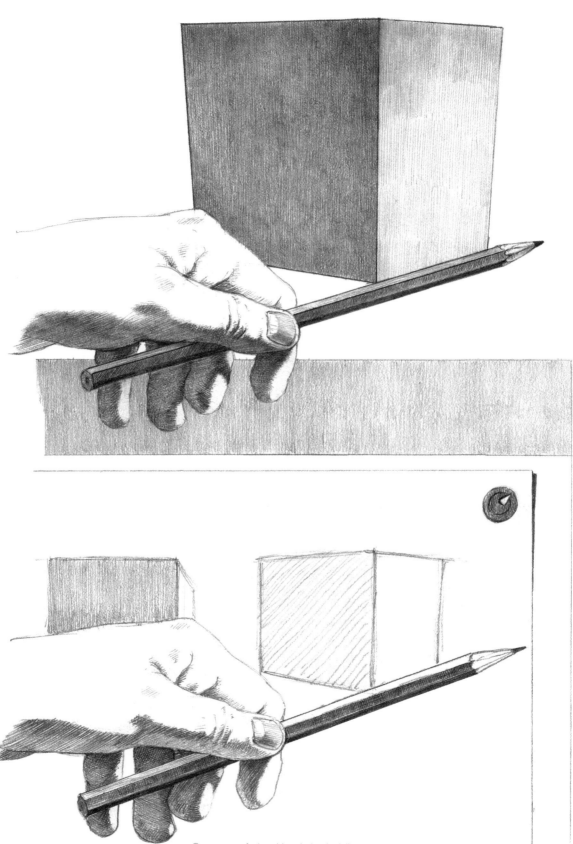

One way of checking is by holding a pencil against each of the cube's edges, keeping your arm straight.

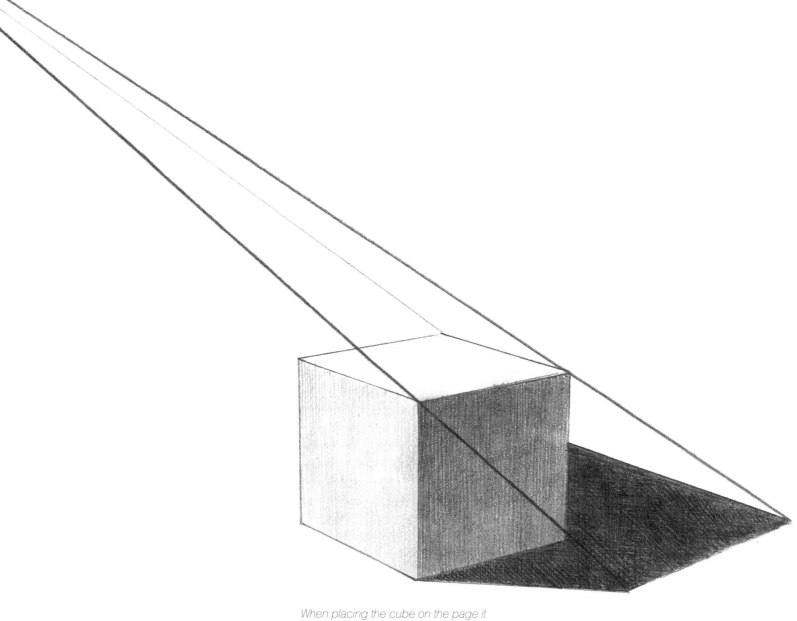

When placing the cube on the page it is vital to draw the shadows that it casts correctly. This is determined by the direction from which the light falls on it.

The **cylinder** is a rotational solid; if you rotate a rectangle or a square around one of its sides or around an axis parallel to an edge, you get a cylinder. A regular cylinder is enclosed at both top and bottom by circular surfaces of equal size. The outer surface or shell of the cylinder is made up of a multitude of the shortest straight lines connecting the edges of both circles. All of these lines are at the same distance from the rotational axis and are parallel to it. The upper and lower circular surfaces of a regular cylinder are at right angles to the shell, while the lower and/or the upper circular surface(s) of an irregular cylinder do not enclose the shell at right angles, so that it may also appear like a cone.

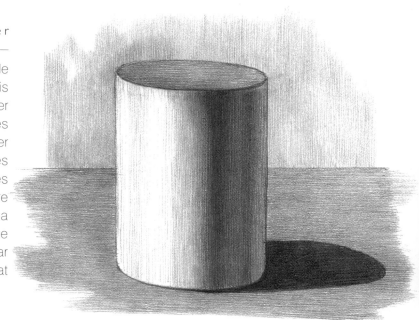

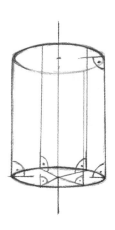

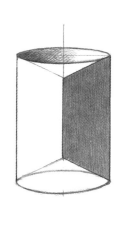

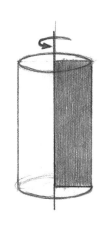

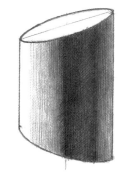

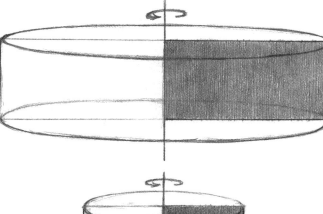

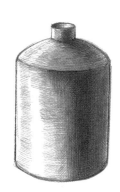

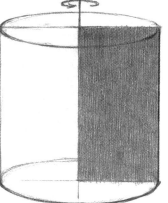

The cylinder has two special aspects: when you look at it from above, you see a circle; when you look at it from the side you see a square or a rectangle.

In the horizontal plane the circle appears as a mere line. The farther away you move the more of the cylinder you see in the top or bottom view, and the wider the ellipse appears. Likewise, if the ellipse is closer to the viewer it appears narrower than one that is farther away.

A common error is simplifying the lower and thus more distant ellipse into a sharply angled arch.

I recommend the following steps when drawing a cylinder. Draw parallel, vertical lines, pressing down evenly with the pencil. Leave no gaps between the lines, or only very small and evenly spaced gaps. At the boundary between the light and the dark (shadowed) sections the shading can be somewhat darker, thus allowing for greater contrast. The shell can also be drawn with parallel arcs which follow the shape of the cylinder. This is rather more difficult, although the same rules apply as in the above case.

It is lightest where the light falls at a right angle to the shell of the cylinder, and becomes increasingly darker from that point. There is a limit at which the rays of light only graze the shell, and from that point on no more light falls upon it. This is the shadowed side, which is given dark shading.

The length of the shadow shows the position of the source of light.

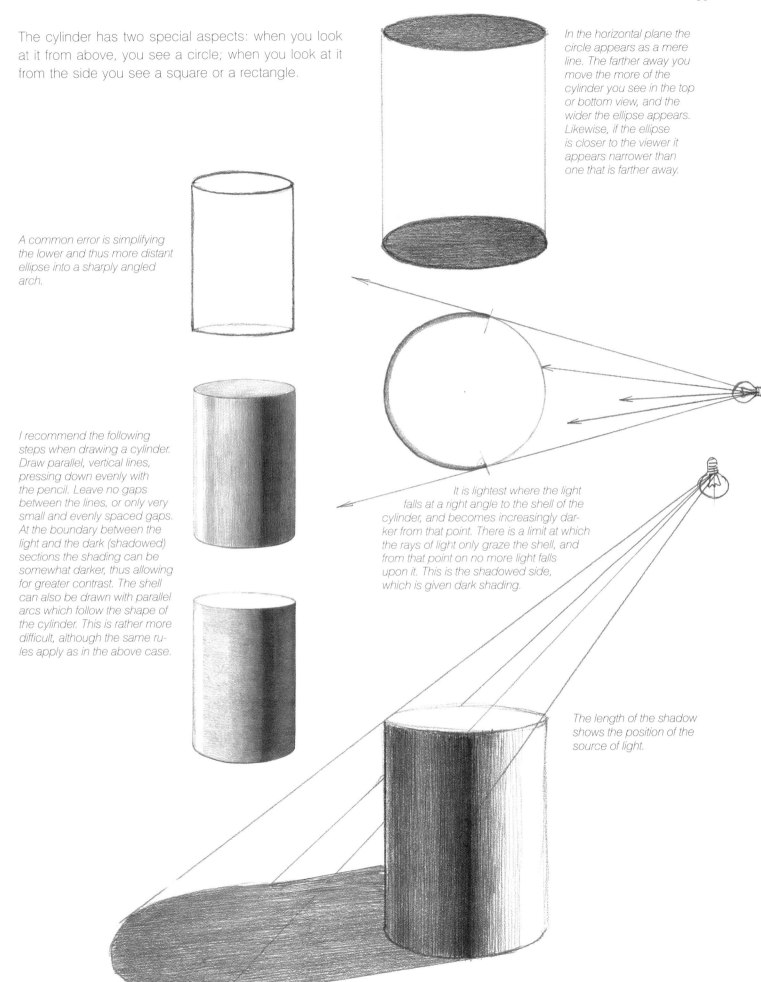

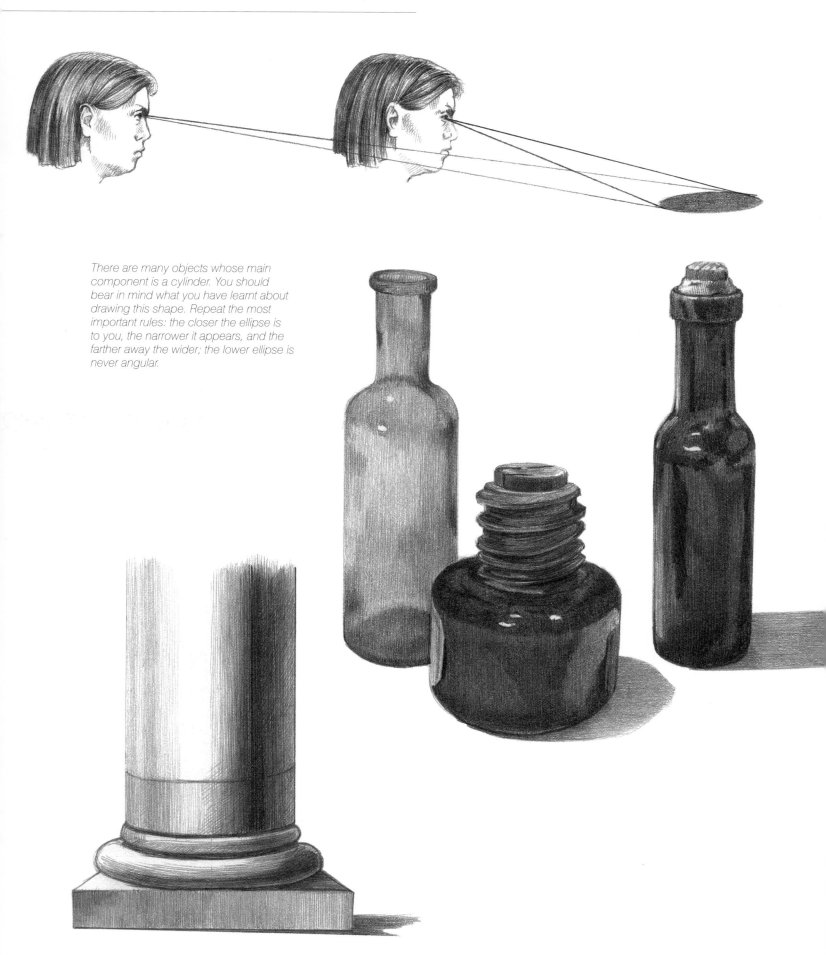

There are many objects whose main component is a cylinder. You should bear in mind what you have learnt about drawing this shape. Repeat the most important rules: the closer the ellipse is to you, the narrower it appears, and the farther away the wider; the lower ellipse is never angular.

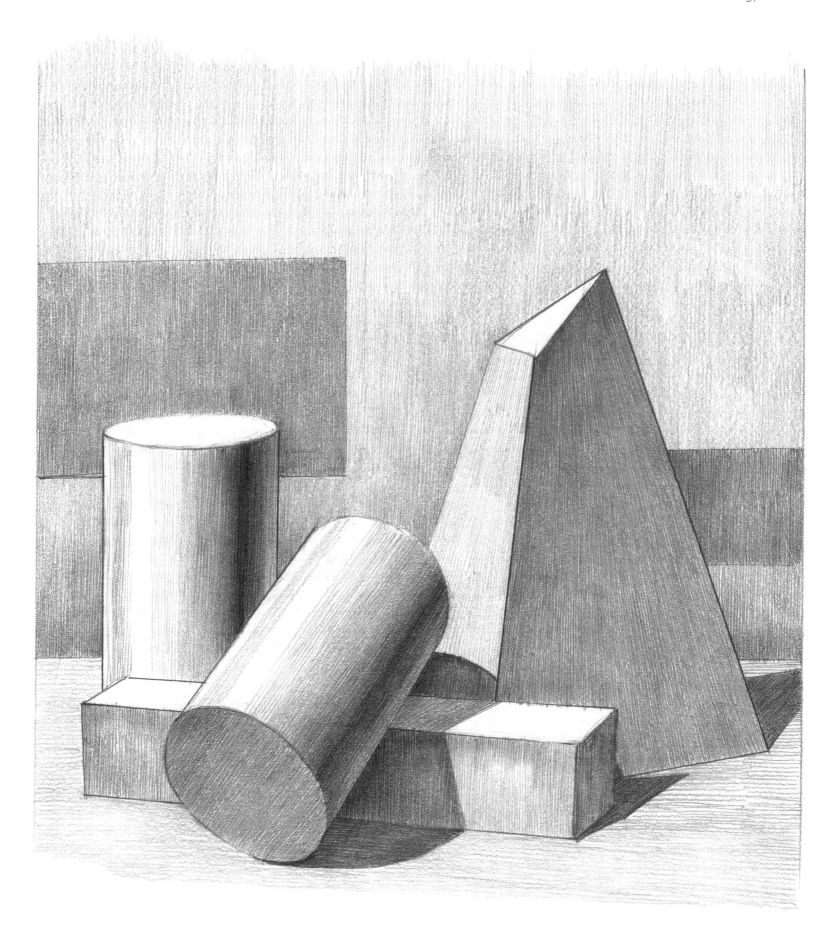

The **cone** is a rotational solid. It is made by rotating a right-angled triangle about one of its sides. This side is the rotational axis and also the height of the triangle, and one of its ends is the top of the cone. The other side gives the base circle of the cone. The shell is made up of myriad "sides." If you were to cut the point off the cone, you would have a truncated cone or frustum. If the rotational axis is not perpendicular to the base circle, this results in a slanting cone.

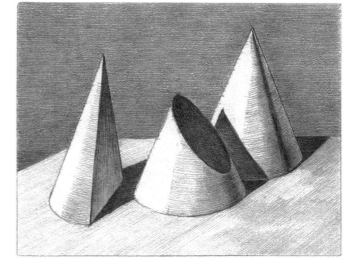

The base of a regular cone in the general position is an ellipse. Light and shadow create areas of transition on the shell of the cone; when shading these areas you should follow the same rules as for the cylinder (see page 55).

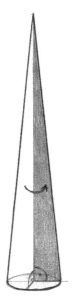

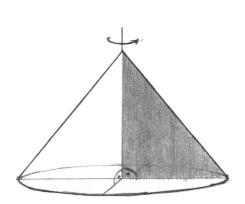

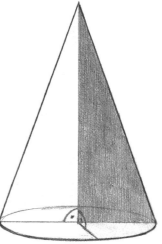

The drawing is wrong if the rotational axis is not perpendicular to the center of the base circle.

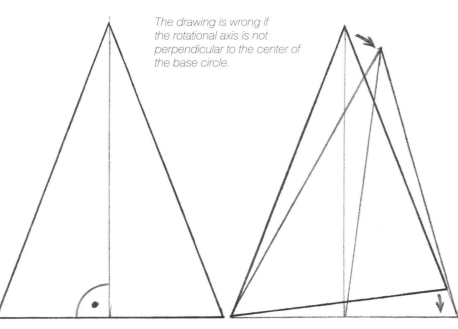

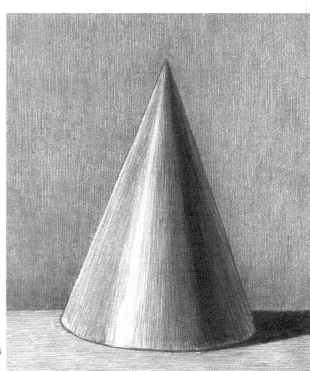

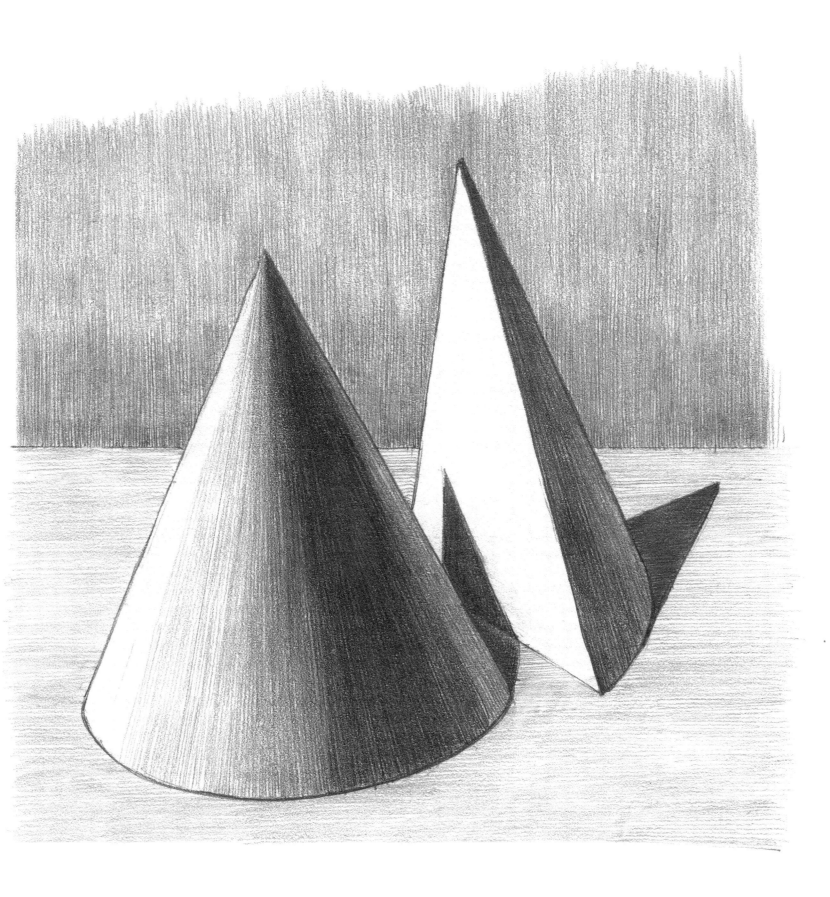

A regular cone has three particular elevations: if the base surface is on the horizontal plane you see an isosceles triangle; from below you see a circular surface; and from above a circle, with the tip of the cone also visible.

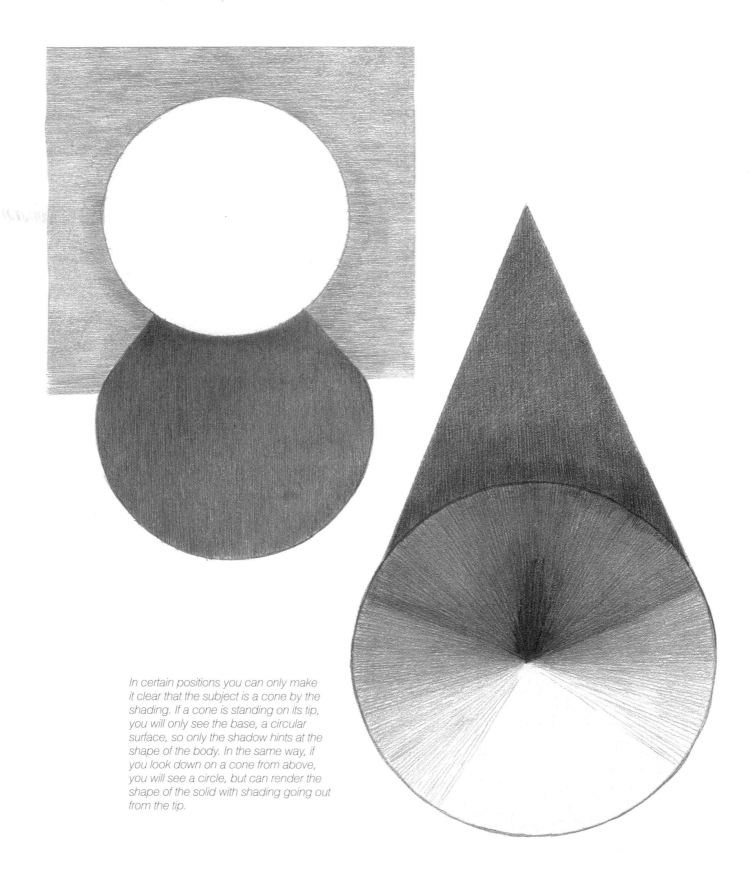

In certain positions you can only make it clear that the subject is a cone by the shading. If a cone is standing on its tip, you will only see the base, a circular surface, so only the shadow hints at the shape of the body. In the same way, if you look down on a cone from above, you will see a circle, but can render the shape of the solid with shading going out from the tip.

Some examples of errors when drawing cones:

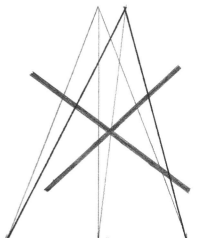

For a regular cone, if a straight line drawn from the tip does not meet the middle of the base circle at a right angle, the drawing is incorrect. This means that the edges of the two sides are not of equal length, so that when the cone is seen straight on it does not appear as an isosceles triangle.

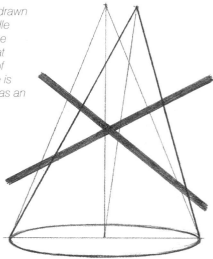

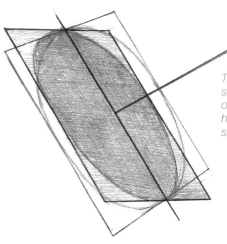

The drawing is also incorrect if the straight line drawn down to the middle of the wide ellipse of the base surface hits it at a right angle, but other details show that it is incorrect.

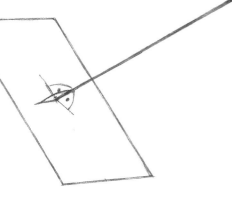

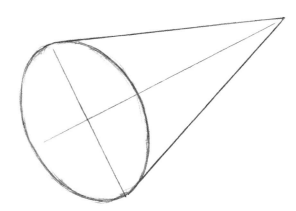

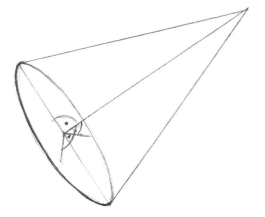

The **pyramid** is a geometrical solid with triangular side surfaces which meet at a common point, the peak of the pyramid, and with a base surface that may be any kind of polygon. If the polygon is regular and the bottom end of a vertical line drawn from the tip to the base lies in its centre, we call it a regular pyramid. In this case the side surfaces consist of isosceles triangles of equal size. In visual art pyramids most commonly have a square base, as this is also the shape of the Ancient Egyptian pyramids.

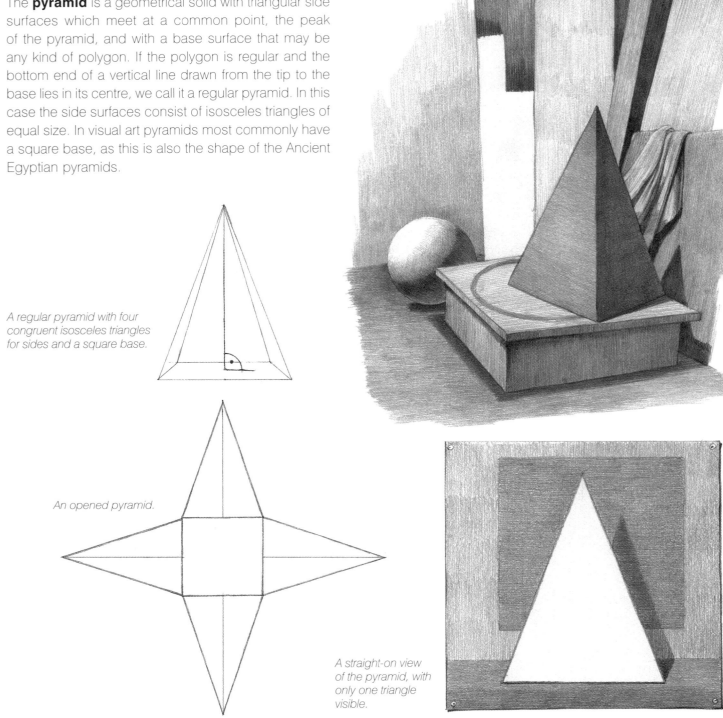

A regular pyramid with four congruent isosceles triangles for sides and a square base.

An opened pyramid.

A straight-on view of the pyramid, with only one triangle visible.

Three sides of a lying pyramid can be seen in the general position. See the section on the square for more details about drawing the base surface (pages 5–8).

Here is another special view of the pyramid, looking down from above. A square can be seen, its diagonals dividing it into four isosceles triangles. The four triangles correspond to the different planes, which are given four different levels of shading. The lightest side is opposite the darkest, and the other two sides can also be shaded differently from one another.

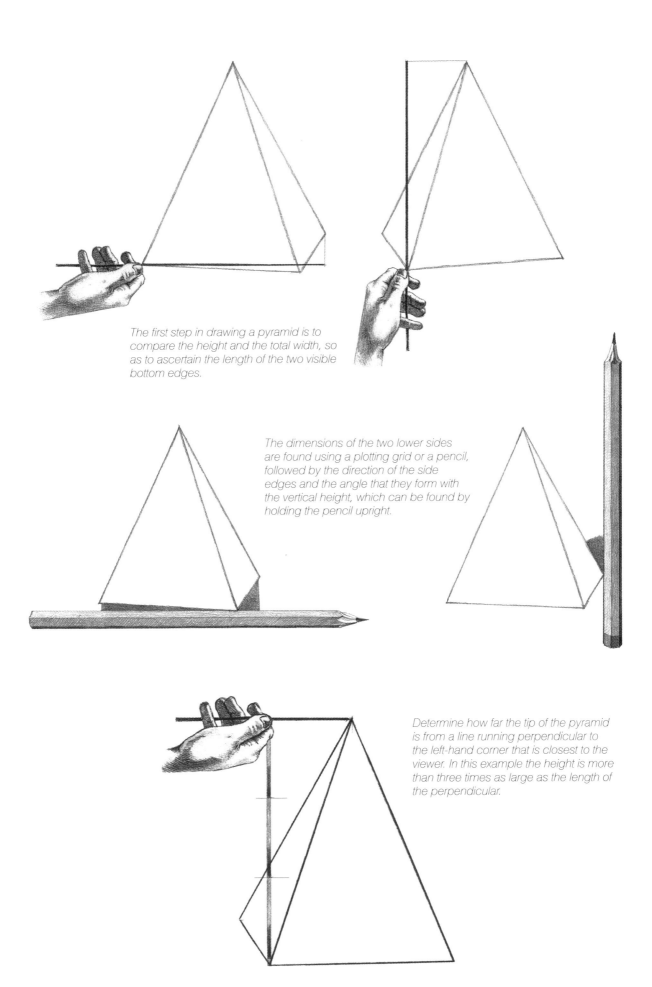

The first step in drawing a pyramid is to compare the height and the total width, so as to ascertain the length of the two visible bottom edges.

The dimensions of the two lower sides are found using a plotting grid or a pencil, followed by the direction of the side edges and the angle that they form with the vertical height, which can be found by holding the pencil upright.

Determine how far the tip of the pyramid is from a line running perpendicular to the left-hand corner that is closest to the viewer. In this example the height is more than three times as large as the length of the perpendicular.

The **sphere** is the most regular geometrical solid. It is a solid of revolution which is made by rotating a circle 360 degrees around its own diameter.

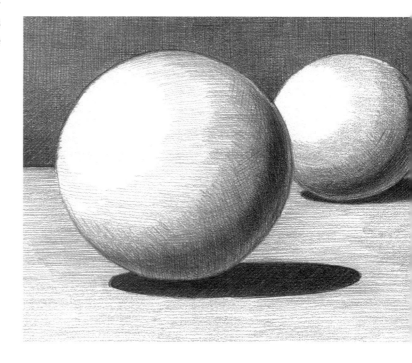

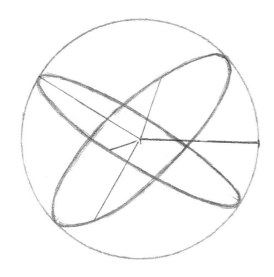

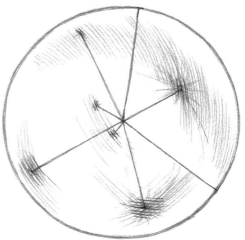

Every point on the surface of the sphere is at an equal distance from its center.

The sphere is the only geometrical body that does not have any view that is distorted in terms of perspective, so it never looks like an egg.

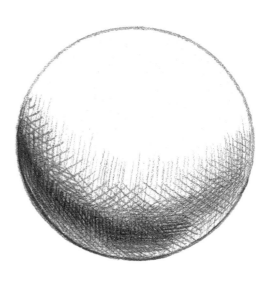

The size of the shadow depends on the position of the source of light.

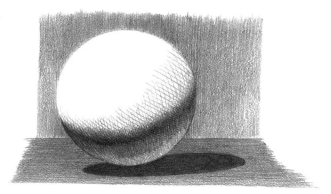

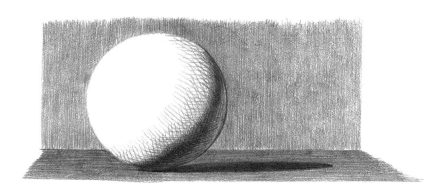

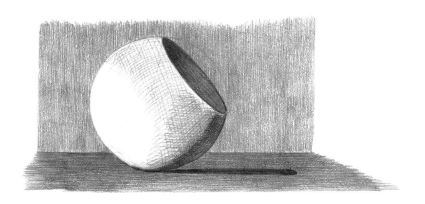

There are many objects that incorporate a sphere in their overall shape. A mixing bowl, for instance, is reminiscent of a sphere that has been cut in half; its exterior is convex and its interior concave. The points where it is lit from the outside are dark on the inside, and where there are shadows on its outer shell, the inner surface is light.

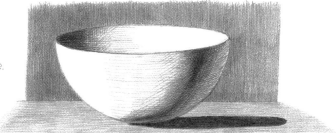

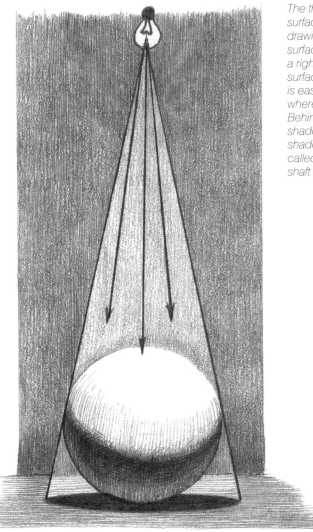

The three-dimensional features of the surface must be represented in the drawing. The lightest point on a sphere's surface is where the light hits it at exactly a right angle. As it curves round, the surface becomes gradually darker. It is easy to make out the outline—this is where the light merely grazes the shell. Behind this the body is dark, in its own shadow. The shadowed side is not evenly shaded, either: there is a lighter patch, called the reflex, caused by the reflected shaft of light.

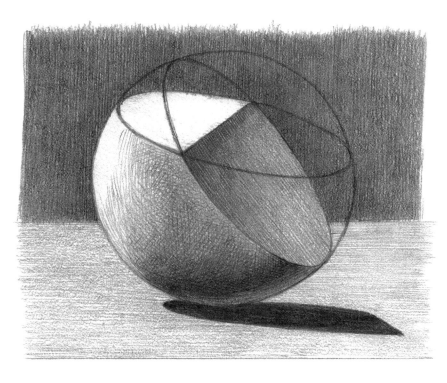

The special thing about the sphere is that all its views and cross-sections appear in the form of ellipses. Generally, cross-sections are drawn as ellipses.

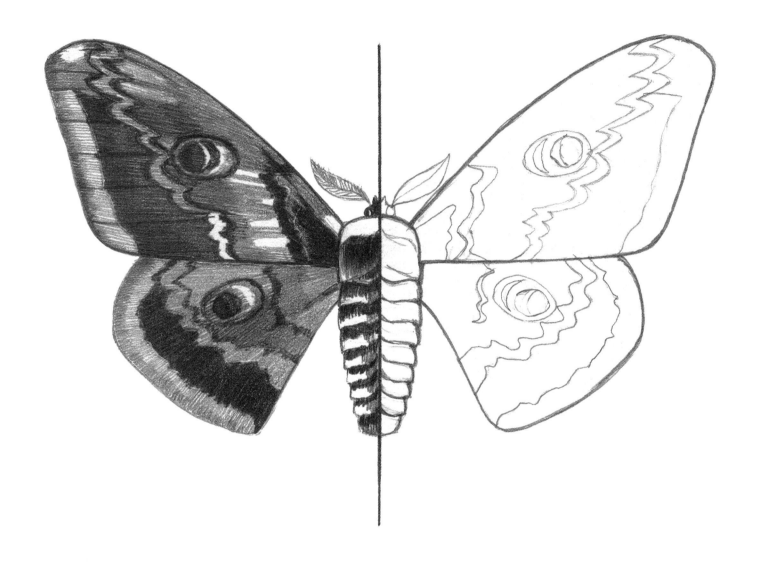

Symmetry

The majority of creatures and objects are symmetrical; they can be divided into two equal, albeit inverted, halves along a bisecting line, the axis of symmetry. Each half on either side of the axis of symmetry is the mirror image of the other. Symmetry is an important component of artistic skill. Reproducing symmetry on paper looks easy if you are drawing the subject from a front view, but it is much harder if the perspective of the object is more distorted.

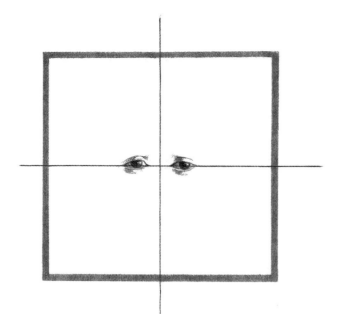

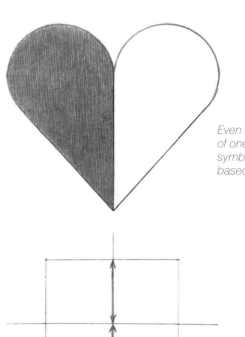

Even the stylized image of one of the most familiar symbols, the heart, is based on symmetry.

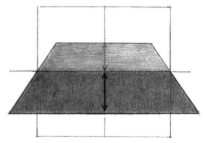

One of the fundamental rules of perspective dictates that the half that is farther from the viewer should be smaller than the closer half, although when seen straight on they are of equal size.

A simple example is an open door. If you do not draw the farthest part according to the rules of perspective, thus making it larger, the imaginary door would be impossible to shut. Clearly, the solution is to measure by comparing the width of both halves. If they are of equal width the drawing is definitely incorrect, as the part that is farther away must be smaller.

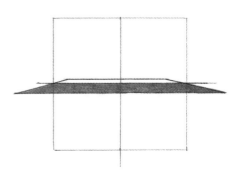

One of the best examples for helping to understand and get a feel for symmetry is the circle, where every point is at an equal distance from the center. This distance is the radius (r).

The circle's symmetry means that you can also draw it using a thumbtack and a pencil tied to a thread.

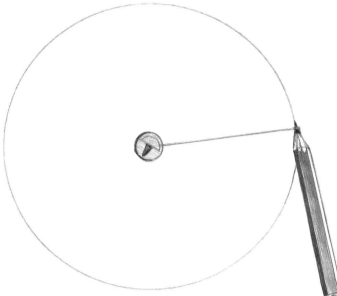

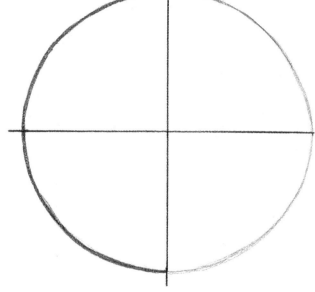

The symmetrical image of the semicircle is the whole circle.

Drawing a circle that has a distorted perspective can be made easier by drawing a square around it. Sketch in the vertical and horizontal bisecting lines of the square and mark the center of the circle. The circle will touch the square at its bisecting points. A circle suspended in space—a circle in the general position, in other words—always appears as an ellipse. You should bear in mind that the half of the square that is farther from the viewer appears smaller than the closer half, and so the half of the ellipse that has been tilted backward also appears smaller.

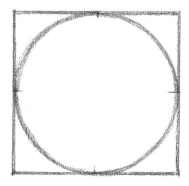

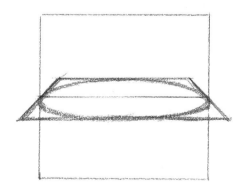

Symmetry is a feature of solids of revolution. Their surfaces consist of a curve rotated about a fixed axis. They are enclosed by two circular surfaces that are perpendicular to the axis of rotations, which can also be reduced to a point, depending on their radius.

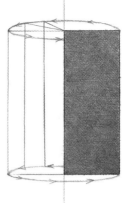

The cylinder is a typical solid of revolution. In one view, the cylinder appears as a rectangle. If you draw in the rotational axis, you get symmetrical rectangles which themselves produce the cylinder if they are rotated.

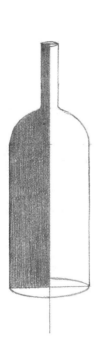
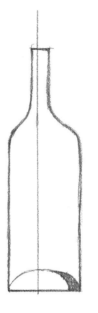
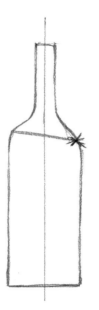
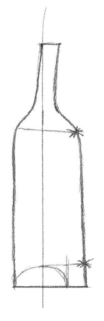

Many everyday objects are solids of revolution. Most errors in drawing such objects are the direct result of a failure to notice their most important detail—symmetry.

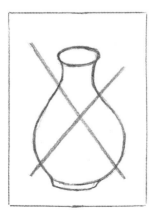

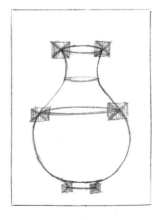
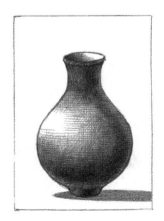

Jugs and vases are typical solids of revolution. Spot the differences between the two false drawings and the correct one. The first picture does not show the

vase's symmetry, and the top view of the lip is too exaggerated, while the ellipse at its foot is almost flat. This should be the other way around, as is shown in the third,

correct drawing. In the second drawing the mistake is that the curve of the ellipse is angular, although it should be an unbroken line.

A great many living organisms can likewise be divided into two symmetrical halves by a straight line, even though there tend to be small imperfections.

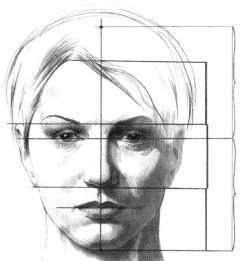

The human face is also symmetrical, although not completely—there are small differences. The head's bisecting line is its principal axis.

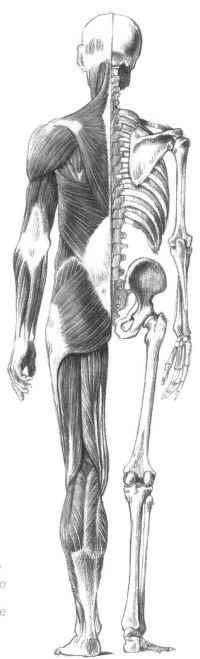

In the same way, a human skeleton and muscular system can be divided into two symmetrical halves. In the front or rear view, the bones and muscles of one side are a symmetrical reverse image of the other.

The exception is the center plane, as in some cases the bones here only appear once. However, this can also be divided into two symmetrical halves by a bisecting line.

You should pay careful attention to symmetry when drawing. An elephant's muscular system is symmetrical; however, to produce a lifelike drawing you must bear in mind that the folds of the skin and the ears should look similar on both sides, but not identical.

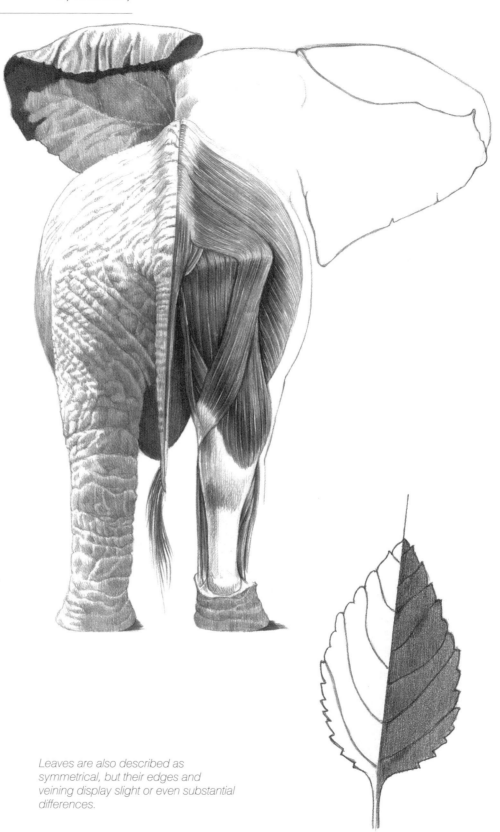

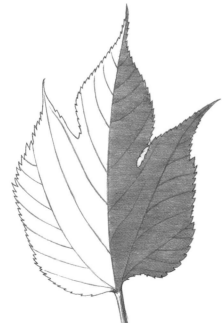

Leaves are also described as symmetrical, but their edges and veining display slight or even substantial differences.

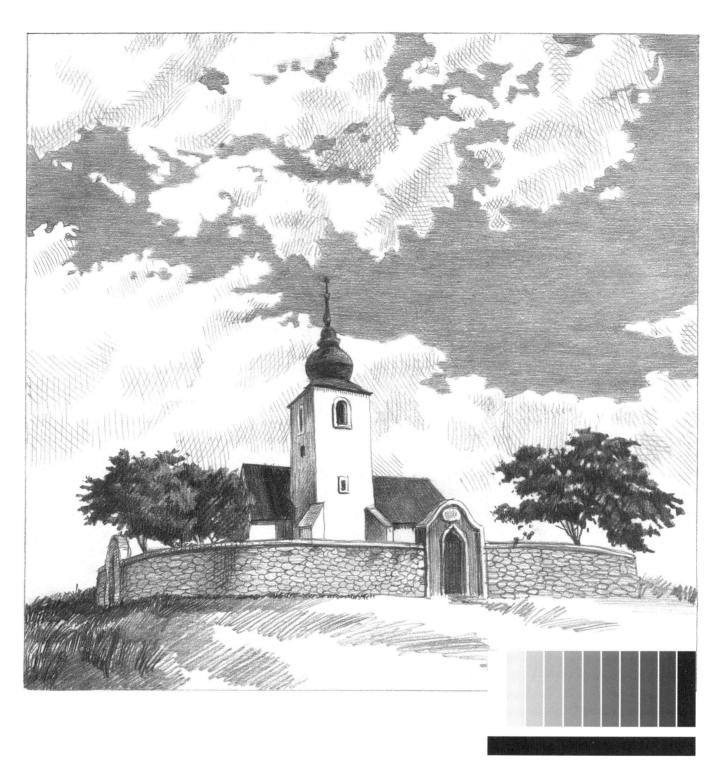

Grayscale

A postcard-sized card with 11 strips of shading, from white to black, is enclosed in this book. This grayscale is an aid to recognizing different levels of shading. This is important in drawing, as contours drawn in with lines can be amplified by shading. The grayscale is easy to use; by holding it over the subject it is easy to see which of the strips corresponds to the shading that you are about to draw. After working out the level of shading, place the grayscale over the drawing and check whether the detail corresponds to what you can see.

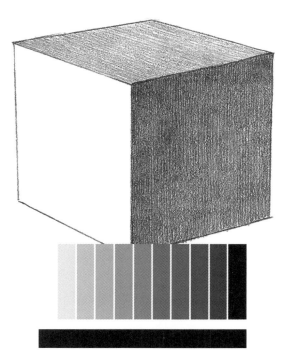

Let us start with something simple. Three sides of a cube are visible, each with a surface running in a separate direction. Even if the direction of one surface is only marginally different from another, they must be given different levels of shading.

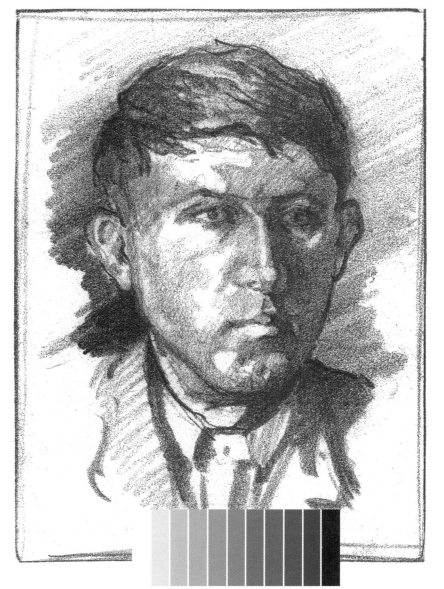

The variety of different shades that appear on a much more complicated shape than the cube, such as a face, presents a big challenge for the inexperienced artist. It takes practice to be able to discern these, but you will soon be able to do it without the grayscale.

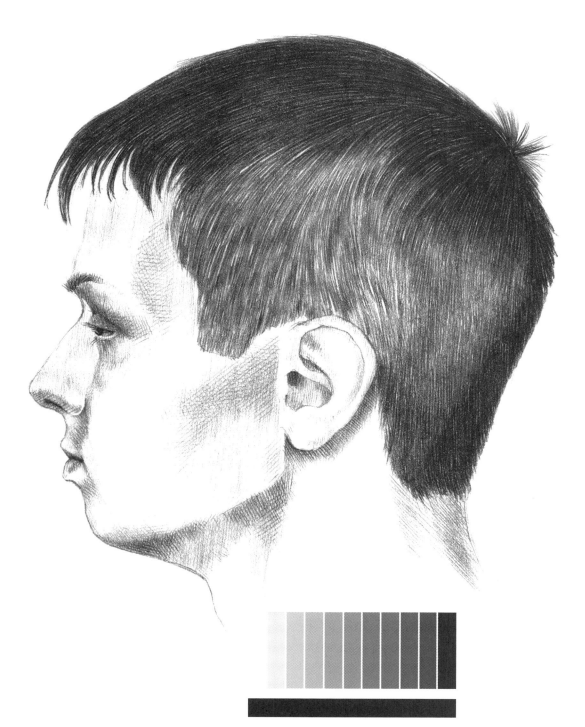

If you look carefully at the hair of the model, you can see different shades. I generally recommend looking at these hues through narrowed eyes, so that your vision is more focused, and you will see the image as an array of shaded surfaces, without excess detail. It is vital to begin the drawing with the darkest shade, and adjust the other tones to this one.

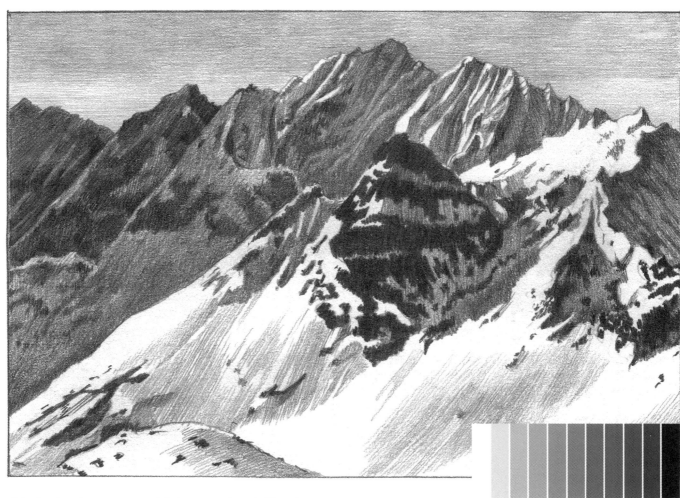

This drawing shows an especially large number of different shades, but the grayscale makes it relatively easy to tell them apart. Hold the grayscale against the drawing, narrow your eyes and work out which strips of shading correspond to the tones in the drawing. These are always adjusted to the darkest areas of shading in the drawing. If the darkest surface is not strong enough and appears paler than the original subject, the remaining areas of shading will be lighter and the drawing is more likely to look dull.

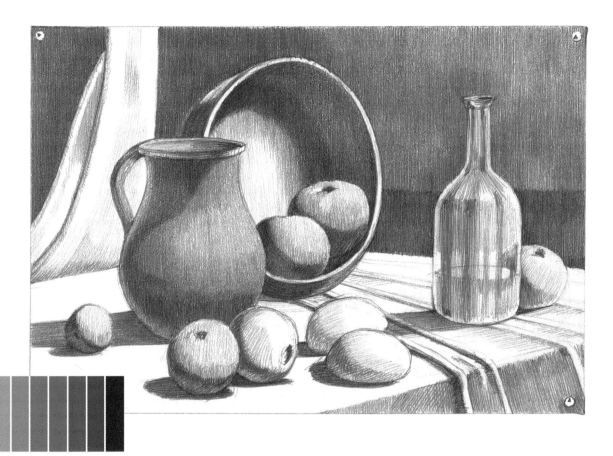

When drawing still lifes you have to take account of the shading of many different materials. Narrowing your eyes to look at what you want to draw helps, as does using the grayscale. In both drawings the most important thing is to capture the gray shading of the background, the shading of the table surface, and the dark shading of the jug accurately. Work out the order of the surfaces, from light to dark. This will also help you to render the transitions between the different areas of shading.

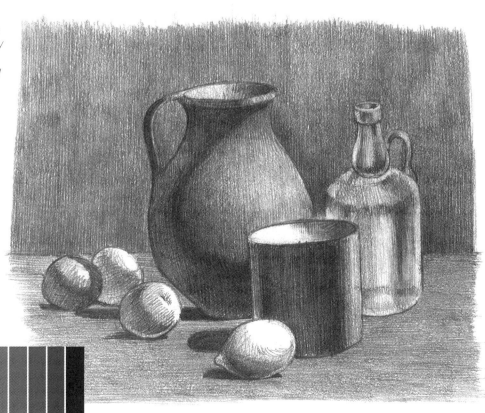

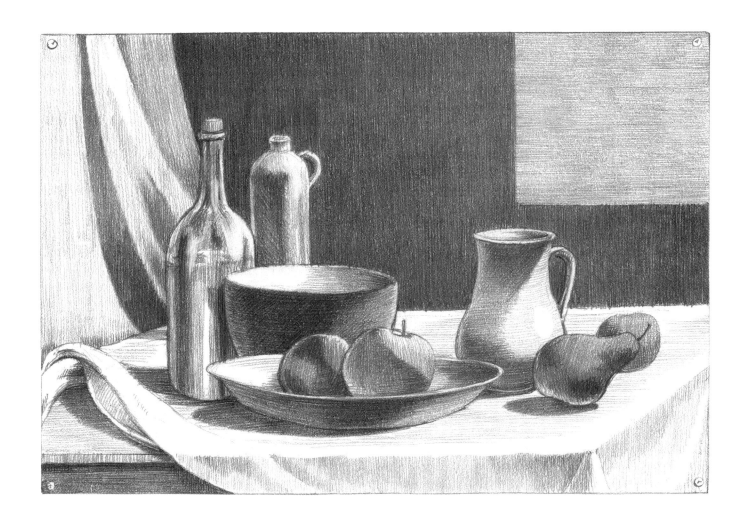

Drawing Objects

Chapter 8

When drawing objects you can apply what you have learned about perspective, simple shapes, shading, symmetry, measuring, and the grayscale. The first step is to work out which simple shapes form the basis for the objects which you have chosen to draw.

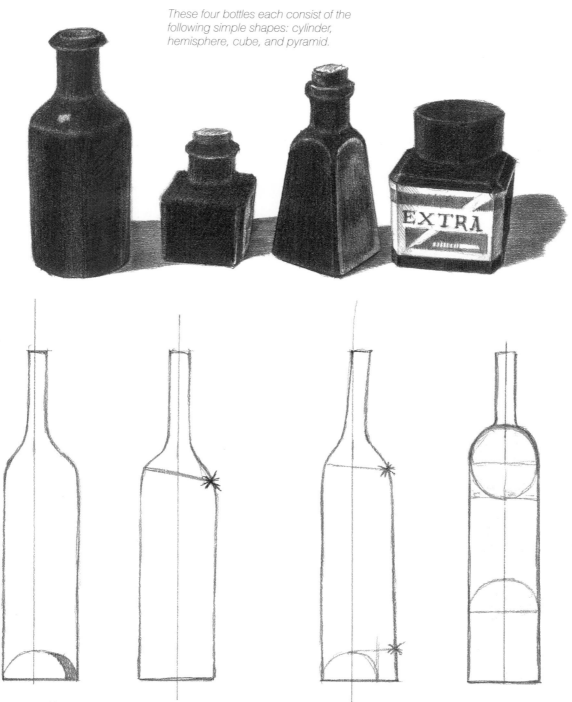

These four bottles each consist of the following simple shapes: cylinder, hemisphere, cube, and pyramid.

You can see that the glass bottle is made up of the simple shapes of two cylinders of different sizes, and a hemisphere. When drawing solids of revolution it is important to sketch in the rotation axis, as the side edges of the neck and the body must be at an equal distance from it. Drawing the neck and the body as though they have different rotational axes is a common mistake. The "shoulders" of the bottle are symmetrical; the best way of making sure of this is to sketch in a circle.

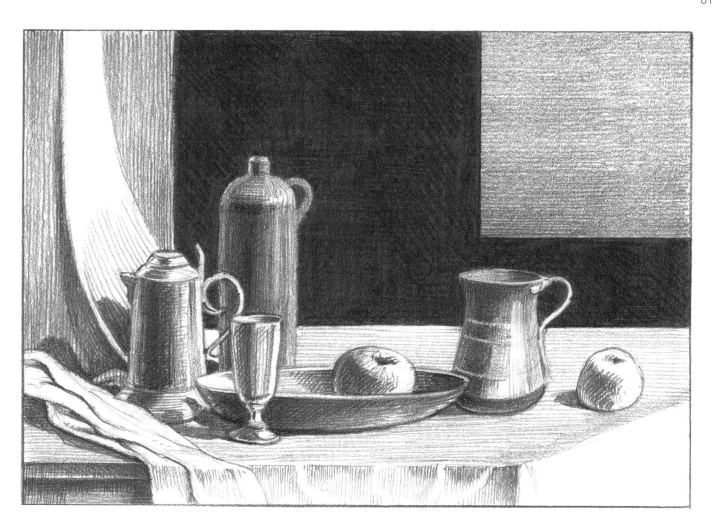

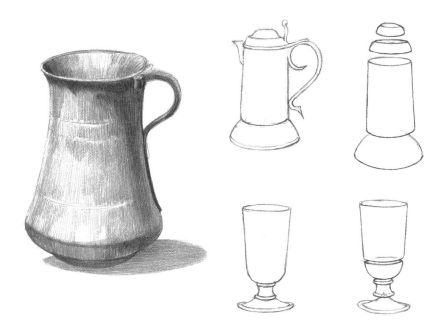

A closer look at the objects in the still life reveals that their shapes are extremely different from one another. Practice by "dissecting" them into the geometrical bodies that form them. As most objects are solids of revolution, you can use the rotational or symmetrical axis as an aid when drawing.

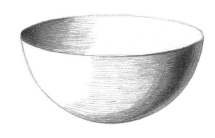

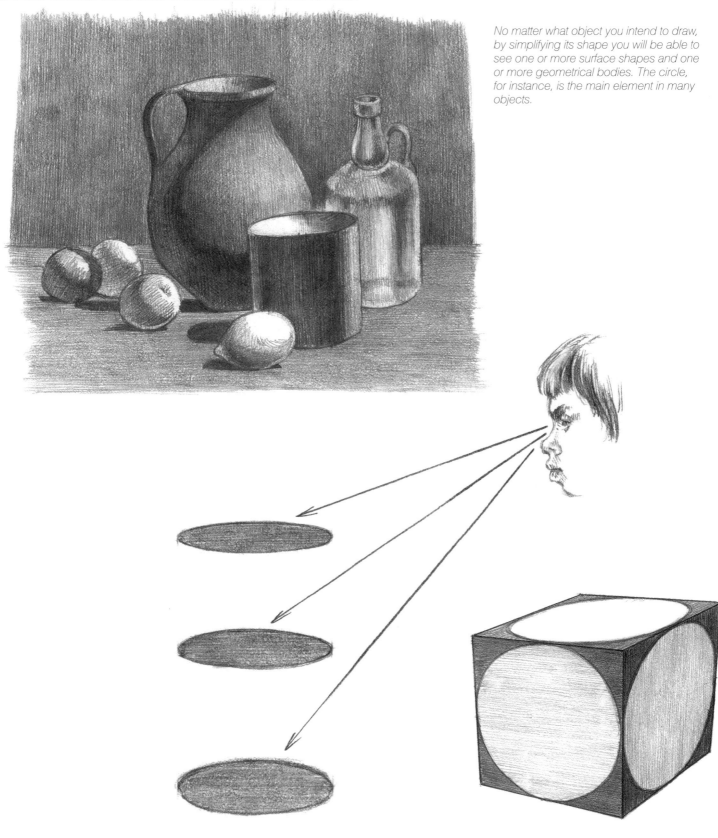

No matter what object you intend to draw, by simplifying its shape you will be able to see one or more surface shapes and one or more geometrical bodies. The circle, for instance, is the main element in many objects.

The farther away the circle, which generally appears as an ellipse, from the viewer, the more of it can be seen. With this rule in mind, you should make sure that the curve of the ellipse that forms the base surface of a jug, glass, etc. is broader than its mouth.

What you have learnt about the circle can also be put to use when drawing objects that appear to have nothing to do with circles; when drawn on the sides of a cube, circles—or rather, as they generally appear, ellipses—will help you to estimate the length of the sides.

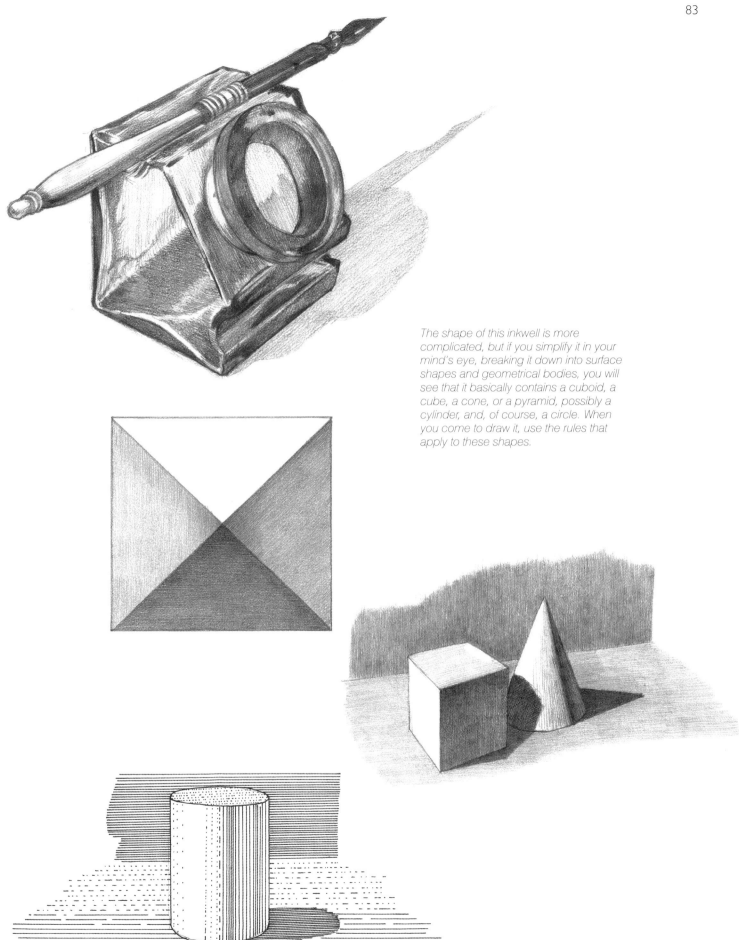

The shape of this inkwell is more complicated, but if you simplify it in your mind's eye, breaking it down into surface shapes and geometrical bodies, you will see that it basically contains a cuboid, a cube, a cone, or a pyramid, possibly a cylinder, and, of course, a circle. When you come to draw it, use the rules that apply to these shapes.

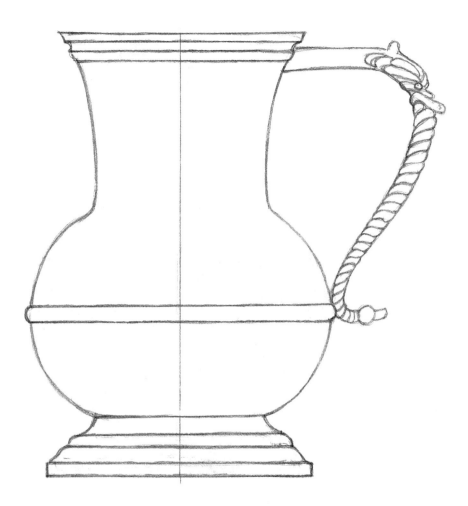

Of course, sometimes a shape cannot be simplified. Even if you break a jug down into rotational bodies that match its shape, there is no template for the curve of the handle. In this case it is best to make measurements and use a plotting grid. You will also find that it helps to concentrate on the "negative space" between the outline of the jug and the inner line of the handle, rather than on the handle itself.

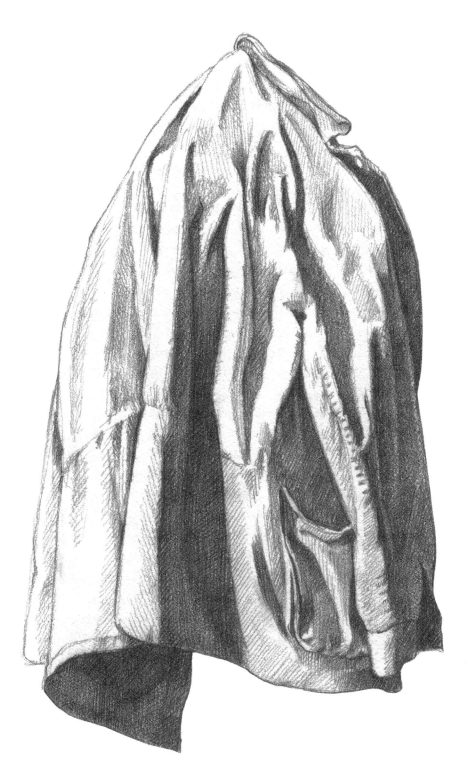

Drapery

Chapter 9

As evidenced by countless works of visual art, drapery is a much used element in paintings and other artwork. In order for it to have the desired effect, however, you must know the rules about how to draw it. In most cases the folds of the drapery follow certain rules, but randomness can also play a part in the composition. Gathers and folds show from how many points the drapery is being hung, hint at the object that it is covering, and offer a clue as to the material that is being used. Drawing drapery presents a challenge for the artist, but by following the rules you can let your imagination run free on the work. No one will know or care to check whether the original subject looked exactly the way you have drawn it.

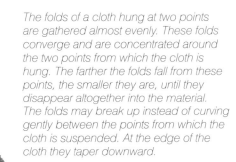

If drapery is hung from a single point, the folds taper away from this point due to the resistance of the material.

The folds of a cloth hung at two points are gathered almost evenly. These folds converge and are concentrated around the two points from which the cloth is hung. The farther the folds fall from these points, the smaller they are, until they disappear altogether into the material. The folds may break up instead of curving gently between the points from which the cloth is suspended. At the edge of the cloth they taper downward.

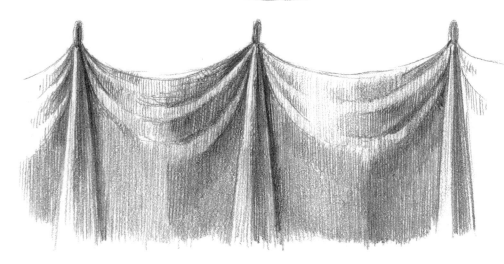

The edges and folds also taper under the hanging points when the drapery is hung from several points. Between the hanging points there may be a row of folds that become less pronounced as it moves downward, before disappearing altogether. The size and density of the folds depend on the distance between the hanging points. The material of the cloth also affects the way in which the folds fall. The cloth in this drawing, hung from three points, appears almost ethereally light.

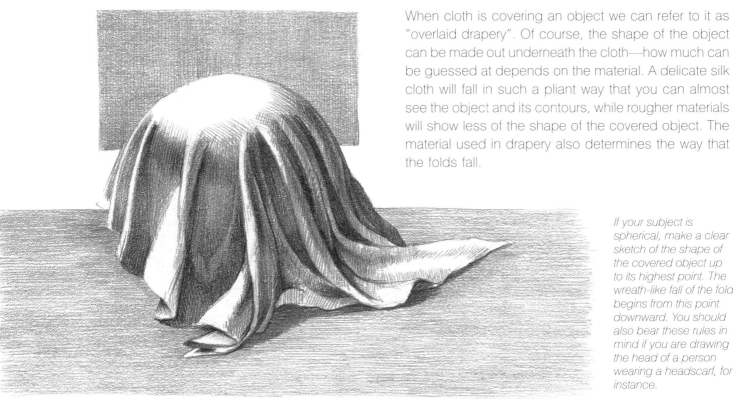

When cloth is covering an object we can refer to it as "overlaid drapery". Of course, the shape of the object can be made out underneath the cloth—how much can be guessed at depends on the material. A delicate silk cloth will fall in such a pliant way that you can almost see the object and its contours, while rougher materials will show less of the shape of the covered object. The material used in drapery also determines the way that the folds fall.

If your subject is spherical, make a clear sketch of the shape of the covered object up to its highest point. The wreath-like fall of the folds begins from this point downward. You should also bear these rules in mind if you are drawing the head of a person wearing a headscarf, for instance.

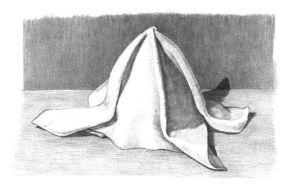

Most of the folds of drapery that is covering a sharp object, a cone, or a pyramid are tapered, but at the point where the drapery meets the floor the shape and direction of the folds become completely irregular.

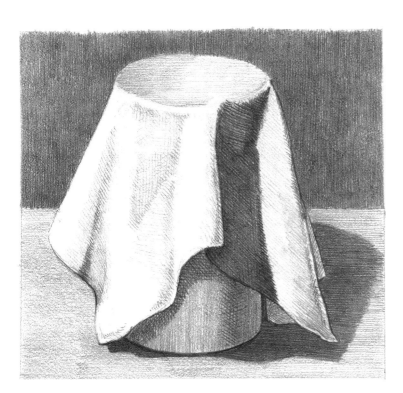

For cylinder-shaped objects such as a circular side table, the round table surface can be seen through the smooth covering, while the folds of the cloth hanging down are tapered.

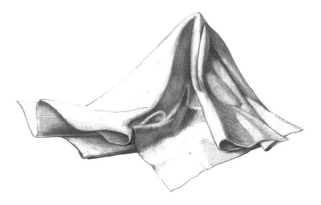

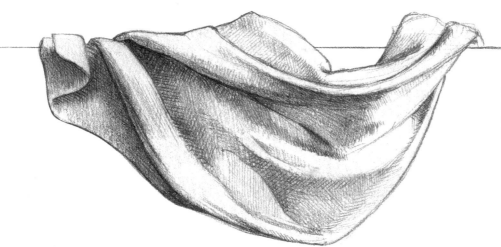

If you cover the object with both ends of the draped cloth, the folds will fall in a similar way to drapery that is hung from two points.

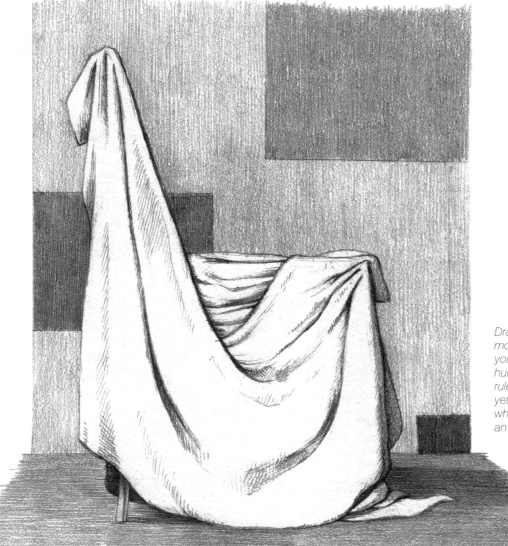

Drapery laid over a chair makes things more complicated. For some sections, you will have to apply the rules for cloth hung from a single point, for others the rules of cloth hung from two points, while yet others follow the rules for the way in which the folds fall if the cloth is laid over an object.

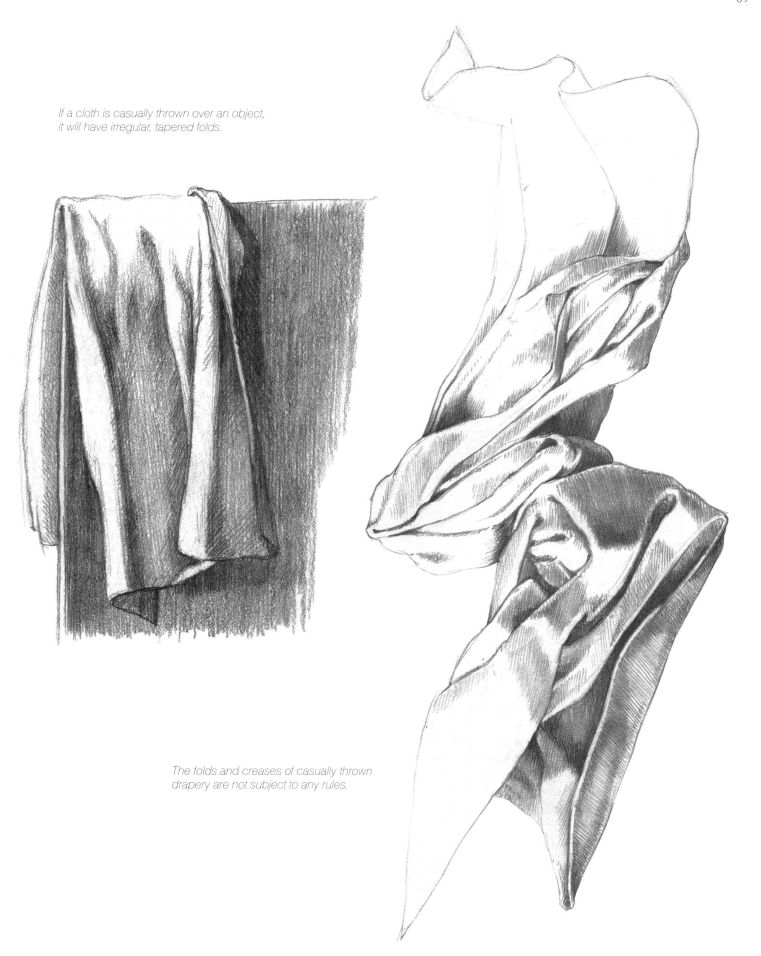

If a cloth is casually thrown over an object, it will have irregular, tapered folds.

The folds and creases of casually thrown drapery are not subject to any rules.

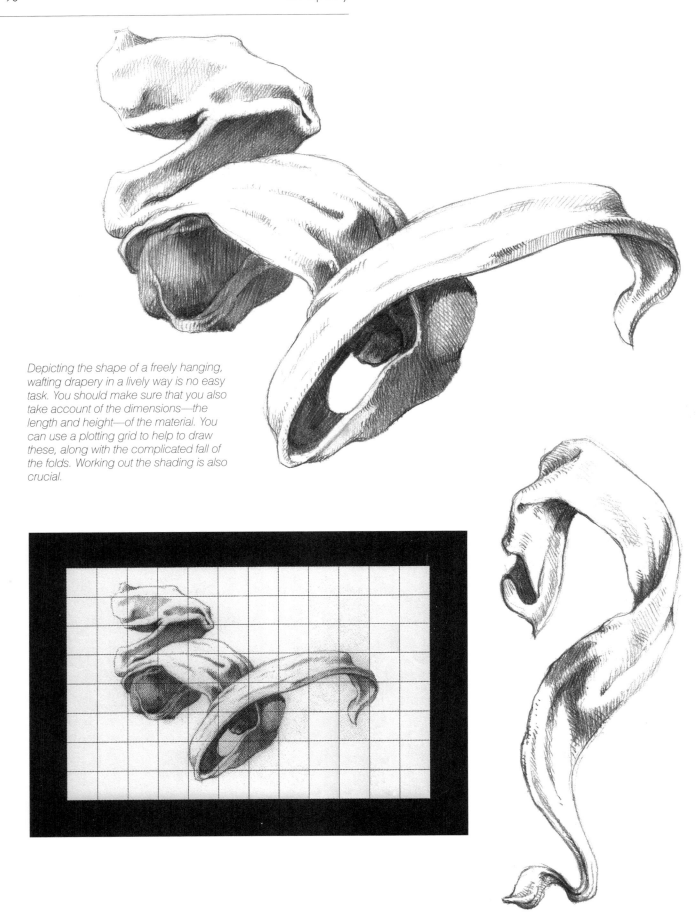

Depicting the shape of a freely hanging, wafting drapery in a lively way is no easy task. You should make sure that you also take account of the dimensions—the length and height—of the material. You can use a plotting grid to help to draw these, along with the complicated fall of the folds. Working out the shading is also crucial.

When drawing drapery you must observe the dimensions and volume of the cloth carefully. A plotting grid will help with this task.

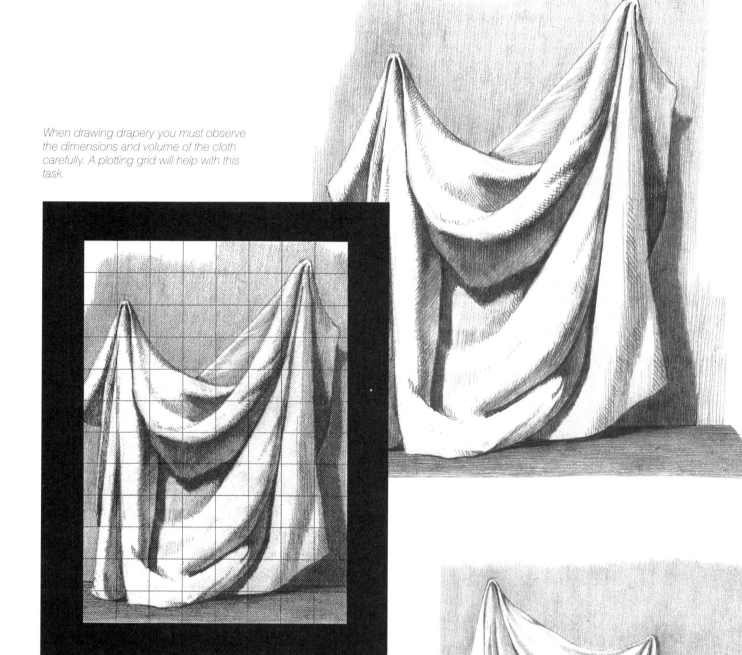

Using drapery enhances the background of a still life. The tapering of the cloth, hung from two points, and the folds between the two points break up the space, while the interplay of shading that this creates gives it a more aesthetically pleasing appearance. In this example the drapery acts not merely as embellishment, but rather brings the objects in the still life together and gives them emphasis.

*The corner of a cushion also has some
interesting indentations. You should make
a habit of noticing the beauty of small,
apparently insignificant details!*

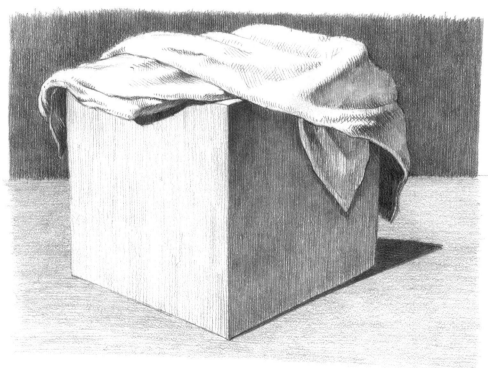

*This drapery, which has been thrown
loosely over a cube, only reveals the
features which I have outlined for overlaid
drapery to a limited extent. The overall
impression is one of randomness. In
such cases you do not have to stick to
the rules; the most important thing is to
achieve a good composition, and this
may mean tweaking the actual reality a
little.*

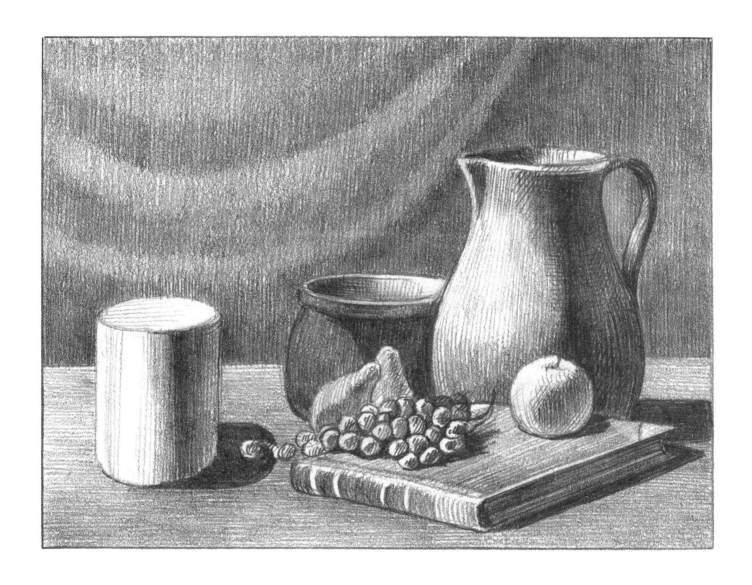

Still life

A still life represents your first opportunity to really immerse yourself in your creativity and draw freely. This type of drawing may seem completely free of rules, but it is, in fact, based on strict principles. In art the phrase "still life" generally describes a collection of objects in our own milieu. These are everyday objects that may reveal something about people and their lives, the age in which they live, and their social background, and can convey a state of mind.

Still lifes are categorized according to the objects depicted in them, such as flowers or fruit. They can serve to convey an atmosphere or simply act as decoration, as in the fruit still lifes in the beautifully preserved frescoes on the walls of houses in Pompeii. In other cases a still life may be used to embellish a work of art.

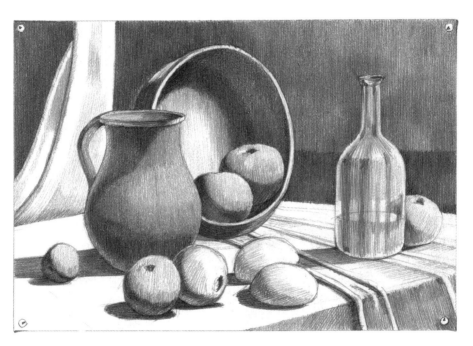

The play of light and shadow gives a special feel to a still life, as do shifts in color and the effects that they create with one another, along with their impact on the picture as a whole. You can give your imagination free rein and play around with shading. The picture can also be rearranged slightly; if the drapery has been casually thrown, no one will wonder how many folds it actually has.

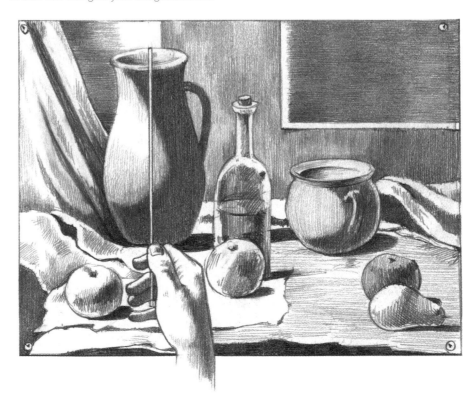

A still life should be planned as carefully as other types of drawing. The picture section and the relationship between the height and width of the subject are important aspects. And now for the individual steps for drawing a still life!

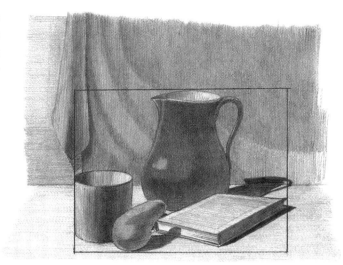

Choose the best and most interesting perspective and then work out the section of the space that you are going to draw. A plotting grid will help with this. Make a small sketch in the top corner of the drawing paper of what you think is the best perspective. This will help when roughly estimating size ratios; in miniature it is easier to appreciate the difference in size between the objects.

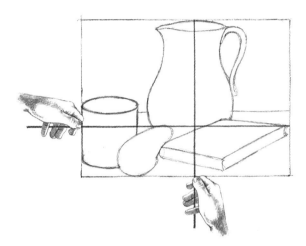

The next step is to work out the ratio of the total height against the total width of the still life. If the width is greater, turn the paper so that it is landscape.

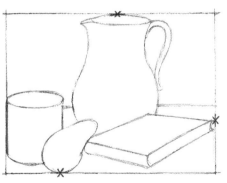

The horizontal lines drawn through the highest and lowest points of the still life mark the upper and lower limits, while the vertical lines drawn through the two farthermost ends mark the edges of the picture. The horizontal and vertical lines of the imaginary rectangle that appears as a result act as reference points for subsequent measurements.

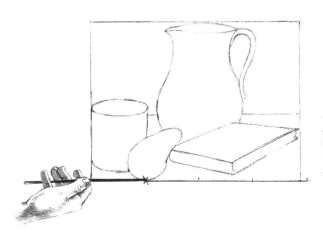

Mark the lowest point of the still life and measure its distance from the edge of the picture. Work out roughly how many times this distance is contained in the total length of the picture.

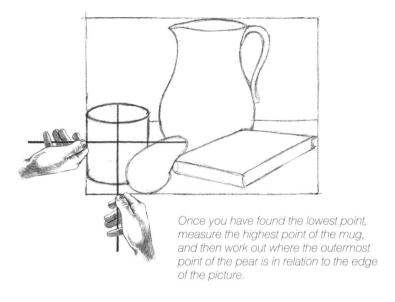

Once you have found the lowest point, measure the highest point of the mug, and then work out where the outermost point of the pear is in relation to the edge of the picture.

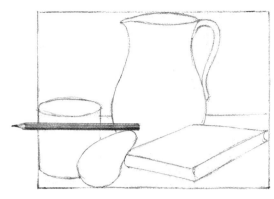

By holding a pencil horizontally you can work out how high the highest point of the pear is against the mug.

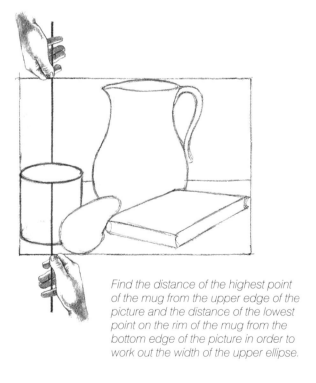

Find the distance of the highest point of the mug from the upper edge of the picture and the distance of the lowest point on the rim of the mug from the bottom edge of the picture in order to work out the width of the upper ellipse.

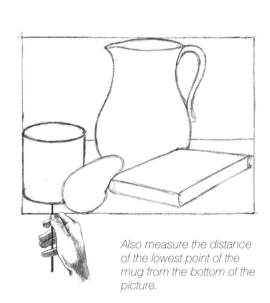

Also measure the distance of the lowest point of the mug from the bottom of the picture.

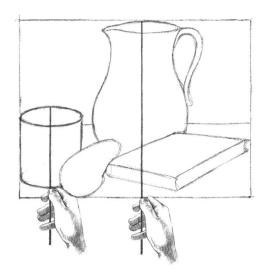

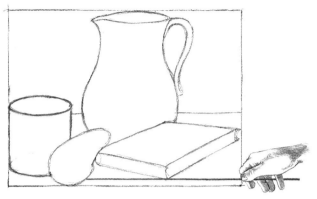

If you lay a measuring stick on the lowest point of the book you can see where the horizontal line runs through the pear, and thus work out how far the lower corner of the book has to be from the bottom of the picture.

It doesn't hurt to do a little checking. Compare the total height of the picture with the height of the mug.

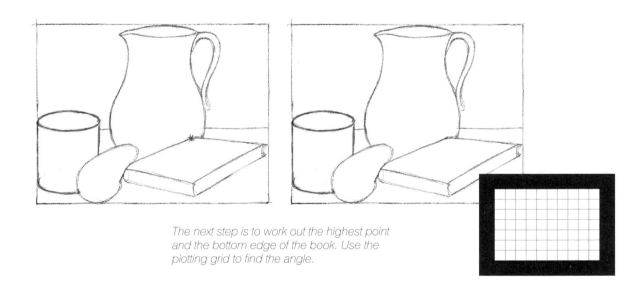

The next step is to work out the highest point and the bottom edge of the book. Use the plotting grid to find the angle.

Drawing the book is difficult. An example of one of the most common mistakes is drawing the opposite parallel lines so that they converge as they come toward the viewer. Refer back to the rules on perspective once again.

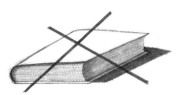

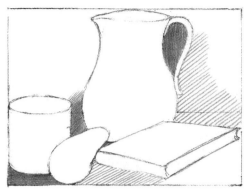

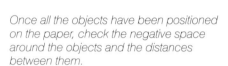

Once all the objects have been positioned on the paper, check the negative space around the objects and the distances between them.

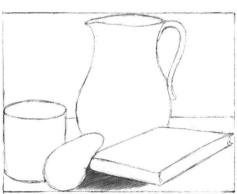

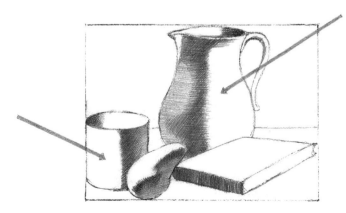

When applying the shading, you should bear in mind the direction from which the light falls on the objects. If the light is coming from the left, this must be clear to see on all the objects.

Objects that are harshly lit have greater contrast. It is important to work out the edges, length, and shading of the shadows according to the source of the light. You can use the grayscale to do this.

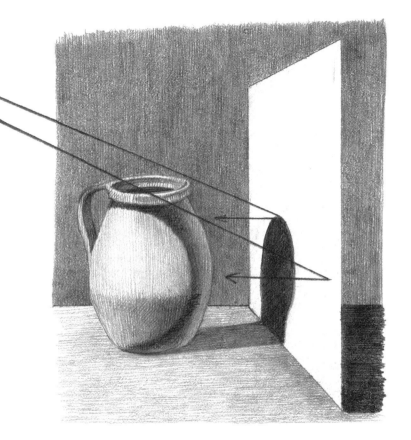

Don't forget to compare the shading of the shadow with the shading of the object. Light is extremely important—you can get a completely different picture of the same object simply by adjusting the lighting. In the drawing to the left you can see that the light reflected by the background has a "reflex" on the object, so the surface is lighter than the base shade.

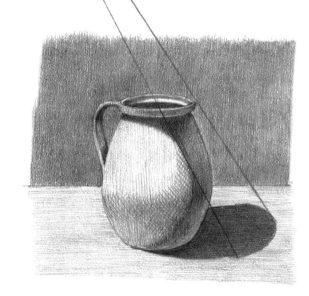

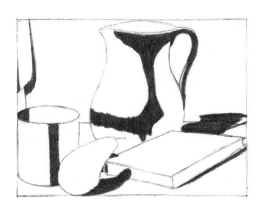
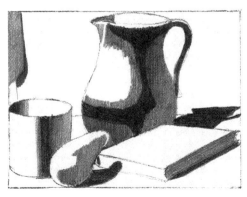
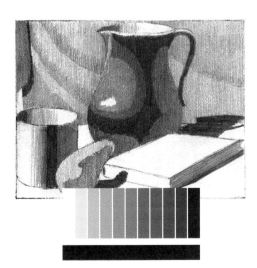

When shading, you should always begin with the darkest surfaces and work toward the lightest. Narrow your eyes when working out the intensity of the shading, and draw clearly defined surfaces. Use the grayscale to decide upon the sequence in which to apply the different shades.

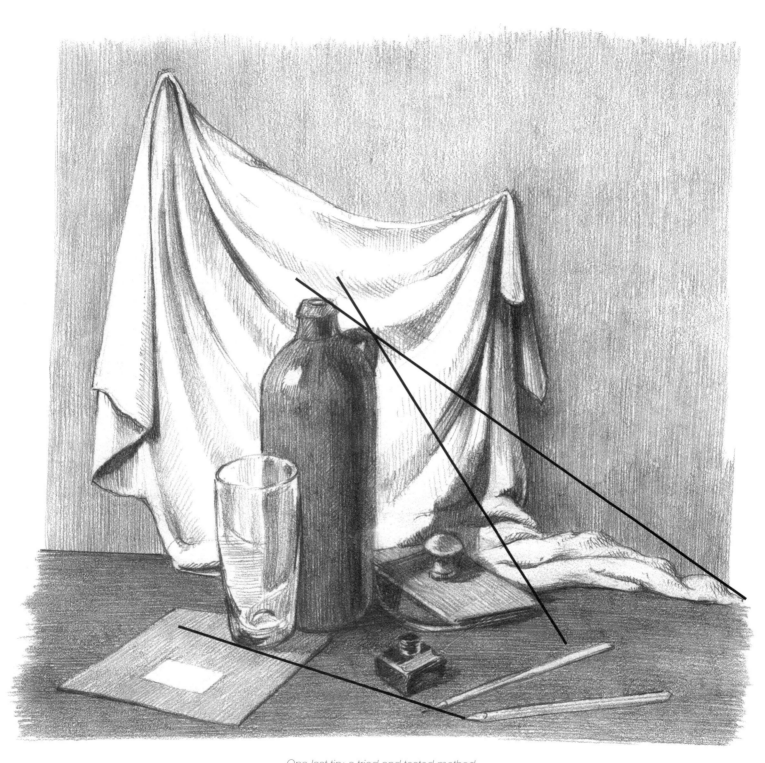

One last tip: a tried and tested method
of checking your drawing is to join
the objects with straight lines. Hold a
measuring stick or pencil against certain
points and check whether the direction of
the lines that join these points is similar to
that between the actual objects.

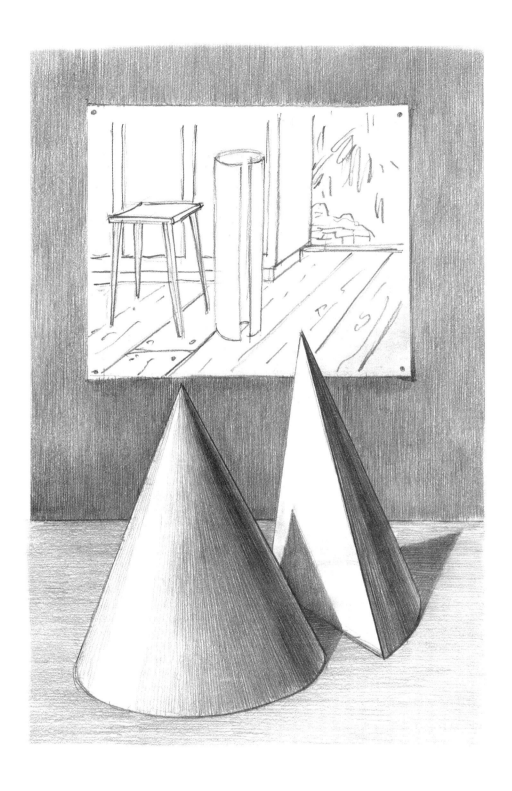

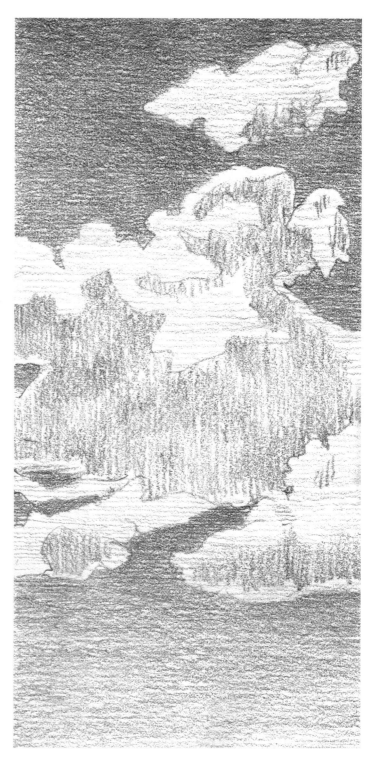

Clouds

The sky forms part of landscapes and townscapes. You can draw a clear sky using different levels of shading, becoming progressively darker from the ground, or the horizon, upward. The drawing will look more interesting if there are also clouds in the sky. Clouds can be depicted in many different ways, and the light is a determining factor: clouds can be lit from the front and above, from below, or backlit from behind. The use of light can express different moods, and suggests the time of day.

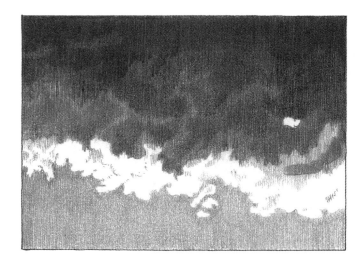

In thunderstorms clouds are dark above and light below. If they are backlit, the three-dimensional nature of their surface is harder to discern—the sphere used here as an example appears as a circle. A backlit cloud likewise appears as a dark expanse.

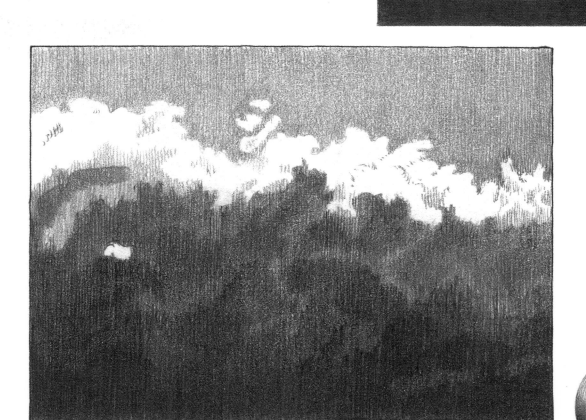

During the daytime light normally shines from above, so the undersides of the clouds are dark. This sphere can act as a simplified example of the resultant shading—light at the top. It is also worth noting that, like the sphere, the shadows of the clouds are visible.

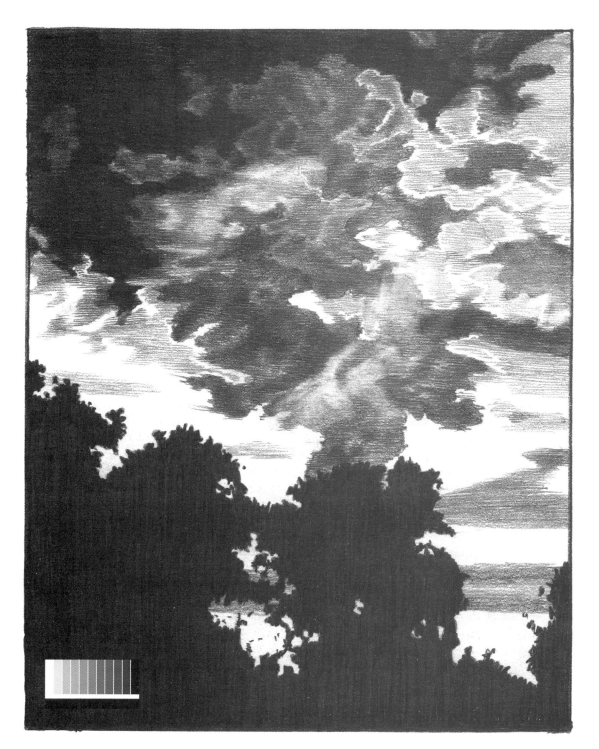

Sunsets are a popular subject. The landscape is still swathed in darkness, and only the silhouettes of the trees can be seen. You can add their jagged outlines in order to make the drawing livelier. The easiest way to decide upon the different levels of shading in the layers of clouds is by using the grayscale.

At twilight the setting sun shines through thin clouds, but thicker layers of cloud appear pitch black. The light is most intense at the edges of the clouds. To render this dazzling light in your drawing you should choose dark shades for the sky.

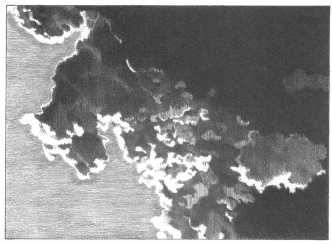

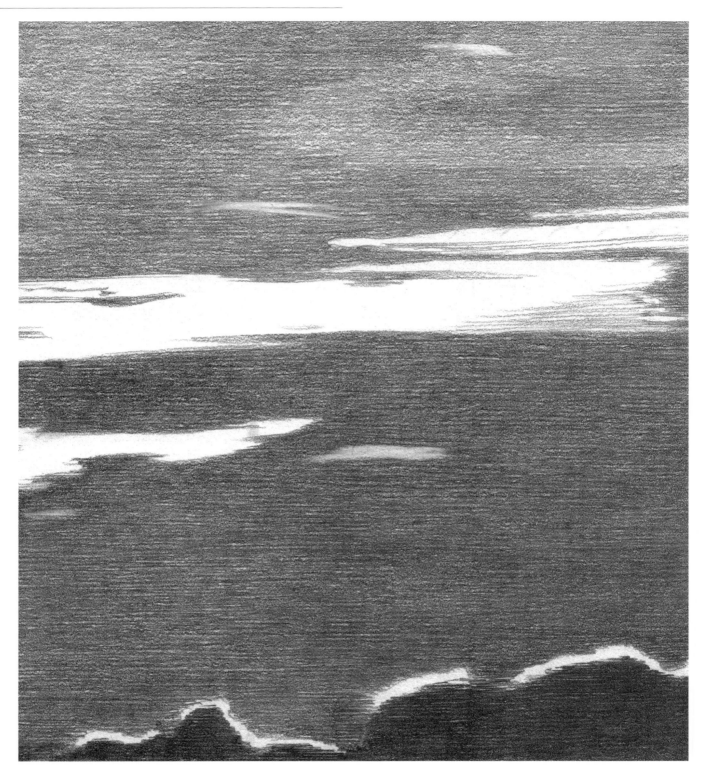

Sometimes clouds are spread out evenly across the sky, almost without any sense of three-dimensionality. In a drawing this would look as though you had cut them out of colored paper and pasted them onto the composition. You need to be especially careful when drawing smooth surfaces; the pressure on the pencil must be completely even, the lines must run parallel, and they must be evenly spaced. If the lines are broken, there will be an unwelcome dark patch at the point at which the lines clash, and the surface will acquire an unforeseen pattern-like effect. If this happens on a small sketch of the drawing, you will know to avoid these unwanted lines when you come to do the real thing.

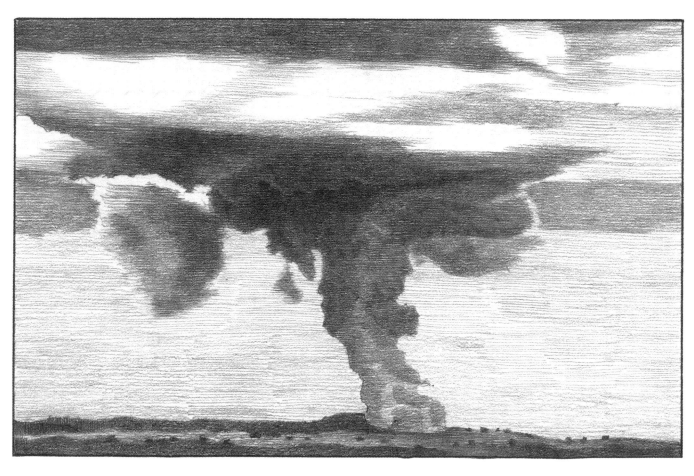

Tornados are a typically funnel-shaped atmospheric phenomenon. The bottom of the thundercloud is dark gray, and the funnel is also dark. It is actually a strong vortex of air, and its movement can be conveyed using horizontal lines and graduated shading. As the surface of the funnel is curved, you can put what you learnt about drawing the surface of a cylinder to use here. The whole cloud is dark, so the earth under it should also be given dark shading.

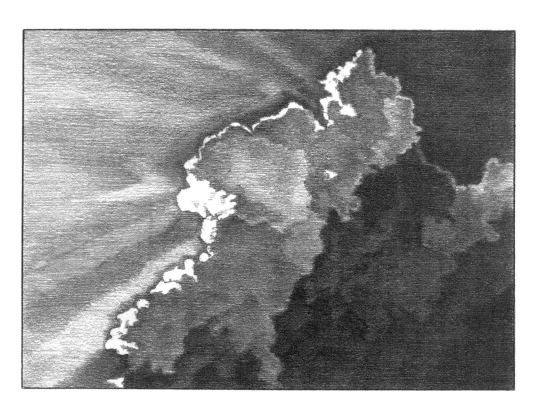

If you look at the cloud more closely, you will see that it is made up of countless ruffles of different sizes. You should give particular attention to the shading of these, as these nuances capture the unique three-dimensionality of the cloud. The sky is darker than the illuminated edges of the cloud, thus emphasizing the gleam of these edges. The rays of sunlight shining out from behind the cloud should be drawn with floodlight-type patches and shafts.

Sometimes both
the clouds and a
wall of the house
in the picture are
white. However,
only one white
surface can
be allowed to
dominate; the
other must be
muted. In other
words, you have
to decide which of
the two is brighter.
If it is the cloud,
the drawing will
normally take on
the appearance
of a sunset. In
strong sunlight,
however, the color
of the wall will
be stronger. The
shading of the sky
is more or less
the same for both
drawings, but the
respective pictures
look different
depending on
whether the
cloud is dark or
light. If the wall
is a dazzling
white, there is
little difference in
shading between
the cloud and
the sky. These
nuances can be
made out more
easily if you look at
the landscape with
narrowed eyes.

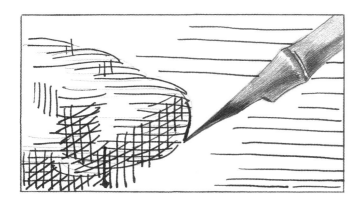

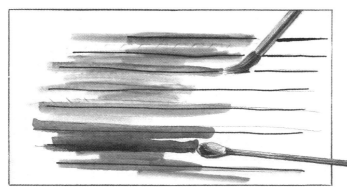

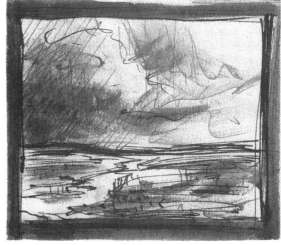

Making sketches is one of the most important steps both in learning to draw and in your later artistic endeavors. Artists fill whole sketchbooks with experimental drawings. Sketching means that you have a record of what you deem to be the important details of the subject, and you will be able to remember them more easily later on. Quick sketches can be done in any medium, but ink works especially well. The rough, thick lines of the reed pen can be embellished with a paintbrush, or a cotton bud for the contours. One, two or more layers of lines and the soft, washed marks make for good landscape sketches.

Ink pens are very popular, as they can absorb a lot of ink and draw a lot of lines, resulting in drier, finer shading.

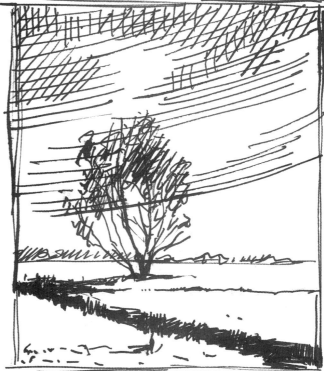

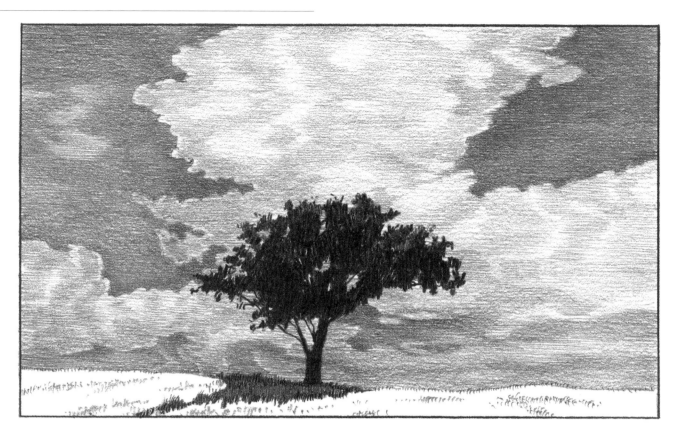

Here the same scene is depicted as a
pencil drawing and as an ink sketch.
Against the strongly lit ground the shading
of the clouds appears more subtle,
while the shadows of the tree appear as
dark blotches. On the ink sketch I have

included the large gray patches, the black
of the trees, and their shadows, while in
the pencil drawing I have captured the
details and soft transitions of the clouds
by referring to the sketch, rather than from
memory.

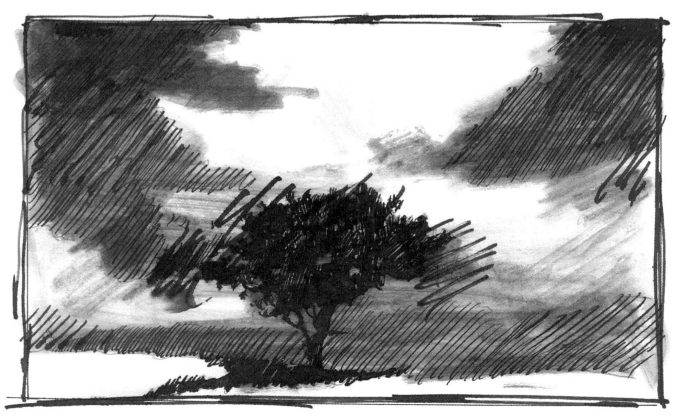

The traditional instrument for creating ink drawings is a simple nib pen, which defined writing and drawing techniques for centuries. It can be used to draw fine, thin lines, and has multiple uses. In this drawing I have tried to shade the sky with horizontal lines. These lines are of different lengths; the irregular spaces between them give the drawing a particular feel.

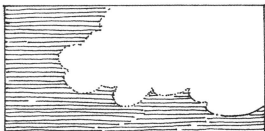

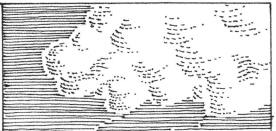

I have drawn the wavy lines of the billowing clouds with dots or very short lines, so as to capture the subtle details. The differences between the shading of the cloud and the shading of the sky are achieved by the density of the lines. The darkness of the cloudless sky can be emphasized by densely packed lines; more widely spaced lines make the surface appear lighter.

Clouds play only a minor role in this drawing, as the tree dominates the composition and the lower part of the picture stands out due to the blades of grass. The darkest element is the shadow of the tree underneath the foliage, and this appears even darker against the sunlit blades of grass.

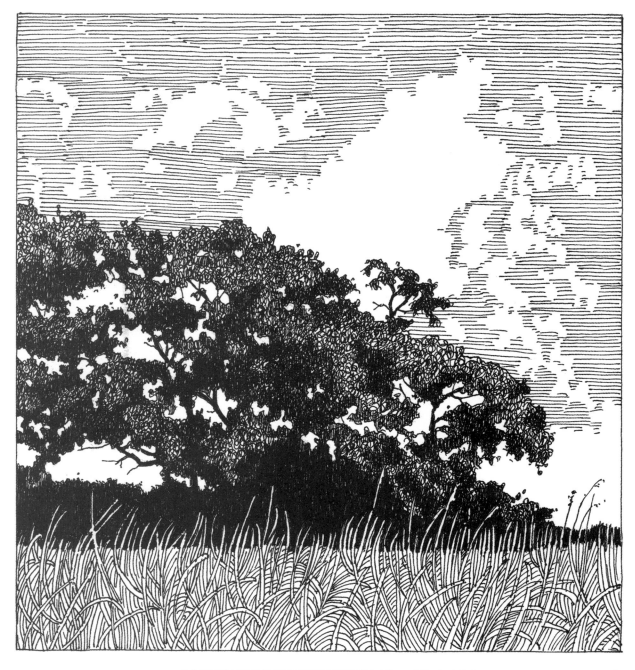

Against a dark background the blades of grass appear light, but against a light background they look dark. The clouds are merely hinted at; the light background makes the tree stand out. Although the light is playing on its leaves and it is by and large well lit, the tree appears dark, due solely to the way in which the background—in this case a bright sky— is shaded.

Flowers and Trees

When drawing plants, the artist has a lot of freedom and can mold the composition to his or her taste; tweaking the actual appearance of the subject by placing a leaf somewhere else, for instance, is acceptable. Of course, the main features must be captured, but it is still possible to go about this in a lively and creative way.

Drawing simple flowers with four petals presents the least difficulties. These are formed within a circle that is divided into four equal parts by two diameters running through the center and at right angles to one another, thus helping you to mark out the position of the petals. The general view of a circle is an ellipse, so a flower head that is turned away has an elliptical outline. The diameters and the longer axis of the ellipse are of equal length.

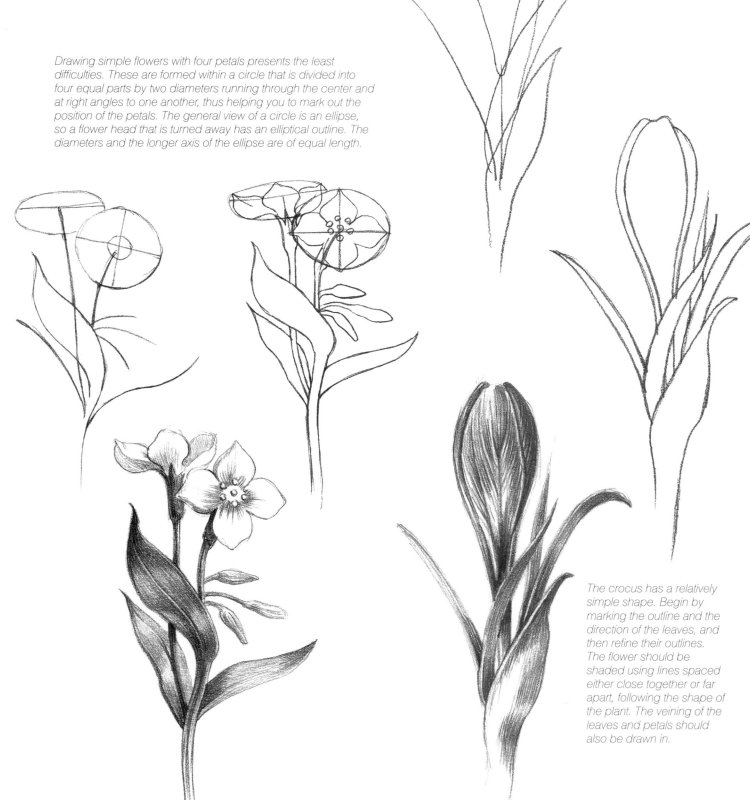

The crocus has a relatively simple shape. Begin by marking the outline and the direction of the leaves, and then refine their outlines. The flower should be shaded using lines spaced either close together or far apart, following the shape of the plant. The veining of the leaves and petals should also be drawn in.

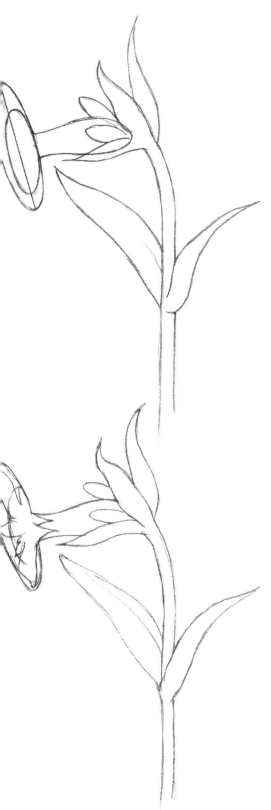

This side view of a white campion (Melandrium album) is highly typical. In order to draw the petals, you should start by marking out their outline, an ellipse. In this case you should draw one for each of the smaller and larger petals alike. The petals are joined in a tube-like formation, surrounded by delicate sepals. You can use your imagination a bit when drawing this, in order to achieve a better result. As a way of checking, work out the proportions between the length of the petals and the total length of the flower head, and between the petals and the leaves. When you come to shade the stem you should use what you have learnt about the cylinder. The surface of the leaves will look more realistic if you shade them with lines that follow their shape, and imitate the play of light and shadow and the subtle nuances in tone. If the petals or stem have a similar level of shading to the background, they can be separated by thin white streaks.

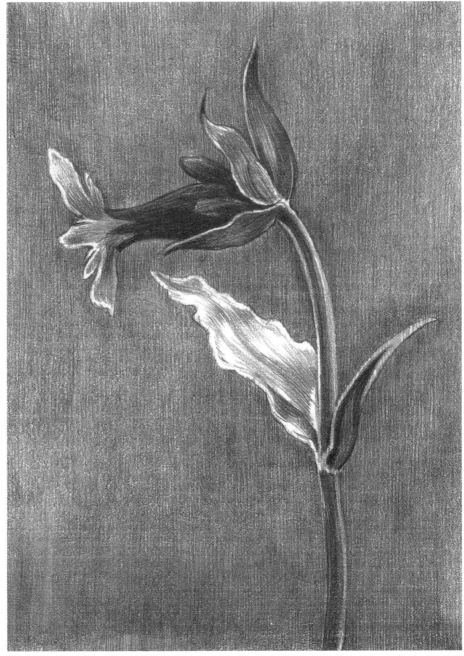

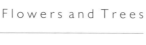

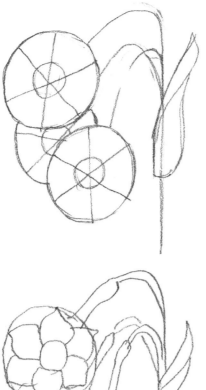

When drawing funnel-shaped flowers with six petals you should begin by drawing a circular or elliptical outline, but sketch in three chords running through the center. The funnel becomes somewhat thicker toward the stem, and you should mark this feature on the sketch. As the flowers are arranged in small clusters, you should plot out the position of the flowers and their stems in relation to one another. Lighter shading can show whether the flowers or their stems are at the front or the back of the cluster. You should also draw the stamen and the stigma, which are found in the middle of the flower.

Often the upper surface and the underside of leaves that have different levels of shading and feel different to the touch can be seen at the same time, and I have depicted this on the sketch by using different shades and lines running in different directions.

Tiger lily (Lilium bulbiferum) petals are arranged in two tiers, with three above and three below, so that the lower petals can be clearly seen between the upper ones. The flower's outline is like two triangles that have been rotated about one another. The lower petals should be given slightly lighter shading. On the upper petals there is a dark, ring-like band with a broken edge, not far from the stamen. This should be given very dark shading. The intermittently jagged edges of the petals can be emphasized using the contrast of the black outline and the white surface. The outer surface of the buds should be shaded with parallel lines.

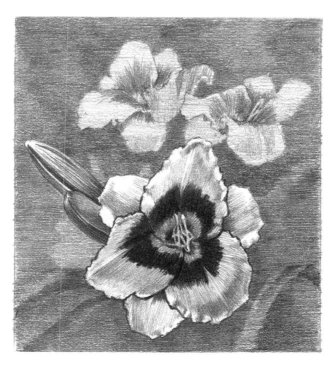

Careful shading of the petals and leaves can
capture the beauty of the autumn crocus
(Colchicum autumnale).

The petals of the opium
poppy (papaver
somnifarum)

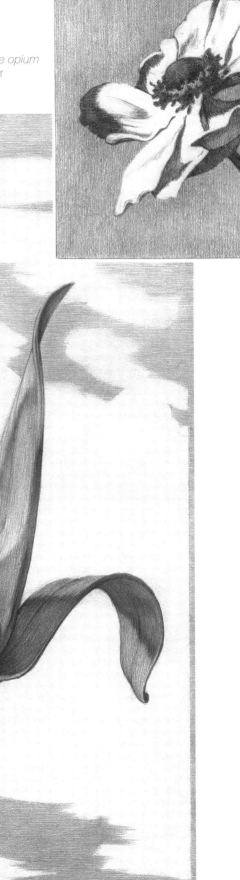

The rose is one of the most beautiful flowers. It is known for its thorny stem, saw-edged leaves of different sizes, its dainty buds, and opened flower. When drawing a rose it is also recommended that you sketch out the outline of the flower first, making sure that the curved shape only vaguely corresponds to the flower itself, as the distinctive thing about the rose is actually the way that the petals stick out in different directions. The petals bend increasingly away from the others as they move outward from the middle, and have a rounded or angular outline. Dark shading is crucial for the leaves and the stem.

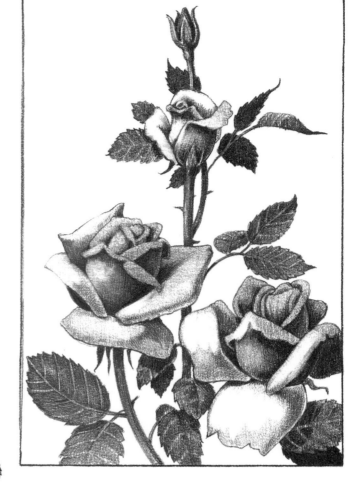

Making a sketch for a drawing of a rose is no easy task. I have used the dotting and line technique in this ink drawing. I have left the leaf veins white to make them stand out. The surface of the petals can be drawn with lines made up of dots or with simple lines. The black shading where the petals meet gives the drawing depth.

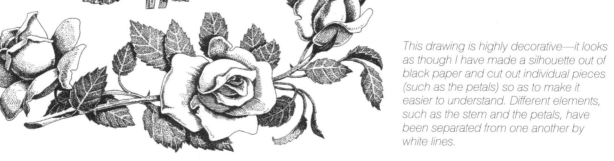

This drawing is highly decorative—it looks as though I have made a silhouette out of black paper and cut out individual pieces (such as the petals) so as to make it easier to understand. Different elements, such as the stem and the petals, have been separated from one another by white lines.

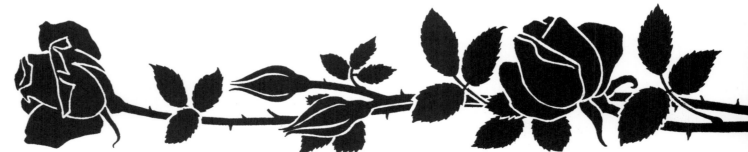

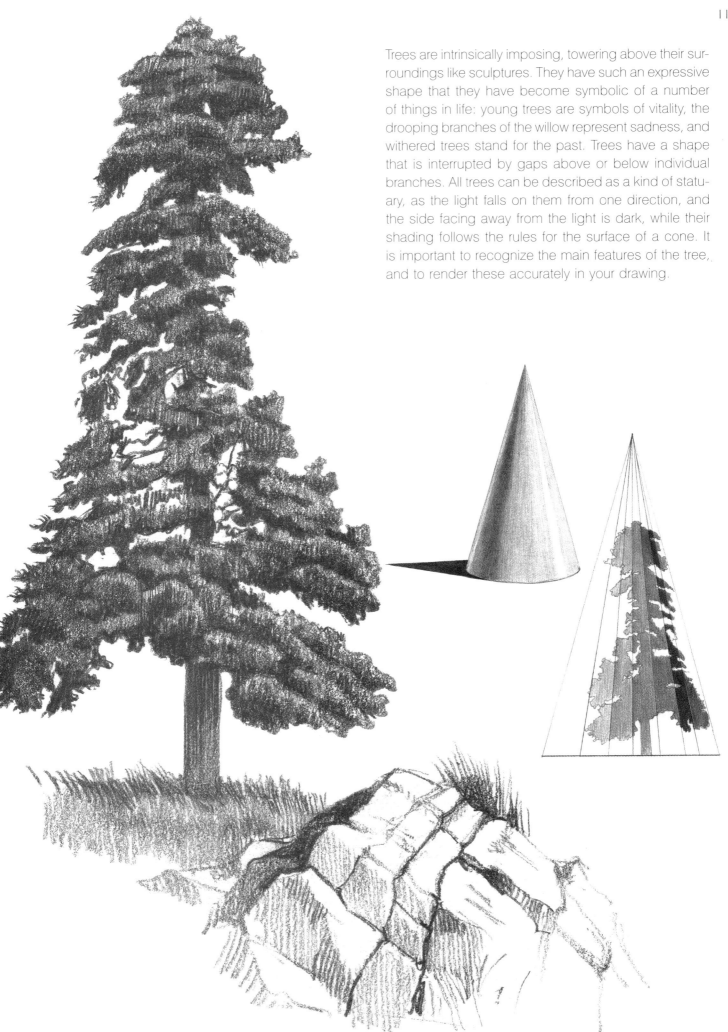

Trees are intrinsically imposing, towering above their surroundings like sculptures. They have such an expressive shape that they have become symbolic of a number of things in life: young trees are symbols of vitality, the drooping branches of the willow represent sadness, and withered trees stand for the past. Trees have a shape that is interrupted by gaps above or below individual branches. All trees can be described as a kind of statuary, as the light falls on them from one direction, and the side facing away from the light is dark, while their shading follows the rules for the surface of a cone. It is important to recognize the main features of the tree, and to render these accurately in your drawing.

Drawing a tree is not easy, as the foliage is broken up by the gaps between the branches. You must bring all these tiny, separate details together to create a certain harmony in your work.

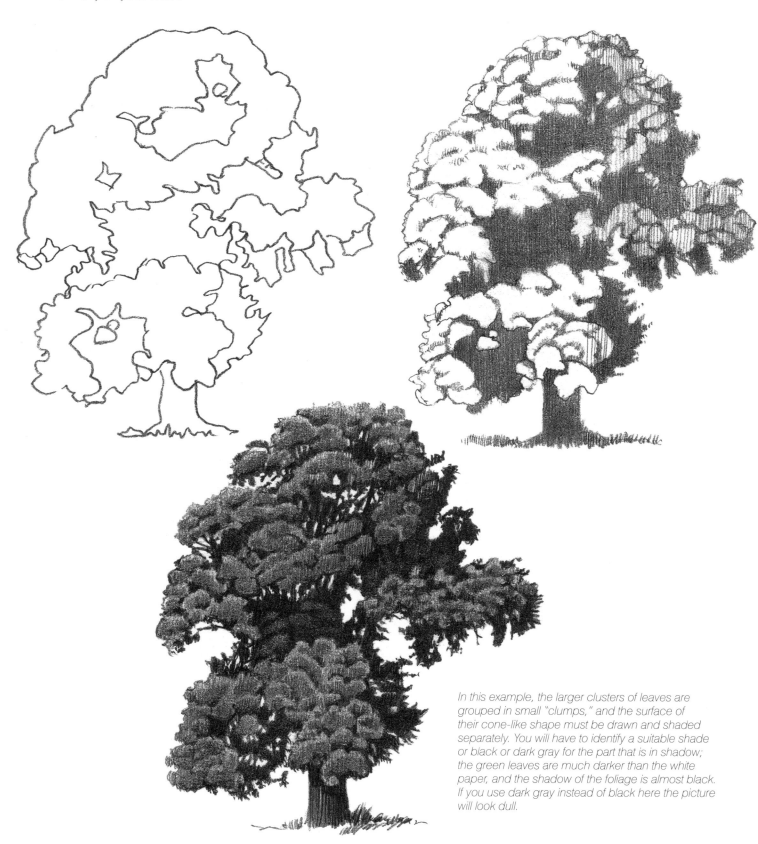

In this example, the larger clusters of leaves are grouped in small "clumps," and the surface of their cone-like shape must be drawn and shaded separately. You will have to identify a suitable shade or black or dark gray for the part that is in shadow; the green leaves are much darker than the white paper, and the shadow of the foliage is almost black. If you use dark gray instead of black here the picture will look dull.

The oak (Quercus) has been my favorite tree ever since I was little. The different species may bear similar fruits, but the leaves and shape of individual trees can be very different indeed. The foliage is usually compact, with few gaps through which you can see the sky, but on some of them it is easy to see individual branches and a view of the sky. Start off by sketching the outline, and check the most important dimensions, such as the total height, the relationship between the foliage and the trunk, the widest part, and the position and thickness of the trunk in relation to it using a plotting grid or measuring stick. You will be able to apply what you have learnt about the surface of a cylinder when it comes to shading the trunk and the branches. It is important to pay attention to both slight and more pronounced abnormalities, bulges, and bends. The shape and density of tiny details within the foliage should also be captured and brought together to form the whole treetop.

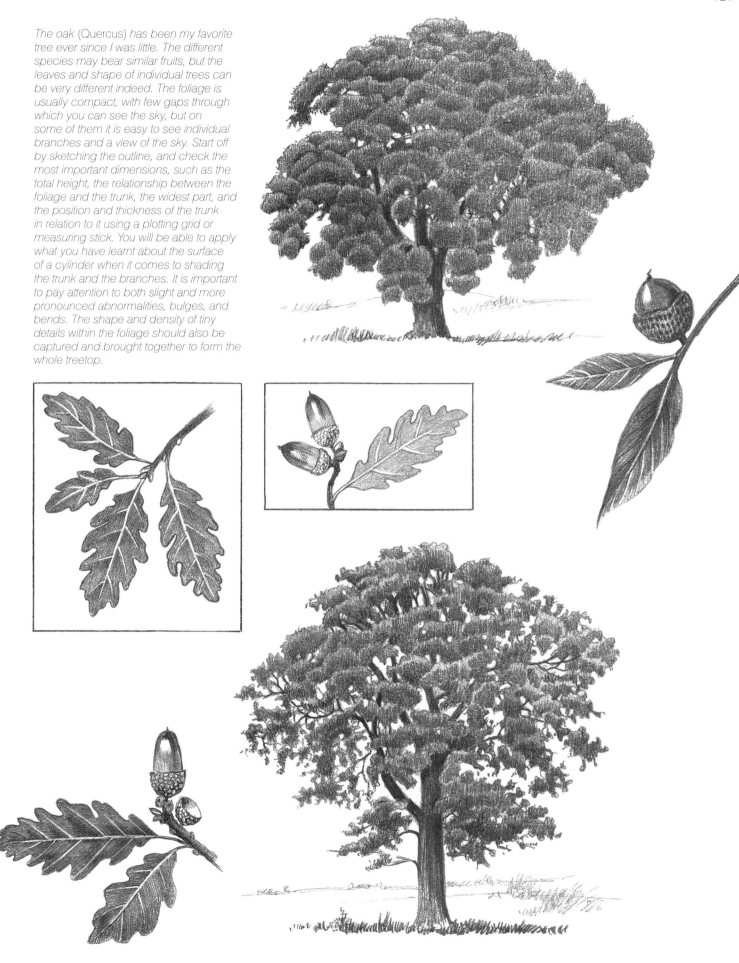

Trees differ greatly from one another—if you are drawing a conifer, for example, you would emphasize quite different characteristics than you would for a deciduous tree.

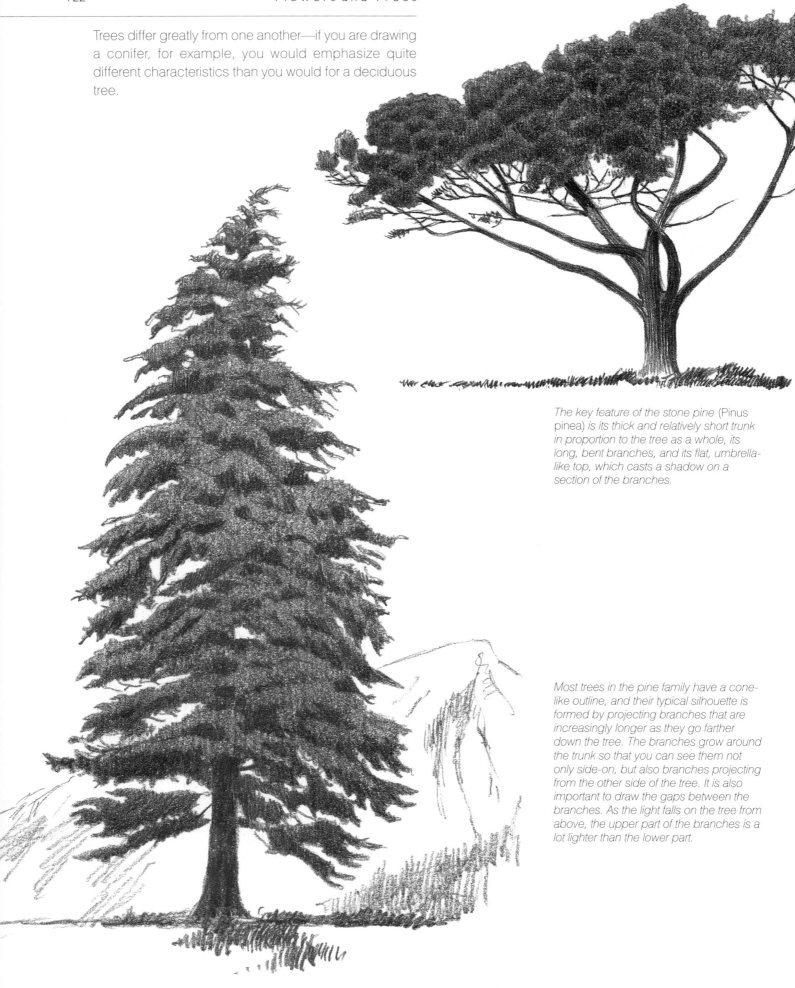

The key feature of the stone pine (Pinus pinea) is its thick and relatively short trunk in proportion to the tree as a whole, its long, bent branches, and its flat, umbrella-like top, which casts a shadow on a section of the branches.

Most trees in the pine family have a cone-like outline, and their typical silhouette is formed by projecting branches that are increasingly longer as they go farther down the tree. The branches grow around the trunk so that you can see them not only side-on, but also branches projecting from the other side of the tree. It is also important to draw the gaps between the branches. As the light falls on the tree from above, the upper part of the branches is a lot lighter than the lower part.

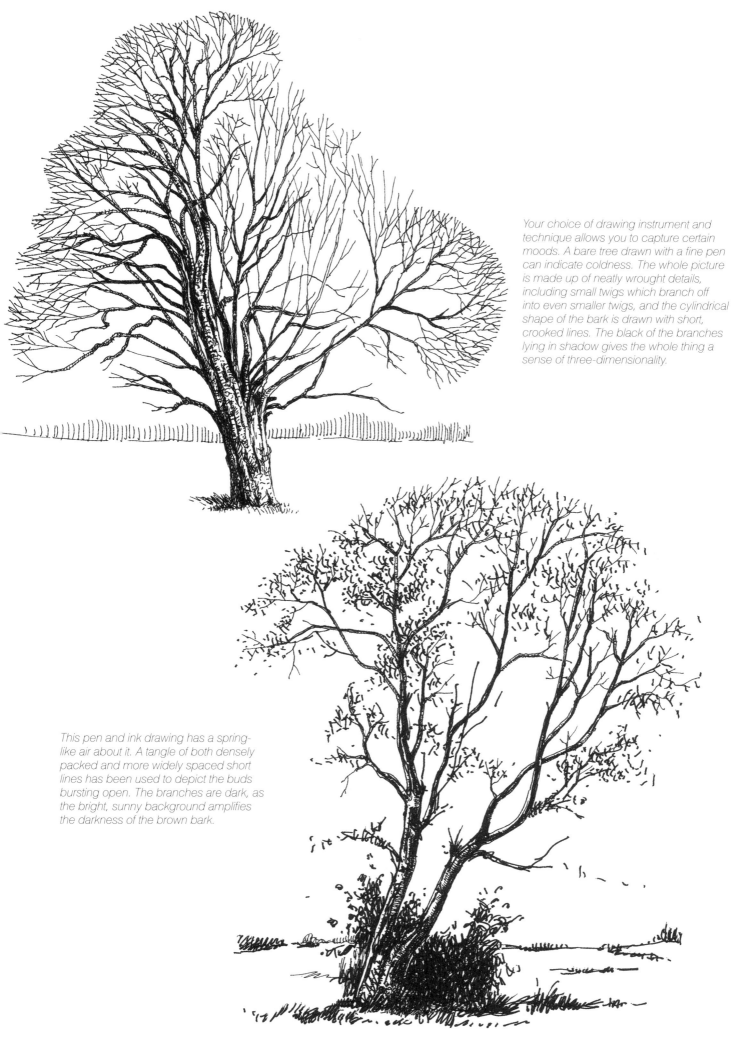

Your choice of drawing instrument and technique allows you to capture certain moods. A bare tree drawn with a fine pen can indicate coldness. The whole picture is made up of neatly wrought details, including small twigs which branch off into even smaller twigs, and the cylindrical shape of the bark is drawn with short, crooked lines. The black of the branches lying in shadow gives the whole thing a sense of three-dimensionality.

This pen and ink drawing has a spring-like air about it. A tangle of both densely packed and more widely spaced short lines has been used to depict the buds bursting open. The branches are dark, as the bright, sunny background amplifies the darkness of the brown bark.

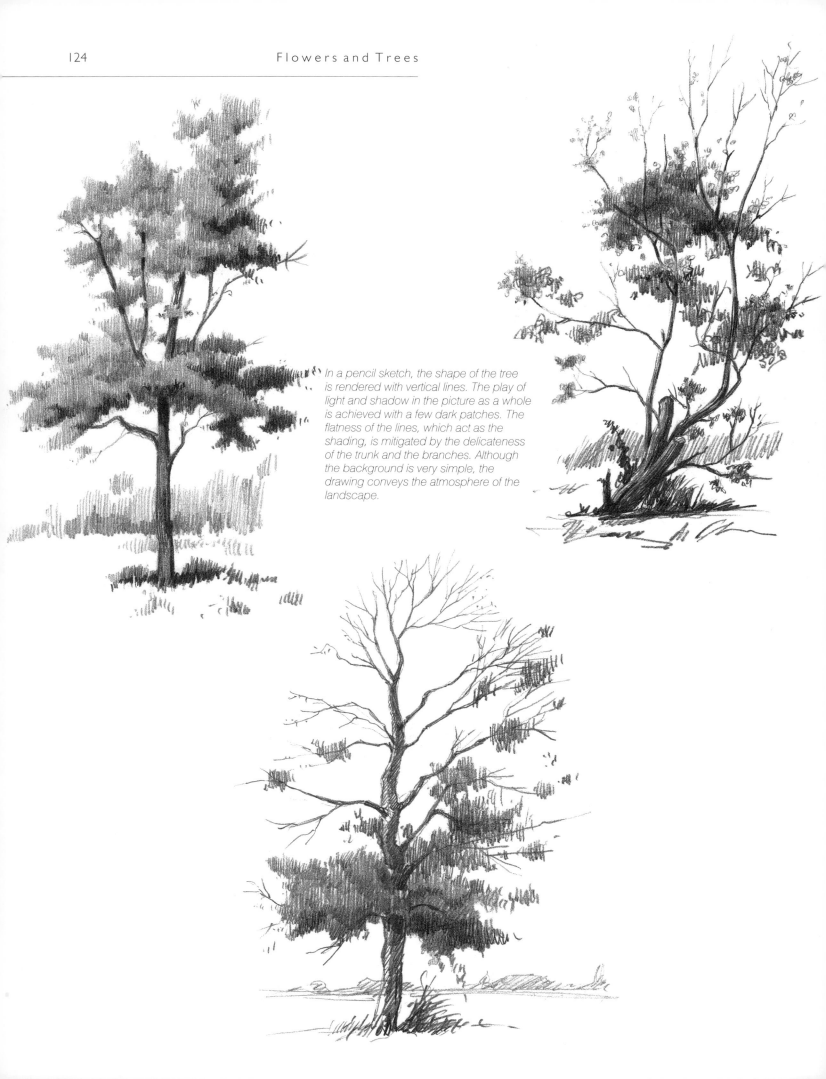

In a pencil sketch, the shape of the tree is rendered with vertical lines. The play of light and shadow in the picture as a whole is achieved with a few dark patches. The flatness of the lines, which act as the shading, is mitigated by the delicateness of the trunk and the branches. Although the background is very simple, the drawing conveys the atmosphere of the landscape.

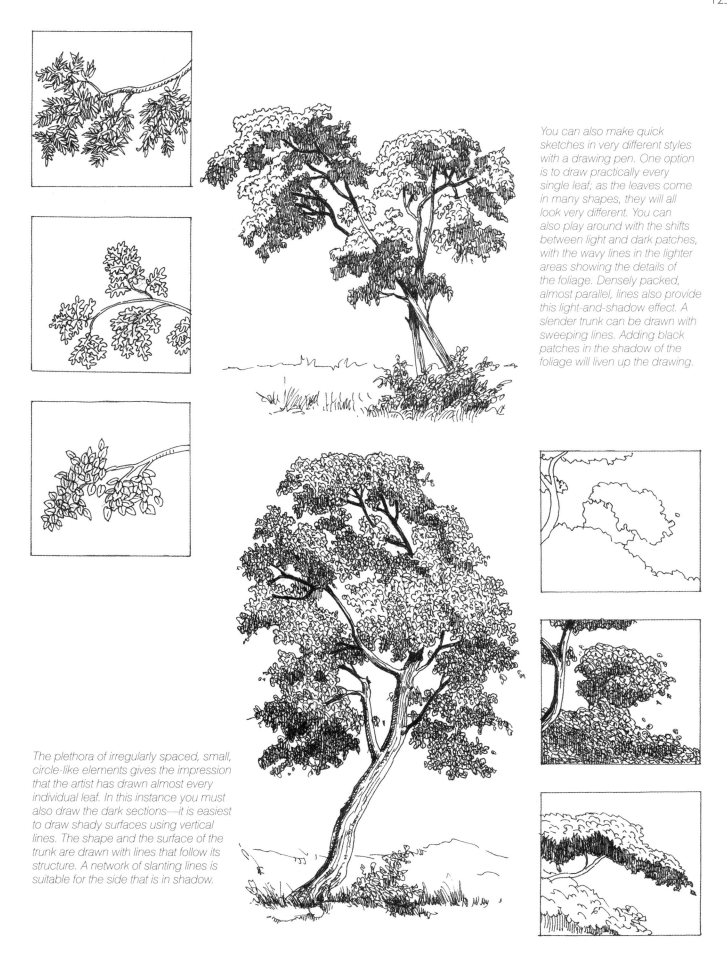

You can also make quick sketches in very different styles with a drawing pen. One option is to draw practically every single leaf; as the leaves come in many shapes, they will all look very different. You can also play around with the shifts between light and dark patches, with the wavy lines in the lighter areas showing the details of the foliage. Densely packed, almost parallel, lines also provide this light-and-shadow effect. A slender trunk can be drawn with sweeping lines. Adding black patches in the shadow of the foliage will liven up the drawing.

The plethora of irregularly spaced, small, circle-like elements gives the impression that the artist has drawn almost every individual leaf. In this instance you must also draw the dark sections—it is easiest to draw shady surfaces using vertical lines. The shape and the surface of the trunk are drawn with lines that follow its structure. A network of slanting lines is suitable for the side that is in shadow.

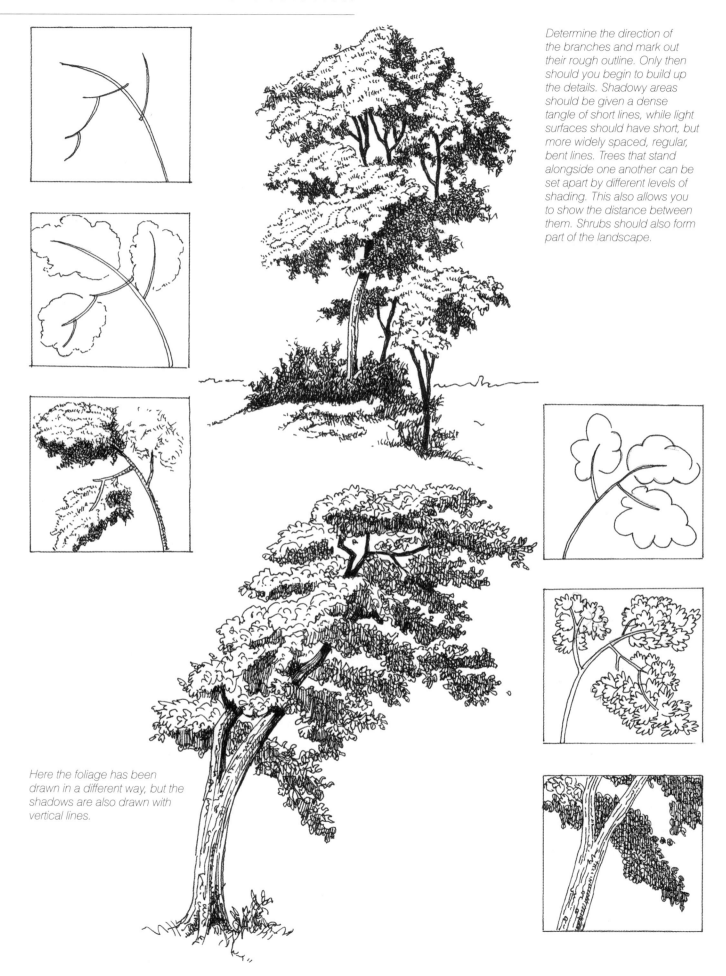

Determine the direction of the branches and mark out their rough outline. Only then should you begin to build up the details. Shadowy areas should be given a dense tangle of short lines, while light surfaces should have short, but more widely spaced, regular, bent lines. Trees that stand alongside one another can be set apart by different levels of shading. This also allows you to show the distance between them. Shrubs should also form part of the landscape.

Here the foliage has been drawn in a different way, but the shadows are also drawn with vertical lines.

Drawing pens can also be used to apply a variety of techniques to sketches. The foliage here consists of a tangle of short lines. Its unity as a whole comes from vertical lines, under which the short lines can be seen.

After the contours of the tree have been marked out, the foliage is sketched out using a drawing pen to create strong, wide lines, along with vertical and diagonal layers of lines. The spherical appearance of the foliage is a result of the marked difference between the light and dark surfaces. The rich texture of the light surfaces must also be captured using deftly placed lines. The sky can be drawn using horizontal lines, while the clouds can be fleshed out at the final stage of the drawing, as an artistic composition does not have to be absolutely faithful to reality. Short, slanting lines are used to show the features of the ground.

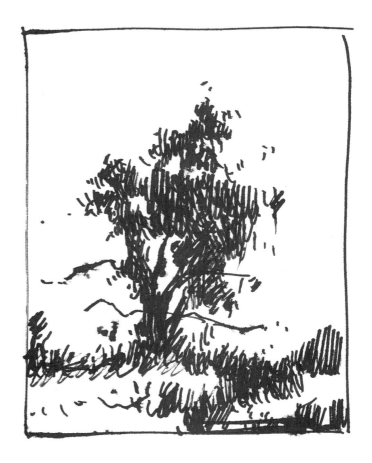

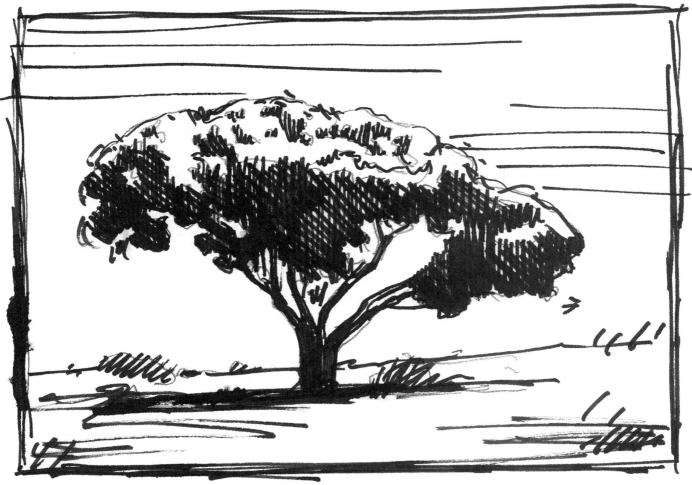

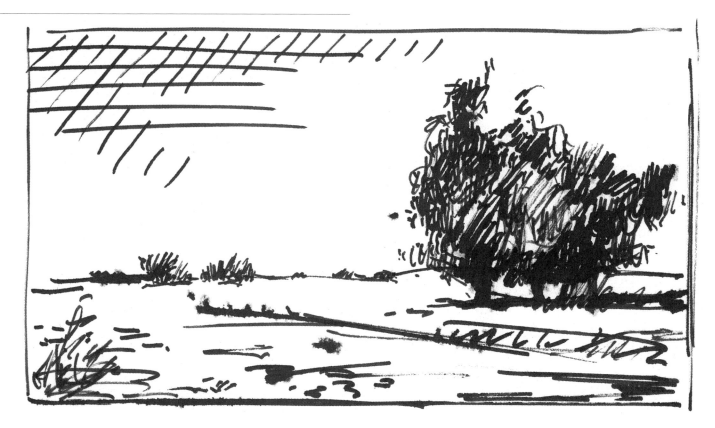

Both drawings are only sketches, yet they are very different. They are great starting points for a finished drawing. The rough sketch (above), which was drawn with a felt tip, contains only the most important features, while the sketch below, which is made up of short lines drawn with a drawing pen is clearly more sophisticated and elaborate. Both tools are great at creating the different shades required.

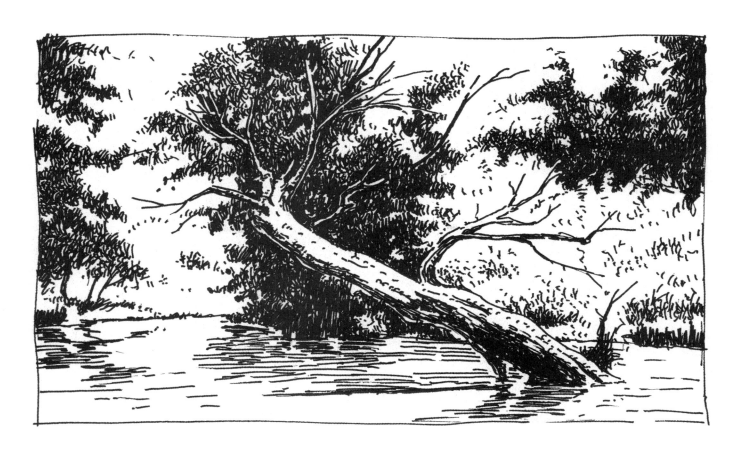

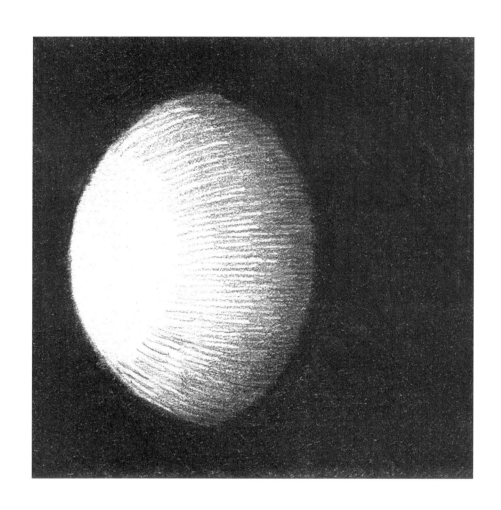

Light and Shadows

Sometimes our surroundings may be well lit, while at other times the light will be dim. If an object or being is not transparent, it interrupts the way in which the light falls. The side on which the object is lit is bright, while the side that is turned away from the light lies in shadow. This is the object's own shadow. In contrast to this, the shadow that the object throws on the floor or onto a surface behind it is called a cast shadow. The cast shadow is always darker than the object's own shadow. (Obviously, this only applies where there are similar levels of shading.)

The position of the source of light and thus the direction from which the light falls has an effect on the appearance of the subject, whether it is an object or a living creature. In the picture to the left, the light falls diagonally from above and from the side, while in the picture to the right it comes from below. The difference between them is clear to see. As previously mentioned, when drawing people the outline of the head is oval, and is shaded accordingly. The difficulty lies in also having to apply shadows around any wrinkles, the nose, the eyes, and so on.

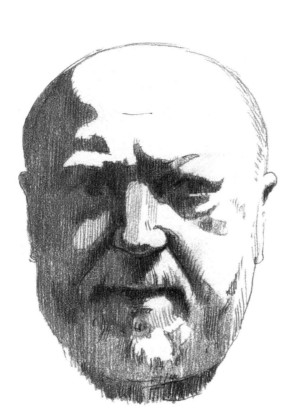

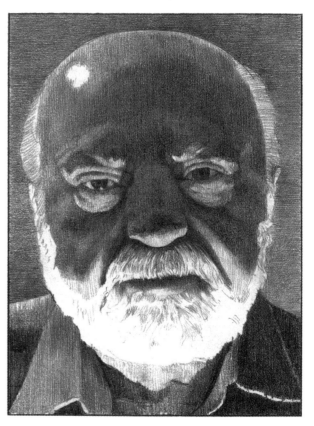

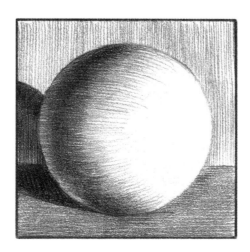

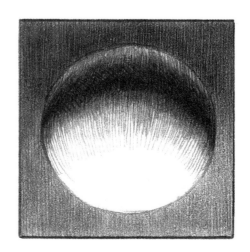

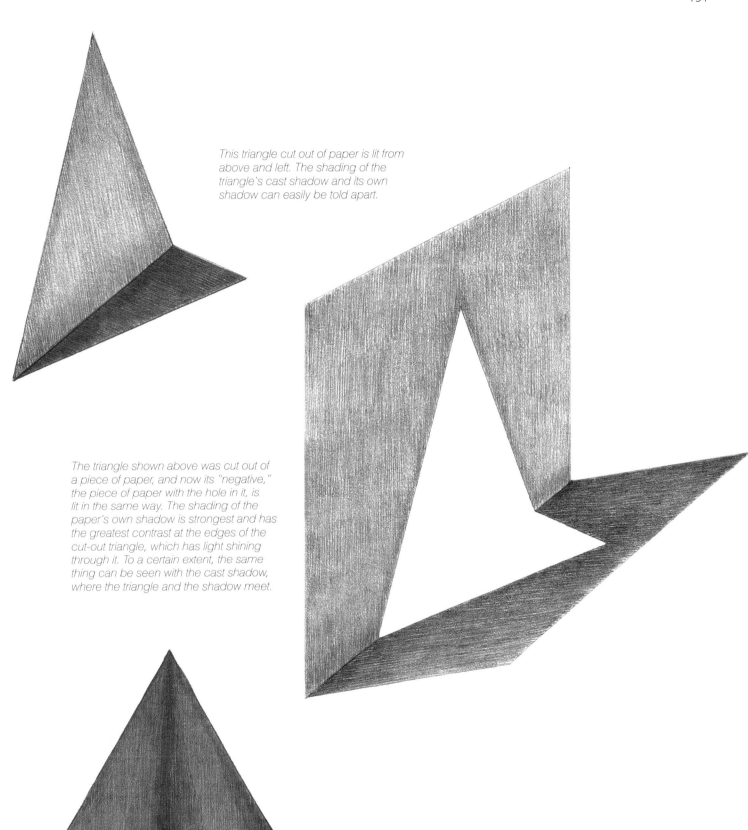

This triangle cut out of paper is lit from above and left. The shading of the triangle's cast shadow and its own shadow can easily be told apart.

The triangle shown above was cut out of a piece of paper, and now its "negative," the piece of paper with the hole in it, is lit in the same way. The shading of the paper's own shadow is strongest and has the greatest contrast at the edges of the cut-out triangle, which has light shining through it. To a certain extent, the same thing can be seen with the cast shadow, where the triangle and the shadow meet.

If you are drawing a backlit cone you should strengthen the edges of the dark shading where the background and the object's own shadow or its cast shadow meet, in order to emphasize the effect of light and shade.

As previously mentioned, you can use light to change the appearance of your subject. In strong light the contrast is greater, as the light surface becomes even lighter, and the dark surfaces darker. The part of the sphere that is closest to the source of light is the brightest, and its regularly curved surface becomes progressively darker. A clear circular line can be seen on the surface of the sphere, along which the shaft of light merely touches the shell, and on the other side of which the surface is dark. This is the sphere's own shadow. Of course, this darker section is not a uniform shade, as the reflex (see page 66) comes into play. The darker band of shading between the light and dark areas should be made stronger in order to give the drawing greater contrast.

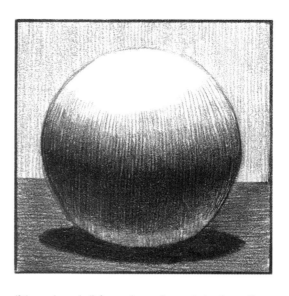

If the sphere is lit from above, its cast shadow will appear as an ellipse.

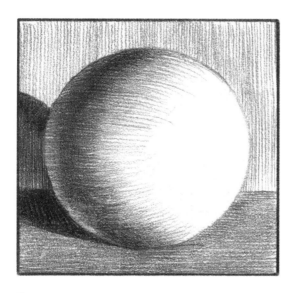

If the sphere is lit from the side, the cast shadow will look like an ellipse.

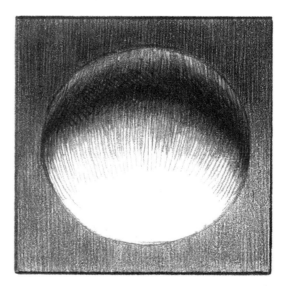

At the farthest point of the surface the sphere's own shadow, or its reflex, is light.

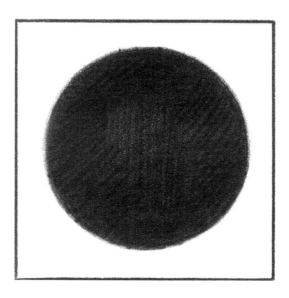

If the sphere is lit from behind, almost all that can be seen of it is a dark circle.

Part of Dürer's *Anatomy* deals with learning to draw. This includes drawing an object with multiple surfaces, which requires a feel for shading. In the case of a cube in the general position, there are three visible side surfaces, and thus three different planes, with different shading for each. You can rank these in terms of shading, from lightest to darkest. For Dürer's object, five different planes can be seen in the general position, so the artist has to pick out five gradations of shading, and apply these to the drawing.

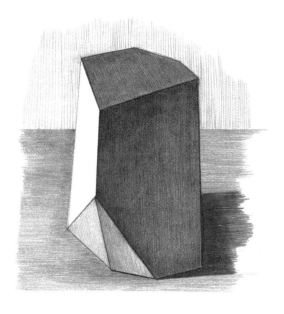

The source of light is to the left of Dürer's object, as is shown by the cast shadow. The uppermost surface is dark, so the light must be shining from below.

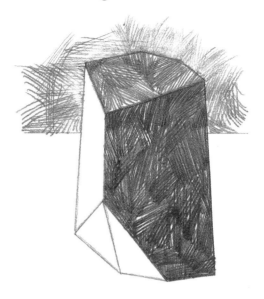

When drawing it is important to get the lines which create the shading effect right, as if there are irregular layers of lines, the smooth side surfaces will look uneven and confused, despite any differences in the intensity of the shading.

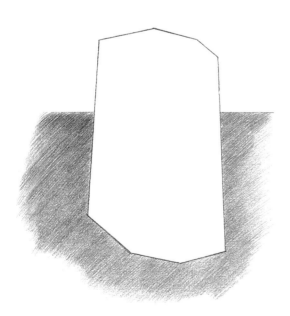

The direction of the lines is also important when drawing the base surface. Although these diagonal lines, at a 45-degree angle, give a smooth, even surface, it looks as though it is sloping too much.

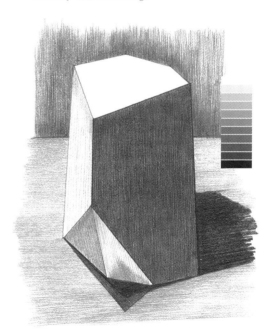

Here is the correct version, with the shading adjusted in relation to the uppermost surface, which is the lightest.

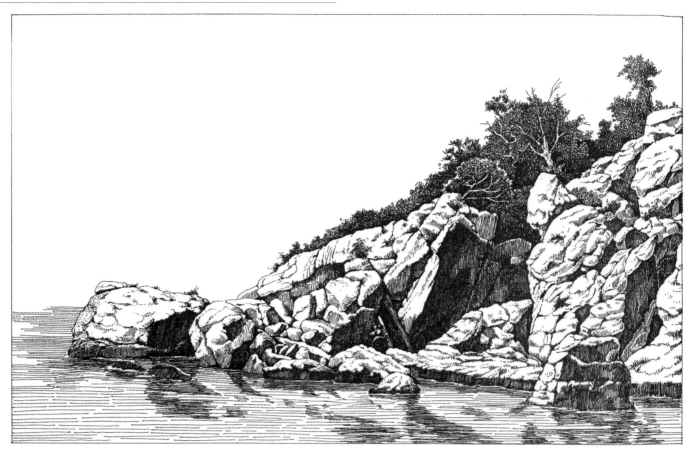

In this picture of rocks by the sea glowing in the blazing sunshine, the rich contrast is immediately apparent.

Lit and unlit areas can be strictly separated from one another. As the lines follow the shape of the subject, individual areas of the fragmented rocks are especially detailed. This instantly makes the drawing interesting, as the different networks of lines divide up the space.

You must also draw the light and dark patches on the surface of the water.

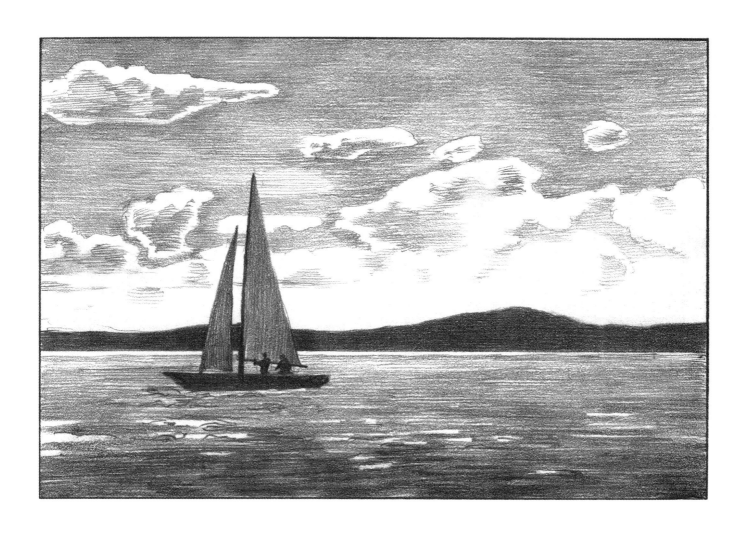

Landscapes

Artists draw landscapes when they have seen or see something that they want to immortalize. Choosing the section of the landscape that looks the best is no easy task, so you can use the plotting grid as an aid by looking at sections as though they are being seen within a frame.

When the artist sets about a drawing, he or she wants to create a work of artistic merit. This means that he should not stick too strictly to what he can see, but can work subtle details like a beautiful tree into the picture, if this will make it more striking.

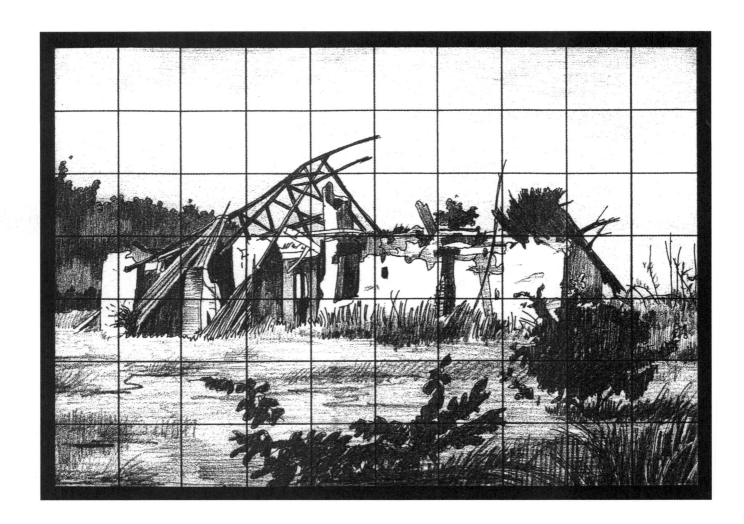

Whether you are painting or drawing, adding shading is absolutely vital. You should rank the levels of shading, and start with the darkest when you come to draw the picture. This is easier to work out if you look at the subject through narrowed eyes, as this makes any distracting details "disappear." You can also work out which shade corresponds to what you can see by using the grayscale. The grayscale is then laid on the paper, allowing you to replicate the shading. There is no shame in using this kind of tool, as being able to instantly recognize the shade that you need requires much practice.

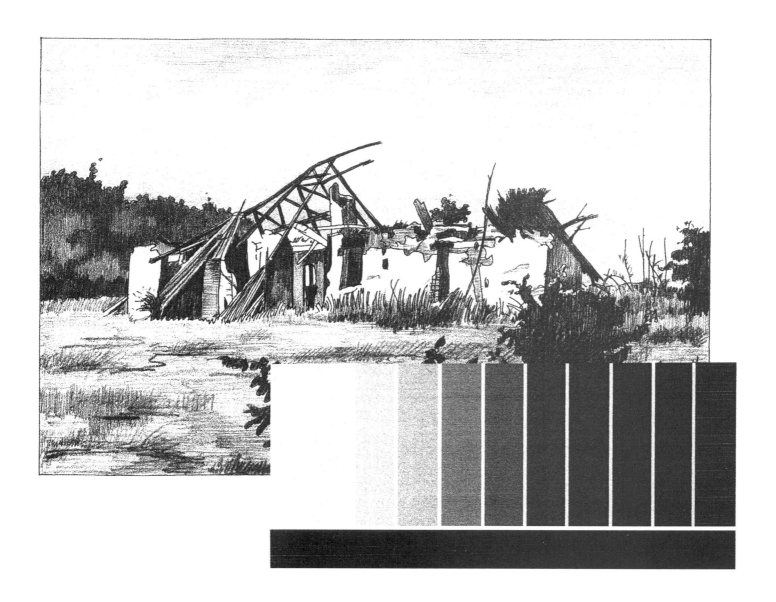

When drawing landscapes, the distance between the viewer and the horizon is normally very far. The intensity of darker shadows and areas within the drawing diminishes the farther they are from the viewer. For instance, the darkness of a bush in the foreground must be differentiated from a bush that is farther away, and this can be achieved by giving it a less intense shade.

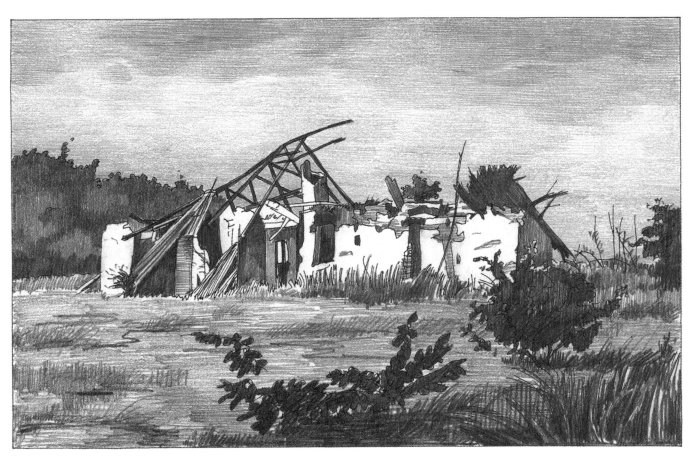

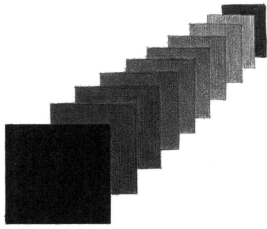

To use another example, I have given the last of the dark squares a shade that is almost as dark as that of the first square, so the rearmost dark surface does not appear to fit here—it looks as though it should be positioned farther forward. The same thing happens if you give a detail of the background the same shading as a detail in the foreground: the drawing looks unbalanced.

One of the best techniques for drawing a derelict farm is an ink drawing. Alongside the fine, almost jabbing lines, the force of the dark patches gives the drawing a particular expressiveness.

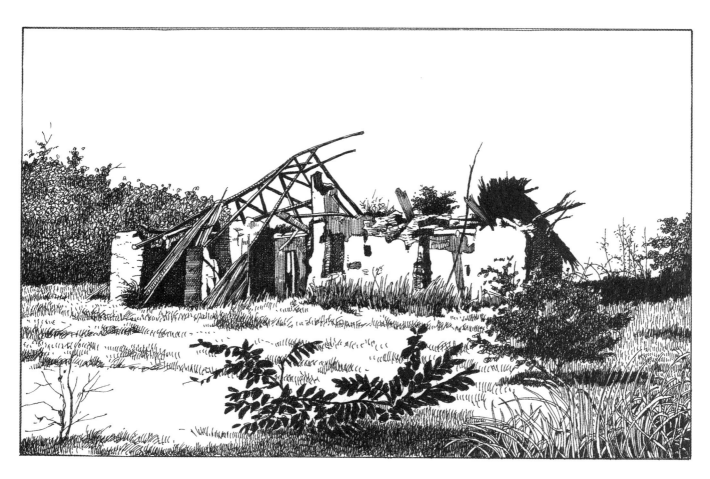

The pen allows you to illustrate details in a number of special ways, as this cutout of some blades of grass shows.

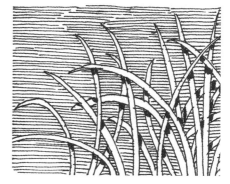

The gaps between the bent blades of grass can be filled in with an intense black, thus emphasizing the shape of the stalks. The tangle of the tips of the blades of grass, outlined in black, can be ideally shown against a white background.

The blades of grass drawn with dashed lines and dots have a softer shade. They appear farther away than in the previous drawing.

In the third version it appears as though the sun is shining brightly. This is suggested by the cast shadow on the blades of grass, and is created by the strong shading of the background and the whiteness of the grass that stands out against it.

Without the sky, the landscape is incomplete. (There
is more information on this in the chapter on clouds;
see pp.103–112.) The clouds in this picture also look
very imposing.

Using ink also gives us a number of different shading options:

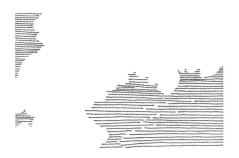 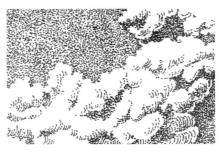 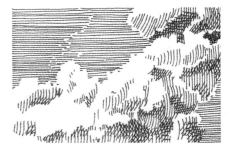

*Shading the sky around the clouds
creates a decorative background. The
intensity of the shading can be varied by
using densely packed or more widely
spaced horizontal lines.*

*The dotting technique creates a very
pretty effect, but it requires a lot of time
and patience. Differences in shading are
achieved by using either densely packed
or more widely spaced dots.*

*You can also work with cross-hatching.
Every layer of lines that you add will make
the shading more intense. It is important
to make sure that the lines are evenly
spaced.*

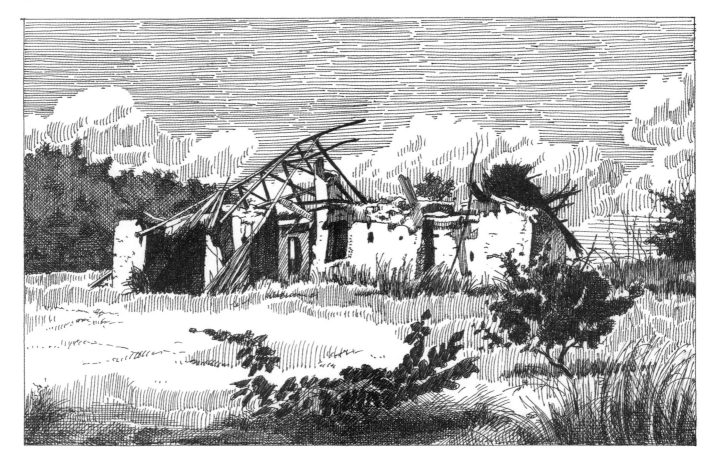

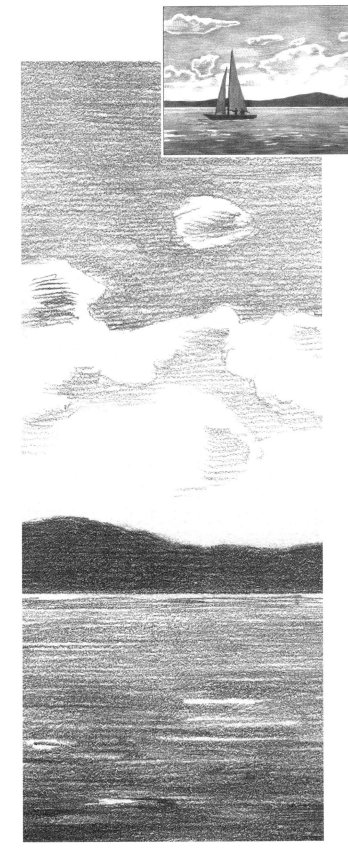

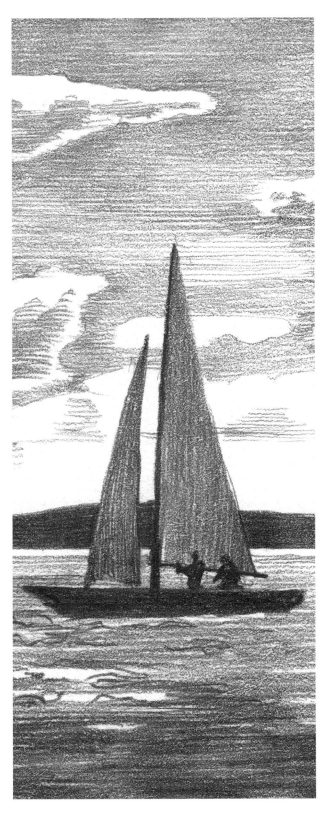

One of the most important rules to remember for landscapes that include water is that the shading of the water is always darker than the sky. The surface of the water can be drawn using subtle gradations of shading, and the ripples can be made livelier by adding wavy lines. The dark smudge of the mountains in the background is emphasized by the light shading of the water and the sky. The sail is actually white, but because of the lightness of the water and the sky it must be shaded dark, as it is lit from behind. This backlight means that the underside of the clouds is dark and shadowy, while their edges are bright from the light shining through them. And one more thing: this picture would be very monotonous were it not for the lively, rippling waves and the sailing boat. It cannot be stressed enough that you are not obliged to stick rigorously to exactly what you see—let your imagination run free!

Using the following drawings I would like to demonstrate how important it is to capture the correct shading and nuances in tone, and how these can transform a drawing.

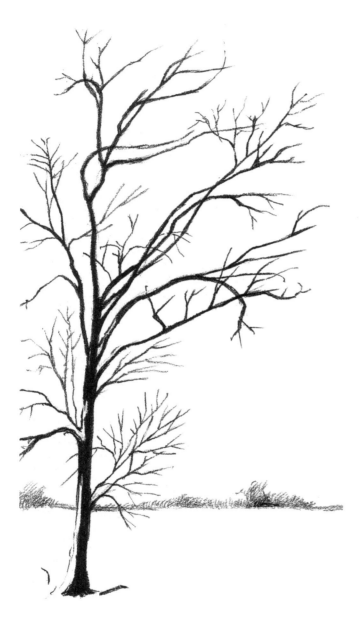

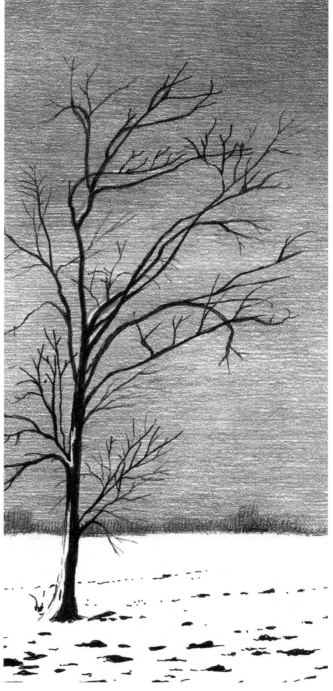

The first drawing shows a snowy winter landscape, but the second, with its different levels of shading, is much richer in variety. In the wintry landscape the brightest shade is the white of the snow. However, since it is markedly different from the gray of the sky, you can get a more forceful drawing by including this shading. Many shades are suitable for the snow clouds, from light gray to dark gray. The snow-covered ground is not an even white, because dark patches of earth can be seen here and there, and the whiteness of the flat landscape becomes less intense as it recedes into the distance.

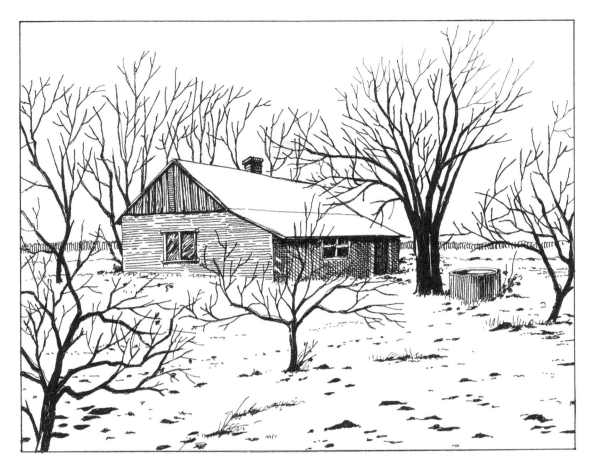

This black and white drawing looks decidedly empty and dull, although it includes all the important details. Adding shades of gray, however, makes it look a lot richer. The gray shading in the foreground gives the drawing depth, as though the house is much farther away than on the first image. The almost imperceptible shading of the sky also hints at wintry snow clouds.

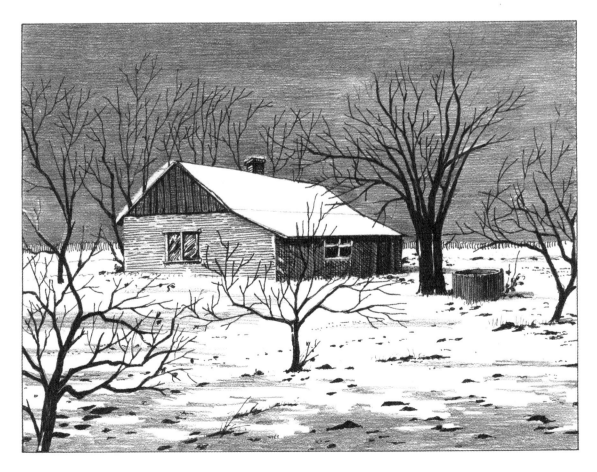

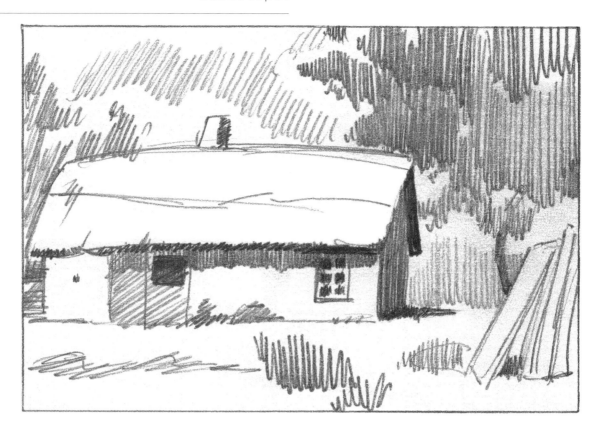

This sketch of a small farmhouse was drawn with simple lines, and is not intended to be perfect. However, it does include the most important differences in shading. This kind of sketch allows you to come to grips with the subject and work out what is important in terms of shapes, shading, and the composition. The picture below still looks like a sketch, but the addition of differences in shading makes it far more vivid. Many different effects can be achieved using cross-hatching with lines running in different directions, and in different places. You must also decide when strong contours or differently shaded patches would be most suitable.

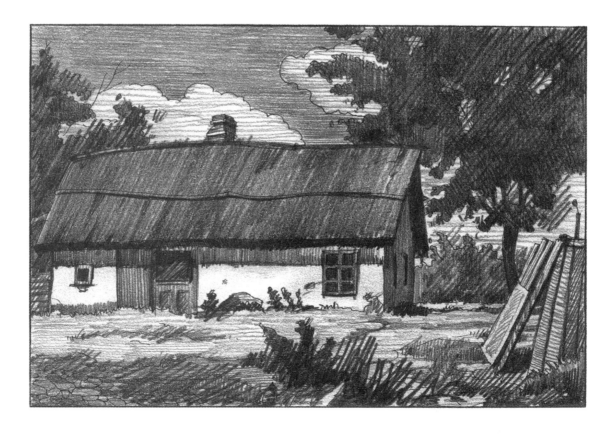

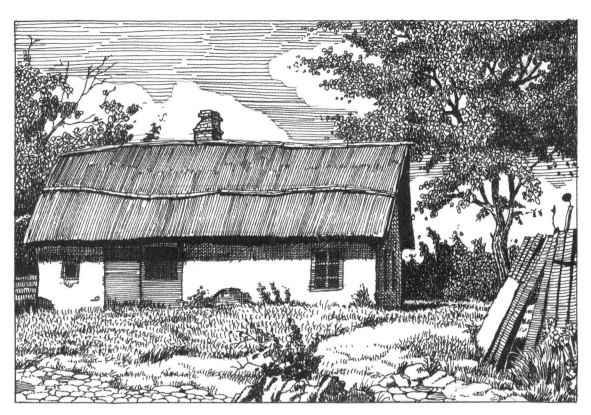

The shading must also be replicated in ink drawings. The drawing instrument used for this work employs different techniques to achieve the same effect as in pencil drawings.

The tree also has its own particular shape. Its foliage is a kind of solid, so it has a lighter side, and a scarcely lit side. Its outline is like that of a cylinder, so when drawing this and the trunk you should apply the rules for shading this solid. The leaves are made up of squiggles and loops, and the darker area uses cross-hatching.

You can make the shading of the tree more subtle by drawing in the shading of the sky. If you draw horizontal lines all the way across, the shading of the tree is more markedly softened than if they stop short earlier, leaving a white edge around the foliage, which makes it stand out.

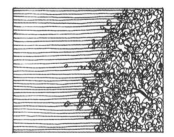

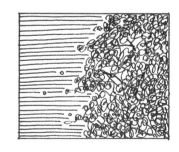

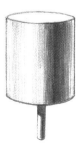

Whenever you begin a complicated drawing
you should mark out the boundaries of the
different areas of shading. Here all the details
of the tree, the house, and the foreground
have been drawn in, so that the picture
consists solely of lines. (Often simple line
drawings can look very good on their own,
so shading is not absolutely necessary.)

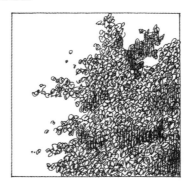

The foliage is made up of little
squiggles and loops. Here and
there you can see freely floating
squiggles—these represent
individual leaves protruding on
thin twigs.

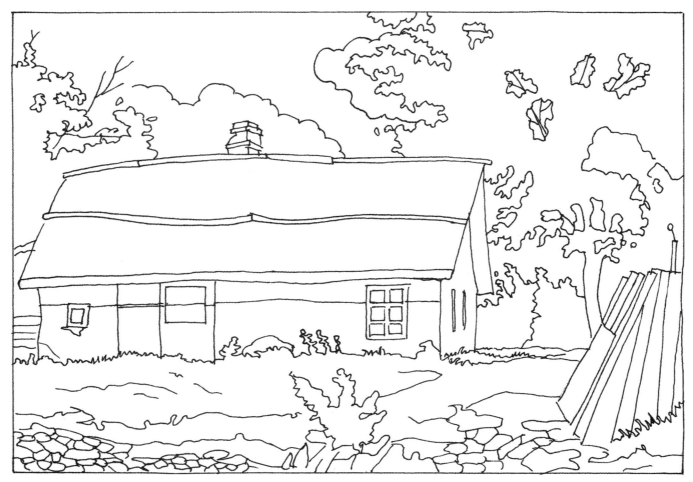

An ostensibly insignificant detail
can be wrought as carefully as
the main subject.

When drawing the ground, you must remove any "blind spots." I have
chosen this as my subject for that reason, because it is reminiscent of
flat stones laid beside one another. I have used this to give structure to
the flat surface and make it more interesting.

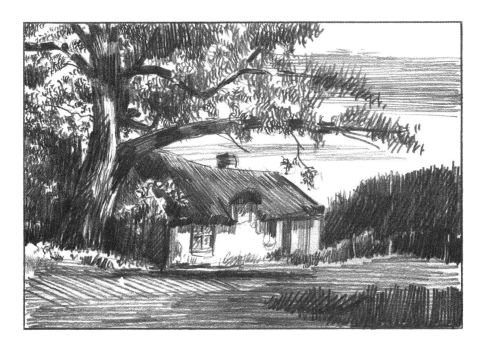

The principle purpose of the sketchbook is to capture what you have seen relatively quickly, effectively storing away an impression of something that you can later bring to mind using the sketch. Sketches can also be used for custom-made works in studios.

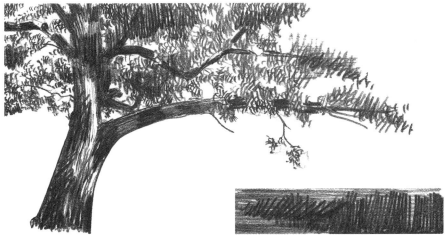

The pencil is a very practical tool for drawing, as it allows you to work quickly, and you only need to apply greater or less pressure to it in order to create darker or lighter areas. You can alter the overall effect of the drawing by using delicate lines for individual details. Larger elements are drawn simply, and everything is merely suggested in the sketch, so as to capture the main features of what you have seen.

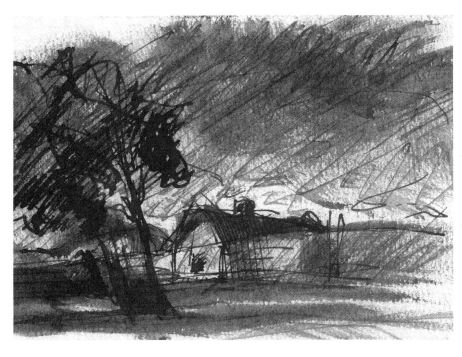

This hasty ink sketch has a similar subject, and by adding a few irregular lines the picture is as good as finished. You can capture a sense of atmosphere by marking on the most important shapes and shading. When you come to completing the drawing proper and adding detail, you can let your imagination run wild; there is no need to stick to the exact reality.

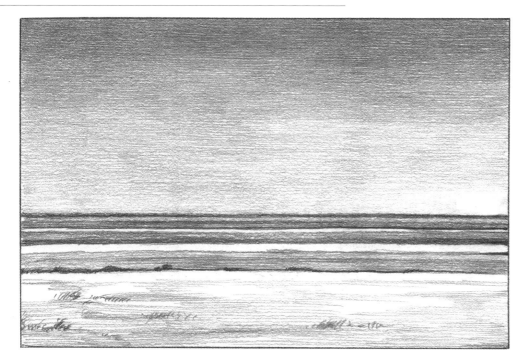

Often the landscape is nothing special in itself…

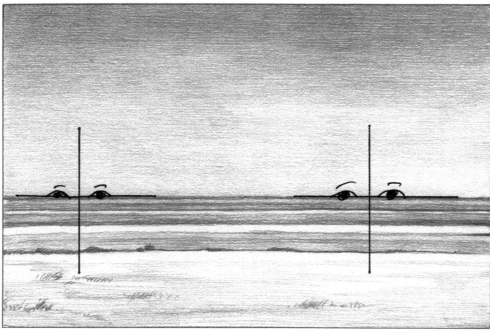

… so any point on the horizon can act as the center of the image.

These kinds of landscapes often resemble barcodes on products: every detail is different, yet they are all more or less the same.

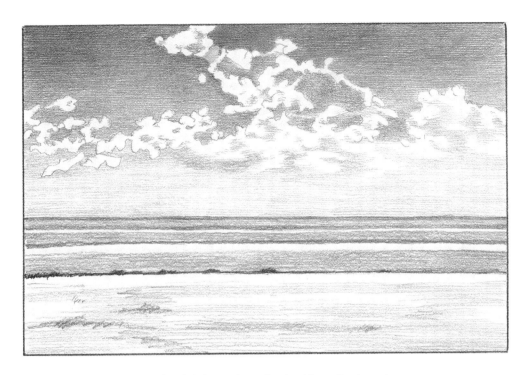

It only takes a dramatic cloud formation to make the scene more interesting. By adding this, the cloud effectively takes precedence over the landscape. When drawing the sky, the following rule will apply in almost every instance: the shading should be light close to the horizon, and increasingly darker as it moves upward. The frayed edges of the cloud are an important detail, and the delicate shading of the clouds will also enhance the picture.

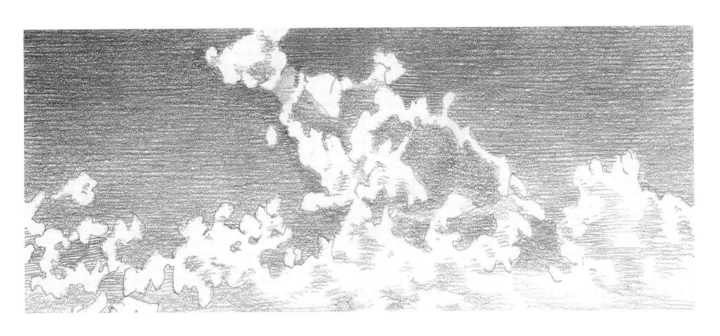

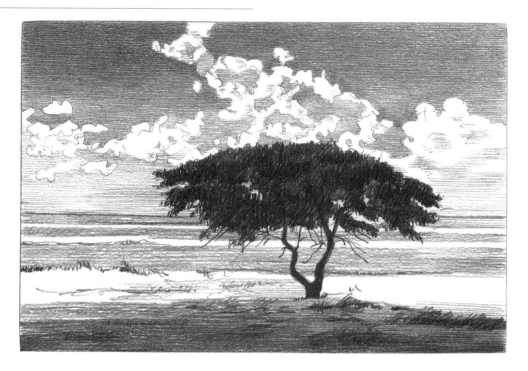

I have rounded out the landscape by adding a tree. Now the drawing has a real focal point worth all the trouble. The shape of the tree dominates the picture. Although I have not placed it in the center, the composition is balanced. I have made the tree stand out not only by placing it against this background, but also by giving it dark shading.

The stronger shading in the foreground counterbalances the dark shading of the sky. It looks as though it is the shadow of something large, like a house. A sense of balance is one of the most important requirements of a good drawing. I recommend turning the picture upside down every so often, as this makes it easier to spot any errors.

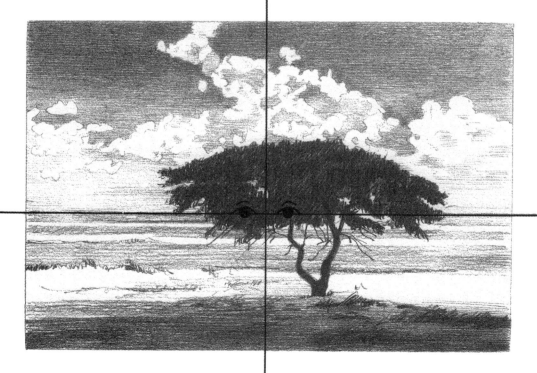

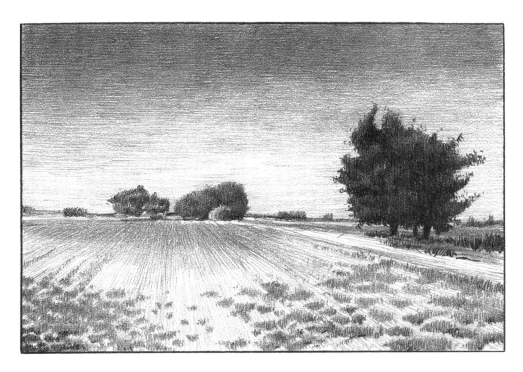

This type of landscape makes the artist's job easy. The parallel furrows almost instantly draw the view toward the middle point of the prospective image. This is marked on by the level line of the horizontal plane and the vertical line crossing it at right angles, dividing up the space.

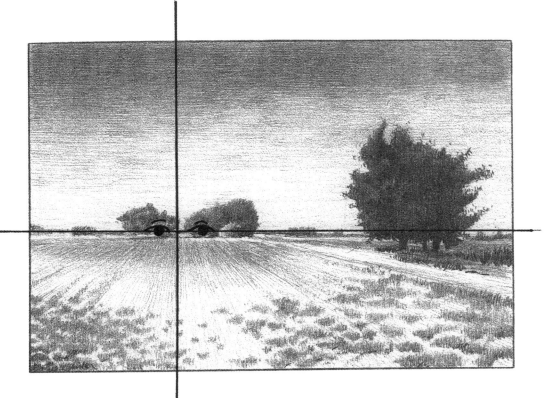

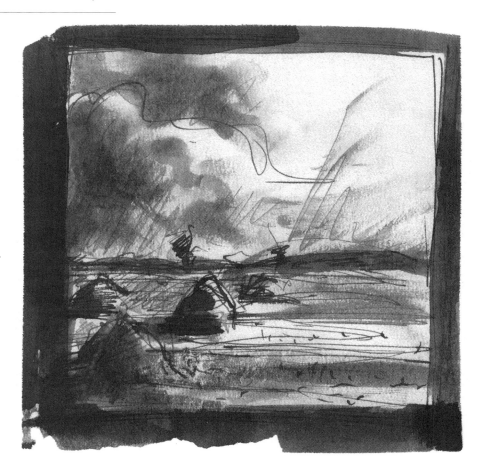

You can also make beautiful yet quick sketches using a combination of ink drawing techniques and ink thinned with water—in other words, washed ink. When painting, and washed ink comes under this category, I recommend that you always start with the light patches. This affords you the possibility of correcting any mistakes by covering them with darker ink, which is not possible for areas that are already dark. You can mix ink and water with a paintbrush, and also smudge existing lines with a cotton bud. Personally, I like to draw a kind of frame around the finished drawing in ink.

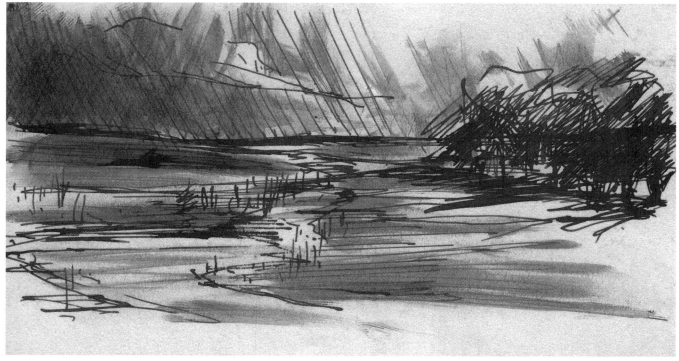

If you are drawing outdoors, you should always begin by working out where the center of the image will be. This is vital because in order to proceed with the drawing and apply the rules of perspective, you need to know what parts of the scene lie under, on, or above the horizontal plane. (A reminder: an object that lies under the horizontal plane is seen from above, and vice versa. You can read more about the horizontal and vertical planes in the first chapter.)

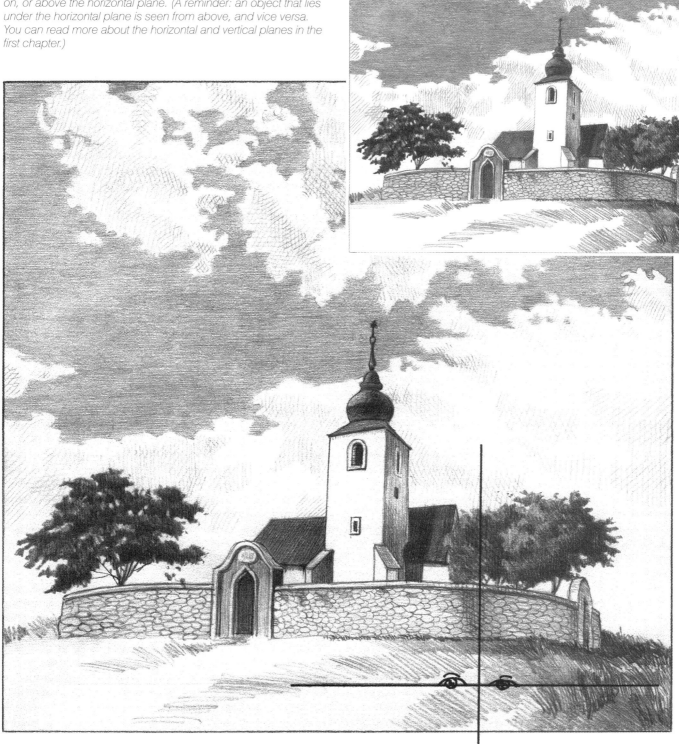

In addition to this, you have to work out where the vertical plane cuts the space in two, and thus which parts of the scene lie to the right and left of it. A church is a pleasant subject in itself, but you can make it even more interesting by adding a cloud formation.

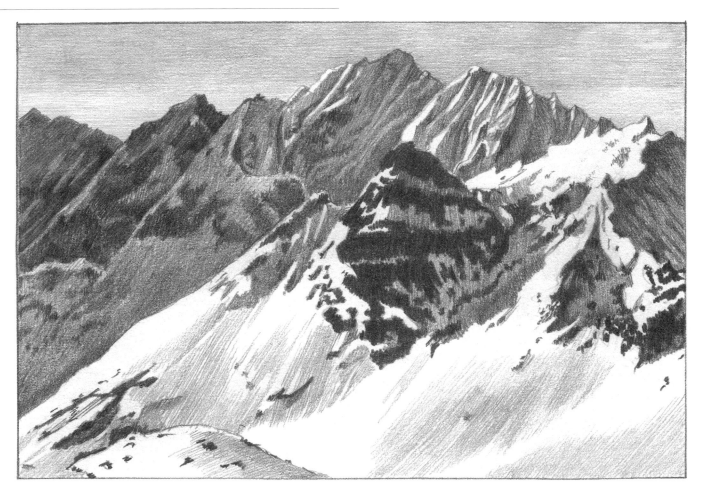

You can really practice subtle nuances of shading when drawing mountains. The distance means that your view is essentially more compact, so there are no little details to distract you. The black rocks sticking out of the white snow and the irregular grooves formed by water give the picture greater variety. At this distance you should also work out where the center of the image is and mark it. The shape of this formation is closest to a pyramid or a cone, so you should shade it accordingly.

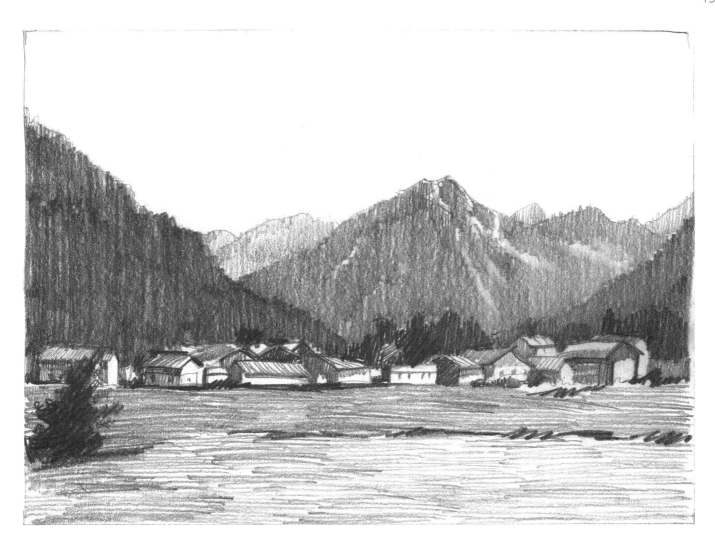

Although the houses in this valley look tiny in comparison with the high mountains, they have an important role in the drawing. I achieved this effect by using white patches which stand out against the shading in the picture, and also hint at sunny weather, and also by placing them in the center of the picture. Everything that is in front of or behind the houses draws the eye toward them: the outline of the mountain in the background (thus darkly shaded), which runs down to the village; the contrasting dark trees positioned behind the white patches; and the shading of the ground in the foreground, which becomes a little darker as it gets closer to the village. One of the basic rules of artwork for commercial advertisements is that the focus of the picture should be emphasized and highlighted by playing down the other elements. A good poster draws the eye toward it, and a good drawing should draw the viewer's gaze automatically to what the artist considers to be the most important element of it.

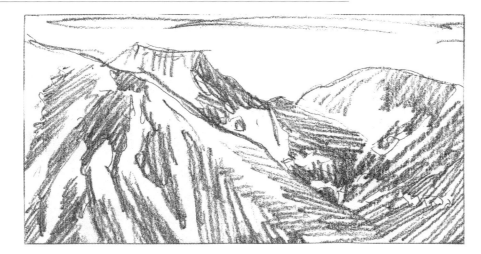

The surface of the mountainsides is uneven. Over millennia, snow, water, and wind have scored deep furrows into their slopes. There are no rules for drawing these, but it is important to try to capture the three-dimensionality and texture of the surface using lines running in several different directions and following the shape of the mountain. In this sketch two superimposed, converging layers of lines represent the opposing slant of the two mountain slopes.

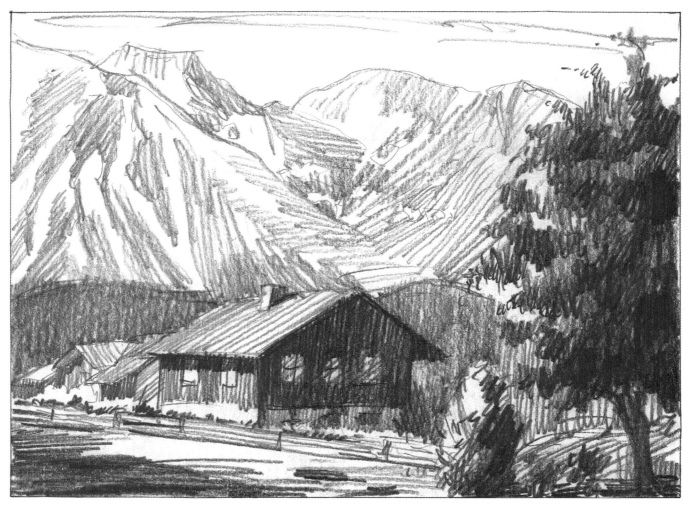

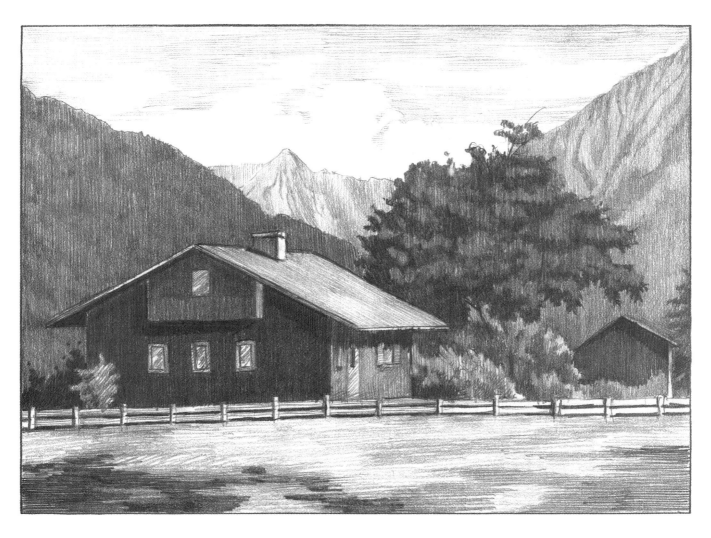

Shading plays an important role in any practice drawing, as the atmosphere that this helps to express is an important part of the picture. The grayscale will help greatly in discerning the shading of diffe-rent areas. A general rule which should also be applied to this drawing, is that the darker surfaces of the houses in the foreground should be more intense that the shading of the house wall, running in almost the same direction, of the building that is farther away. This also goes for the mountains in the background: the darker shading shows which of them are closer.

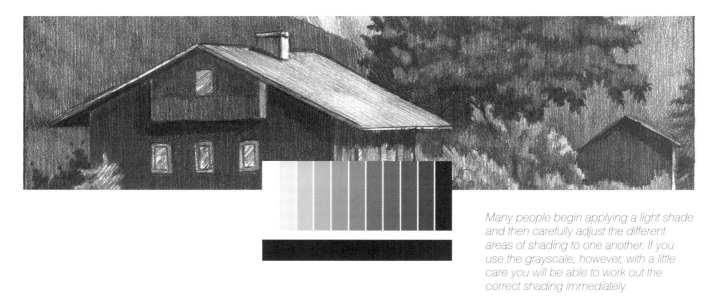

Many people begin applying a light shade and then carefully adjust the different areas of shading to one another. If you use the grayscale, however, with a little care you will be able to work out the correct shading immediately.

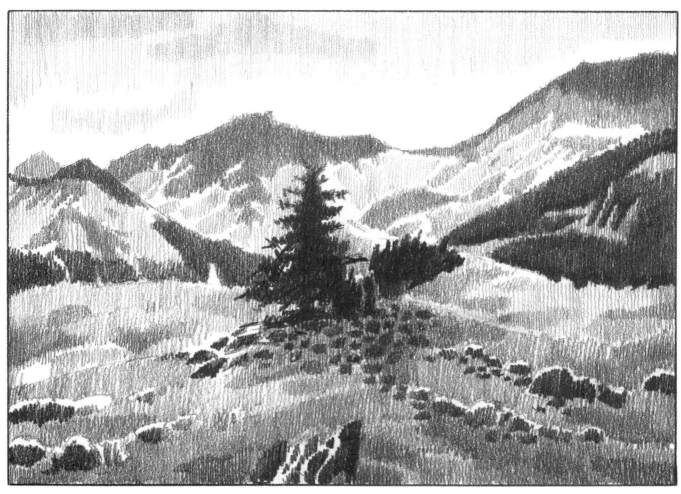

The special thing about this drawing is that it is made up of only vertical lines. When discussing the cylinder shell, we talked about the expressiveness of lighter and darker parallel lines. This technique can also be turned to other subjects—pressing down more or less firmly with the pencil allows you to capture stronger and closer details, or paler elements that are farther away on paper. You can achieve smoothly shaded areas by making sure that the lines are evenly spaced. The dominant feature here is clearly the spruce tree—it lies in the middle of the picture and is the darkest element. This is the only place where I have deviated from the vertical lines, using short, horizontal strokes for the ends of the branches.

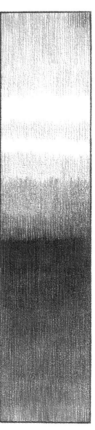

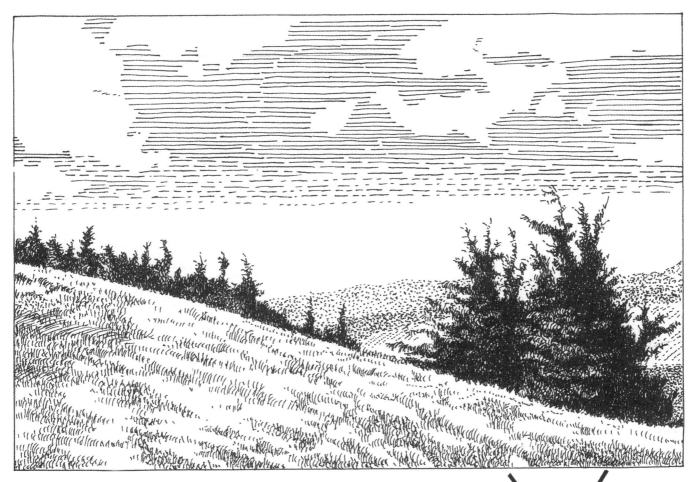

If you are doing an ink drawing, you can create interesting nuances in shading by using both denser or more widely spaced dots and short lines. Regularly spaced dots can also be used instead of lines. There is a smooth flow of ink from the pen, enabling you to keep lines at an even thickness. However, using this method incorrectly can result in a botched drawing. A tangle of lines does not fit well with this line technique, if evenness is necessary. This method is most suitable for sketches that can prompt your memory when you later come to do proper drawings.

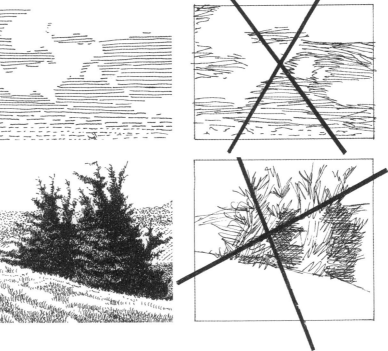

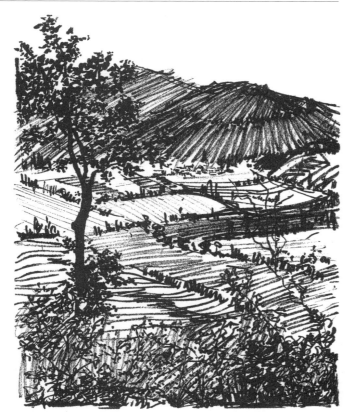

A sketch is ideal for drafting out a landscape quickly. Without adding details, you can hint at trees, lines of trees, and so on, using breaks in the lines that follow their shape, and by using other groups of lines.

If the foreground is important the trees and houses there can be shaded, or drawn more darkly, and the background given lighter shading.

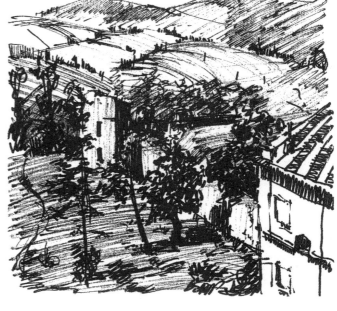

In this sketch of Rákóczi Castle in Sárospatak, Hungary, the castle towers up out of the landscape, while its surroundings look rather humble and inferior. The clean line of the castle wall cut the space in two, while the shading in the foreground makes the castle stand out, as the shading draws your eye toward the main subject of the picture.

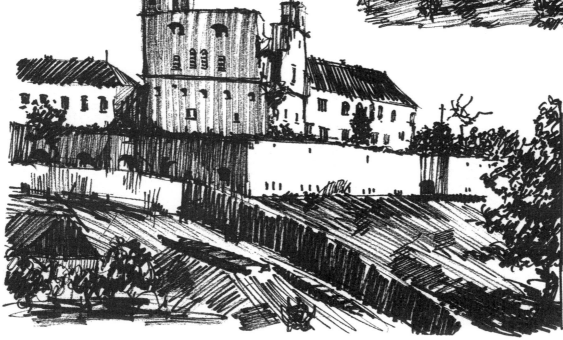

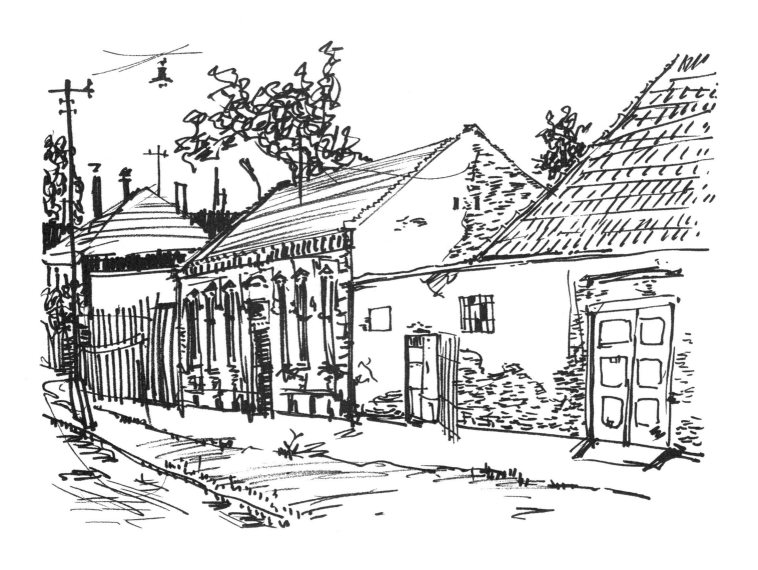

Townscapes

In townscapes, the subjects are built-up areas, groups of buildings, roads, streets, and so on. As our built-up surroundings are made up of extremely regular shapes, what you have learned about rules on perspective and the cube will be very helpful when it comes to drawing them.

Using a schematic drawing of a house you can work out the most important proportions with reference to the length and the height, as you did for the rectangle and the cuboid. If you look at buildings straight on, the opposite edges run parallel to one another.

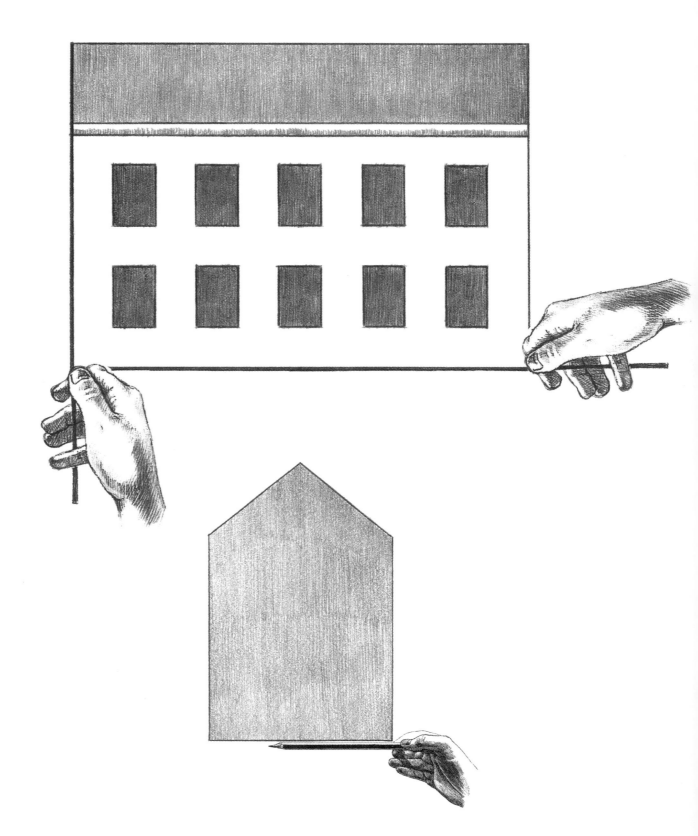

Buildings normally appear in a neutral position in space, so when drawing them you should follow the rules of perspective.

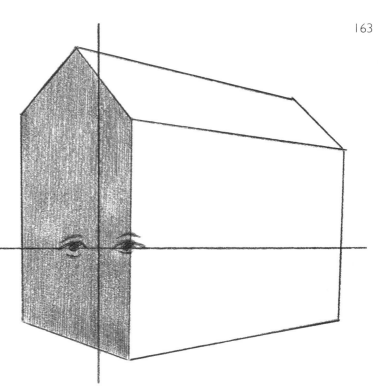

The first step is to work out where the center of the picture is, as this is needed in order to apply the rules of perspective. Once you have drawn in the horizontal and vertical planes so that they divide up the space, any deviation in perspective by the vertical and horizontal edges and lines will be easier to spot.

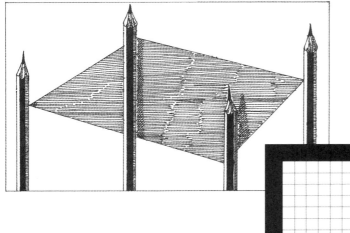

Work out the distance between the corners of the base surface—in other words, between the vertical edges of the house. A plotting grid, pencil, or measuring stick can all be used to find the measurement.

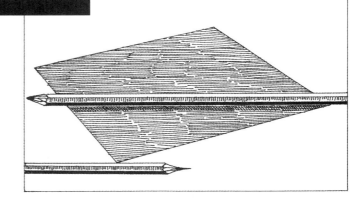

Using the horizontal lines you can find the distance between the corner that is closest to the viewer and the other corners.

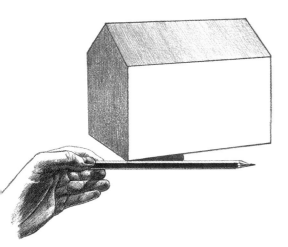

In the neutral position, the bottom edge of the house clearly slants away from the horizontal plane. You can find the angle of this slant by holding a pencil against the corner.

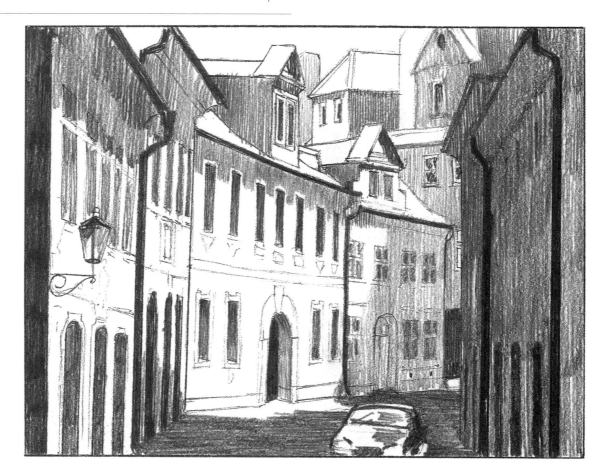

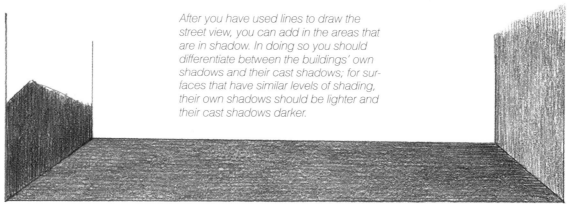

After you have used lines to draw the street view, you can add in the areas that are in shadow. In doing so you should differentiate between the buildings' own shadows and their cast shadows; for surfaces that have similar levels of shading, their own shadows should be lighter and their cast shadows darker.

Certain planes or shapes are shaded using lines drawn in pencil; these lines should follow the shape. Incorrect layers of lines will result in an obscure, uneven surface.

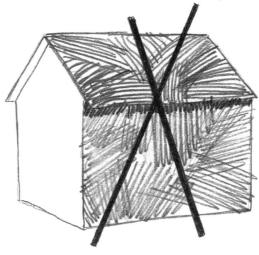

The slanting lines are both even and parallel, but their direction gives the impression that the houses are leaning *steeply. It is easiest to draw lines running at a 45-degree angle to you.*

 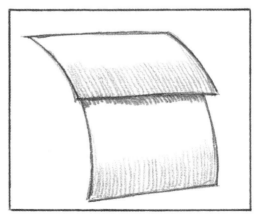

One common mistake is drawing slightly bent, slanting lines, which distort the drawing and *make the surface look very unlike one intended for a roof or a wall.*

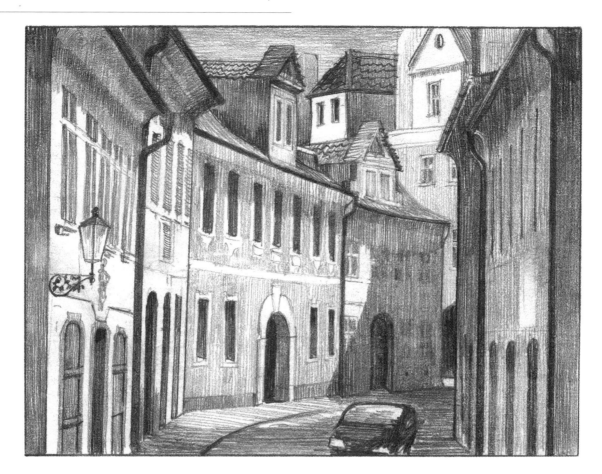

When shading by using lines that follow the contours of your subject, you should ideally shade house walls with vertical lines, streets with a layer of horizontal lines, and roofs with cross-hatching that follows their outline. Capturing the correct level of shading is a little harder, and you must, of course, adhere to the rules of perspective. Parallel lines intersect at infinity, while objects that are closer to the viewer appear bigger—a rule that is especially pertinent when drawing adjacent windows and working out the height of façades.

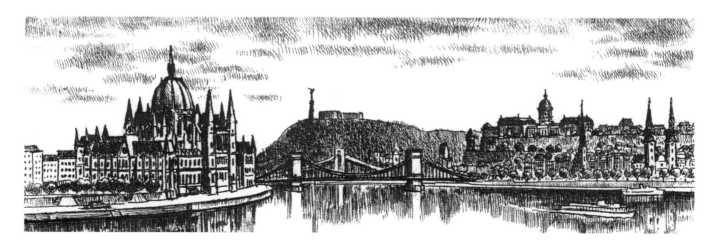

Vertical lines are almost always of use when doing sketches. Curves and diagonal lines can be used to enhance the drawing.

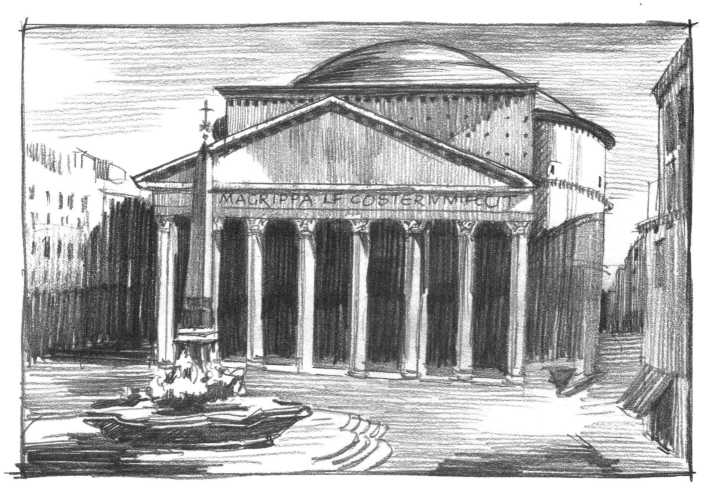

A beautiful building may be the sole subject of a picture, in which case the surrounding buildings are merely hinted at. The prominent features—the dome, the tympanum, and the row of columns—are made vivid through the use of shading. When drawing subjects that are as rich in variety as this, I recommend that you always use the grayscale, as when you are intent on fleshing out the little details it is easy to forget to look at the picture as a whole.

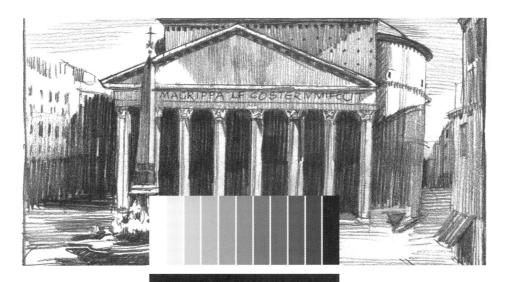

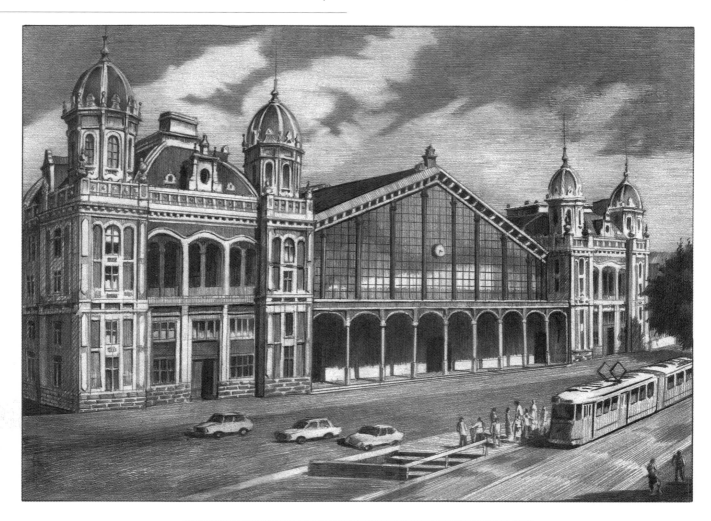

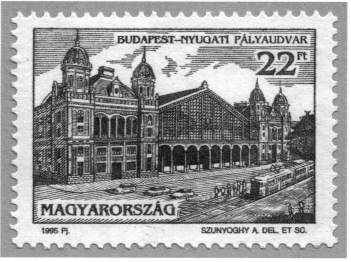

This carefully crafted pencil sketch is a design for a copper engraving as an image on a stamp. When they are reduced in size, pencil drawings that include shading must be turned into line drawings. If you compare the two pictures you will see how the same effect can be achieved with fine cross-hatching.

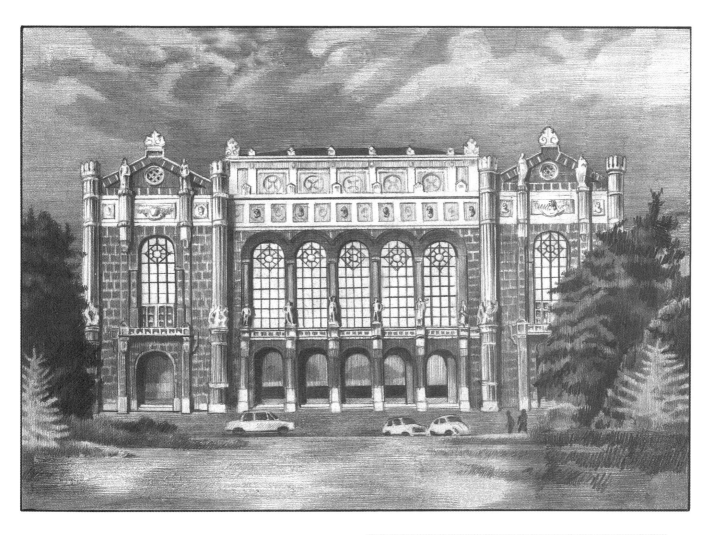

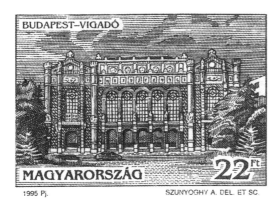

Individual details of the subtle pencil drawing must be transformed into decorative elements for the stamp design, as on the stamp they will be so small that this is effectively the only way that their shapes can be seen. Examples of these elements include the trees at the edges of the picture.

Two prints of the shaded drawing were made. In one, the parallel lines used to shade the sky went up to the outline of the roof, thus blurring its outline. The white clouds in the other version make the shape of the roof stand out and emphasize its contours.

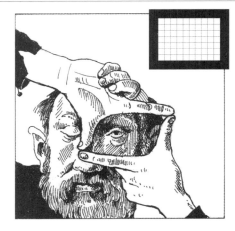

It is always difficult to choose what section
of a scenery to draw, but the plotting grid
makes it easier. If you don't have one to
hand, you can make a "frame" using both
forefingers and thumbs.

With its narrow alley, this mosque in Tripoli
provides a fascinating view. The impres-
sion of dazzling sunshine is heightened by
the white walls, which can only be cap-
tured by giving the sky darker shading.
The use of light and shadow, such as the
walls' own shadows and their long cast
shadows, indicates that the sun is setting.
This dramatic perspective clearly draws
the viewer's gaze toward the end of the
alley. Lines have been used to create
the shading, following the contours of the
walls; the drawing is made up of horizon-
tal and vertical lines.

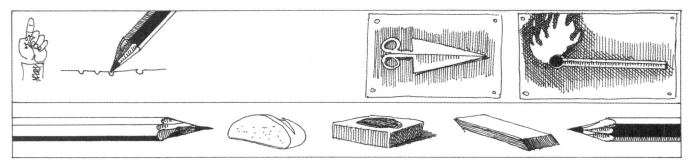

I would discourage you from drawing with
pencils that are H hardness or harder,
since they are very hard and only give a
weak color, but leave grooves in the paper
that make it fit only for having scissors or
a match taken to it. Rather, I recommend
using a soft pencil, and an eraser or
breadcrumbs for making corrections.

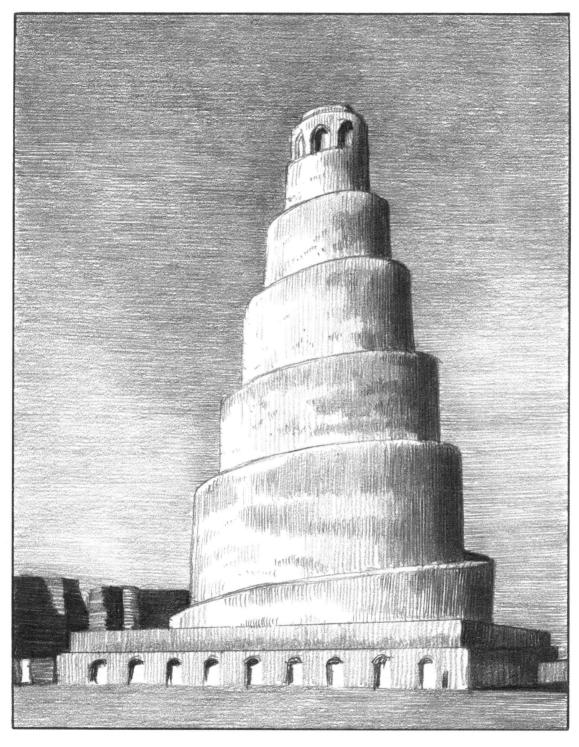

The minaret of the red-brick Great Mosque in Samarra is an awe-inspiring structure. The top is reached via an 8–10 foot-wide spiral path. The biblical Tower of Babel must have looked something like this.

When drawing it, the rules about shading a cylinder apply. In order to give the picture greater contrast, the sky next to the lit side is shaded somewhat darker, while the sky to the shaded side is lighter. You should take great care over shading the

sky. One tip is to turn your paper around, so that you can draw the lines that will actually run horizontally as vertical lines, as this is much easier to do. Uneven lines will not do here.

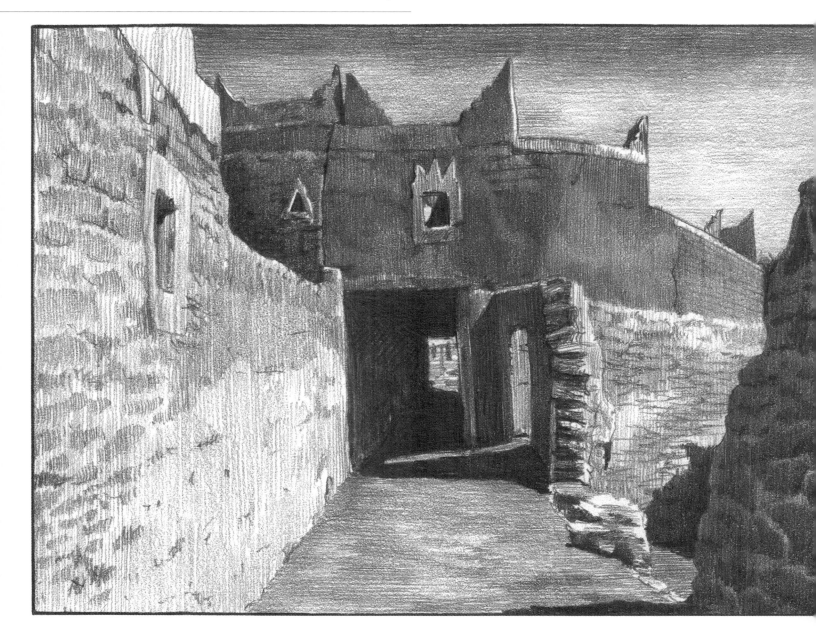

A group of clay buildings in an Arab country. When drawing these, the most important things to bear in mind are the composition, the image section, and the shading. As this picture contains large, dark gray surfaces in the middle and toward the top, the shadowy section of wall to the right must be given dark shading.

I will demonstrate some important elements in the picture by focusing on the following cut-out sections.

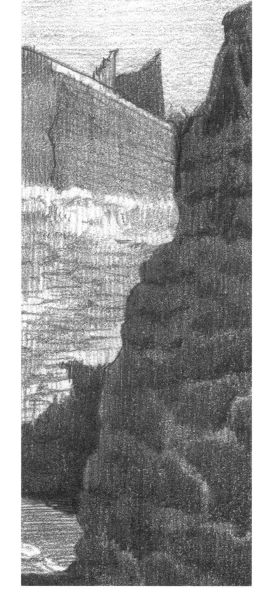

The shading of the walls' own shadows and their cast shadows are different, and the contrast between them must be emphasized.

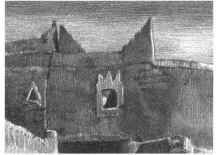

Despite its crookedness, this window is very attractive. The sunlight forms a white edge around the decorative window frame jutting out from the house wall, and inside you can see that this results in a bright patch where the light has fallen on the wall. The dark shading of the cast shadow makes for a good contrast.

The rows of clay bricks on the left-hand wall draw your gaze toward the center of the picture, as though the purpose of this drawing were to demonstrate perspective. If careful attention is not paid to these lines, the structure of the wall and the picture's perspective will appear muddled.

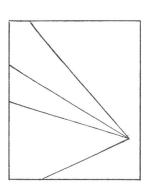

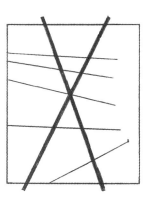

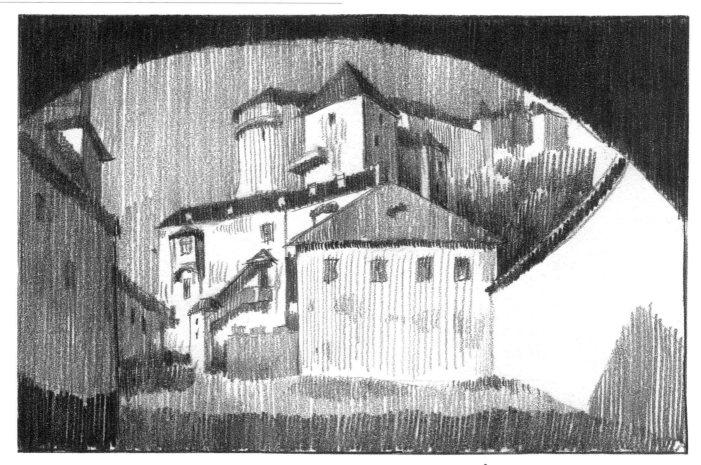

The curved archway adds interest to this
image section, and this is heightened
by its strong contrast with the sunlit walls.
Although almost only vertical lines have
been used for shading in the sketch, it
contains important information that will
help you to put together the final drawing.
As with any drawing, you have to work
out where the center of the image will be,
as this alone allows you to draw the lines
according to the rules of perspective.

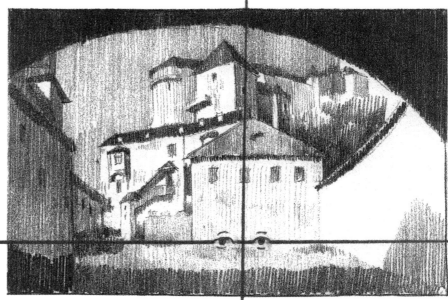

You can also work out the ideal center of an image if you are looking out from an upper floor. Once you have found it, it will be much easier to apply the rules of perspective. This scene contains several simple shapes, such as a pyramid, cylinder, cone, and cuboid, so you must follow the rules that apply to these shapes if you want to create a good drawing. Looking at the cylinder-shaped building, you can see that the elliptical curve that is lower and thus farther from the horizontal plane stands out more than the one that is closer to the plane. It is also interesting to note the way in which the parallel lines run toward one another in relation to the horizon, marked by a horizontal line. The thin yet very dark streak on the shadowy area of the left-hand building counterbalances the shadowy yet light patches on the right-hand side.

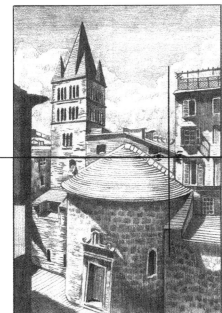

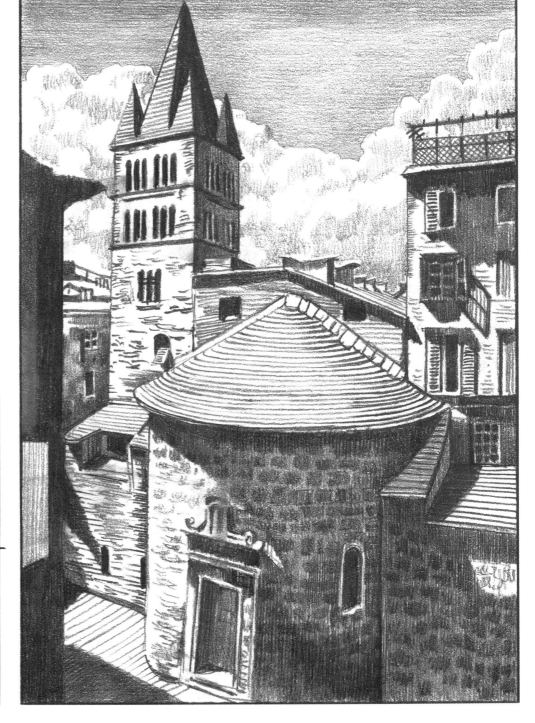

This Georgian church in the Caucasus is a complex structure. When you take a closer look at it, however, you realize that it incorporates a number of simple shapes, such as squashed cuboids, cylinders, cones, and the prisms of the roofs, made up of triangles. Once you have spotted this and worked out where the center of the image lies, the sketch will no longer be such a daunting task.

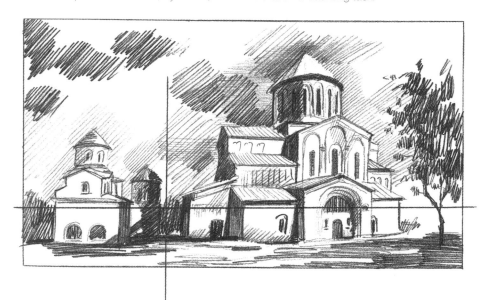

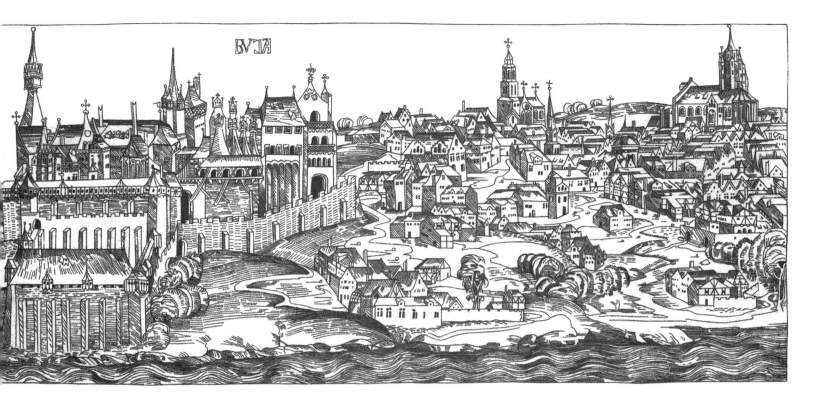

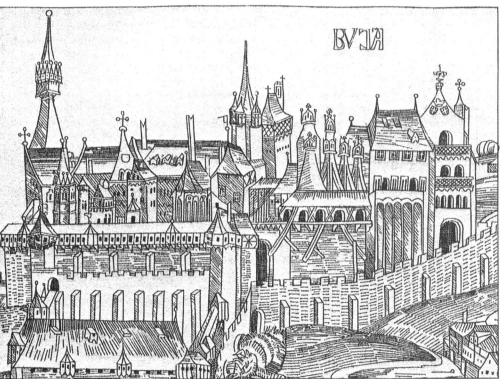

Now for a small experiment with style: the charm of old woodcuts lies in the awkwardness of their attempt to show perspective. One house might look as though you are looking down on it from above, while another's lines correspond to a view from below, and yet the picture is absorbing. The accomplished cross-hatching used for the details soon makes us forget the piece's flaws in terms of perspective. It is good practice to identify the horizontal and vertical planes of individual elements in the picture. The levels of shading are very similar throughout, but the trees are scored with curves, and the river with wavy lines. Looking more closely, you will see that many of the roofs have been shaded with horizontal layers of lines, and others with lines that follow the shape of the subject. The similarities in shading are a result of the lines being evenly spaced throughout.

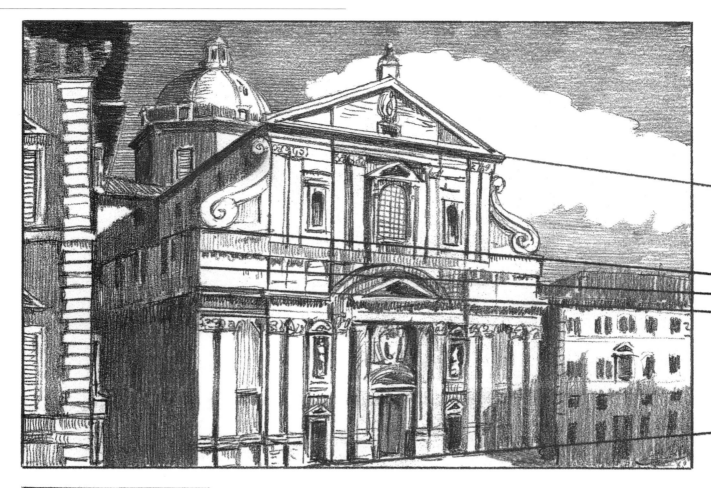

When drawing a complicated building you should begin by working out the angle of the slanting lower edge against a horizontal line. Following that, you should find the eye level height (the horizontal plane), and the angle at which the parallel sides deviate from this; the horizontal plane determines the direction in which the parallel horizontal lines will run toward one another. If the horizontal plane cuts toward the bottom of the building, the parallel upper edges are steeper; if the horizontal plane lies toward the top of the building, the lower edges are steeper.

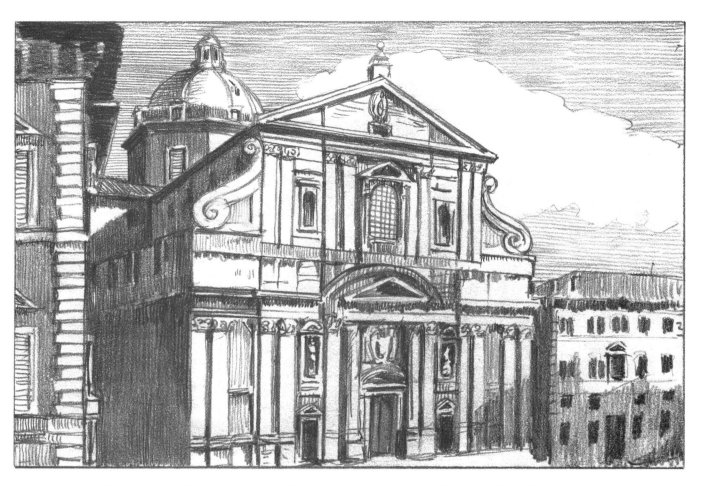

The grayscale will prove to be a great help when it comes to shading. The drawing will look really vivid if you render the play of light and shade carefully. Balanced shading is crucial, so if you think that the drawing will only look its best if an area of shading is made more intense or stronger than it is for the actual subject, you are free to adjust it, as in the above image—this is up to your discretion as the artist.

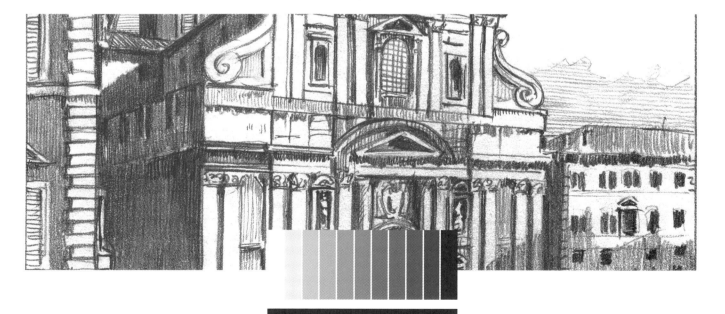

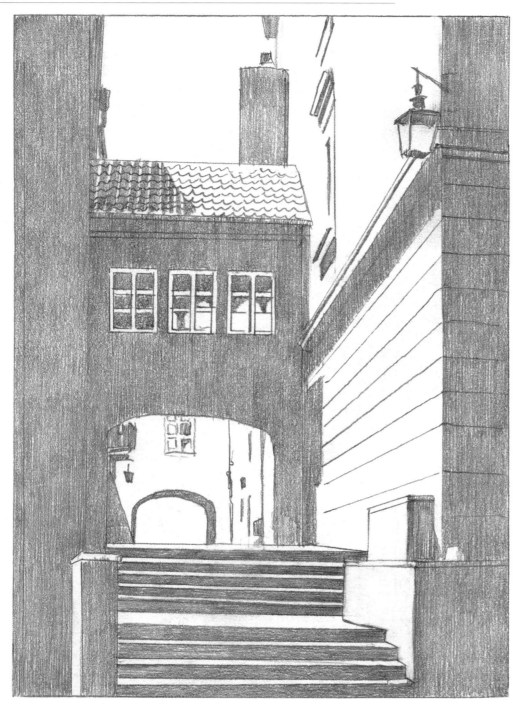

The lines on the right-hand wall plainly
draw the gaze toward the horizontal plane.
Although they are not quite horizontal, the
steps clearly demonstrate that you can see
more of them from above the farther they
are from the horizontal plane. As practice
you can sketch in the horizontal plane and
the intersecting parallel lines that you need
in order to find the center of the image.

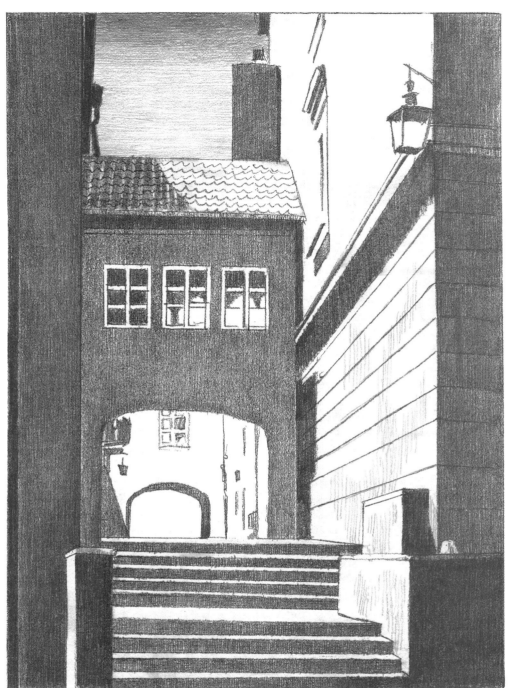

These two drawings are not identical. In the left-hand picture the walls' own shadow is lighter and their cast shadow is darker, corresponding to the real scene.

In the picture on the right, the walls' own shadow is stronger, and the cast shadow is lighter. It is easy to miss this mistake at a brief glance.

Being able to find the horizontal plane—eye level—is
a vital skill.

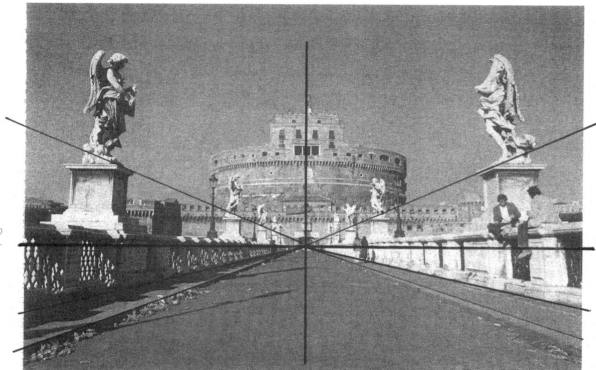

This is not difficult
in the photo of
the bridge of the
Castel Sant'Angelo
in Rome. The pho-
tographer stood in
the middle of the
bridge to take the
shot, so the stone
balustrades on
either side draw
the gaze toward
the center of the
picture.

It becomes more
difficult if the scene
is viewed from an
upper floor. The
horizontal plane of
the Baptistery in
Florence lies at the
upper edge of the
door. This means
that in this view of
the building, the
parallel lines that
are above the
horizontal plane
run downward,
while those that lie
below the plane
run upward, and
they all intersect at
a single point.

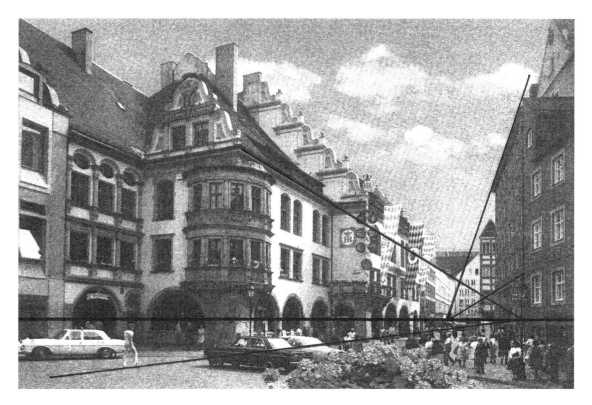

The Hofbräuhaus in Munich and the buildings opposite it are not parallel, but run toward each other at an angle, so that their various parallel lines meet at different points. However, both of these points of intersection are on the horizontal plane.

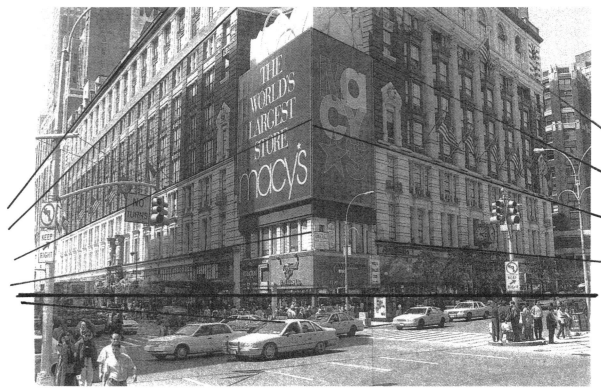

A detailed view of Herald Square in New York. The horizontal lines of the windows and the course of the gutters draw the gaze, making it easy to find the horizontal plane.

As has been mentioned previously, an increasingly wider strip of the steps can be seen below the horizontal plane. Despite this, they are not easy to draw, since their own shadow and cast shadow alter the view. The steeply sloping parallel lines on the right-hand wall will help you find the horizontal plane; they show that the viewer is looking at the steps from some way below the plane.

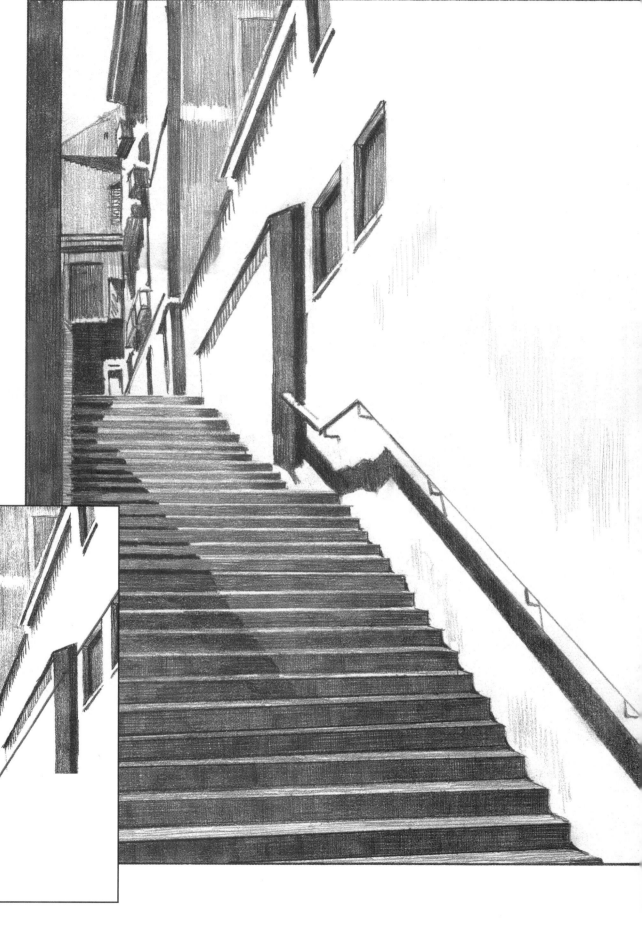

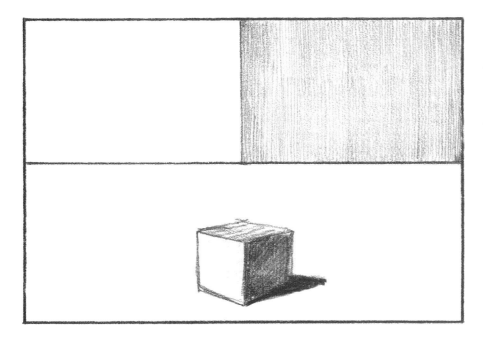

As you have learnt for simple shapes, the three sides of a cube have different levels of shading. The differences between them can even be seen if the directions of the planes scarcely differ from one another.

The shading of the steps' cast shadow is stronger than that of its own shadow. If no distinction is made between these, the only thing to tell the surfaces apart is a line, and the picture no longer appears to make any sense. The shadow that falls on the stairs must be strongly shaded, as this is the cast shadow.

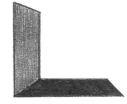

A view of Budapest, with the Clotilde Palace in the foreground and the Elizabeth Bridge in the background. I have shaded individual elements in the picture using lines running in different directions, but parallel lines within an individual detail. I have used regular cross-hatching for the roof tiles, which gives the impression that very careful attention to detail and precision has been used to create the drawing.

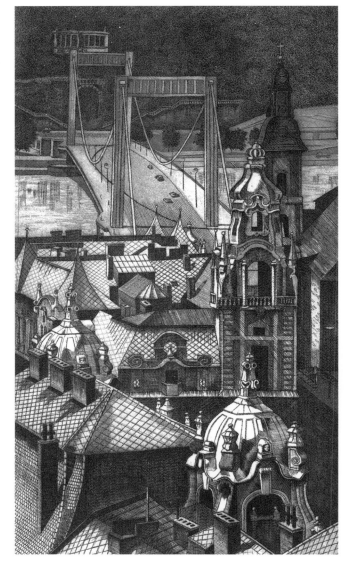

A view of Vajdahunyad Castle, Budapest, which houses the Agricultural Museum. This complex of buildings, which includes architectural styles from several different centuries, is made more vivid by capturing the play of light and shadow. I have added the dark tree on the right-hand side in order to balance the shading.

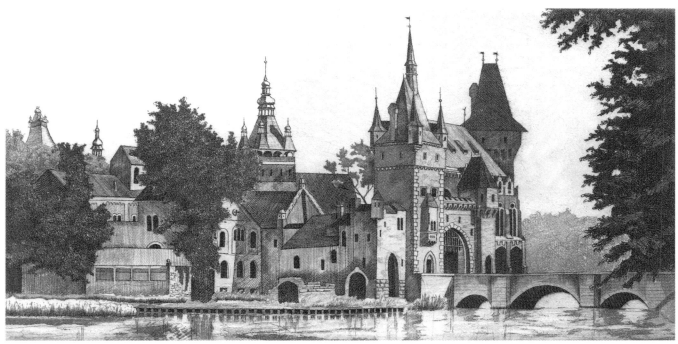

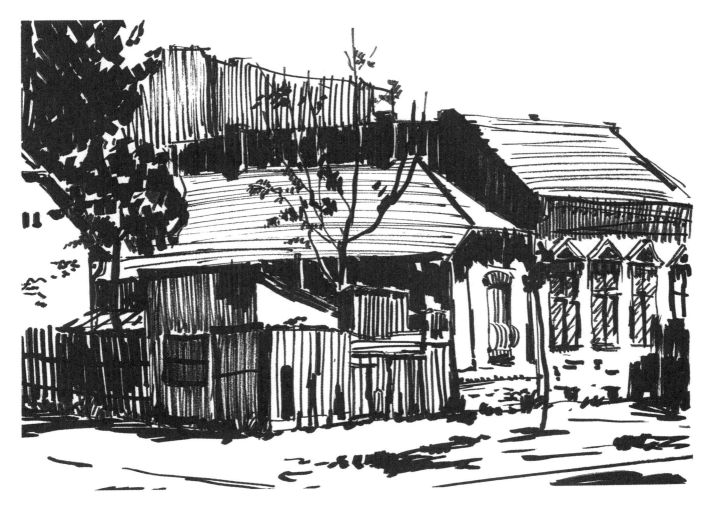

Drawing sketches with a felt tip pen is not easy, as it is very difficult to make corrections; the only effective way of doing this is to draw a thick black mark over the top. This means that you need to capture the subject at speed. Felt tips are especially recommended for scenes that are rich in contrast, but not for drawings which require subtle shading. The only way of altering the intensity of the shading is by changing the space between the lines; larger spaces correspond to shades of gray, while narrower spaces result in dark-looking surfaces.

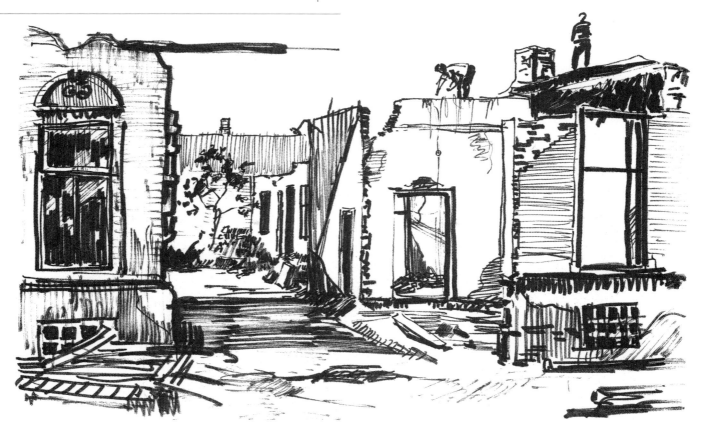

You can draw this intriguing view of an abandoned house with a few simple lines, which succeed in making even the crumbling walls and the people on the roof appear lifelike.

This sketch of a street is also made up of a few swiftly drawn lines which suggest peeling plaster and the burgeoning weeds on the sidewalk, and succeeds in depicting the old, dilapidated houses. I should also mention that the ink from felt tip pens soaks through paper and sometimes makes a mark on the next sheet. It also tends to fade if exposed to sunlight.

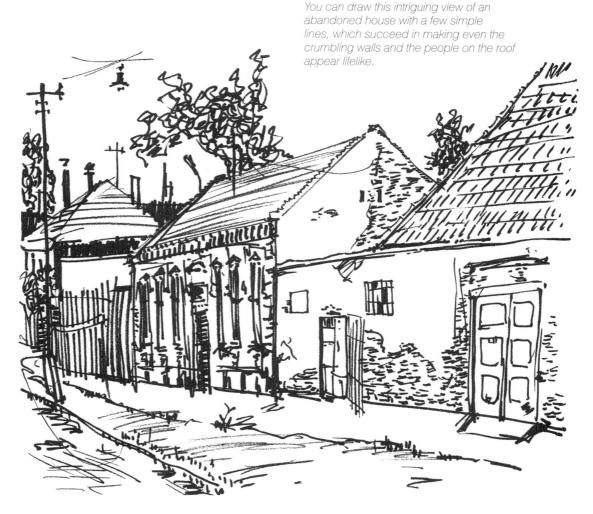

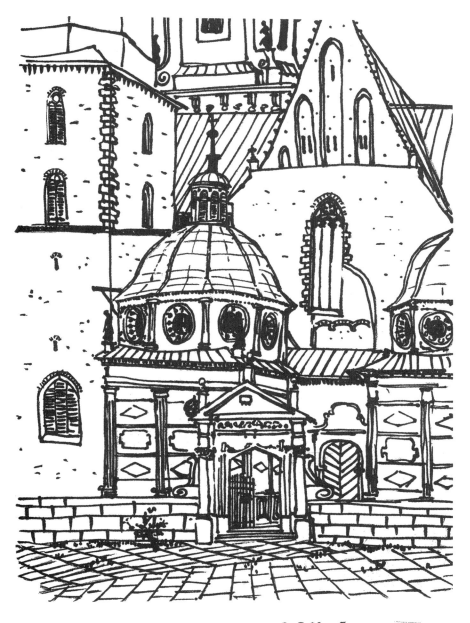

It is also possible to draw the details of a magnificent building using only lines, with no shading. The important thing about drawing freely is that it does not have to be precise; often it is the very awkwardness of a cornerstone, say, that gives it its charm. If you look more closely you will see that almost everything in the picture has been drawn casually.

In this view of a section of a street seen through a window, part of the window frame is joined to the street. This line drawing is also complete in itself.

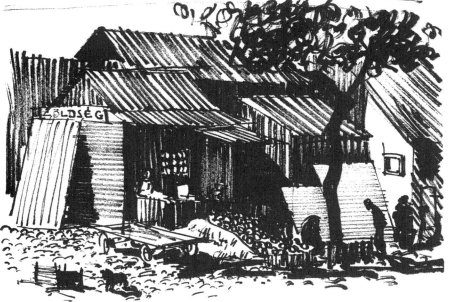

This drawing of some shacks is made up of a series of strung-together, simple planes with line shading that follows their shape; the surfaces of the roofs are shaded with parallel lines that run toward the tent-like roof, while the walls are shaded using vertical lines. The sunlight means that objects in the picture have a strong shadow of their own, and cast strong shadows themselves, so a felt tip pen is ideal for producing this sketch.

When drawing quick sketches it is vital to
establish aspects like the position of the house,
the position from which the sun is shining on
it, the size of the trees, and so on. You are not
trying to be too precise about the details, but
you should mark down the most important
features of the picture. The atmosphere of the
scene must be expressed
in the sketch.

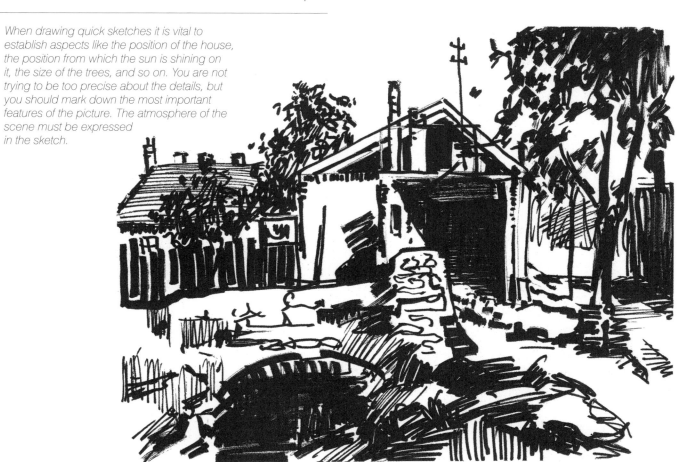

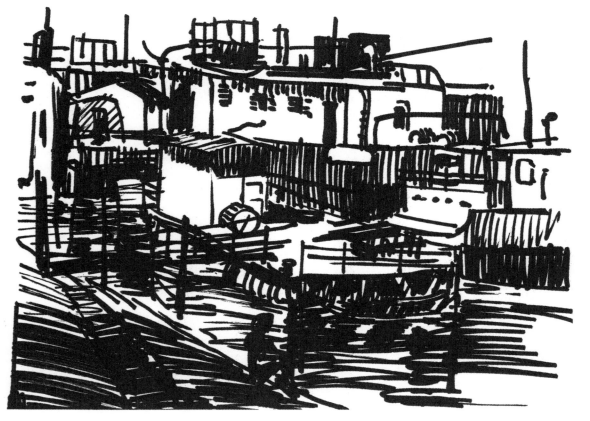

A few distinctive
features of the
boats stand out
from the similar,
monotonous
elements of this
sketch, which
illustrates a harbor
inlet. It was drawn
using very simple
techniques:
vertical lines
suggest the parts
of the boats, and
horizontal lines the
water.

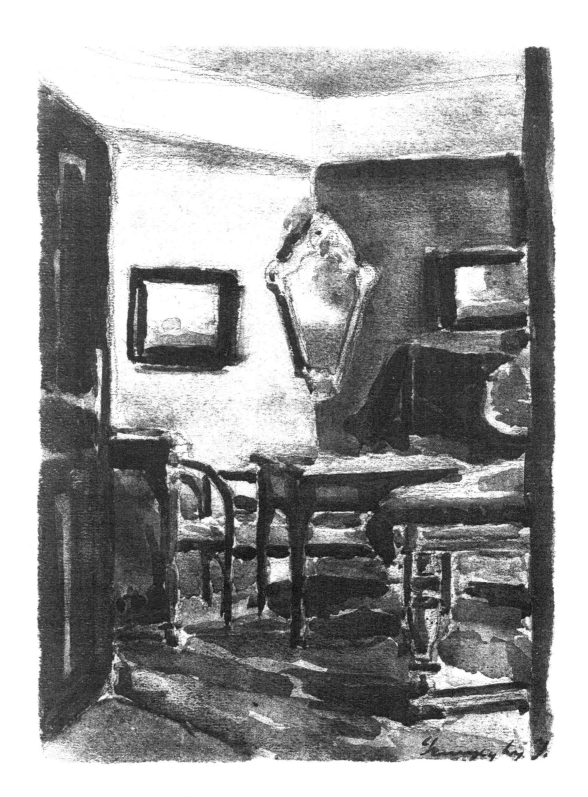

Interiors

An interior is the furnishings of the inside of a house—in other words, a space that has been built, along with all the furniture and decorative elements that it contains. In art, the term *interior* encompasses all of this.

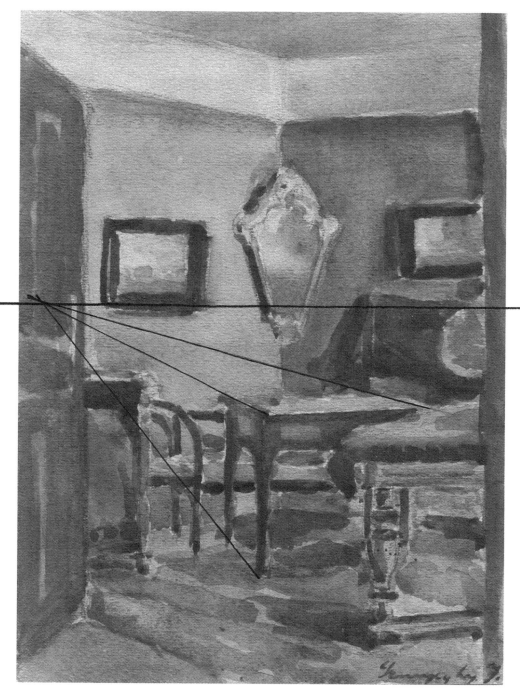

The furnishings of an old bourgeois apartment. The shapes may look complicated, but if you look more closely you will see that they can be dissected into simple geometrical bodies, thus allowing you to use what you have learnt about simple shapes when drawing them. If you look at the depiction of an interior, you are doing so from the same angle as the original artist. This is because the artist knew the rules of perspective and adhered to them when making the drawing. It is therefore important that your first step should be to

work out the position of the corresponding eye level–in other words, the horizontal plane. The horizontal lines of the objects that appear above the horizontal plane run downward and toward one another. The lines of objects below the horizontal plane run upward and intersect on the horizontal plane. However, this applies only to objects that are standing on the ground; the parallel lines of shapes suspended in the air run in a different direction toward one another. This makes your task more difficult, as you will have to work out the

vanishing points and thus the points of intersection for the parallel lines of each of these objects separately. When drawing you will find the plotting grid useful not only for working out the ideal picture section, but also for finding the relationship between the objects, their differences in size and their distance from one another. The black shading of the objects in the foreground is stronger than that for objects that are farther away.

The drabness of this room is only soft-
ened by the presence of the furniture.
In this case, drawing the simple shapes
and sticking to the rules of perspective
does not prove difficult. Using the plotting
grid makes it easy to find the sizes and
relationships of the objects to one another.
Rendering the differences in shading is
more interesting, as the dark surfaces
of objects in the foreground are always

darker; the black of the armchair is more
intense than that of the sofa, and the gray
of the table is darker than that of the wall
beside the window.

This drawing of a library room demonstrates ways of depicting rounded rooms. It is vital to adhere to the rules of perspective in such instances. The shape of the room is conveyed using the direction of the arc of the bookcase. The shelves opposite the viewer appear to run parallel; there is little or no discernable deviation from the horizontal. The shelves on the right-hand wall curve increasingly downward or upward the farther they go from the horizontal plane, and the parallel lines "open up." The rules of shading described earlier for cylinders and cones are applied here.

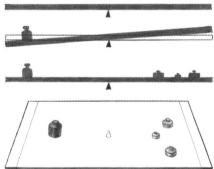

This austere room is given some interest using the size of the rectangles, the standing or lying position, and a variety of different shades for the individual elements. Giving the picture a sense of balance is particularly difficult here—if it were not offset by the fitness equipment, the black surface of the television table would disrupt the picture. You can imagine balancing the shading as laying a weight on a drawing board supported on a single point, which could only be balanced by placing three smaller weights on the other side. The bleakness and angular shape of the room are softened by the delicate shape of the fitness machine, accentuated by the white background. The dark shadow next to the television table also helps to balance the picture.

Of course, interiors do not comprise only living spaces—this drawing, which includes a human figure, does not really come under this category. I have hinted at the carpenter's movements using the folds of his clothes. The distortion of the horizontal panel in terms of perspective strengthens the impression of space.

This sketch of the inside of a winery illustrates several aspects. The angle of the beams and the skewed perspective of the door and the window heighten the sense of the room's depth. The curves of the hoops on the wine press run from above and below toward the horizontal plane, which is at about the height of the windowsill. The basket in the foreground illustrates something that is crucial when drafting all drawings: you cannot tell from the sketch what it contains, but it looks important and stands out precisely because it is in the foreground and at the center of the picture.

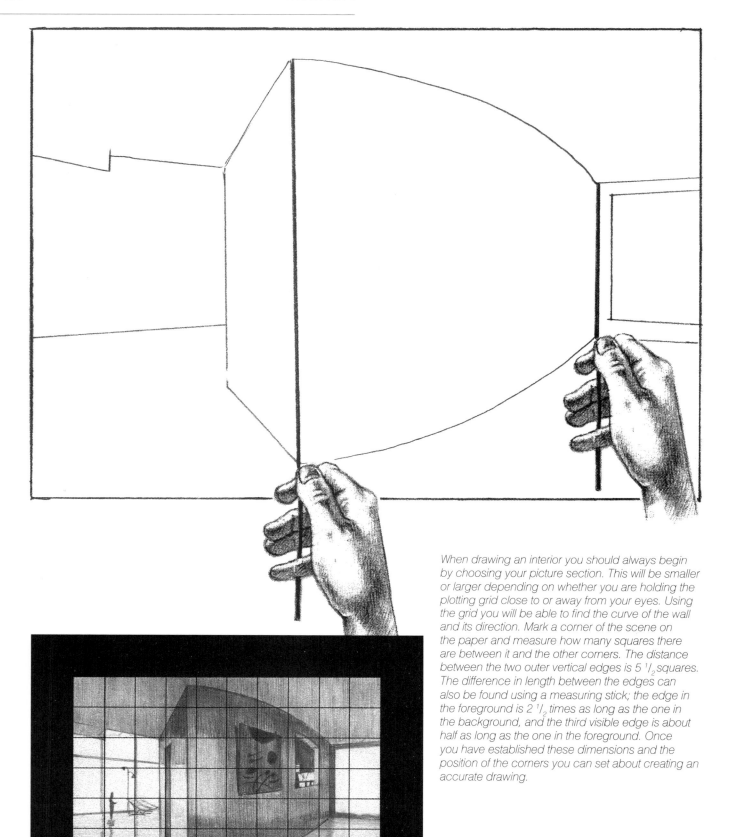

When drawing an interior you should always begin by choosing your picture section. This will be smaller or larger depending on whether you are holding the plotting grid close to or away from your eyes. Using the grid you will be able to find the curve of the wall and its direction. Mark a corner of the scene on the paper and measure how many squares there are between it and the other corners. The distance between the two outer vertical edges is 5 $\frac{1}{2}$ squares. The difference in length between the edges can also be found using a measuring stick; the edge in the foreground is 2 $\frac{1}{2}$ times as long as the one in the background, and the third visible edge is about half as long as the one in the foreground. Once you have established these dimensions and the position of the corners you can set about creating an accurate drawing.

The next step is to rank the levels of shading. The ceiling is darker than the floor. The different shades on the curved wall are applied as described for the surface of a cylinder, using vertical lines. In this example the floor has been shaded with diagonal layers of lines so that it looks as though it is sloping, and the whole room appears to be sliding towards the viewer.

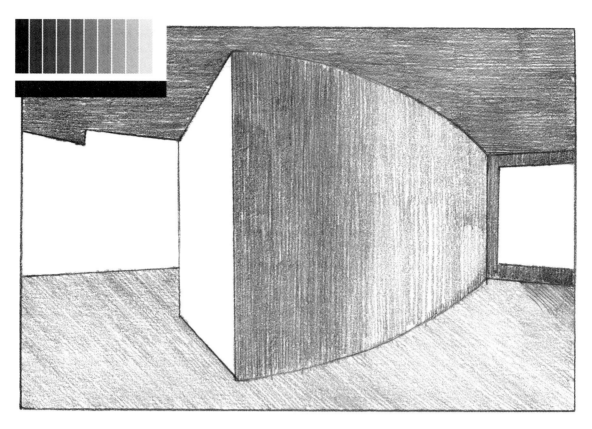

In this example you can see how much better the floor looks when it is shaded using horizontal lines.

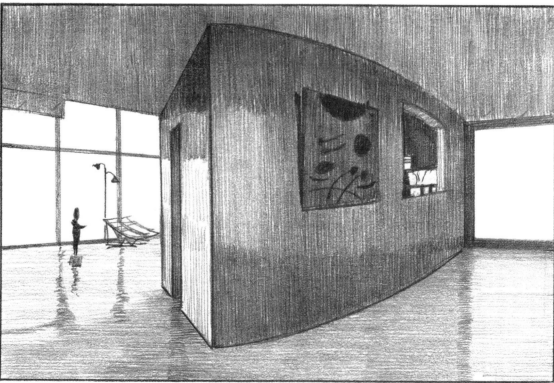

The drawing is enhanced by adding details. The center of the image is the curved wall with the picture and the window opening, which are relatively hard to draw due to their subtle details.

All the rules on perspective need to be applied here, and the difference between the two squares also needs to be drawn in; one stands out from the wall a little, while the other is an opening, with a different depth. Rendering the many shades on the floor is a real challenge. Light streams in through the huge windows, and the shadows, backlight, and reflection are drawn accordingly.

The Finished Drawing

Pencil, charcoal, chalk, and pastel drawings are delicate and have to be protected. Fixing effectively makes the drawing "stick" to the paper. Sometimes the paper becomes weak and stops absorbing charcoal or graphite. In this case it is also worth fixing the roughened surface with adhesive, as this allows you to go on using it. You can buy ready-made fixative, but it is also possible to make your own. You do this by dissolving shellac (which also goes to make polish) in denatured alcohol. Add as much as the alcohol is able to absorb. The solution will be ready after a day or so; in the meantime you should shake it several times.

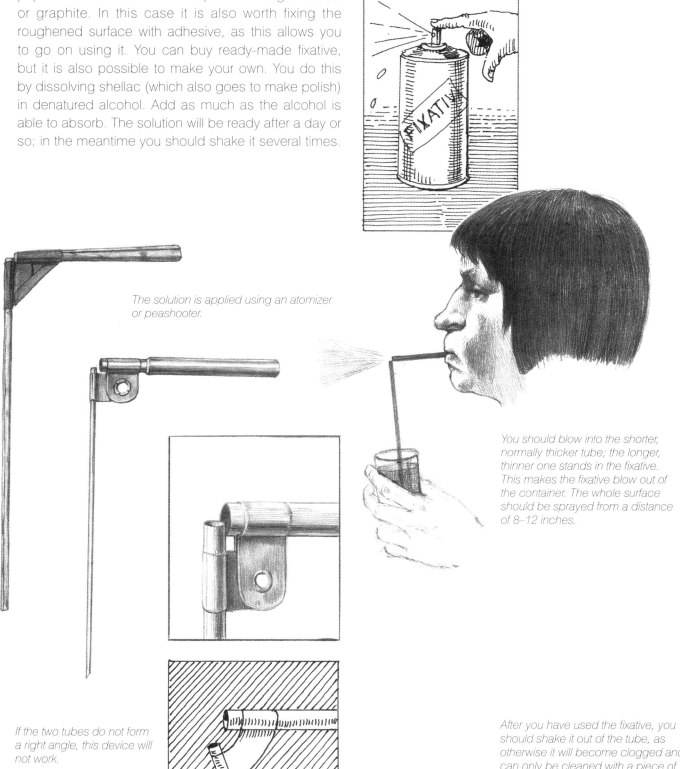

The solution is applied using an atomizer or peashooter.

You should blow into the shorter, normally thicker tube; the longer, thinner one stands in the fixative. This makes the fixative blow out of the container. The whole surface should be sprayed from a distance of 8–12 inches.

If the two tubes do not form a right angle, this device will not work.

After you have used the fixative, you should shake it out of the tube, as otherwise it will become clogged and can only be cleaned with a piece of wire or a needle. Ready-made sprays are not cheap, but they are quick, reliable, and easy to use. You should also spray ready-made fixatives from a distance of 8–12 inches.

Drawings and graphic works are given a frame made of paper or cardboard, called a mount. A regular mount consists of two sheets. The upper sheet is the window, and the work is glued to the lower sheet. The window of the mount is usually a little ($\frac{1}{5}$– $\frac{2}{5}$ inch) larger than the picture.

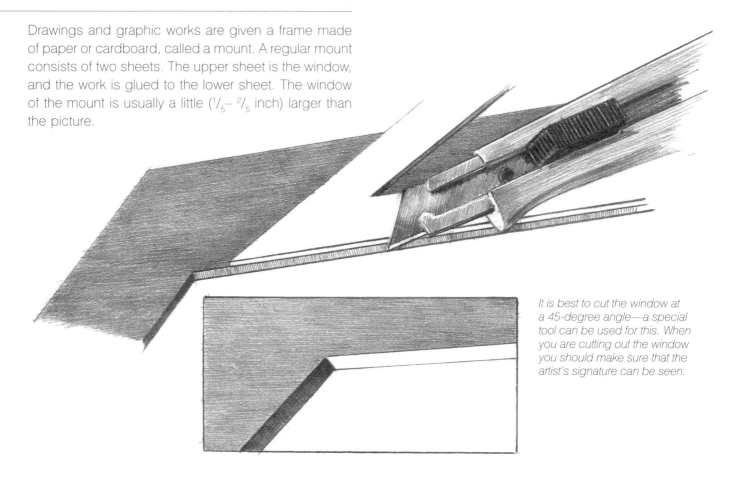

It is best to cut the window at a 45-degree angle—a special tool can be used for this. When you are cutting out the window you should make sure that the artist's signature can be seen.

Graphic works, pencil drawings, etchings, copper engravings, linocuts, screen prints, lithographs, and pastel drawings are always signed with a pencil, while ink, charcoal, and chalk drawings are signed with the material that was used to create them. The title and year of the print appear on the left—this also applies to prints of graphic works—and the name of the artist on the right. The title or artist's name are never written on the mount.

Glue with a paper base is used to stick the mount down, as adhesive tape can leave greasy traces on the paper over time.

Tanya –Lino– 23/100 Szemzőglu András

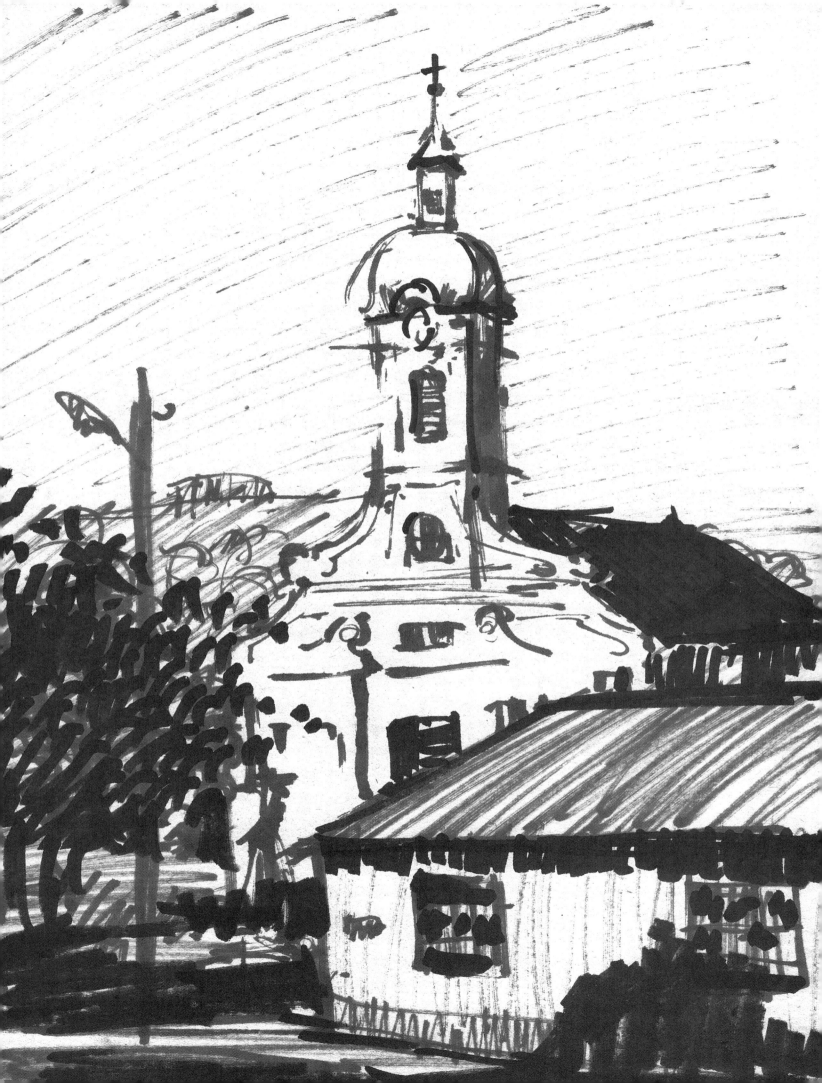

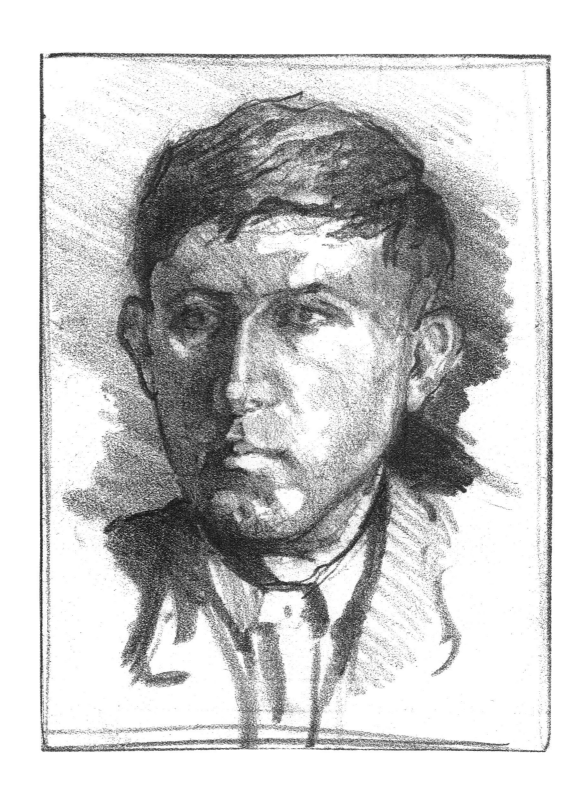

The Head

The human head is one of the most difficult things to draw. In order to do so you have to know the rules of perspective, and a fundamental understanding of anatomy is also indispensable. The axes of the head will prove a great help in this.

The shape of the head is closest to that of an egg. It is therefore worth studying a hard-cooked egg in order to help us understand the head's axes.

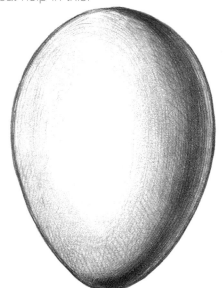

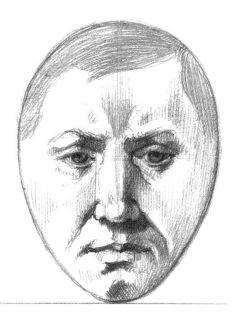

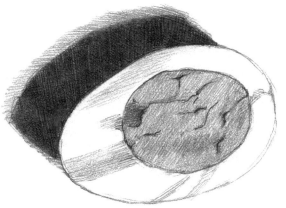

If you cut a peeled, hard-cooked egg down its length you will get two symmetrical halves whose cut surface is an irregular ellipse.

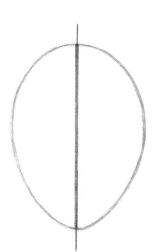

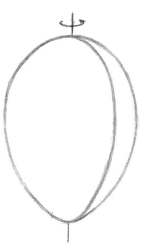

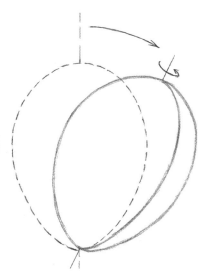

Like the egg, a head can be divided along an imaginary axis into two symmetrical halves. If you look at a head straight on, it is bisected by a vertical

*plane which we call the axis of symmetry, or the **principal axis**. If you look at the head face on, this principal axis is straight. If the model is rotated, this axis follows the*

shape of the head, becoming—as we have shown with the egg—a curved line.

When drawing, the **lateral axes** indicate important proportions for the head. The axis of the eyes runs at right angles to the principal axis and bisects the head, while the distance between the lowest point of the chin and the axis of the eyes is the same as that between the axis of the eyes and the crown of the head. The other axes run parallel to the axis of the eyes, and they allow the head to be divided into three areas of equal size: the distance between the hairline and the axis of the eyebrows is the same as that between the axis of the eyebrows and the lowest point of the nose, which in turn is the same as the distance between the lowest point of the nose and the bottom of the chin.

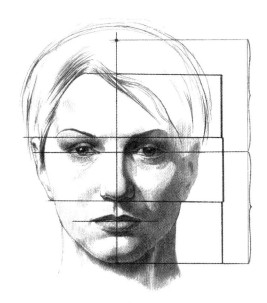

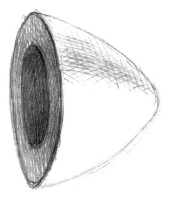

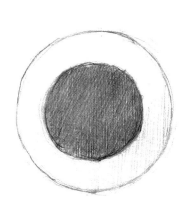

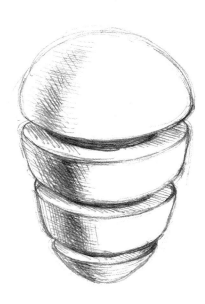

The hard-cooked egg can also help to illustrate the lateral axes: the cut sections of an egg that has been cut across are circles, for which the general shape is an ellipse. The lateral axes of the head are structured in the same way.

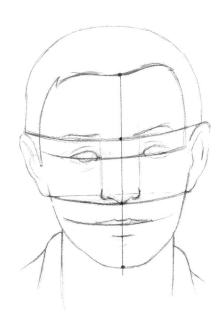

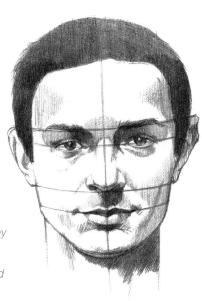

The lateral axes also run parallel to one another if they are drawn as ellipses. You can tell whether the model is sinking or raising his head by their deviation from the horizontal plane and the direction of the curve of the ellipses.

Here are the first steps in drawing a head.

You should begin this exercise by measuring the height of the head—in other words, the distance between the bottom of the chin and the crown of the head. This comes to about 8–9 inches (20–23 cm).

Next, find the width of the head.

The outline of the head is mainly sketched with straight lines.

Be careful—the head is never egg-shaped, as the model also has hair. The whole shape of the head should be sketched out in this way.

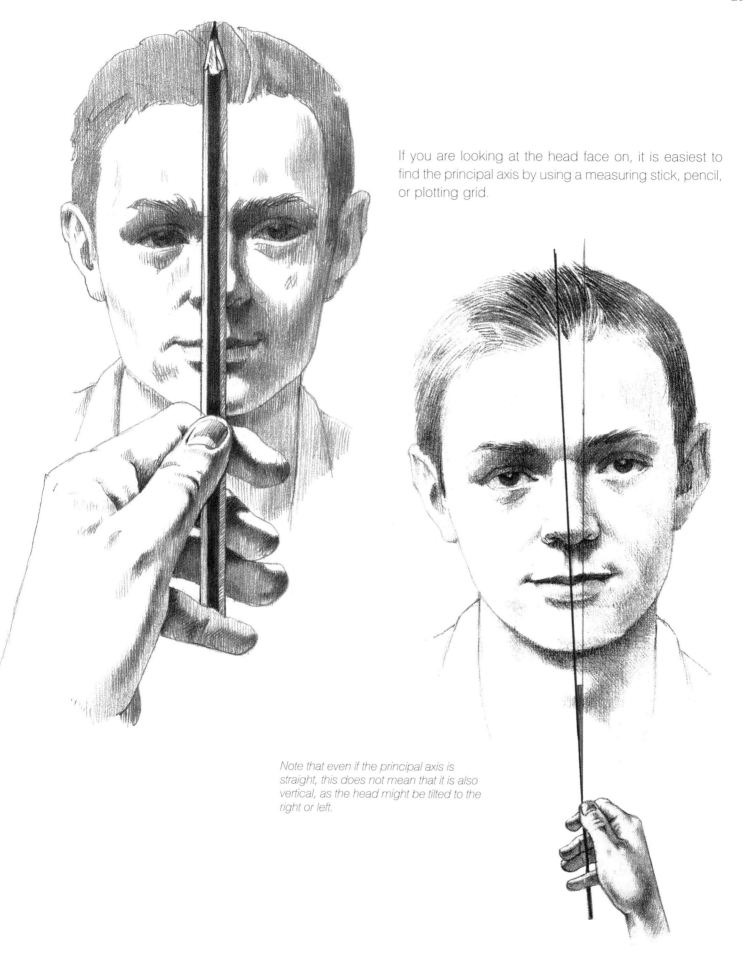

If you are looking at the head face on, it is easiest to find the principal axis by using a measuring stick, pencil, or plotting grid.

Note that even if the principal axis is straight, this does not mean that it is also vertical, as the head might be tilted to the right or left.

The next step is to determine the lateral axes. The axis of the eyes is worked out first of all. The drawings show several versions of the position of the axis of the eyes.

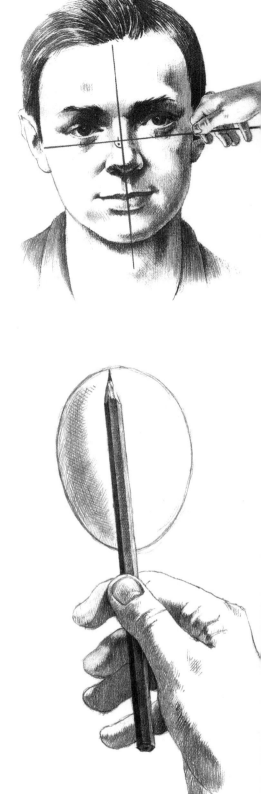

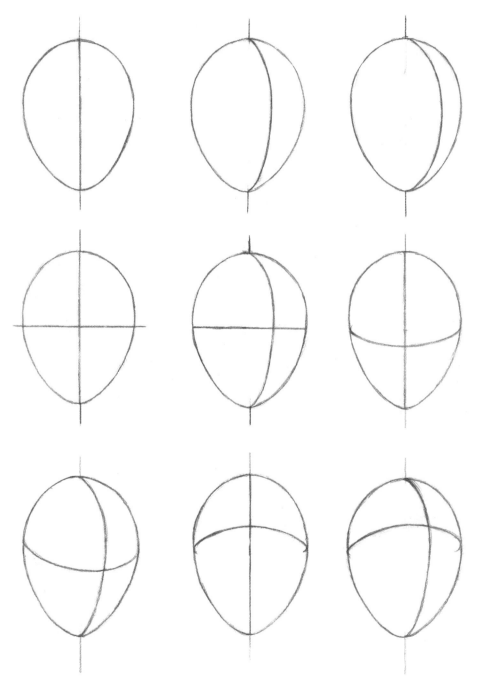

If you place a pencil against the principal axis you will be able to tell immediately whether it differs from the vertical axis, and if so, by how much. The axis of the eyes always runs at a right angle to the principal axis—this is worth stressing, as it is often positioned incorrectly.

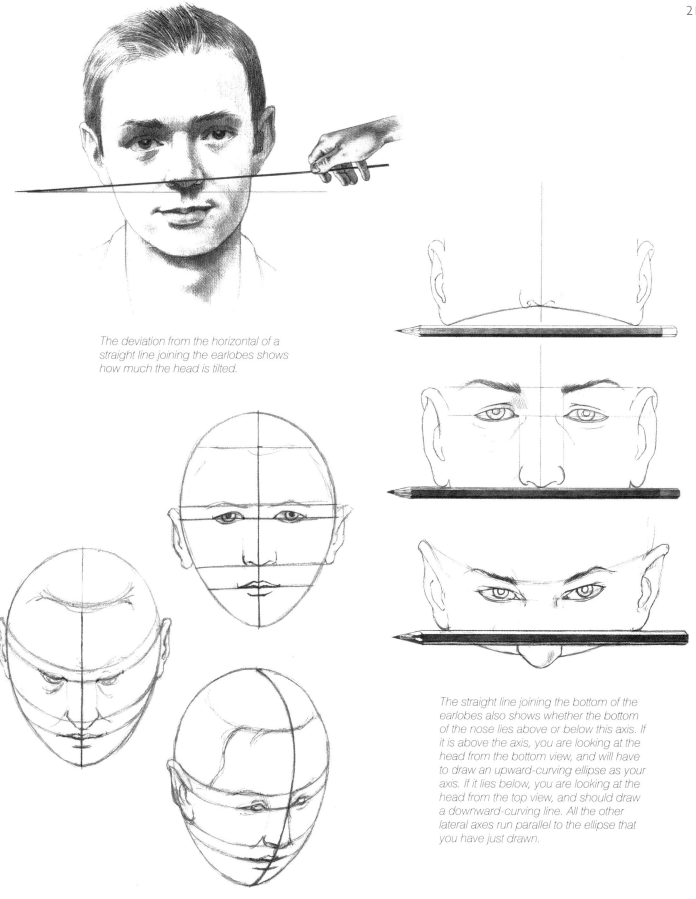

The deviation from the horizontal of a straight line joining the earlobes shows how much the head is tilted.

Remember: the principal axis runs at right angles to the lateral axes, which are parallel with one another.

The straight line joining the bottom of the earlobes also shows whether the bottom of the nose lies above or below this axis. If it is above the axis, you are looking at the head from the bottom view, and will have to draw an upward-curving ellipse as your axis. If it lies below, you are looking at the head from the top view, and should draw a downward-curving line. All the other lateral axes run parallel to the ellipse that you have just drawn.

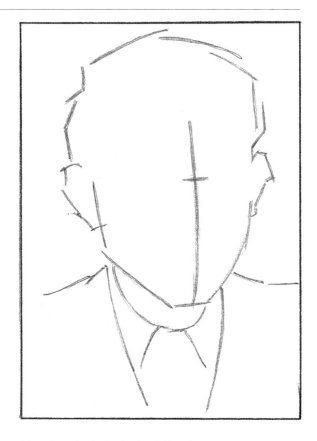

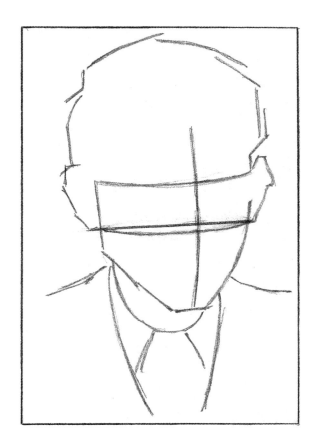

Now the principal axis should be drawn onto the sketch, as described earlier, along with the axis of the eyes, which lies roughly halfway down the head.

The bottom of the nose is below the line joining the earlobes, so a slightly downward-curving ellipse must be sketched in. This is also the axis of the nose. All of the head's lateral axes run parallel to this axis.

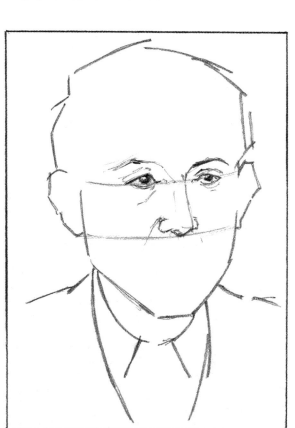

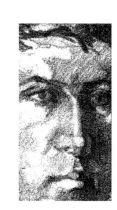

Once you know the position of the ellipse that indicates the direction of the axis of the eyes, the eyes can be drawn in. Make sure that the eyes do not look like plum stones (see also pages 217–19) and that the distance between the axis of the eyes and the axis of the nose is not too large.

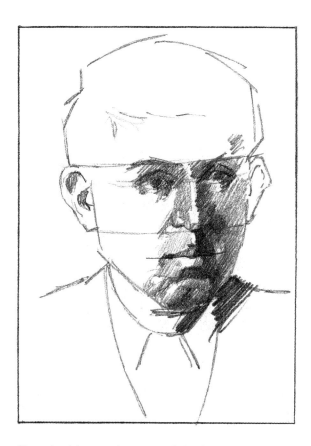

The ears are between the axis of the eyebrows and the axis of the nose.

When you are drawing, make sure that you take care over the details. The ears should not look cartoonish; their individual characteristics should also be captured (see also pages 224–5).

The axis of the mouth runs parallel to the axis of the nose. If the face is tilted to the side, the mouth tilts with it, and the side that is farther from the viewer appears shorter.

It is important to draw the hair in the right place in relation to the face. You can measure this, but the best way of working it out is to use a plotting grid.

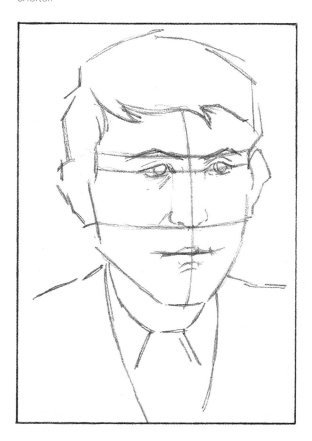

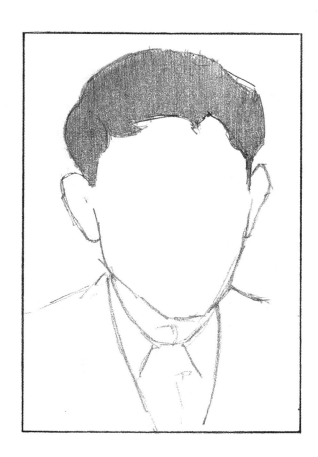

When you are drawing a head in profile, the axis of the eyebrows, the axis of the nose, and the other axes are all straight lines if the model is holding his head straight. If he tilts his head to the side, however, the axes become elliptical curves.

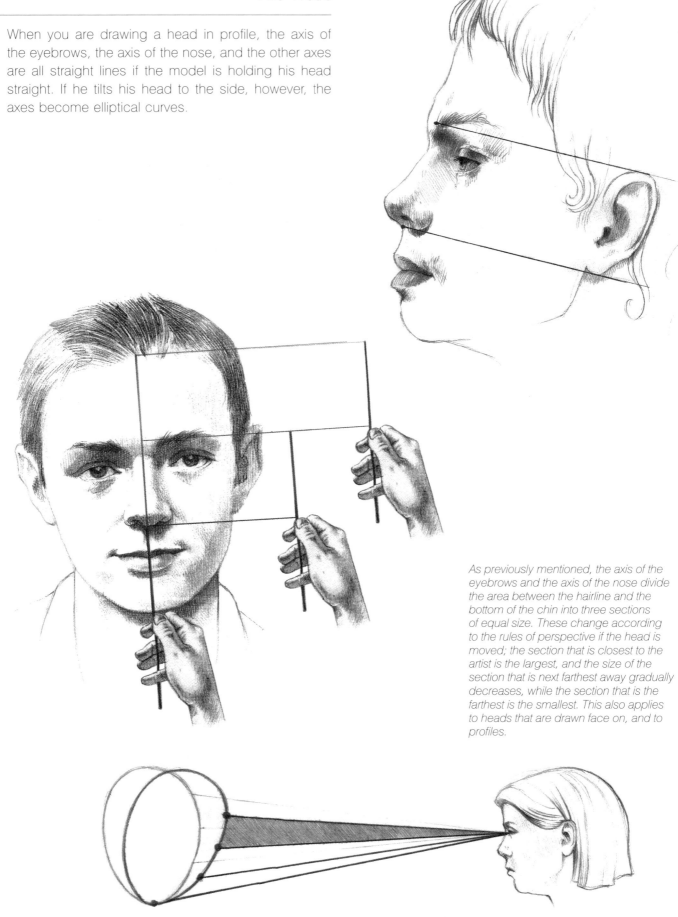

As previously mentioned, the axis of the eyebrows and the axis of the nose divide the area between the hairline and the bottom of the chin into three sections of equal size. These change according to the rules of perspective if the head is moved; the section that is closest to the artist is the largest, and the size of the section that is next farthest away gradually decreases, while the section that is the farthest is the smallest. This also applies to heads that are drawn face on, and to profiles.

The secret of a good profile drawing is to capture the individual character of the face. The angle of the profile can help you with this, as it is different for everyone and is therefore ideal for checking the accuracy of the drawing.

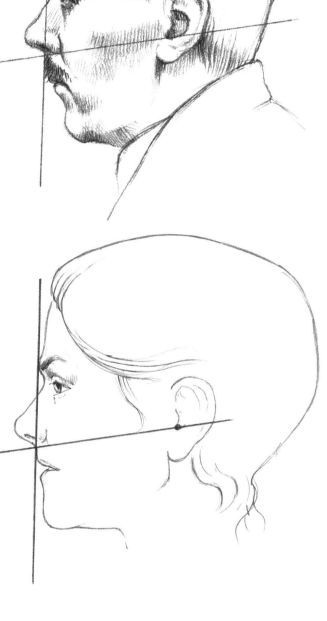

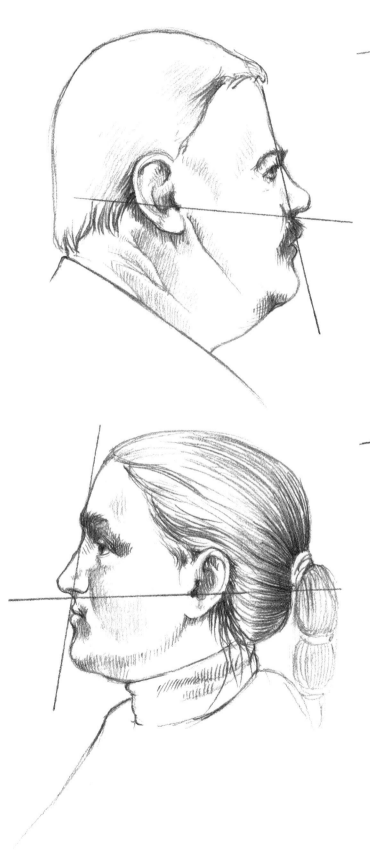

The angle of the profile is the angle formed by two straight lines in the profile of the face. One joins the forehead and the bottom of the nose, and the other the outer ear canal and the bottom of the nose. The angle of the profile varies from person to person, and from an acute to an obtuse angle.

This page covers a number of mistakes that are commonly made in drawing the axes of the face. These can be avoided by taking control measurements and exercising care.

This drawing is incorrect because the distance between the eyebrows and the axis of the nose is too large in comparison with the distance between this axis and the bottom of the chin.

All measurements and axes should be adjusted with reference to the principal axis. If this has been done incorrectly it will be impossible to produce a good drawing. Here, for example, the head is turned to one side, but the principal axis has not followed the surface of the "egg," making it a straight line rather than an ellipse.

The ellipses of the lateral axes are the problem here too, as they converge in a fan-like shape on one side.

These lateral axes are incorrect, as they should be running parallel to one another.

The rounded surface of the eyeball is covered in a sclera, which has a circular, transparent area at the front, the cornea. Behind this is the iris, which gives the **eye** its color. The pupil is in the middle of the iris, and narrows and widens according to the amount of light.

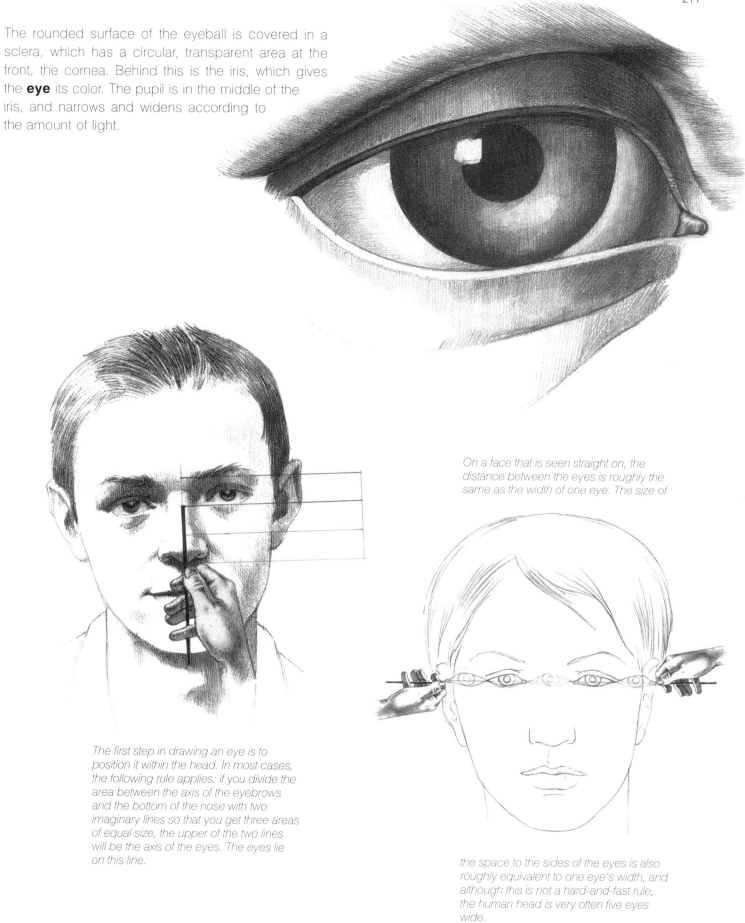

On a face that is seen straight on, the distance between the eyes is roughly the same as the width of one eye. The size of

The first step in drawing an eye is to position it within the head. In most cases, the following rule applies: if you divide the area between the axis of the eyebrows and the bottom of the nose with two imaginary lines so that you get three areas of equal size, the upper of the two lines will be the axis of the eyes. The eyes lie on this line.

the space to the sides of the eyes is also roughly equivalent to one eye's width, and although this is not a hard-and-fast rule, the human head is very often five eyes wide.

The outline of the eyes is an irregular rhombus shape. If you divide this along its length with a diagonal line, you get two triangles, of which one is higher and the other is more acute. You should begin sketching the upper eyelids from the inner corner of the eye; their shape can be drawn with a steeply rising and a softly falling line. The lower eyelids are less curved, and are drawn with a more steeply falling line from the outer corner of the eye, and then a softer and longer rising line.

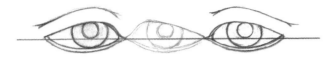

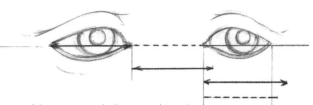

If the model turns his head, the eyes which appear to be of equal size when seen straight on and the distance between them change according to the rules of perspective. On the drawing the

larger of the two eyes is the one closer to the viewer, the distance between the eyes is smaller, and the smaller eye is the one which is farther away.

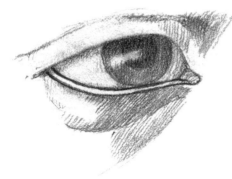

The upper part of the iris is obscured by the upper eyelid, while the lower part just touches the lower eyelid.

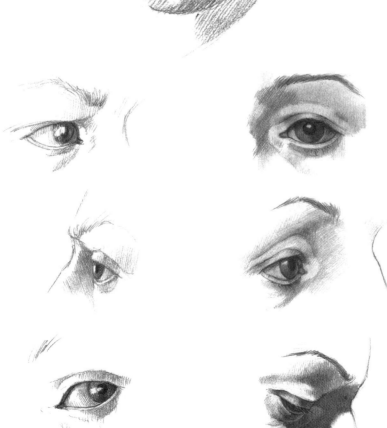

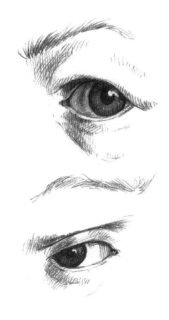

The eyes are a very expressive feature of the human face, and they can show a multitude of emotions: astonishment, interest, anger, anxiety, joy, and much more.

Here are the most common mistakes made when drawing eyes.

In many drawings the eyes have the shape of a plum stone, as they consist of two symmetrical lines, while the outline of

the eyes is a rhombus. Another common mistake is that as much can be seen above the iris as below it.

When shading you should make sure that the sclera does not remain dazzlingly white if all the other areas are shaded darker. If you look at the eyes of the model with narrowed eyes, you will see how much darker the dermis actually is.

If you are drawing a profile you should always work out how large the eye would be were it seen face on. The eye in this drawing would be too wide.

The eyebrows must be positioned correctly. If you test this on your own eyes you will see that they are positioned over the edge of the eye sockets. If you draw them too close to the eyes, it will look as though they are under the edge of the eye sockets.

As mentioned previously, the distance between the eyes and the eye that is farther away appear shorter if the head is turned. In this drawing the three distances are equal—a common mistake in portraits.

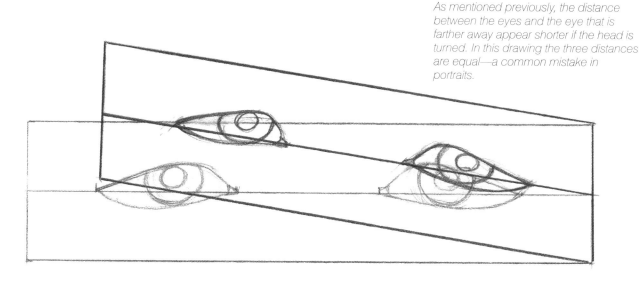

The shape of the **mouth** is determined by the upper and lower lips, which meet at the corners of the mouth. The upper lip is longer and thinner in the middle than the lower lip. The small indentation under the nasal septum is the Cupid's bow.

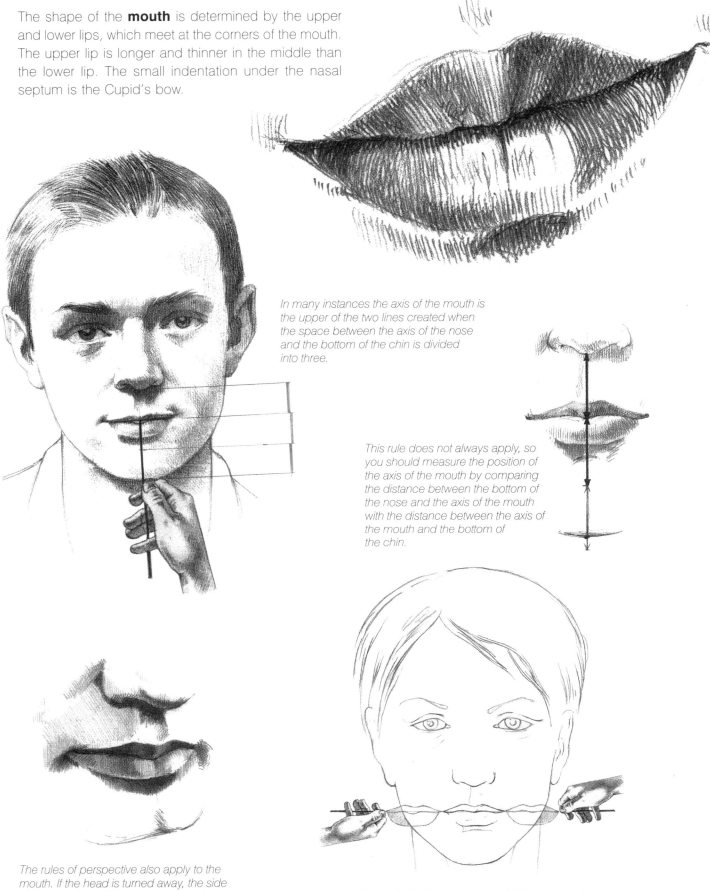

In many instances the axis of the mouth is the upper of the two lines created when the space between the axis of the nose and the bottom of the chin is divided into three.

This rule does not always apply, so you should measure the position of the axis of the mouth by comparing the distance between the bottom of the nose and the axis of the mouth with the distance between the axis of the mouth and the bottom of the chin.

The rules of perspective also apply to the mouth. If the head is turned away, the side of the mouth that is farthest from the viewer appears smaller than the closer side.

The width of the mouth should be measured horizontally to make sure that it is neither too big nor too small.

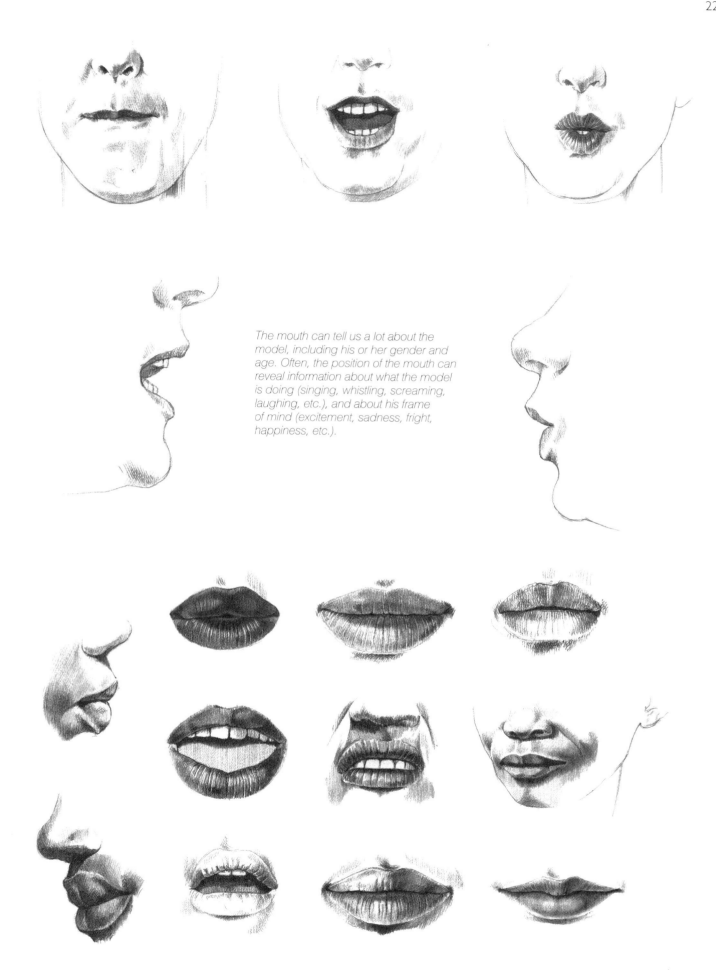

The mouth can tell us a lot about the model, including his or her gender and age. Often, the position of the mouth can reveal information about what the model is doing (singing, whistling, screaming, laughing, etc.), and about his frame of mind (excitement, sadness, fright, happiness, etc.).

The **nose** is in the middle of the face, in the area between the axis of the nose and the axis of the eyebrows, and it is bisected by the principal axis. It is by far the most distinctive feature of the human face. Unfortunately, there are no rules for drawing noses, since their shape is completely different for each individual.

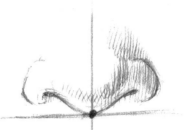

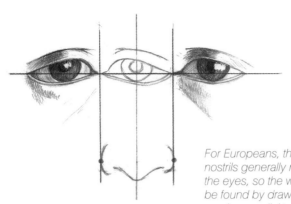

For Europeans, the distance between nostrils generally matches the width of the eyes, so the width of the nose can be found by drawing two straight lines running parallel to the principal axis down through the inner corners of the eyes.

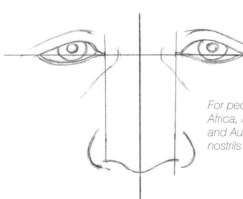

For people of many other ethnicities in Africa, Asia, North and South America, and Australia, the distance between the nostrils is larger than the width of an eye,

and the nostrils are a little higher than the bottom of the nose.

The axis of the nose runs through the lowest point of the nose, not through the tip of the nose, so the point of the nose is covered by the axis of the nose if the head is raised.

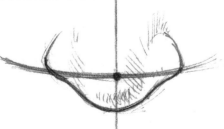

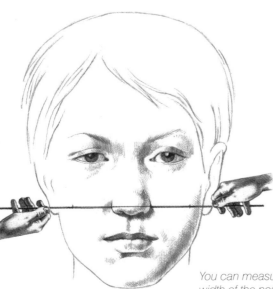

You can measure how many times the width of the nose fits into the width of the face as a means of checking.

The shape of the nose is determined by the cartilage inside it. Noses come in countless different shapes, from snub and straight to aquiline, in addition to special characteristics for different ethnicities.

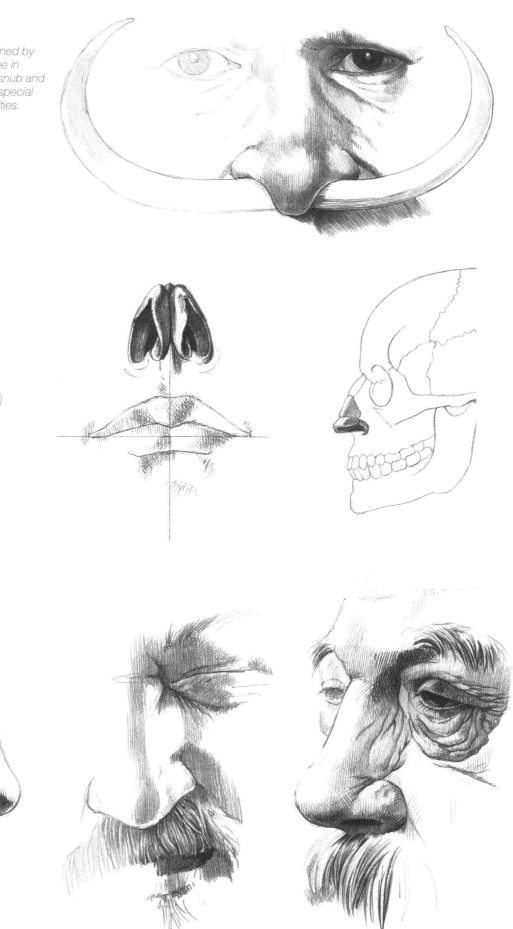

Like the nose, the **ears** stand out from the skull. They
are positioned roughly in the middle, between the point
of the chin and the skullcap, or, more precisely, between
the axis of the eyebrows and the axis of the nose. Their
outline forms an irregular ellipse.

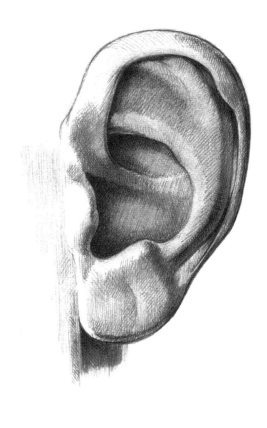

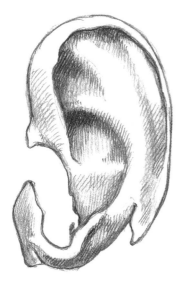

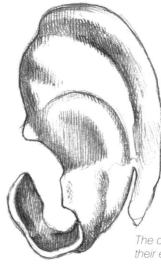

*The cartilage inside the ears determines
their external shape.*

*The outline of the
ear is shaped
like an irregular
ellipse, but their
appearance
varies greatly from
person to person.*

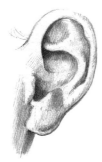

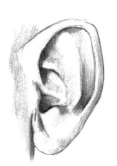

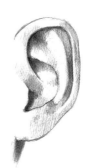

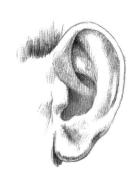

*Out of interest, it is worth mentioning here
that ear ornaments can also act as the
distinctive mark of an ethnic group.*

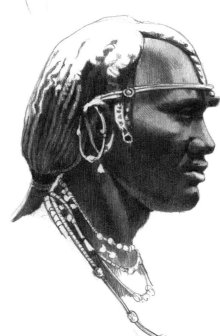

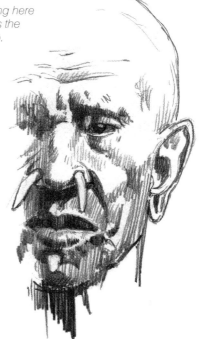

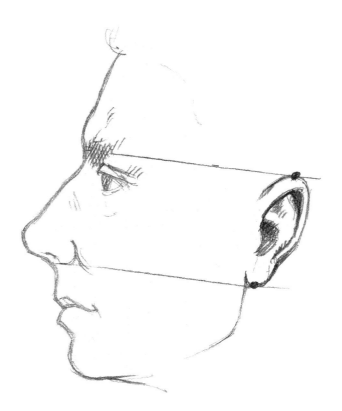

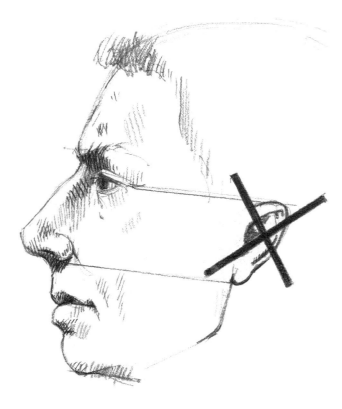

The ears are positioned between the axis of the eyebrows and the axis of the nose.

A common mistake is to draw the ears between the axis of the eyes and the axis of the nose, making both their position and their size incorrect.

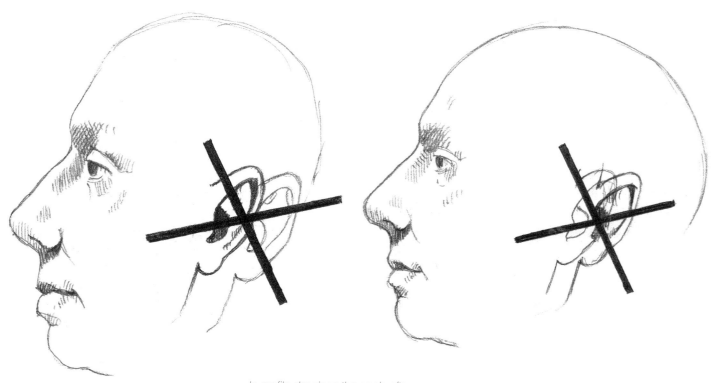

In profile drawings the ear is often positioned at an incorrect distance from the eye. If it is too far away this enlarges the skull, and if it is too close it makes the head look smaller and distorted.

Hair and facial hair such as mustaches and beards are important features of the face which are carefully cultivated by their wearers. They suggest not only the taste and the age of the person, but also the historical age in which they lived or are living.

It is very easy to make mistakes when drawing hair, as it covers the curve of the skull. If you estimate the proportions incorrectly you will end up with the skull either flatter or more curved than it is in reality. You should constantly compare the outline of the locks of hair with the size of the face, ideally using a plotting grid.

Drawing hair is far from easy. Like all three-dimensional shapes, hair has depth. When drawing it you should always start with the easiest areas, and proceed to the most difficult. Start by sketching the outline of the head of hair as you would a diagram, without any shading. Next, add the simple (lighter and darker) nuances of the shading and gradually draw in the smaller and larger waves. Concentrating on the shape and the shading will allow you to achieve the right effect. When working out the shading it helps to look at the model through narrowed eyes or to hold the grayscale against the hair.

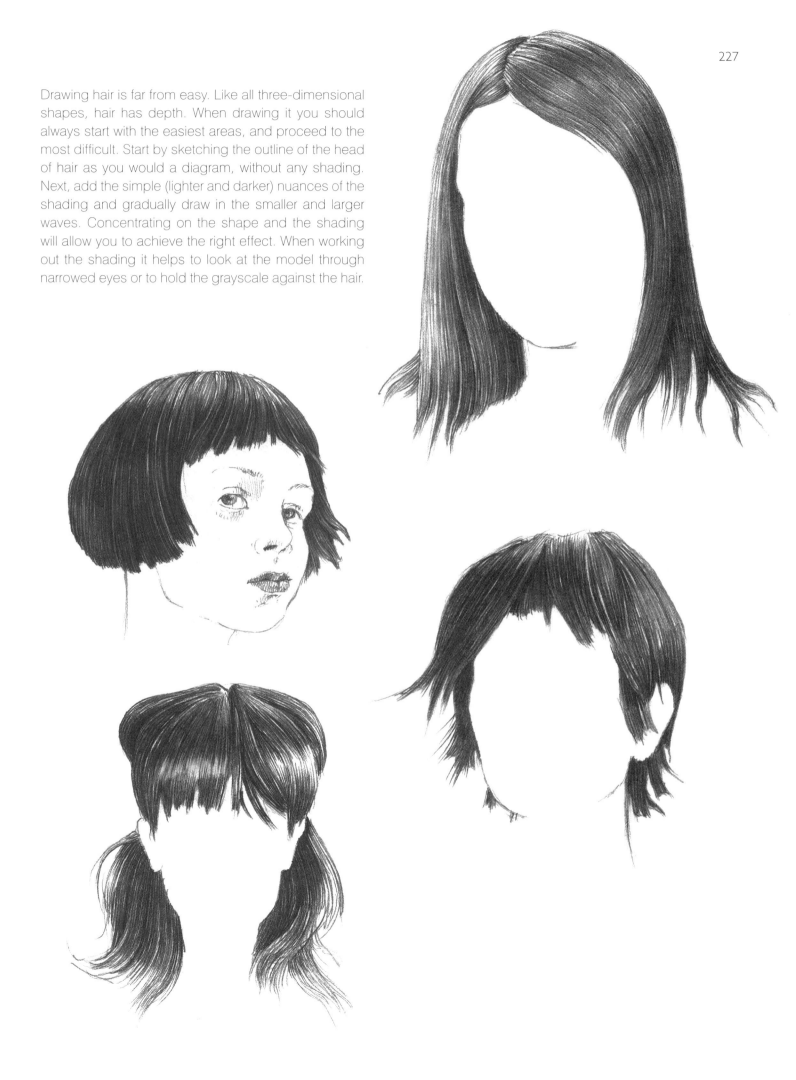

By drawing individual hairs you can show whether the model is moving or still, or perhaps standing in the wind. On still models, straight hair hangs down in slightly curved parallel lines which can be broken here and there to give a more vivid effect. Curly hair can be drawn using sweeping bends and curves. If the head of hair is built up out of individual hairs it will look neat. The shape may be formed by thinner, thicker, closely packed or more widely spaced lines. Cross-hatching is also often used. Two adjacent patches of the same shade can be separated from one another by drawing a line.

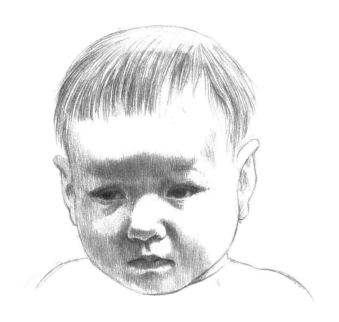

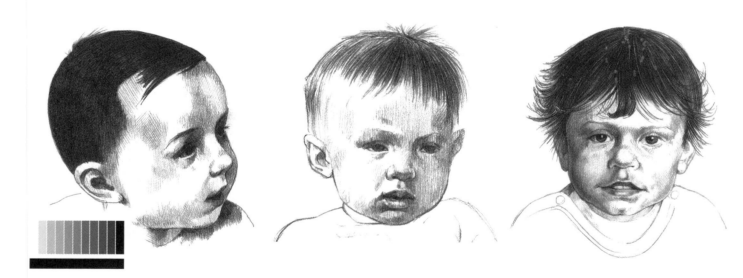

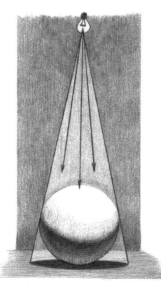

As mentioned previously, the head is roughly egg-shaped, so when capturing the play of light and shadow you should apply what you have learned about the sphere. The lightest point on the sphere is the point at which the light hits it at an exact right angle, depending on the position of the source of light. The rounded surface becomes gradually darker from this point, and a line can clearly be seen at which the light merely grazes the surface; beyond this the shell is dark. The part that is in shadow does not have completely even shading, either; the light part that results from the reflected light is called the reflex. One particular difficulty in drawing the hair is that planes that deviate only a little from one another reflect the light in different ways.

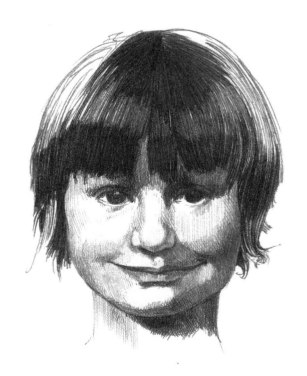

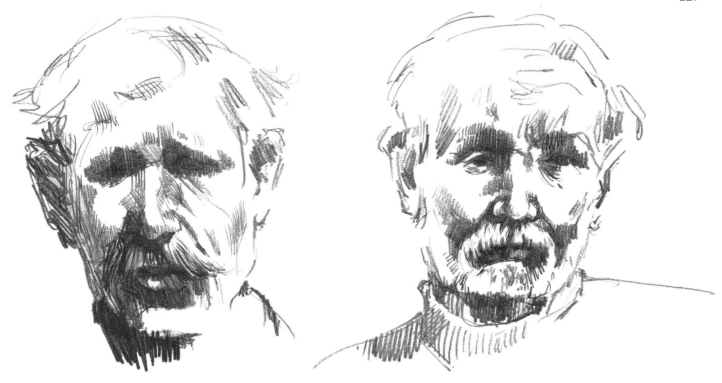

Long beards mostly curve to the right and left of the principal axis which bisects the face.

Always pay attention to the direction of the whiskers. In this case the mustache hair is almost vertical, but it curves slightly toward the mouth, while the whiskers in the middle of the chin stand out slightly, at a 45-degree angle. Both left and right sides of the principal axis are virtually symmetrical.

You should do a bit of planning if you are going to draw a long mustache or goatee. Individual hairs stick out in both directions from the principal axis, which bisects the face. Normally there are shorter hairs growing in a fan-like formation under the underlip, which form a separate part of the goatee. The whiskers on the side of the face grow downward in parallel curved lines.

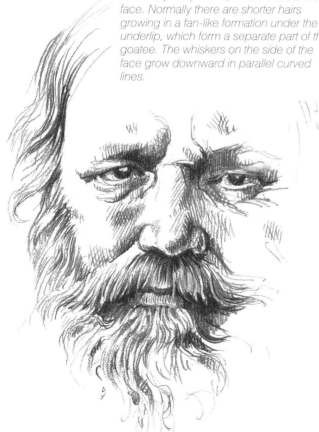

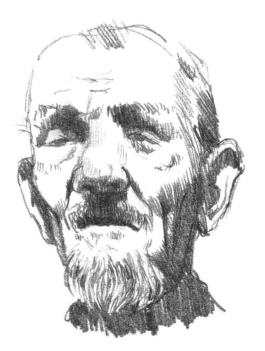

The principal axis is also important if you are drawing a pointed beard, as the hair curves slightly to the right and left of this, in opposite directions.

Composition. There are strict rules governing the composition of the drawing, or its positioning on the paper. This applies not only to portraits, but also to whole figures, still lifes, landscapes, etc.

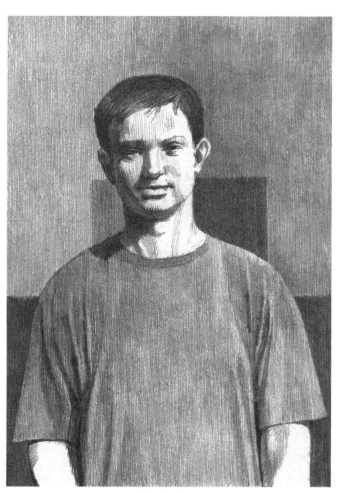

When the head is seen straight on, less space is left above it, and more below. The figure is positioned in the middle of the paper.

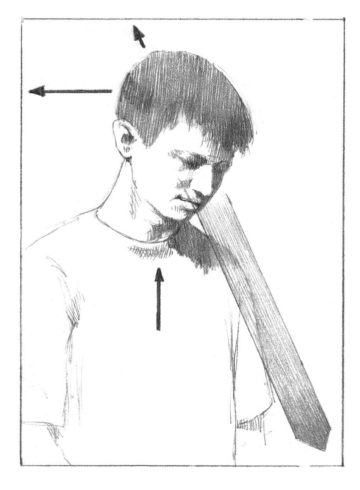

One basic rule of composition dictates that the figure should be placed on the opposite side of the paper to the way the head is turned. If the head is tilted downward and to the right, the figure must be shifted left and upward from the center of the paper.

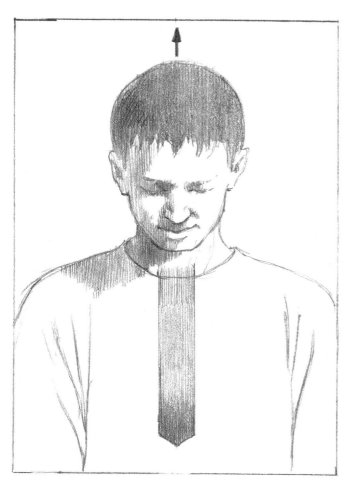

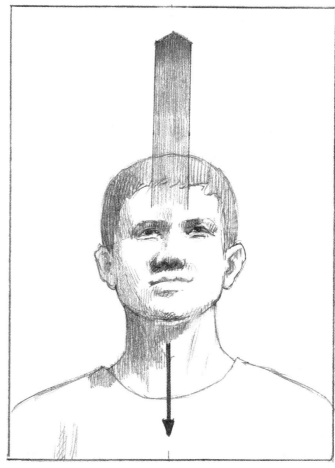

If the model is facing straight on but looking down, the figure must be placed in the middle of the page and then shifted upward. This leaves lots of space underneath the head, as the figure is looking at something in that direction.

If the face is drawn straight on, but looking upwards, you should leave more space above the head in order to emphasize the fact that the model is looking at something above his head.

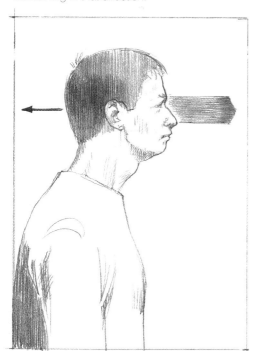

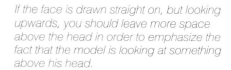

If the model is turned to the right, the figure is shifted a little way to the left.

If the model is turned to the left, the figure is shifted slightly to the right from the middle of the page.

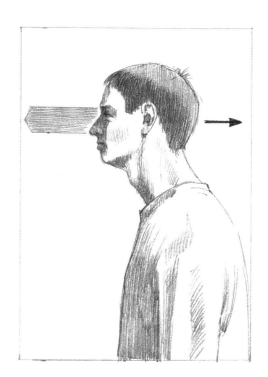

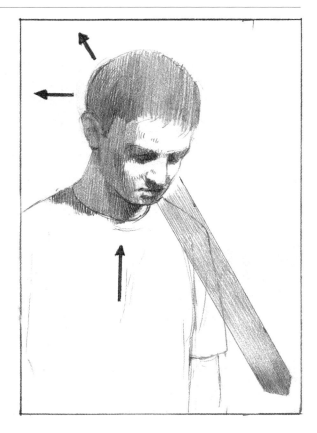

*If the model is looking down and to the
right, the drawing is shifted upward and to
the left from the center of the page.*

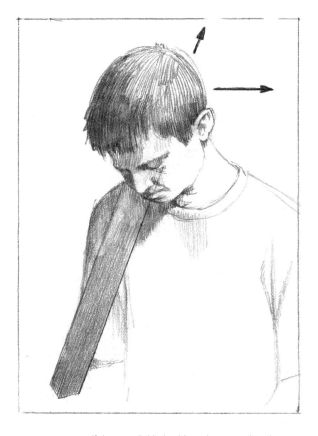

*If the model is looking down and to the
left, the figure is shifted upward and to the
right.*

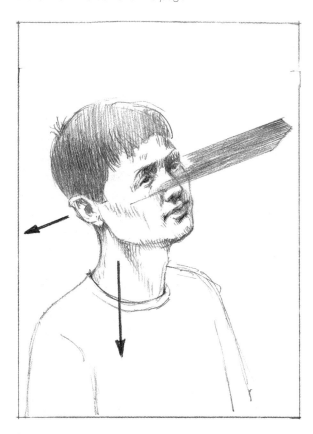

*The figure of a model looking up and to
the right is shifted from the center of the
page downward and to the left.*

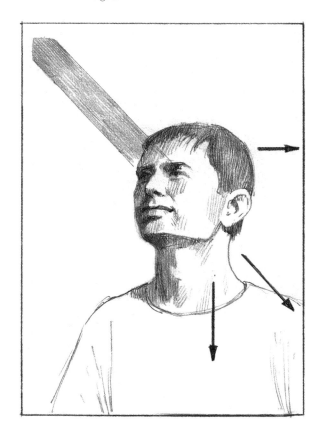

*If the model is looking up and turned to
the left, the drawing is shifted so that it is
closer to the right and bottom edge of the
sheet.*

When drawing something you have seen and checking the finished drawing, it helps to compare the "negative space" around the head, ears, neck, shoulders, and so on, which surrounds the figure in the drawing and in reality. If, for instance, the line of the shoulders has been drawn incorrectly, the area between the head, the neck, and the shoulders will be different on the drawing and in reality.

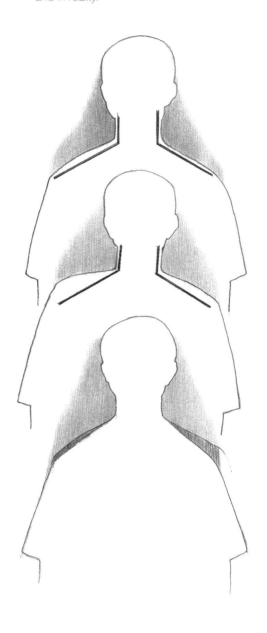

If you use a C sheet of paper (approx 17 x 22 inches), you should include both the head and part of the upper body in the composition. It is generally recommended that you position the head in such a way that the area under it is about four to five times as large as the area above it. This will result in a good picture section, although the artist can, of course, choose a detail from a completely different perspective. Using a plotting grid will make it easier to choose the ideal picture section.

Start by working out the height of the head, which is about a handspan, and marking it on the paper. A handspan is roughly the size of an adult-sized head.

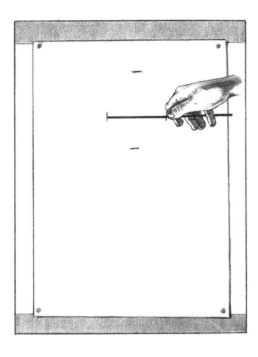

After the height has been worked out, the width of the model's head is measured and compared with the measurement that has already been marked on the drawing. The difference between this measurement and the one that has already been marked should also be included in the drawing.

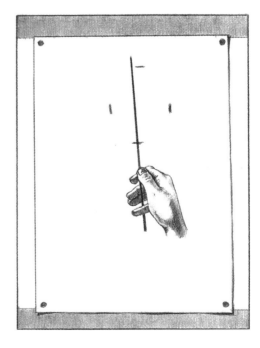

Next, work out the tilt of the head so that you can mark it on the principal axis.

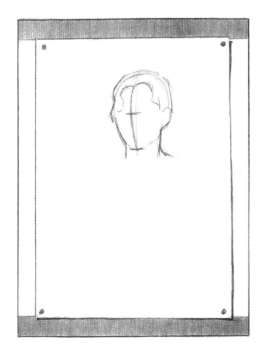

The axis of the eyes, which bisects the height of the head exactly, is marked on the principal axis.

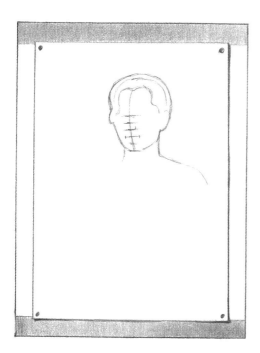

The distance between the axis of the eyes and the point of the chin is split into five equally sized lengths. The second mark under the axis of the eyes corresponds to the lowest point of the nose, while the third is the axis of the mouth.

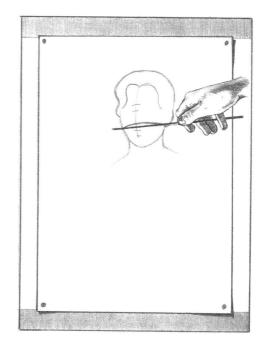

By drawing an imaginary straight line through the bottom of the earlobes you can find the position of the bottom of the nose. In the above example an ellipse has been drawn above the straight line through the bottom of the earlobes and the bottom of the nose. This is the axis of the nose.

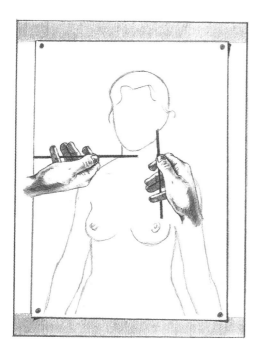

Now the length of the two sides of the neck are measured and compared with the size of the turned shoulders to determine the right proportions.

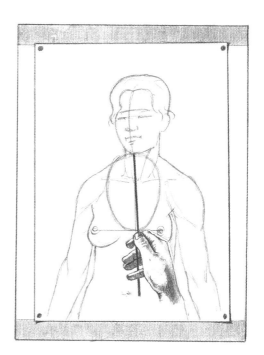

In order to draw in the axis of the chest you should be aware that the nipples are roughly the height of a head from the chin and are always parallel to the axis of the shoulders.

If a model is drawn face on, the width of the shoulders is about twice the length of the height of the head, so about a head's height from the point where the collarbone and the breastbone meet.

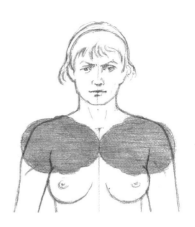

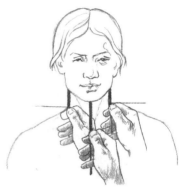

The position of the line of the shoulders must be known in order to measure the length of the neck. Both sides have to be measured, as they may not be of equal length. The third measurement establishes the position of the small hollow between the clavicles.

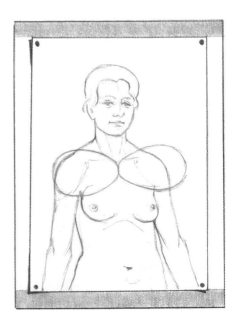

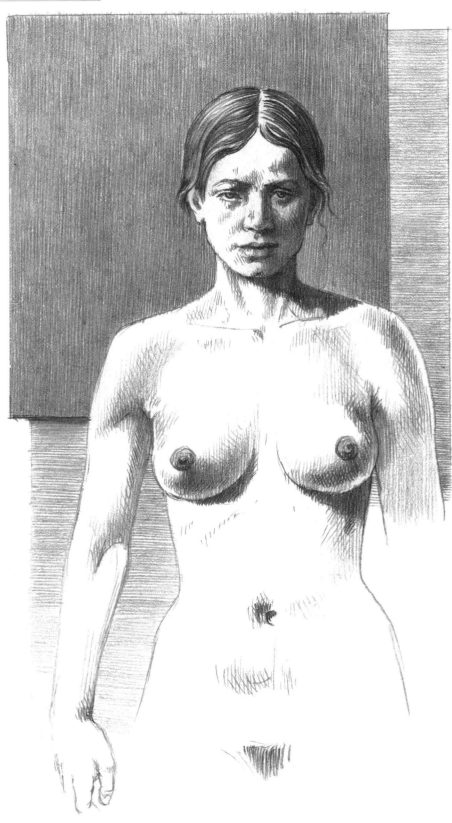

If the model turns, the width of the shoulders, which corresponds to two head heights, changes according to the rules of perspective; the shoulder that is farther from the artist is shorter, meaning that more measurements are required.

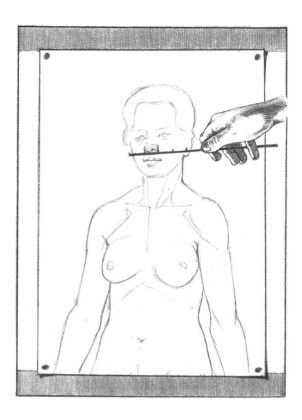

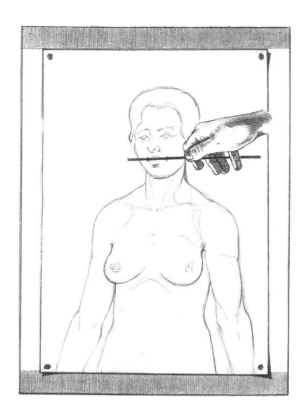

After all the main features of the figure have been sketched, you can turn your attention to the details. It is recommended that the best way to find the width of the nose is to measure how many times it fits into the right- and left-hand sides of the face. Drawing a nose that is too narrow is a common mistake.

The width of the mouth in relation to the width of the face is marked out in the same way. Beginners commonly make the mistake of drawing the mouth too small, too large, or too close to the nose.

Also check how many times the width of the eye that is closest to you fits into both sides of the face.

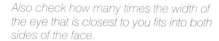

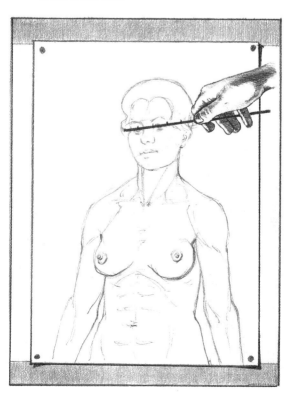

If the neck is not covered by clothing, you can see its muscles. As people turn their heads using the sterno-mastoid muscle, the drawing of the muscles through the neck skin depends on the head movement. Humans have a sternomastoid on both the right and the left sides of the neck.

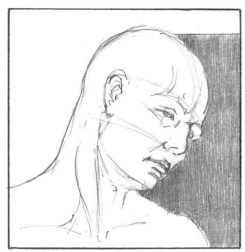

If only one of the sternomastoid muscles is being used, the head will turn in that direction. The sternomastoid on the other side should therefore be drawn so that it stands out on the neck.

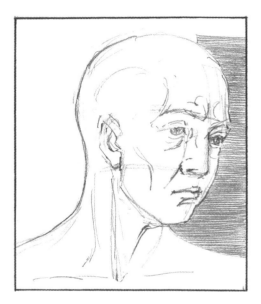

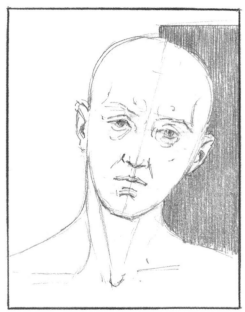

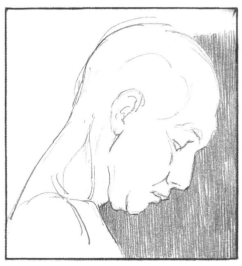

This is how the sternomastoid muscle is drawn if the head is in profile and bowed forward.

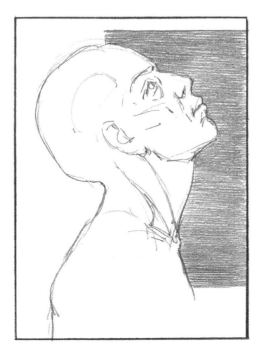

The trapezius muscle allows the head to bend backward. In this case the sternomastoid can clearly be seen on the taut neck.

Shading is an important stage in drawing. The very first mark that you make on the white paper disrupts the balance of the surface.

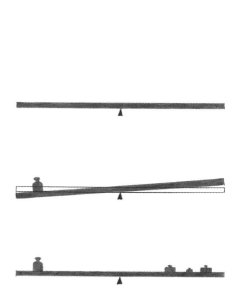

Playing around with shading can be imagined as placing a weight on a drawing board that is balanced on a single point, so that the other side can only be balanced by placing three other weights on it.

If you want your piece to look harmonious you must make sure that the balance has been maintained within it. A large black surface can be balanced with large black areas of equal size, or by several lighter areas, or possibly several smaller patches of the same shade.

The following two portraits of the same model show how different feelings and content can be expressed depending on the choice of technique.

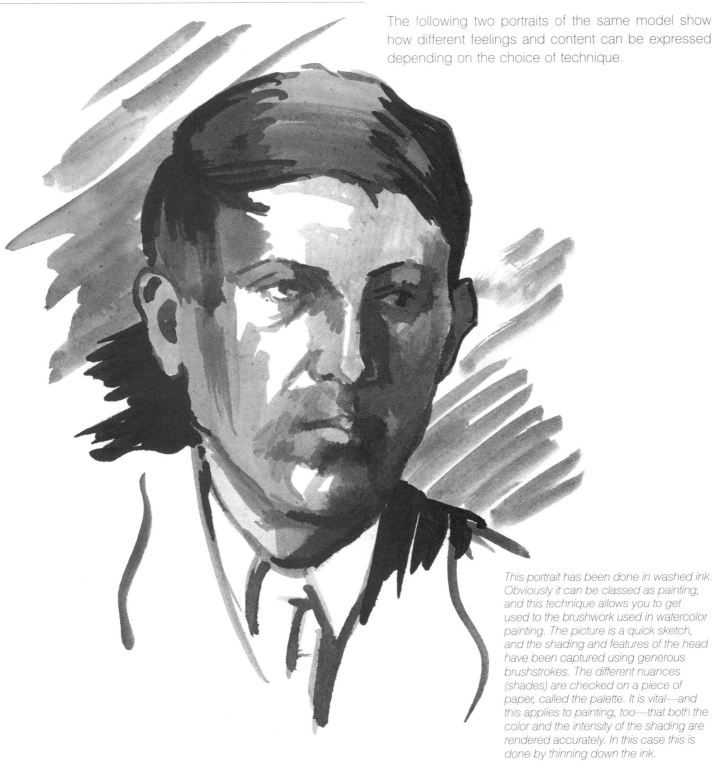

This portrait has been done in washed ink. Obviously it can be classed as painting, and this technique allows you to get used to the brushwork used in watercolor painting. The picture is a quick sketch, and the shading and features of the head have been captured using generous brushstrokes. The different nuances (shades) are checked on a piece of paper, called the palette. It is vital—and this applies to painting, too—that both the color and the intensity of the shading are rendered accurately. In this case this is done by thinning down the ink.

241

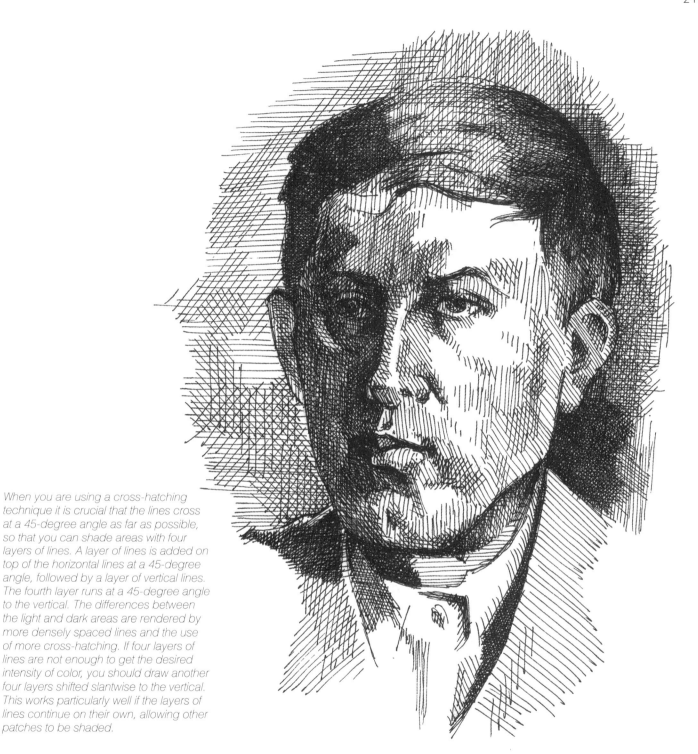

When you are using a cross-hatching technique it is crucial that the lines cross at a 45-degree angle as far as possible, so that you can shade areas with four layers of lines. A layer of lines is added on top of the horizontal lines at a 45-degree angle, followed by a layer of vertical lines. The fourth layer runs at a 45-degree angle to the vertical. The differences between the light and dark areas are rendered by more densely spaced lines and the use of more cross-hatching. If four layers of lines are not enough to get the desired intensity of color, you should draw another four layers shifted slantwise to the vertical. This works particularly well if the layers of lines continue on their own, allowing other patches to be shaded.

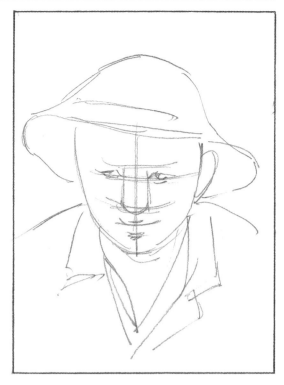

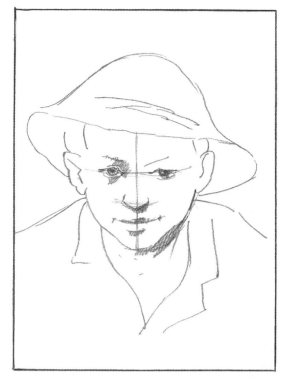

Every drawing starts with the same steps: the model is sketched, and the principal axis and the lateral axes marked on. The lines must follow the contours of the model. It does not matter if not all the lines are in the right position or run in the right direction—this is perfectly normal at this stage.

Once you have finished the sketch, it is time to correct the lines and refine the drawing. At this stage you can also work on certain details, such as the area around the eyes and the shadows under the nose and chin.

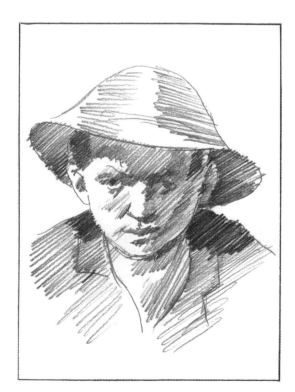

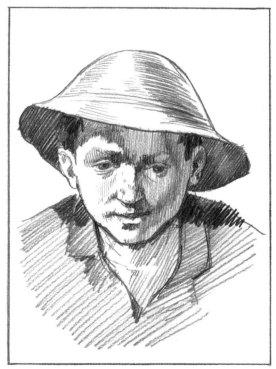

When shading the whole drawing, you are aiming at a rough sketch. All the shades are sketched out to begin with, and only then are the dark patches filled in.

The next step is to refine the details: superfluous lines that make the eyes look too dark are rubbed out, and large or irregular spaces between the lines are filled in. In order to achieve smooth shading it is vital that the lines are drawn while exerting even pressure on the pencil. Any spaces between the lines that are too wide are removed or balanced by adding another.

The Hands

The hands are the most agile part of the human body. They are mainly seen flat or clenched. They owe their movement to the finger bones, or phalanges; the thumbs have two, and the other fingers have three. The thumb is the only finger that can act in opposition to the others, which makes it very important for gripping.

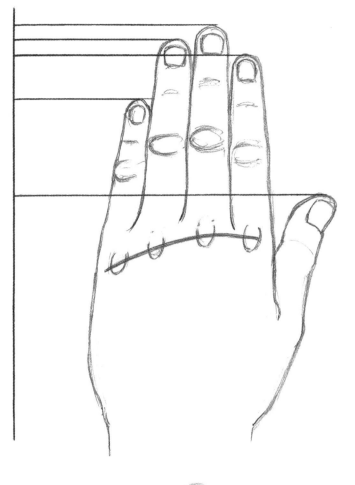

The longest finger is the middle finger, followed by the ring finger, the forefinger and the little finger. The thumb is set the farthest down the hand. There are marked wrinkles over the joints of the first and second finger bones. You can see a curved line where the first finger bone and the back of the hand meet; this is most obvious if the hand is clenched in a fist.

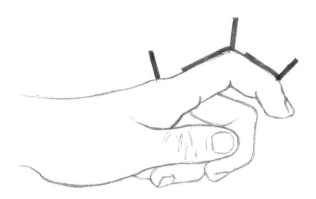

Drawing hands is made easier by the rule that the length of the first finger bone is two thirds of the length of the second, and the length of the third finger bone is two thirds that of the second.

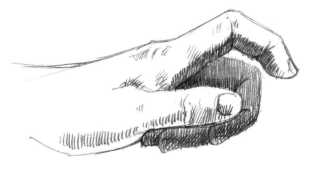

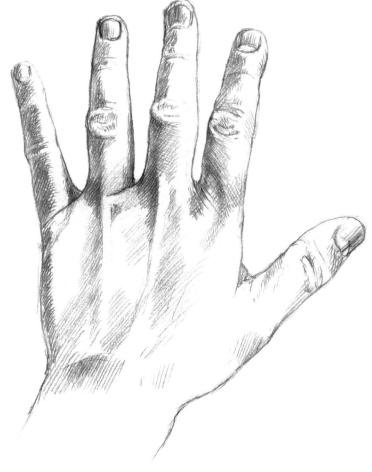

The folds at the bottom of the fingers run right and left from the middle finger.

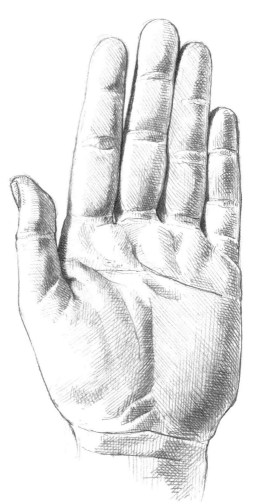

The palm of the hand is "padded". Its surface has a very varied texture, with strong, deep creases. These separate the individual small raised areas from one another, thus giving the hand its sense of three-dimensionality. There are marked creases over the knuckles between the finger bones.

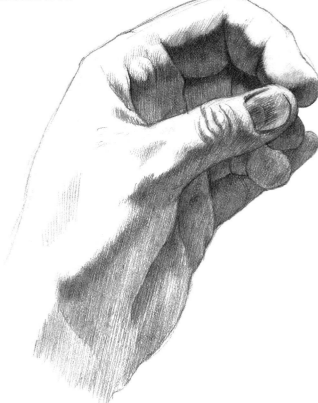

The flexibility of the wrist allows us to move our hands right and left, and forward and back.

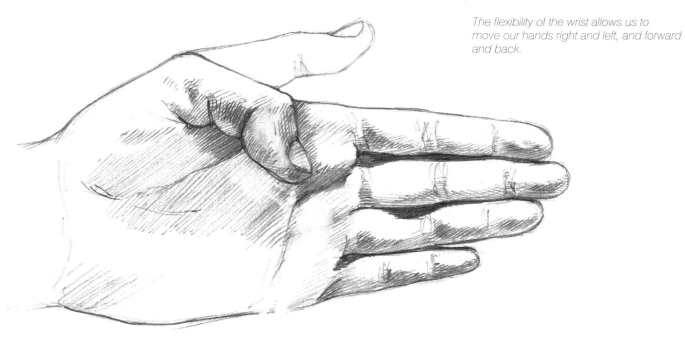

When studying the palm of the hand, you should pay particular attention to the movement of the thumb. It is thanks to this that we can grip objects so firmly.

You will find that it is easiest to draw hands if you use your own as a model. When depicting the different versions of a fist it is best to make quick sketches, as these are particularly helpful in allowing you to notice the details and typical lines and shading. This sketching stage is the time to work out the levels of shading, even though this may not yet be accurate.

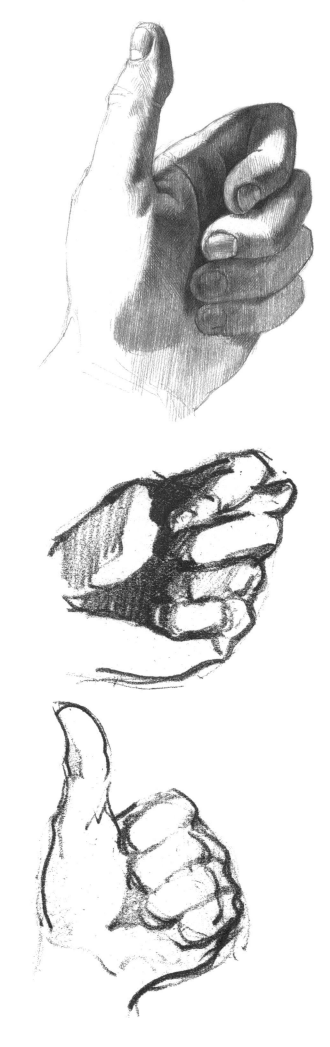

Study different hand movements from different angles. When drawing, you should always choose the pose that works the best. The rough picture in your quick sketch will be crucial when it comes to working on the final drawing.

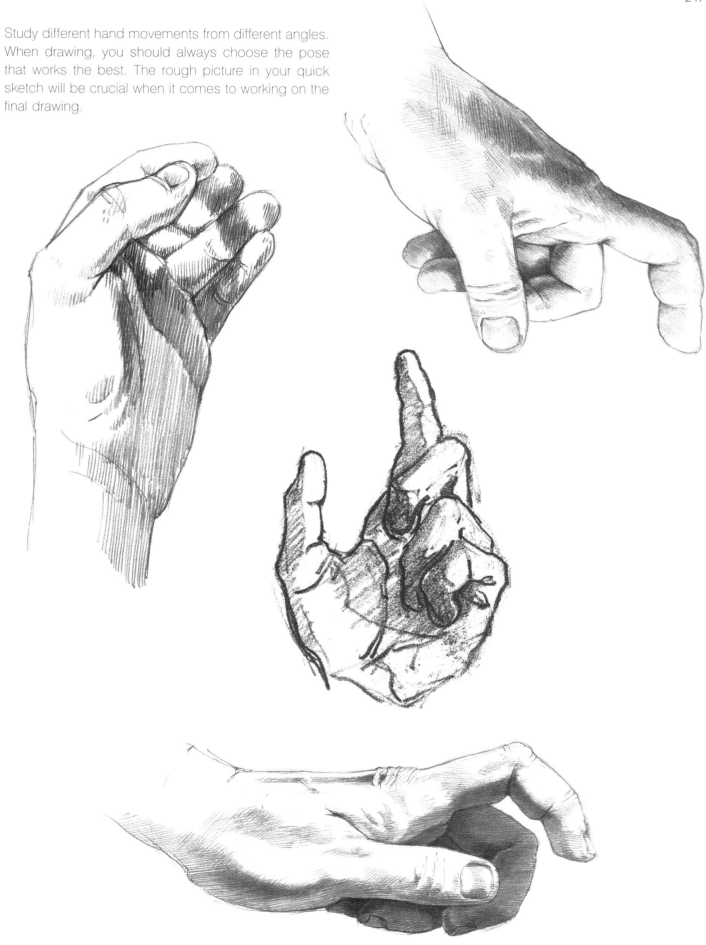

The hands play a major role in body language, so it is particularly important to draw their movements and the arrangement of the fingers in a lifelike way.

This sketch of a hand holding a tool shows a less common view of the hand, so you should take particular care when drawing it. Using a plotting grid or measuring stick will prove helpful in finding the exact position of the thumb. The other fingers can be accurately drawn using the creases on the knuckles between the first and second finger bones.

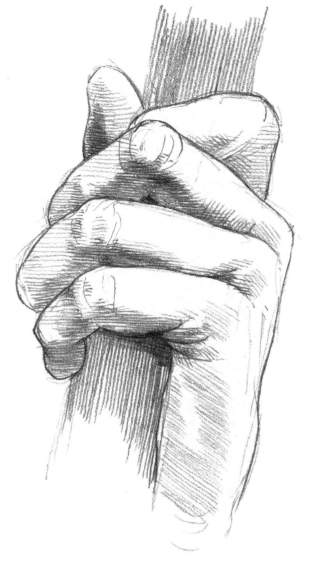

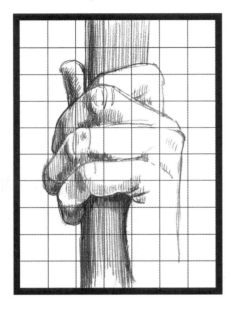

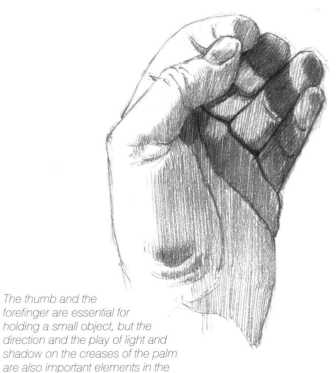

The thumb and the forefinger are essential for holding a small object, but the direction and the play of light and shadow on the creases of the palm are also important elements in the picture.

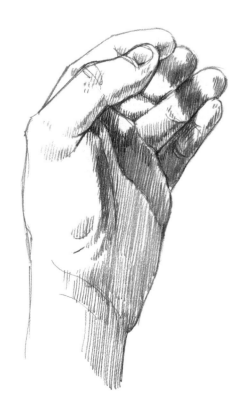

The stages for practicing drawing a hand holding up three fingers.

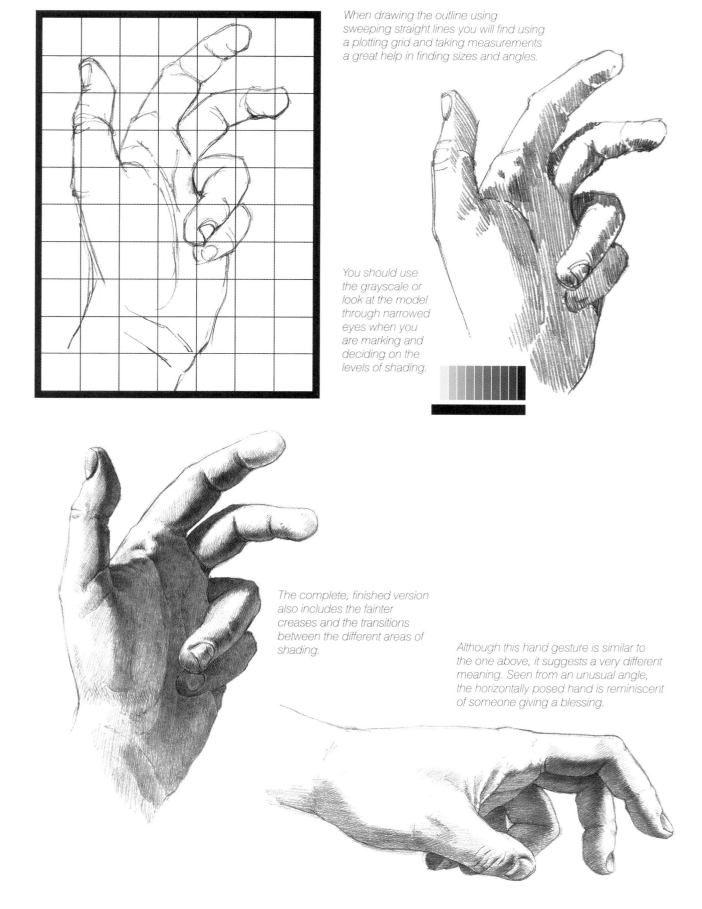

When drawing the outline using sweeping straight lines you will find using a plotting grid and taking measurements a great help in finding sizes and angles.

You should use the grayscale or look at the model through narrowed eyes when you are marking and deciding on the levels of shading.

The complete, finished version also includes the fainter creases and the transitions between the different areas of shading.

Although this hand gesture is similar to the one above, it suggests a very different meaning. Seen from an unusual angle, the horizontally posed hand is reminiscent of someone giving a blessing.

The most important thing here is to notice the most striking and typical detail of the hand gesture, as you will only be able to capture the real sense of the hand by drawing this detail in a sensitive way.

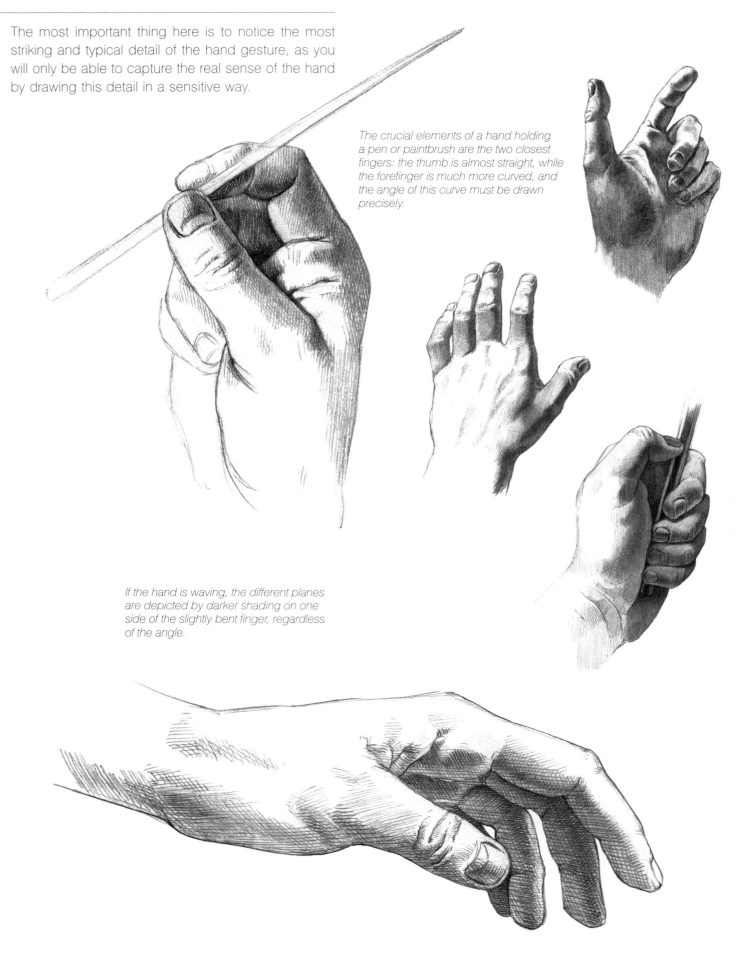

The crucial elements of a hand holding a pen or paintbrush are the two closest fingers: the thumb is almost straight, while the forefinger is much more curved, and the angle of this curve must be drawn precisely.

If the hand is waving, the different planes are depicted by darker shading on one side of the slightly bent finger, regardless of the angle.

Different hand postures as exercises in drawing hands. Mistakes are likely to arise if you want to draw a movement from memory and think that you can remember the details accurately. It is worth testing the difference between a drawing carried out from memory, and one done by studying a model. This will make you aware of how many details there are to include when drawing from a model. When shading it is perhaps even vital to have the model in front of you.

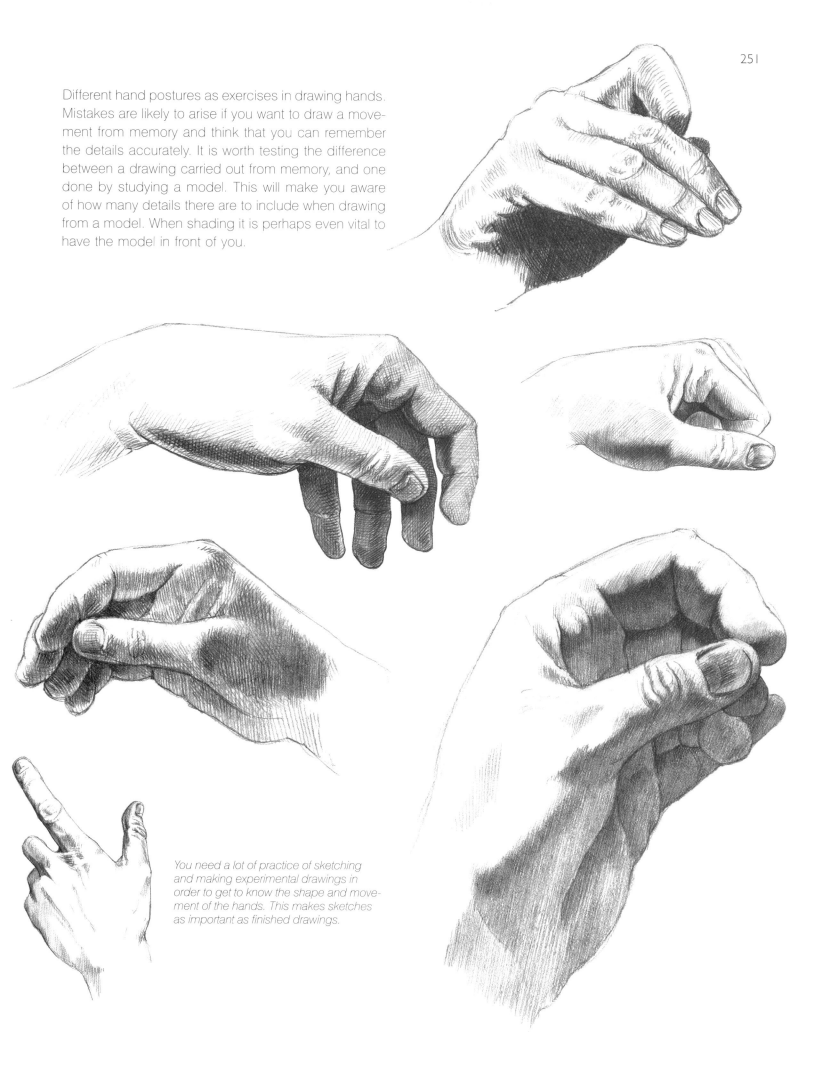

You need a lot of practice of sketching and making experimental drawings in order to get to know the shape and movement of the hands. This makes sketches as important as finished drawings.

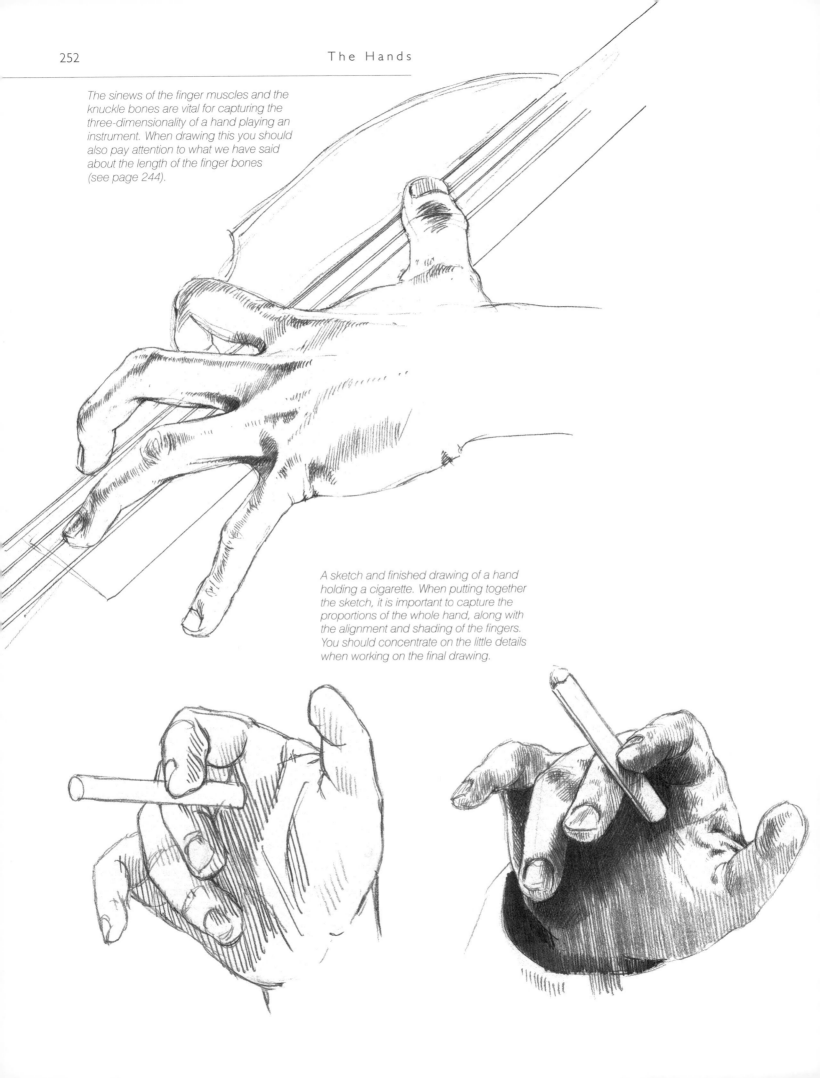

The sinews of the finger muscles and the
knuckle bones are vital for capturing the
three-dimensionality of a hand playing an
instrument. When drawing this you should
also pay attention to what we have said
about the length of the finger bones
(see page 244).

A sketch and finished drawing of a hand
holding a cigarette. When putting together
the sketch, it is important to capture the
proportions of the whole hand, along with
the alignment and shading of the fingers.
You should concentrate on the little details
when working on the final drawing.

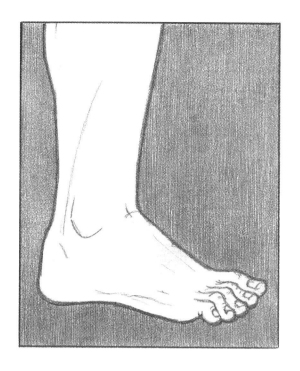
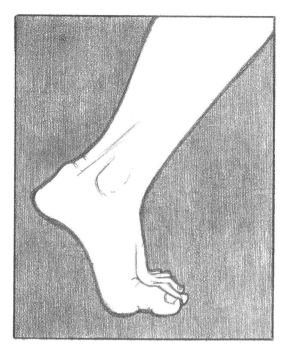
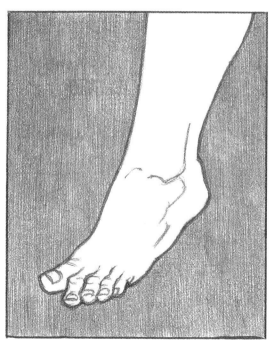
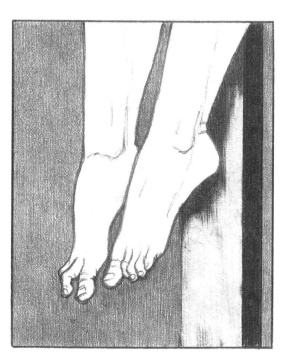

Feet and Legs

Being at the end of the lowest limbs, the feet bear
the weight of the whole body.

*The toes are arranged in a curve, and
by lengthening the lines relating to the
spaces between them you can see that
they slant toward the inner ankle. The
toes are very short in comparison to the
fingers.*

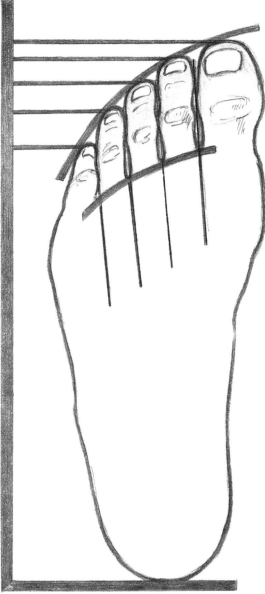

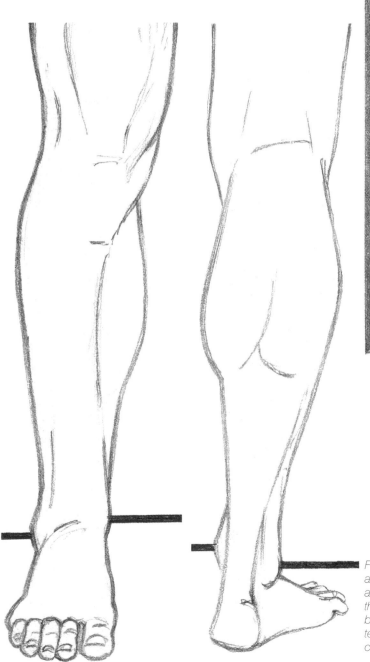

*From behind you can clearly see that the inner
ankle is higher than the outer ankle; the inner
ankle is the lowest part of the shin bone, while
the outer ankle is the lowest part of the calf
bone. In the view from behind, the Achilles
tendon really stands out as a detail of the foot,
creating deep indentations.*

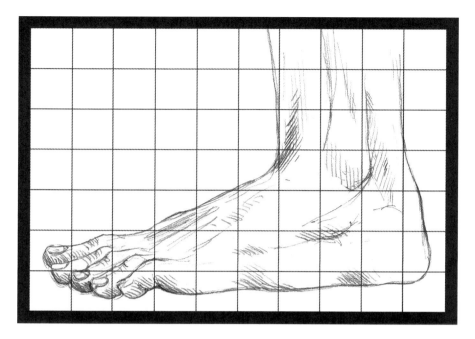

When they are seen side-on the outer edges of the feet, the heel and the bones of the toes appear to rest on the ground. The three-dimensionality of the outer ankle is very pronounced, and is highlighted even more by the Achilles tendon and the hollows that it creates. The curve formed by the toes is another noticeable feature. The area formed by the roots and points of the toes is roughly shaped like a rectangle. When drawing them, you should work out the whole length of the foot, and find out how many times the length of the toes fits into this measurement.

The flexible curve of the sole can be seen on the inside edge of the foot, which presses closer to the ground when it is weighed down, and goes back to its original position when the load is taken off it. The big toe is the largest and most powerful, and thus almost obscures the other toes. The heel and the Achilles tendon are also important elements of the whole picture from this angle.

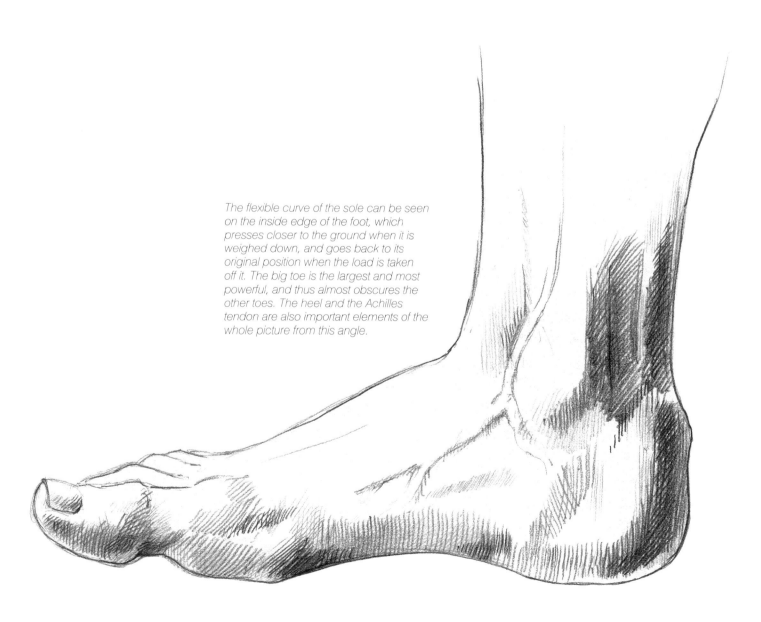

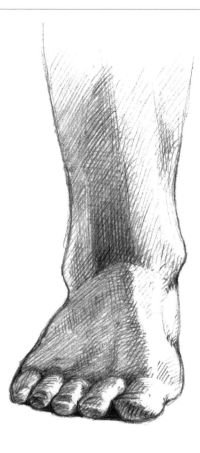

If you look at the foot from the front, you will see that the inner ankle clearly appears higher than the outer ankle. The upper part of the foot, the arch, curves toward the inner ankle, which separates the foot from the leg. It is therefore vital to include it in the drawing, even if it is only suggested. The curve of the cylinder-shaped toes should also be shown.

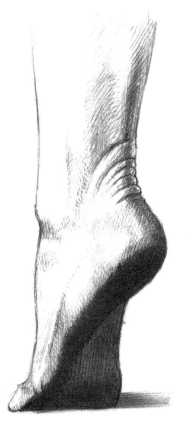

When seen from behind, the folds in the skin on the heel and the dark shading on the sole of the foot give it some interesting textures.

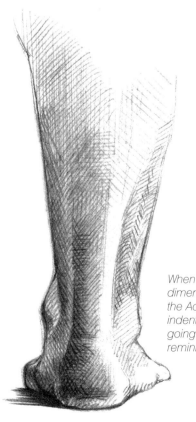

If the model stands on his tiptoes, you can see a strong dividing line between the arch of the foot and the toes. Here there is barely any difference between the plane of the lower leg and that of the arch, but the dividing curve should nevertheless be shown in the drawing.

When seen from behind, the three-dimensionality of the foot is largely due to the Achilles tendon and its pronounced indentations. The foot becomes a little wider going out from the ankle, and its shape is reminiscent of an acute-angled triangle.

The different stages in taking a step. When you are sketching this it is worth starting with shapes with simple outlines and proceeding to those that have the most detail, before adding in the shading.

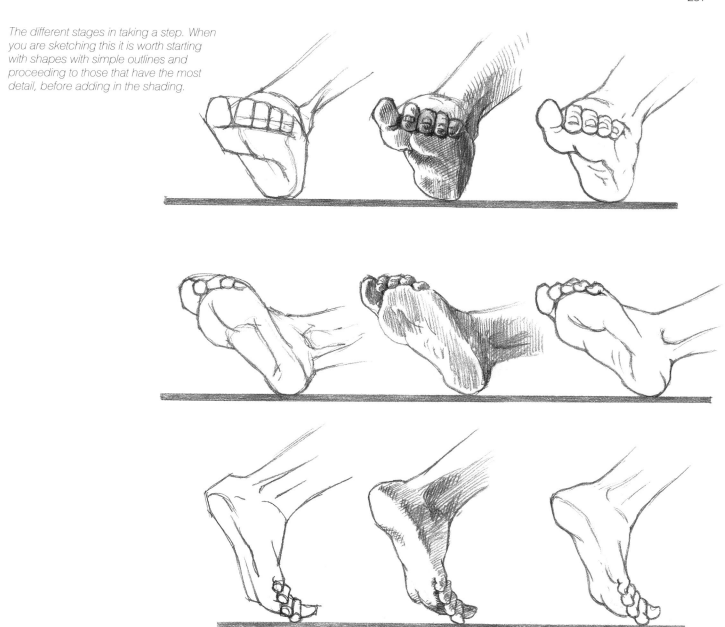

You should bear a number of rules in mind when drawing the foot. In the outer view the little toe and the outer ankle dominate the picture. The first bone in the toes runs horizontally, while the others are at a slight angle to the ground. If you are drawing the inner side of the foot, the big toe, the heel, and the curve between the bones of the toe are the most important features. The toes also allow the feet to suggest certain moods: ease, elegance, playfulness, or the opposite of these.

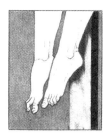

In most cases the whole lower part of the limb is drawn—in other words, the foot, lower leg, and upper leg. Capturing the distinct proportions for individuals and the angles typically formed when these three sections of leg move is vital—whether it is still or moving vigorously. You should use a plotting grid or measuring stick to make sure that the drawing is true to life.

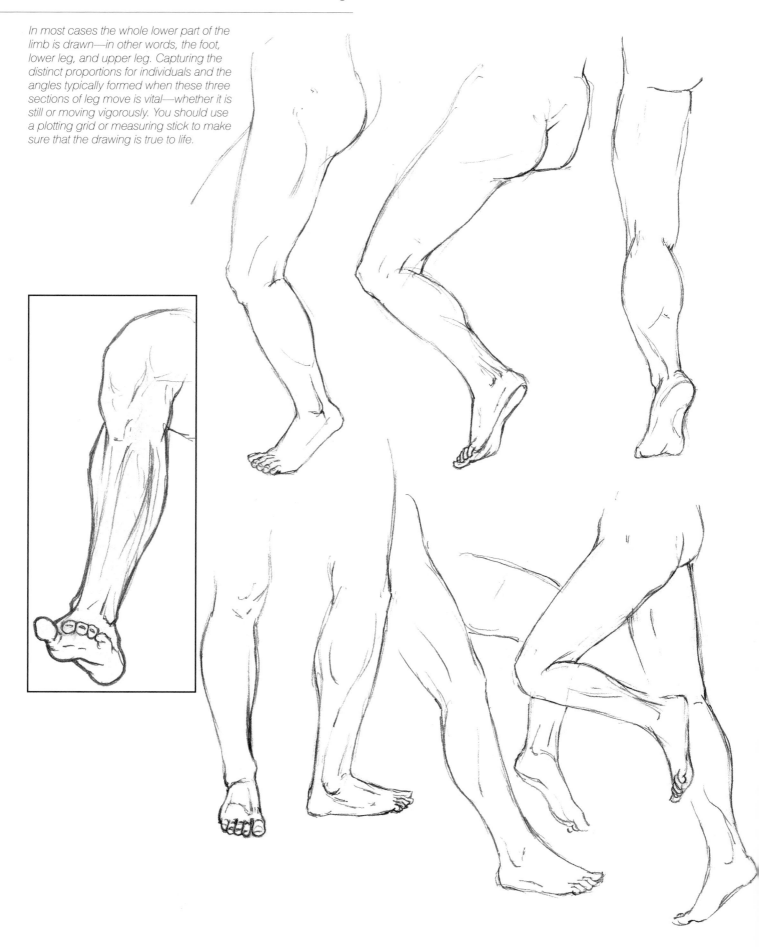

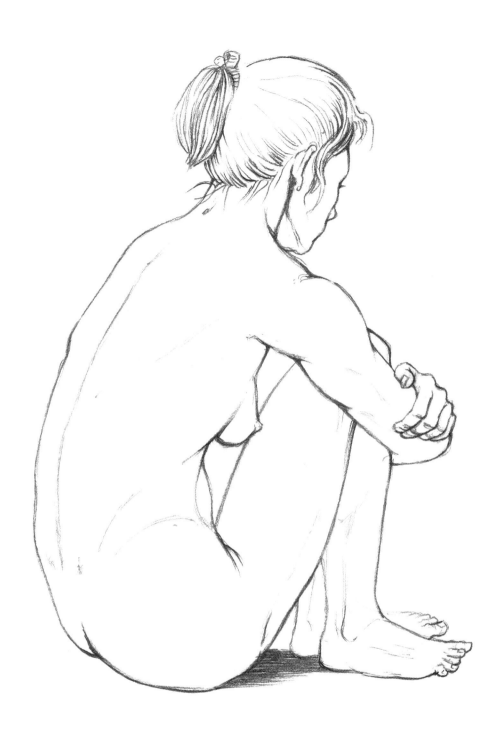

The Nude

Drawing the naked human body is one of the most
difficult stages in learning to draw. It requires extensive
preliminary study and the application of everything
that you have learned so far about simple shapes,
perspective, drapery, and portraits.

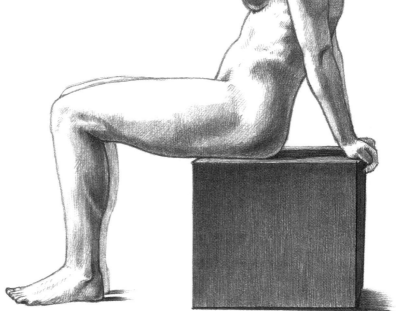

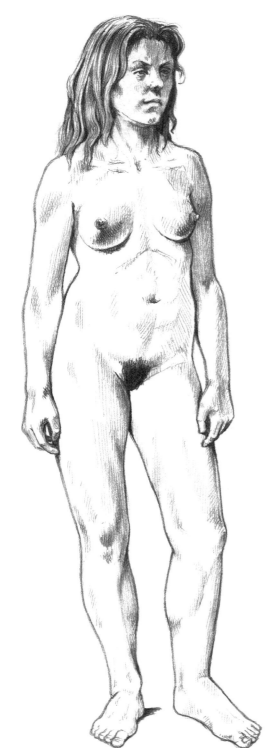

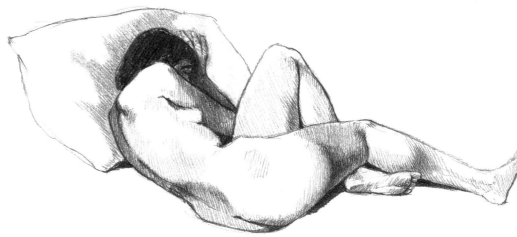

*A knowledge of proportions, an ability to
measure precisely, and skill at shading are the
basic requirements for a good drawing.*

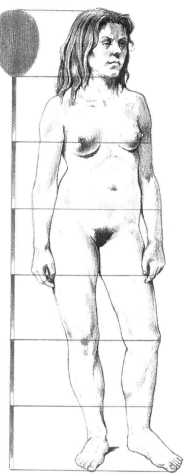

Next, mark the point halfway down the body. This is usually at the height of the pubic bone.

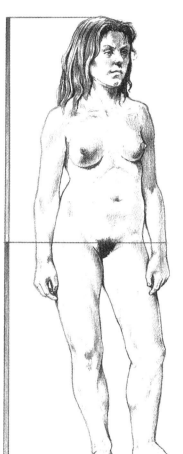

As you have done previously, mark a measurement on a blank sheet of paper that can be used as a reference for the other dimensions of the model, and the drawing as a whole. When drawing a nude, the most suitable measurement is the size of the head. This is the height of the head from the bottom of the chin to the parting in the hair, but without the hair itself, as a strongly backcombed hairstyle, for instance, would give a completely misleading measurement.

Begin the drawing by working out how often the height of the head fits into the height of the body, regardless of whether the model is standing, sitting, or lying down.

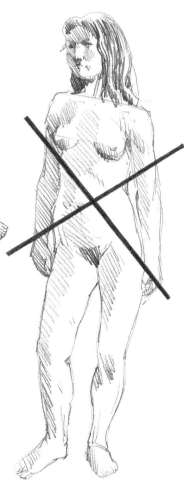

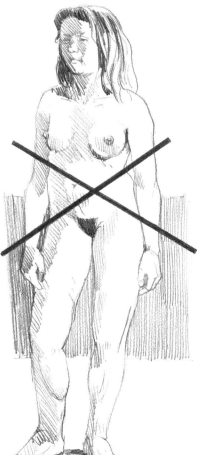

If you do not mark this point halfway down the body it will be easy to botch the drawing, as the legs will be too short or too long in comparison with the height of the body.

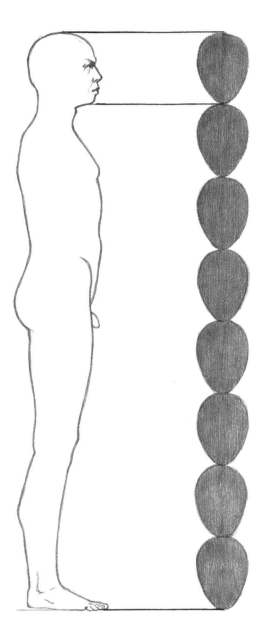

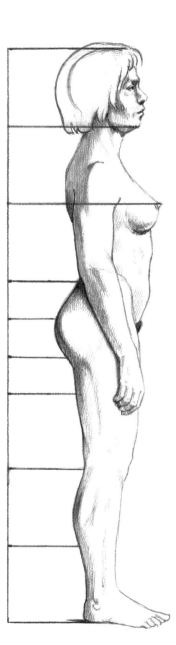

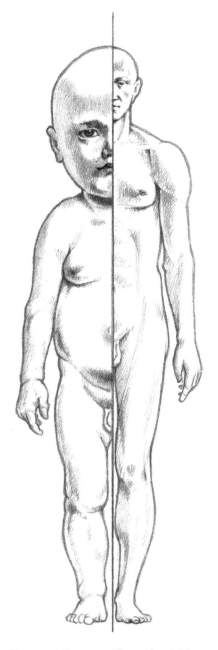

For an adult male, the height of the head is contained seven to eight times in the height of the body. Out of interest, it is contained seven times in Michelangelo's David.

For an adult female, the height of the head is contained six to seven times in the height of the body.

The proportions are different for children. The size of the head in comparison to the rest of the body is at its largest in babies—it is contained three to four times in the height of the body. For two- and three-year-olds the height of the body equates to four or five times the height of the head, and six to six and a half times for 15-year-olds.

The human body is symmetrical; the features on the right-hand side are mirrored on the left. It also has an axis of symmetry (the principal axis), which should not be confused with the center of gravity. The latter is an imaginary vertical line which is used to make sure that the figure you have drawn does not tilt. If the figure is seen face-on, this line runs downward and at a right angle to the ground from the point where the collarbone and the breastbone meet.

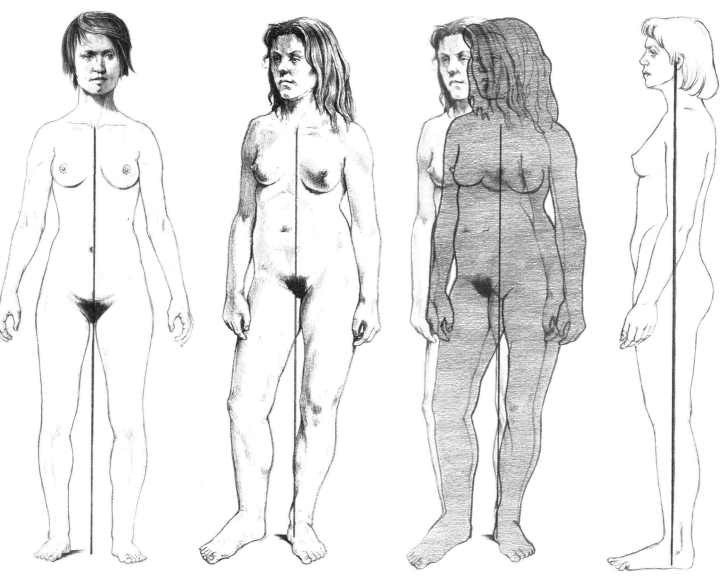

If the figure is standing on both feet with her legs slightly apart, her body weight is spread evenly across both her legs. In this example the center of gravity runs between her legs to the ground, and is the same as the axis of symmetry.

If the weight is placed on one leg due to the other knee being slightly bent (called the contrapposto stance), the hip moves in the direction of the bent leg, and the axis of the shoulders bends in the opposite direction. In this case the center of gravity runs through the inner ankle of the stretched out, weight-bearing leg.

If the center of gravity does not form a right angle with the ground, the figure appears to tilt.

The position of the center of gravity in profile.

When drawing nudes, as when drawing the head, you should use the so-called axes of the shoulders, breasts, hips, and knees as an aid.

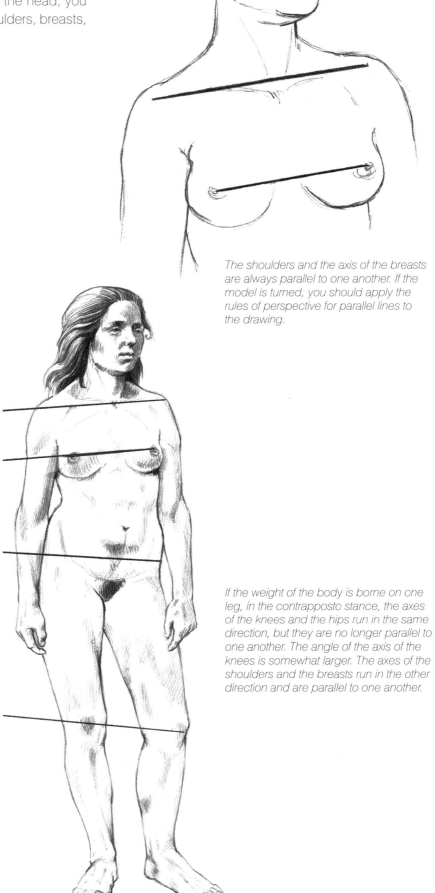

The shoulders and the axis of the breasts are always parallel to one another. If the model is turned, you should apply the rules of perspective for parallel lines to the drawing.

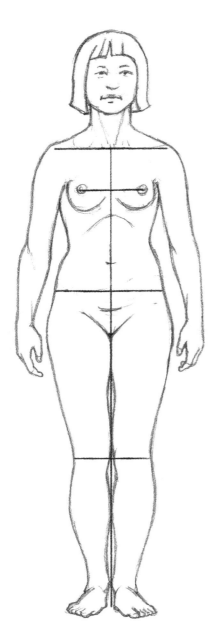

The axes of the model facing straight on and standing on both feet are horizontal and parallel to one another.

If the weight of the body is borne on one leg, in the contrapposto stance, the axes of the knees and the hips run in the same direction, but they are no longer parallel to one another. The angle of the axis of the knees is somewhat larger. The axes of the shoulders and the breasts run in the other direction and are parallel to one another.

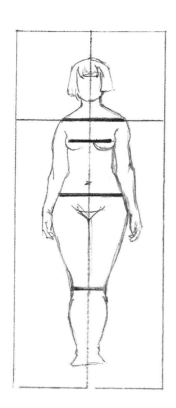

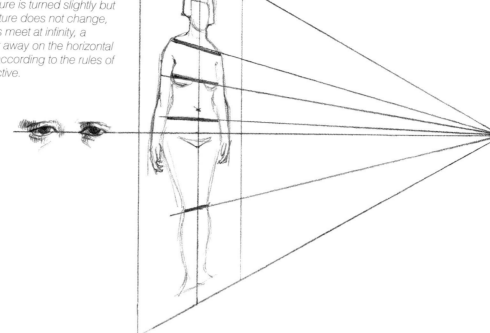

The axes of the model facing straight on and standing on both feet are parallel to one another. If the figure is turned slightly but her posture does not change, the axes meet at infinity, a point far away on the horizontal plane, according to the rules of perspective.

In the contrapposto stance the axes of the shoulders and the hips likewise meet the axis of the knees at infinity.

You can work out the direction of the individual axes using a plotting grid or pencil.

It is easy to work out the direction of the weight-bearing leg by holding a pencil against it.

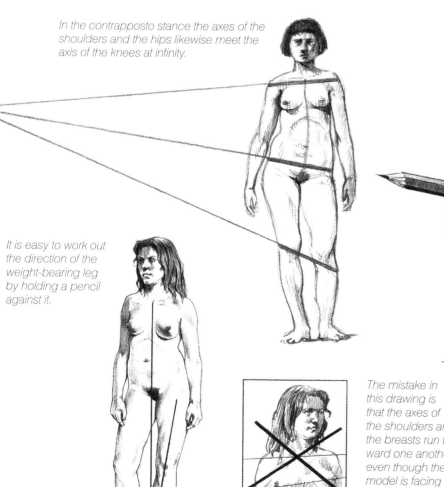

The mistake in this drawing is that the axes of the shoulders and the breasts run toward one another, even though the model is facing straight on.

The exact angle formed by the horizontal and slanting axes must be found. You should use the plotting grid to find the right proportions and check the drawing.

There are certain rules and fixed proportions that make drawing the human body easier.

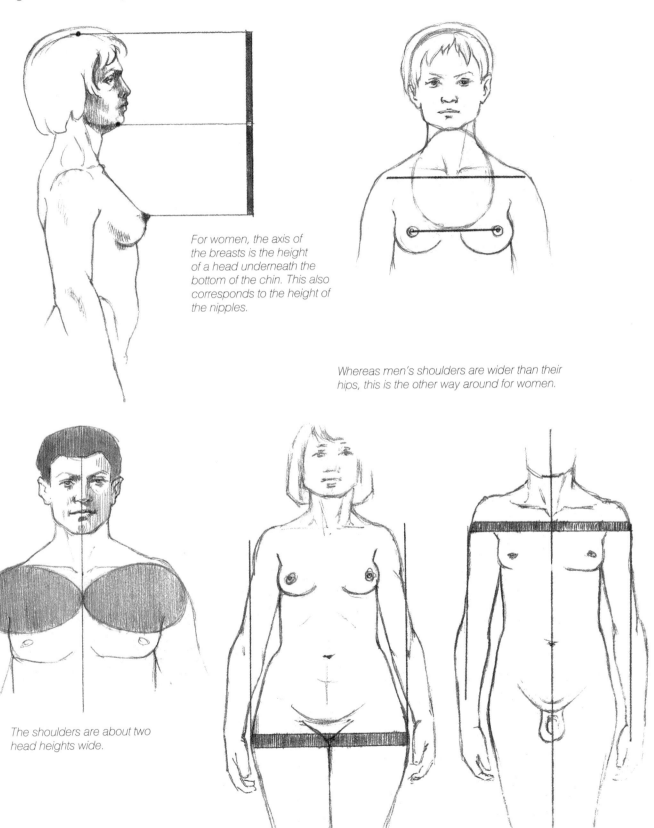

For women, the axis of the breasts is the height of a head underneath the bottom of the chin. This also corresponds to the height of the nipples.

Whereas men's shoulders are wider than their hips, this is the other way around for women.

The shoulders are about two head heights wide.

You can make sure that the drawing is accurate by finding several measurements and directions. All measurements are compared against the height of the head, which acts as a yardstick.

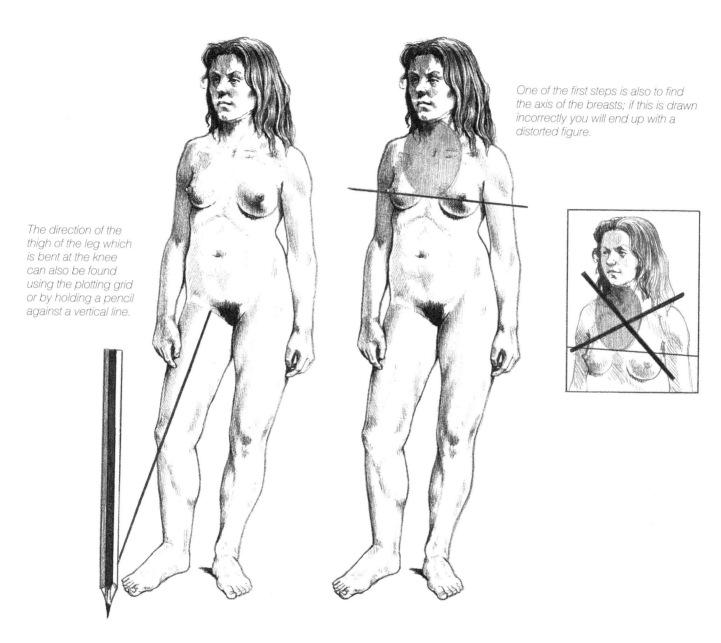

One of the first steps is also to find the axis of the breasts; if this is drawn incorrectly you will end up with a distorted figure.

The direction of the thigh of the leg which is bent at the knee can also be found using the plotting grid or by holding a pencil against a vertical line.

If the model turns, the shoulders alter the picture according to the rules of perspective: the shoulder that is farther away is shorter than the one that is closer to the viewer. If you draw both of them the same size when the model is in this position, it will look as though her hips are turning toward the viewer.

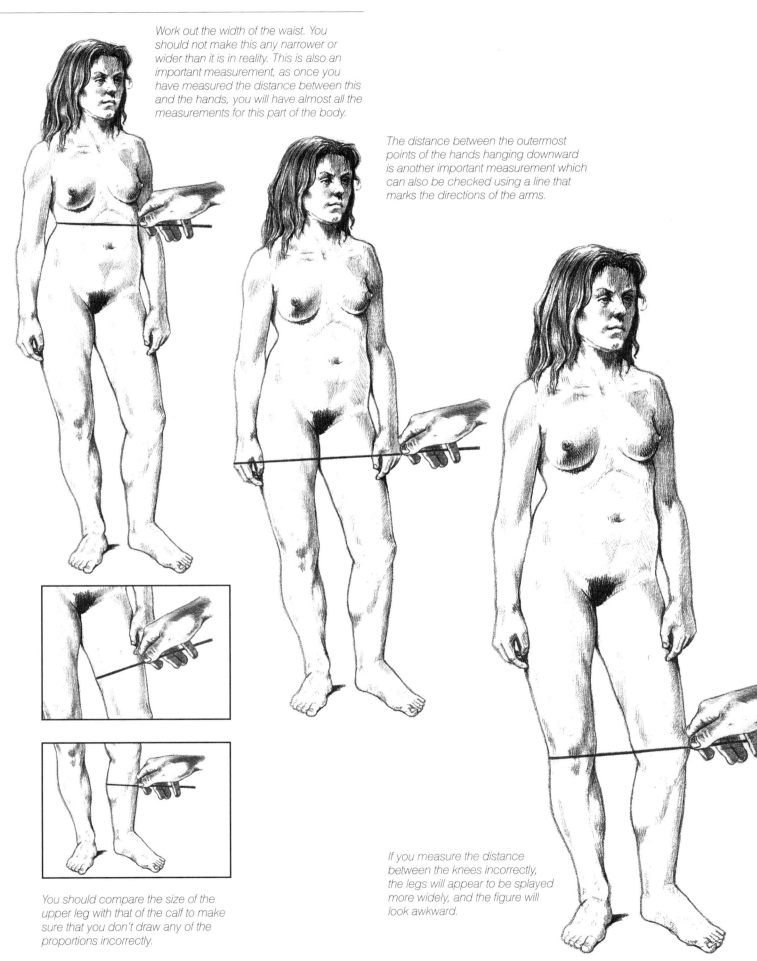

Work out the width of the waist. You should not make this any narrower or wider than it is in reality. This is also an important measurement, as once you have measured the distance between this and the hands, you will have almost all the measurements for this part of the body.

The distance between the outermost points of the hands hanging downward is another important measurement which can also be checked using a line that marks the directions of the arms.

You should compare the size of the upper leg with that of the calf to make sure that you don't draw any of the proportions incorrectly.

If you measure the distance between the knees incorrectly, the legs will appear to be splayed more widely, and the figure will look awkward.

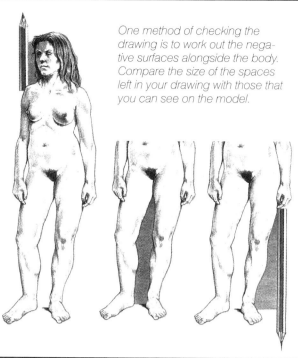

One method of checking the drawing is to work out the negative surfaces alongside the body. Compare the size of the spaces left in your drawing with those that you can see on the model.

Check your drawing repeatedly while you are working, as this will make it easier to make adjustments. Hold a pencil vertically against a point on the body of the model in order to work out which point on the body the line runs through, and check whether this is also the case in the drawing.

Work out the position of the hanging hands. If the shoulders are turned, one hand may be closer to the kneecap and the other farther away. The line joining the lowest points of the hands is shifted so that it is parallel to the axis of the shoulders.

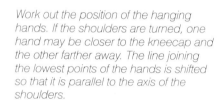

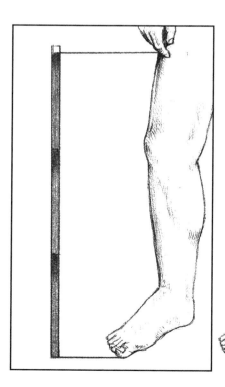

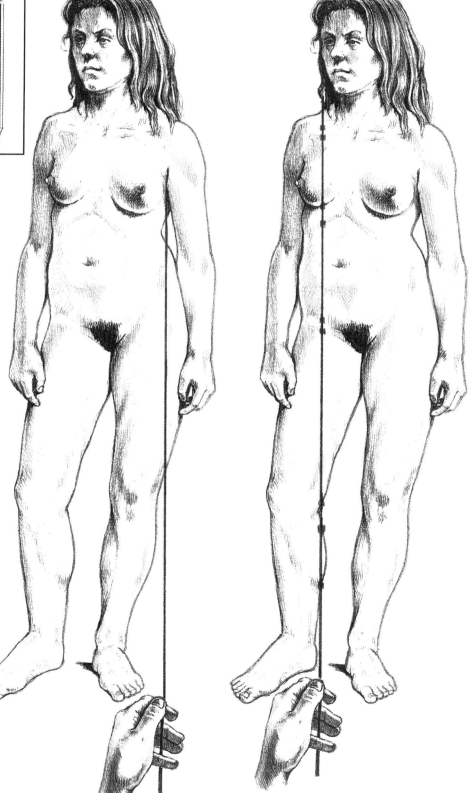

These 36 small drawings show the different ways in which you can measure and check your work, and they will make it easier for you to succeed in producing a lifelike drawing. Work out the position of the center of gravity, and check the direction of the axes and the limbs, along with the negative spaces beside the body.

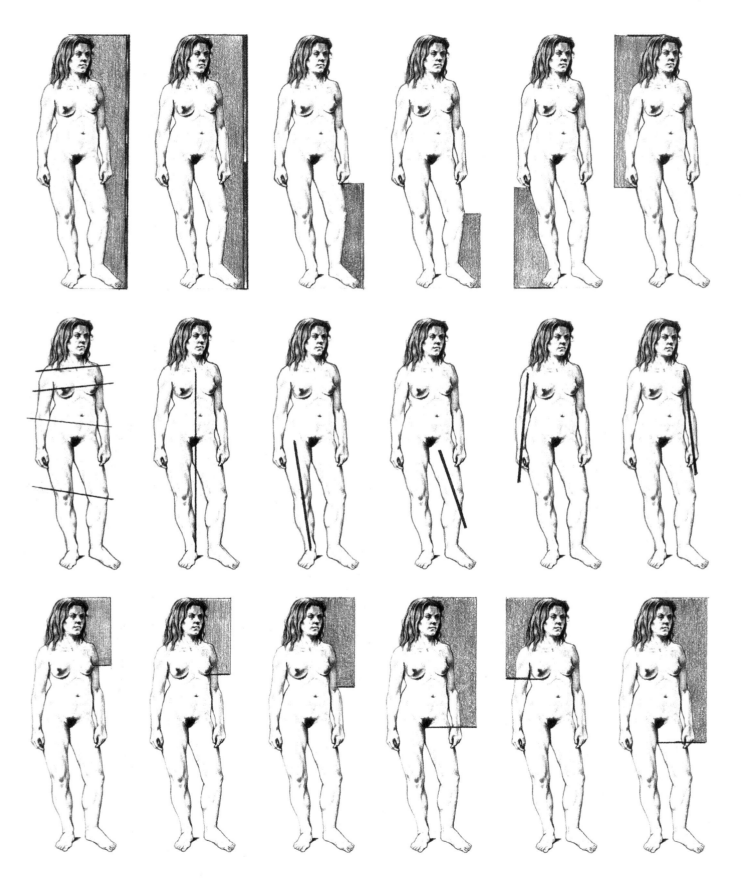

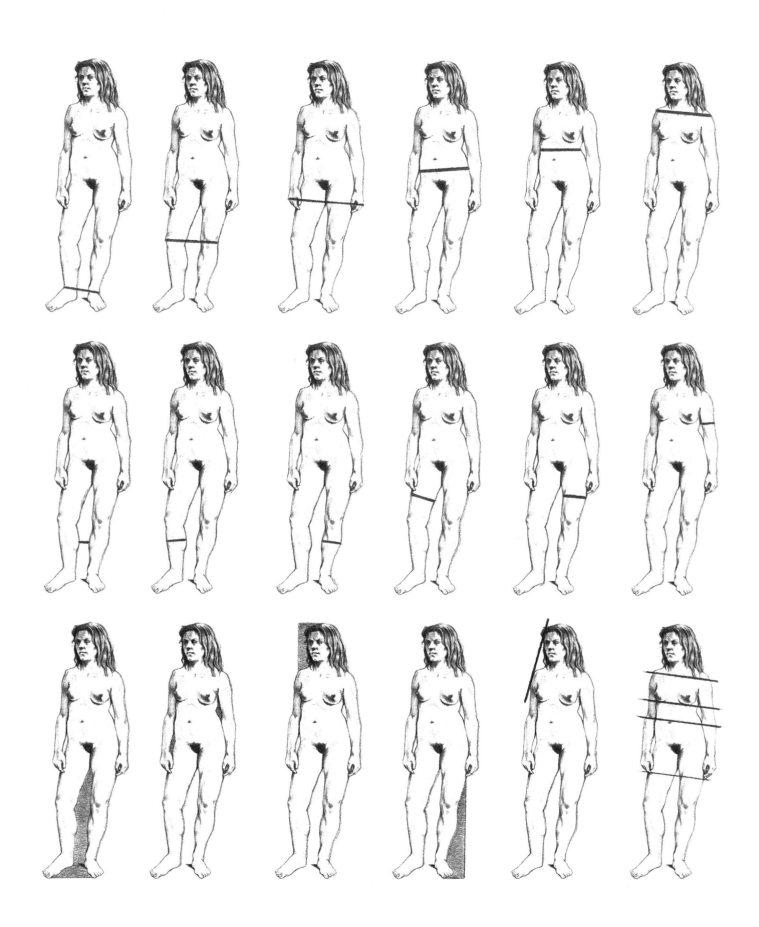

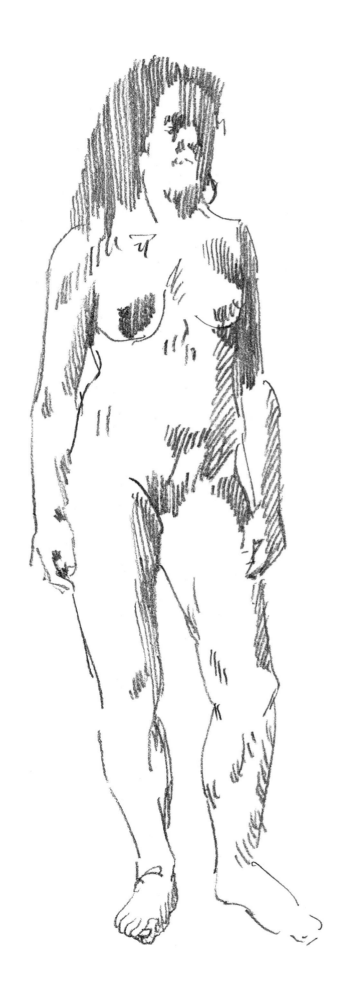

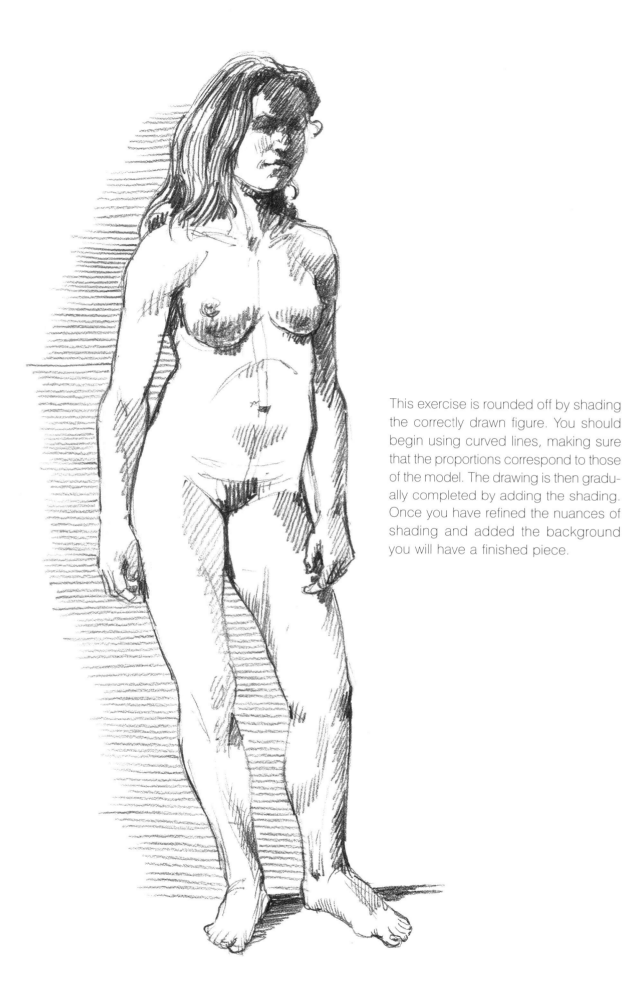

This exercise is rounded off by shading the correctly drawn figure. You should begin using curved lines, making sure that the proportions correspond to those of the model. The drawing is then gradually completed by adding the shading. Once you have refined the nuances of shading and added the background you will have a finished piece.

In order to give the drawing lifelike shading, you have to know the structure of the body. I have labeled some important muscles here.

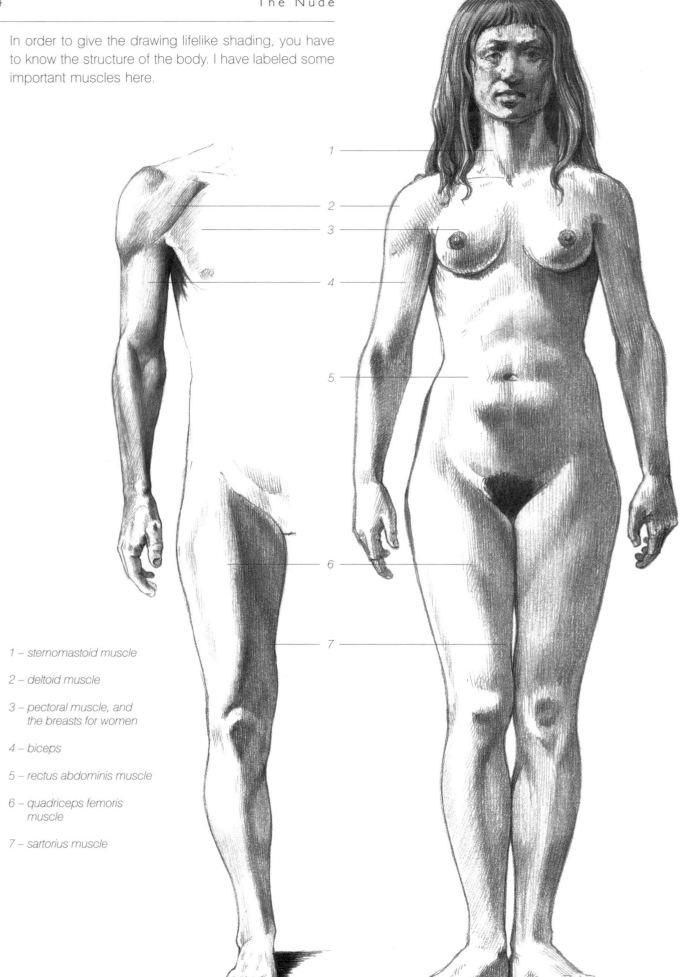

1 – sternomastoid muscle

2 – deltoid muscle

3 – pectoral muscle, and the breasts for women

4 – biceps

5 – rectus abdominis muscle

6 – quadriceps femoris muscle

7 – sartorius muscle

The profile is perhaps the easiest of all the different postures to draw, but even in this stance you will need to make many more measurements in order to produce a precise drawing.

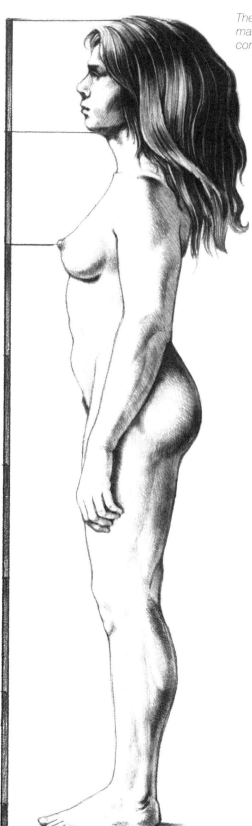

The first step is to work out how many times the height of the head is contained in the height of the body.

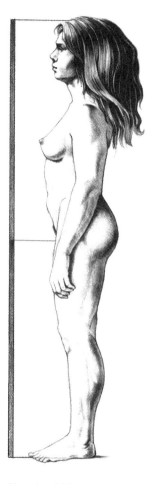

You should then mark the point halfway down the height of the body.

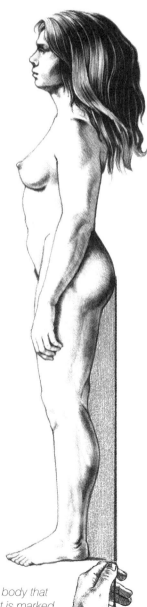

The buttocks are the part of the body that protrudes the farthest. This point is marked on the height of the body; in this example it is at roughly the same height as the halfway point. This gives you a negative surface for checking the drawing.

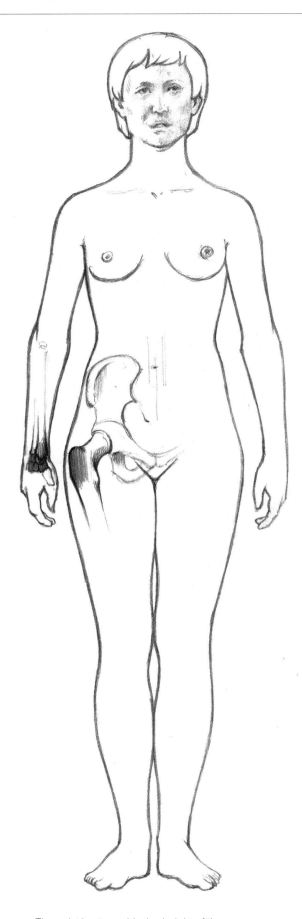

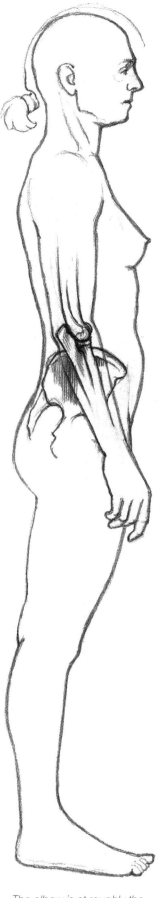

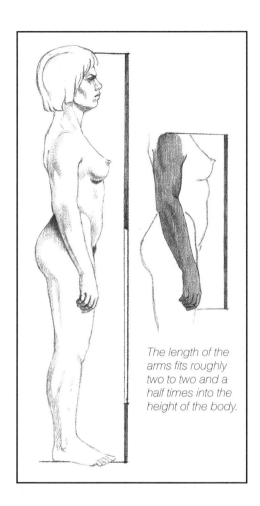

The length of the arms fits roughly two to two and a half times into the height of the body.

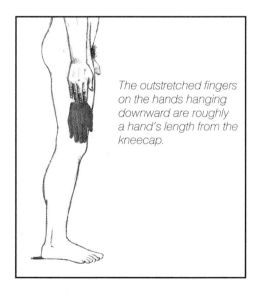

The outstretched fingers on the hands hanging downward are roughly a hand's length from the kneecap.

The wrist is at roughly the height of the "bulge" of the thigh bone, the greater trochanter.

The elbow is at roughly the same height as the blade of the pelvis.

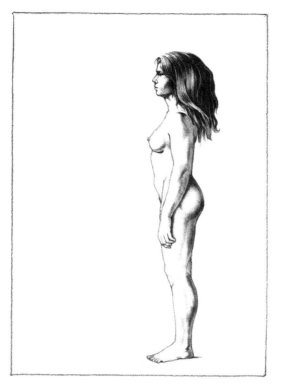

According to the rules of composition, when drawn in profile the figure must be shifted from the middle of the page in the opposite direction to the way that she is looking. She should not, however, be positioned at the very edge of the paper, as this will mean that she is partly obscured by the mount, besides disrupting the balance of the drawing. Ideally there should be more space in front of the figure, but still a little space behind her.

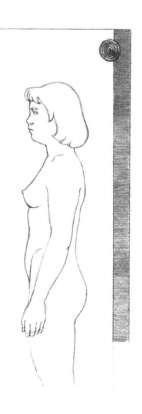 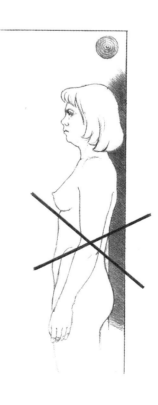 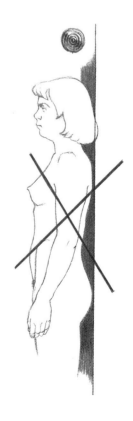

You will only be able to produce an error-free drawing
if you constantly check your work as you go.

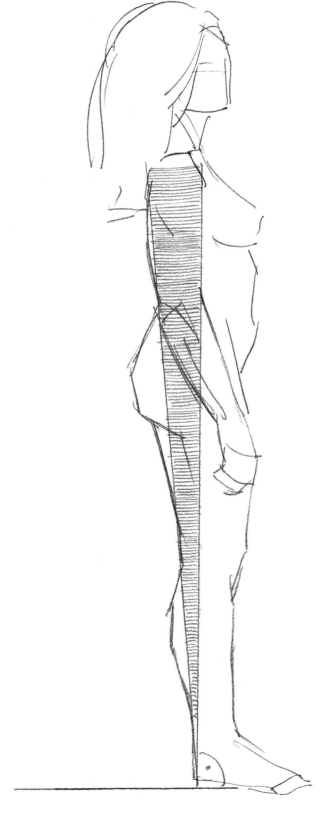

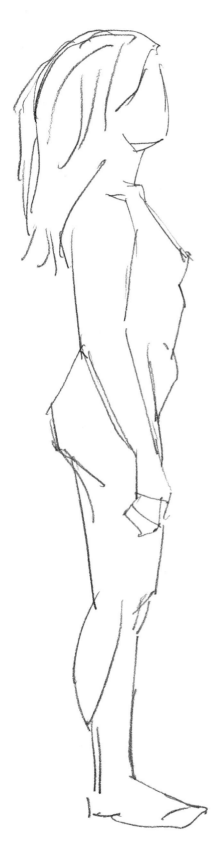

*If the center of gravity does not form a
right angle with the ground, the figure will
appear to tilt, usually backward.*

*Even if you are drawing your sketch with
angular lines, all the different parts of
the body must be positioned correctly,
although you can correct any mistakes
later on by measuring.*

Even with drawings in profile you should make sure to check the lines that join the body's extremities and the "negative spaces" between its contours. If the size of the negative areas on the model no longer agrees with those on the drawing, this means that the drawing is

incorrect. You should use a pencil or plotting grid to check this. You can also check the direction of the lines connecting two chosen points on the body by seeing how far they deviate from the vertical or horizontal.

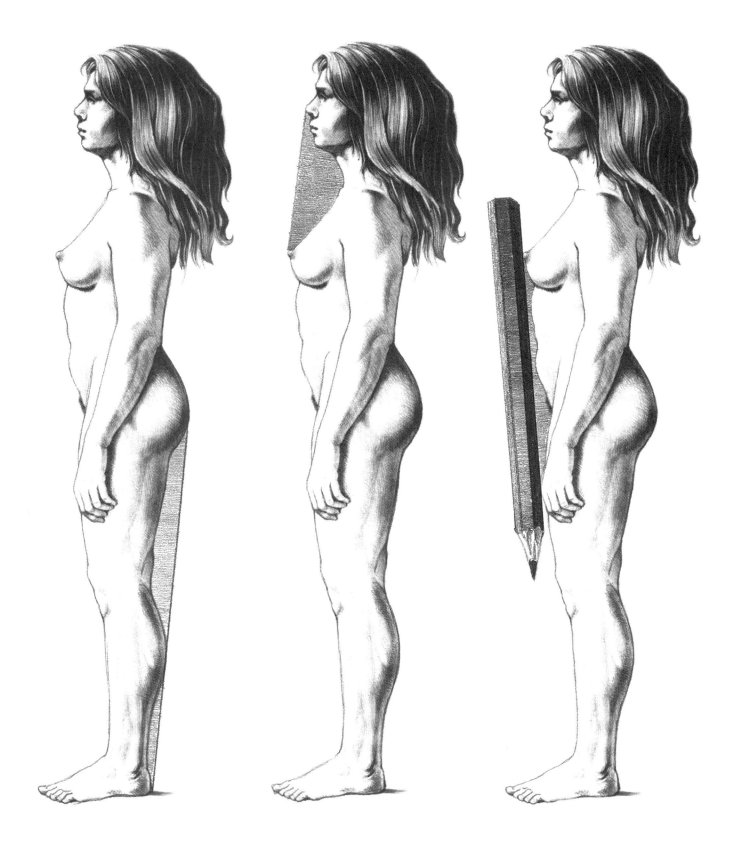

You should know the important parts of the human muscular system in order to understand the three-dimensional structure of a figure drawn in profile.

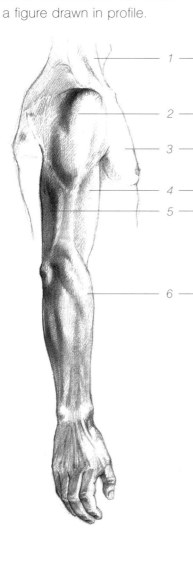

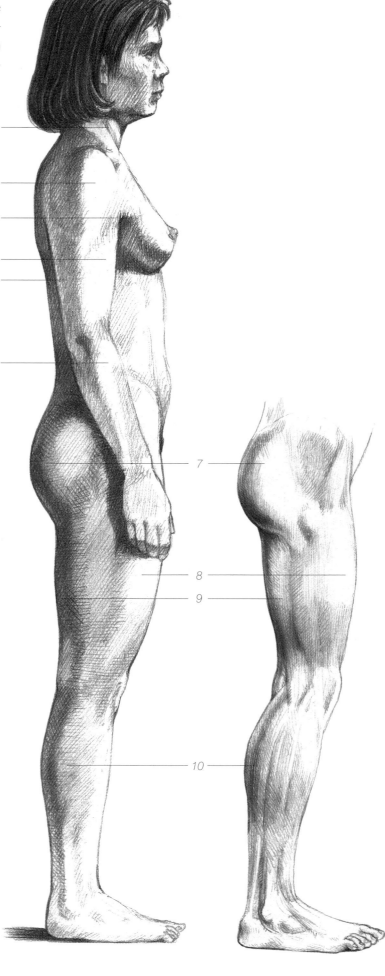

1 – sternomastoid muscle

2 – deltoid muscle

3 – major pectoral muscle

4 – biceps muscle

5 – triceps muscle

6 – extensor carpi radialis muscle

7 – gluteus maximus

8 – quadriceps femoris muscle

9 – biceps femoris muscle

10 – gastrocnemius muscle

Drawing a nude from behind is somewhat harder, because you cannot see the length of the head. This means that you should start the drawing in a different way.

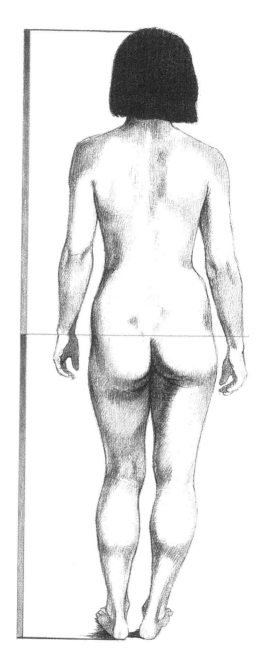

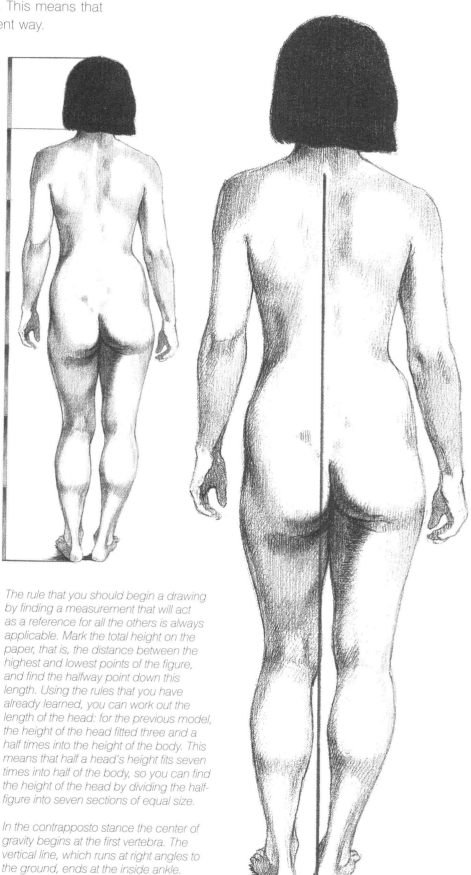

The rule that you should begin a drawing by finding a measurement that will act as a reference for all the others is always applicable. Mark the total height on the paper, that is, the distance between the highest and lowest points of the figure, and find the halfway point down this length. Using the rules that you have already learned, you can work out the length of the head: for the previous model, the height of the head fitted three and a half times into the height of the body. This means that half a head's height fits seven times into half of the body, so you can find the height of the head by dividing the half-figure into seven sections of equal size.

In the contrapposto stance the center of gravity begins at the first vertebra. The vertical line, which runs at right angles to the ground, ends at the inside ankle.

A woman's body is much softer and more heavily "pad-ded" than the muscular body of a man, which makes the outlines of the muscles more difficult to discern. However, these muscles give the body its structure, so you should learn the most important of them.

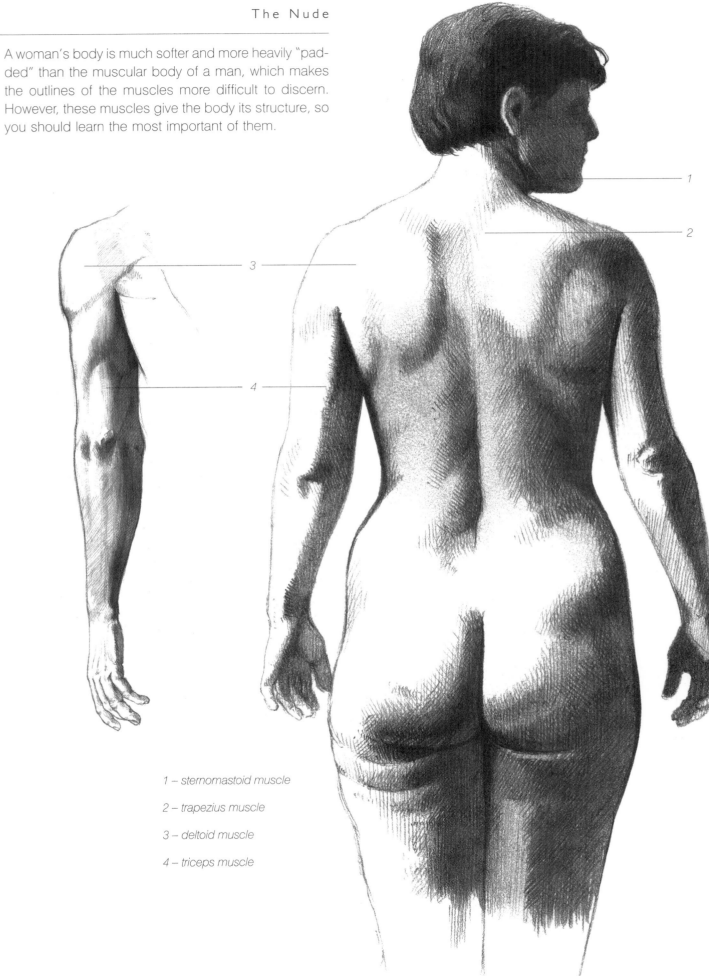

1 – sternomastoid muscle

2 – trapezius muscle

3 – deltoid muscle

4 – triceps muscle

1 – trapezius muscle

2 – deltoid muscle

3 – triceps muscle

4 – latissimus dorsi muscle

5 – gluteus maximus

6 – biceps femoris muscle

7 – gastrocnemius muscle

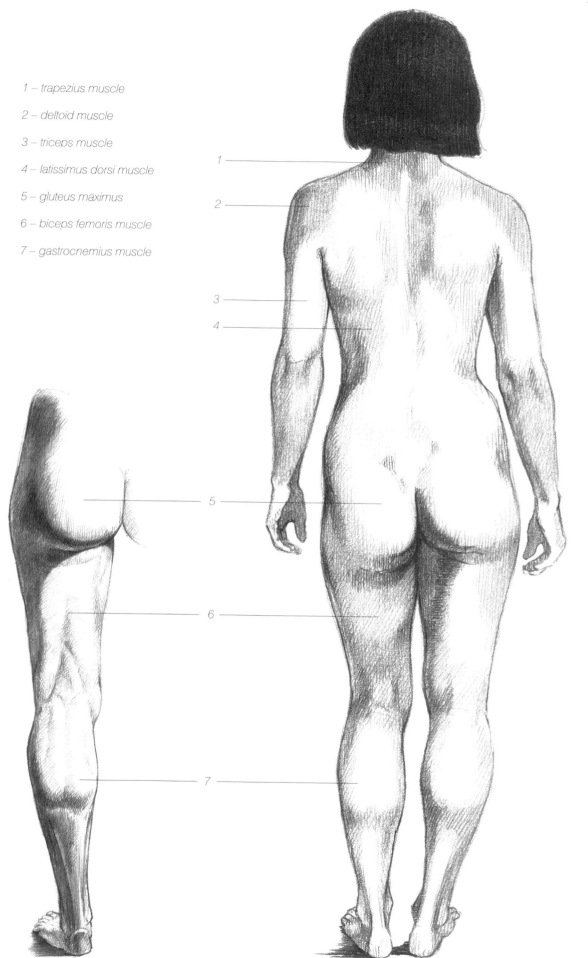

A knowledge of the most important surface muscles in the human body is indispensible when learning to draw figures. As these are normally not visible on living models, plaster statues are used for instruction. These are used all over the world and are of more use than any book of anatomy, as you can feel the dimensions of the muscles. You can also experiment with lighting and study the sculptures from many different angles.

One of the most famous plaster statues is The Archer, *whose creator is unknown. Copies of this work have nevertheless been helping budding artists to learn to draw for hundreds of years.*

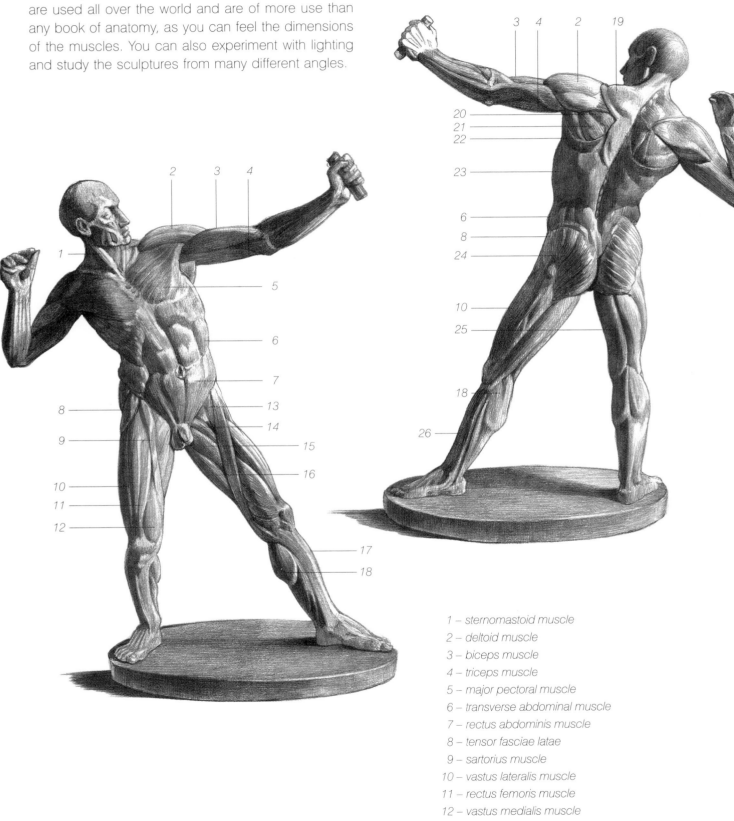

1 – sternomastoid muscle

2 – deltoid muscle

3 – biceps muscle

4 – triceps muscle

5 – major pectoral muscle

6 – transverse abdominal muscle

7 – rectus abdominis muscle

8 – tensor fasciae latae

9 – sartorius muscle

10 – vastus lateralis muscle

11 – rectus femoris muscle

12 – vastus medialis muscle

13 – pectineus muscle

This plaster statue of a muscular man waving is also popular amongst those who are learning to draw. It was being used as a teaching aid as early as the late 1800s. By looking closely at him you can also study the hidden inner muscles of the moving limbs.

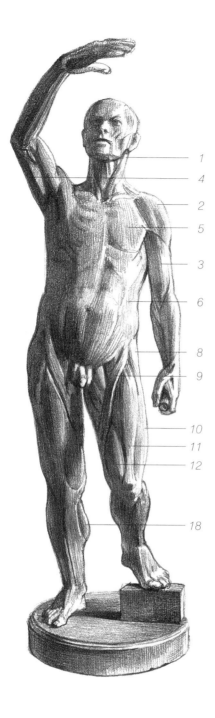

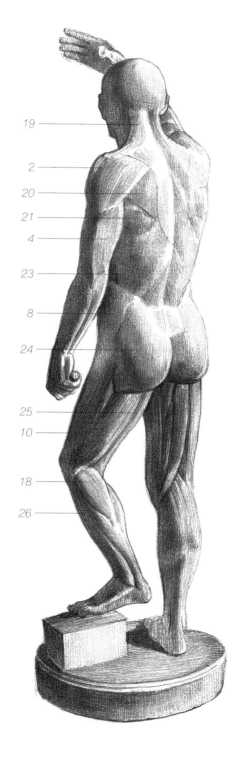

14 – adductor brevis muscle

15 – adductor longus muscle

16 – adductor magnus muscle

17 – anterior tibial muscle

18 – triceps surae muscle

19 – trapezius muscle

20 – infraspinatus muscle

21 – teres minor muscle

22 – teres major muscle

23 – latissimus dorsi muscle

24 – gluteus maximus

25 – biceps femoris muscle

26 – peroneus longus muscle

Up to this point we have discussed the simplest bodily postures, but now I would like to introduce a few that differ from the basic stationary stances.

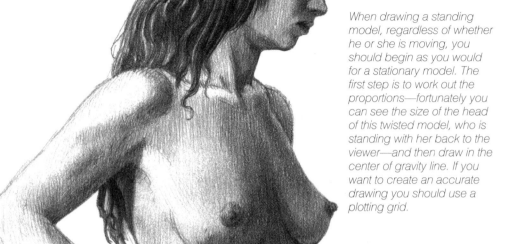

When drawing a standing model, regardless of whether he or she is moving, you should begin as you would for a stationary model. The first step is to work out the proportions—fortunately you can see the size of the head of this twisted model, who is standing with her back to the viewer—and then draw in the center of gravity line. If you want to create an accurate drawing you should use a plotting grid.

When drawing reclining nudes you should also halve the length of the body. You can find the imaginary rectangle formed by the four farthermost points of the body by using the bisecting line. The two halves of the height of the body can be halved

again, so that the vertical lines mark the sections of the body. You can use a plotting grid or what you have learned about measuring in order to find angles and dimensions.

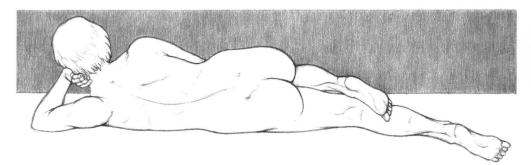

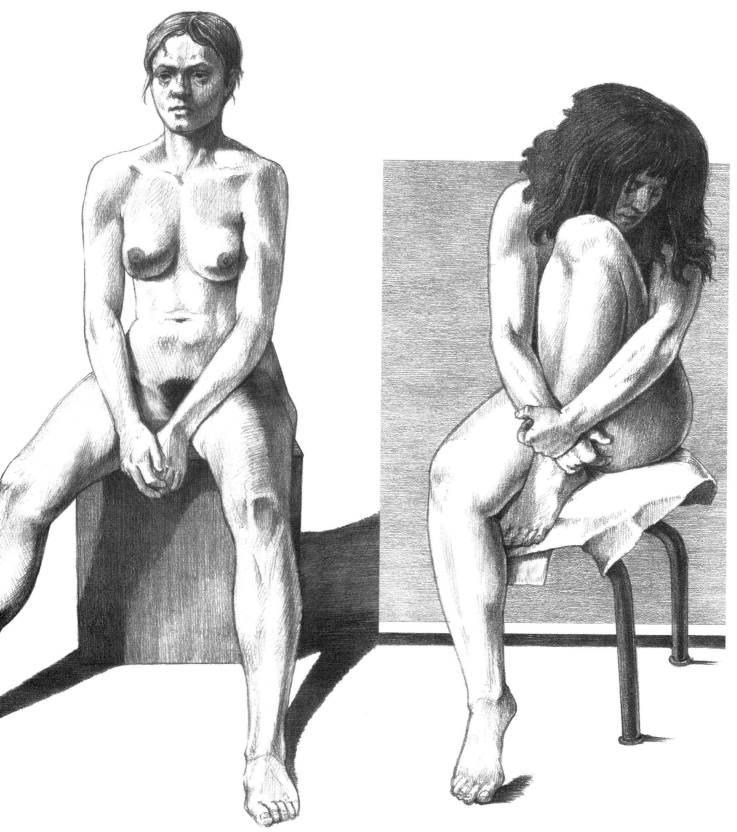

The balance of a sitting figure is quite different. As the body's support is due to its sitting position, you do not need a center of gravity line. This means that the limbs—particularly the legs—have much more room for movement.

The body's movements are less restricted, and this often makes the drawing more interesting. Another advantage of the sitting pose is that the model can often be drawn far larger on a C sheet of paper than a standing figure.

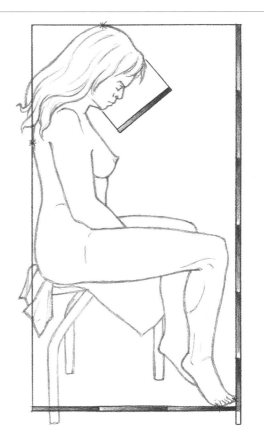

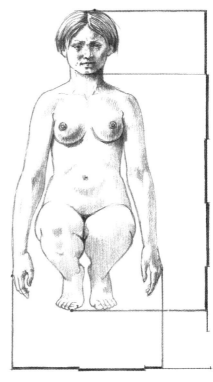

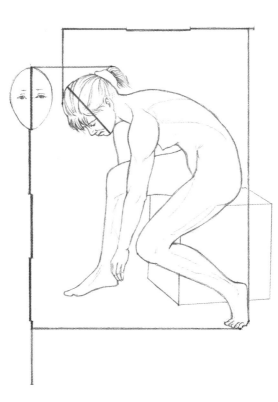

Regardless of whether the figure is sitting or crouching, its height, width, and other dimensions can be compared against the height of the head. This is important because you can use this size to work out the proportions of the figure and the relationships of its various features to one another. Once you have done this you can proceed with the drawing as you would for a standing figure.

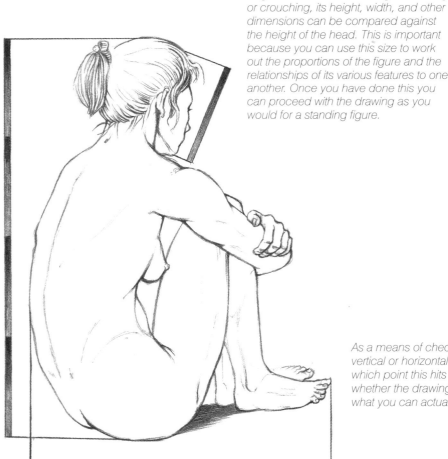

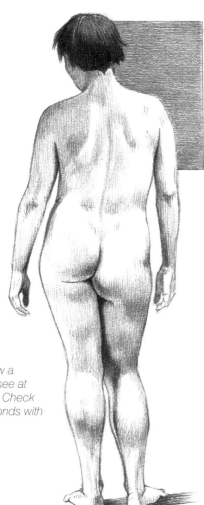

As a means of checking, draw a vertical or horizontal line and see at which point this hits the body. Check whether the drawing corresponds with what you can actually see.

Here I would like to demonstrate how the height of the head can be applied to a sitting model drawn in profile. If you want to create an accurate drawing you will, of course, need to make many more measurements than those shown in the examples.

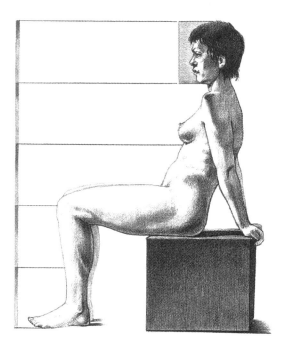

Measure how many times the height of the head fits into the total height of the body.

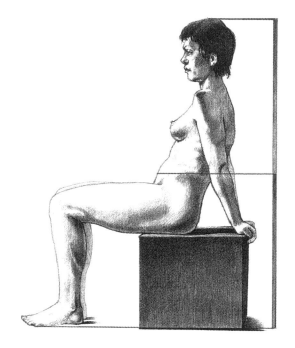

Find the bisecting line for the total height and work out which part of the body it runs through.

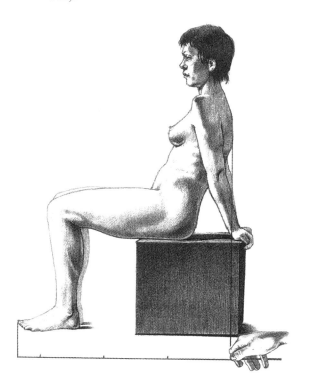

Measure how many times the height of the head fits into the total width—in this example, from the farthest projecting point of the back to the tips of the toes.

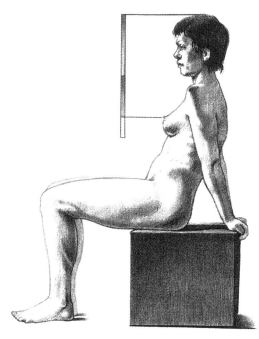

The distance between the individual parts of the body can also be found using the height of the head. You can work out the position of the breasts in terms of head heights from the highest visible point of the head.

In the following drawings I will demonstrate a few more important measurements that can be carried out using a plotting grid or measuring stick. Of course, to produce your drawing you will need to make more measurements than these.

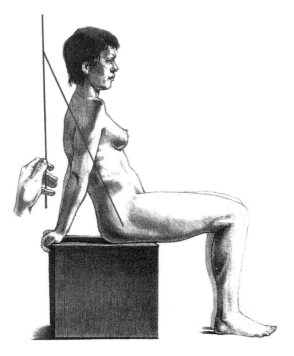

You can find the direction of the back by working out the angle between an imaginary line that follows the model's posture and the vertical.

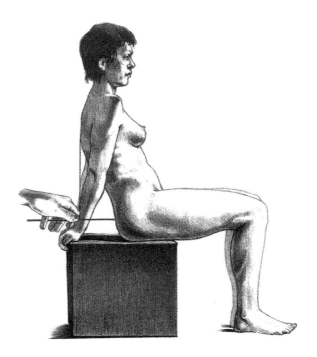

The distance between the farthermost point of the back from the hip is also important.

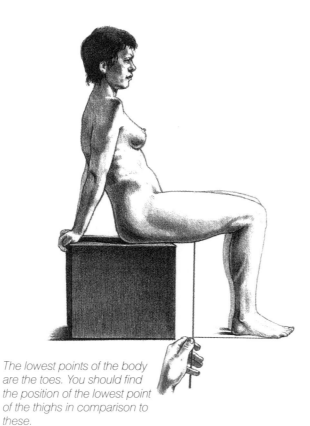

The lowest points of the body are the toes. You should find the position of the lowest point of the thighs in comparison to these.

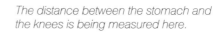

The distance between the stomach and the knees is being measured here.

An ideal method of checking is comparing the negative spaces in the drawing. To do this, connect any two points and compare the size of the negative surface that is made on the drawing with the actual subject.

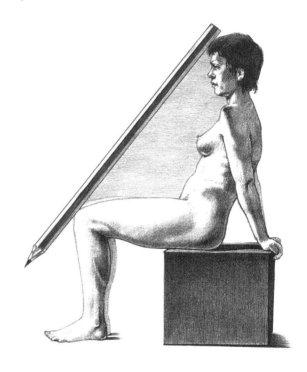

This sketch is drawn with sweeping straight lines that are later made more precise by applying measurements. The shading should also be suggested in the sketch. Common mistakes caused by imprecise measuring include making the thighs longer than they are in real life, and making the upper body too short or too long. If you are unsure about using the measuring stick, you should use the plotting grid as an aid.

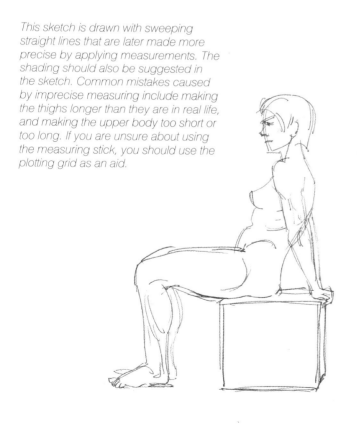

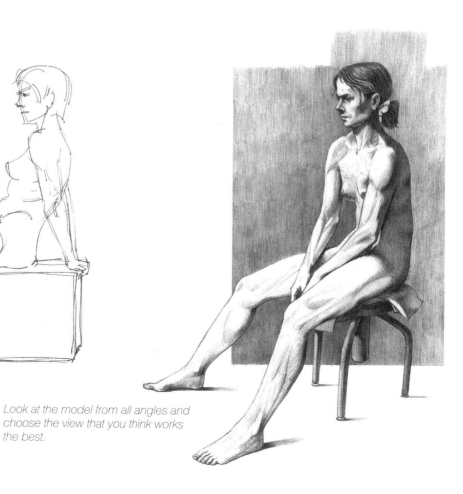

Look at the model from all angles and choose the view that you think works the best.

The figure is positioned on the page according to the rules of composition that you have already learned. If the figure is in profile, it should be shifted from the middle of the page in the opposite direction to the one in which it is looking.

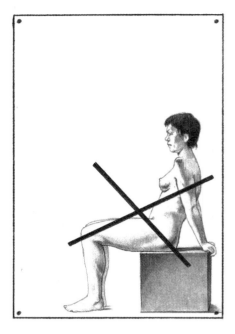

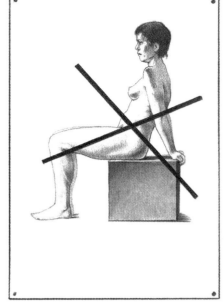

This positioning is incorrect, as the drawing is too far into the corner of the page, and there is not enough space behind it.

In this example, placing the drawing directly in the center of the page, without moving it to the right, is a mistake in terms of composition. In addition, it is too close to the other side of the page, which means that there is too little space under and behind it.

The composition is poor here, as there is a lot of space behind and underneath the figure, but only a little in front of and above it.

If a drawing has a good composition the blank space around it is ideally distributed: most of it should be in front of and above the figure, but with enough underneath and behind it, too.

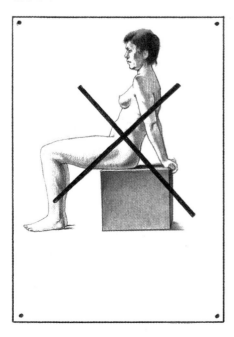

The Clothed Figure

Chapter 22

Drawing clothed figures is like drawing the details of drapery covering a body, plus the body itself. In order to do this you will need to apply everything that you learned in the chapter on drapery.

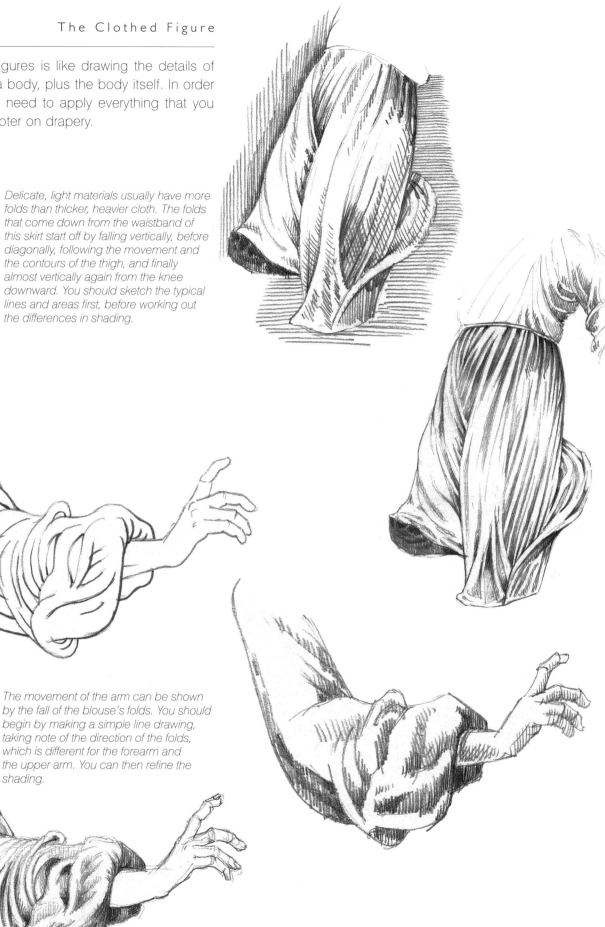

Delicate, light materials usually have more folds than thicker, heavier cloth. The folds that come down from the waistband of this skirt start off by falling vertically, before diagonally, following the movement and the contours of the thigh, and finally almost vertically again from the knee downward. You should sketch the typical lines and areas first, before working out the differences in shading.

The movement of the arm can be shown by the fall of the blouse's folds. You should begin by making a simple line drawing, taking note of the direction of the folds, which is different for the forearm and the upper arm. You can then refine the shading.

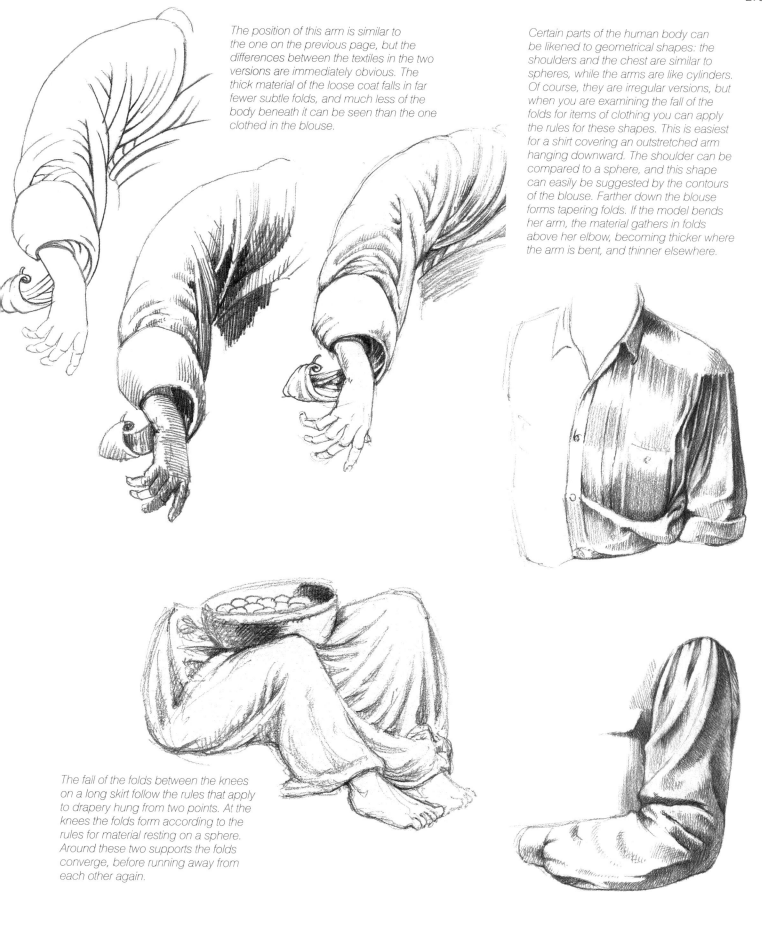

The position of this arm is similar to the one on the previous page, but the differences between the textiles in the two versions are immediately obvious. The thick material of the loose coat falls in far fewer subtle folds, and much less of the body beneath it can be seen than the one clothed in the blouse.

Certain parts of the human body can be likened to geometrical shapes: the shoulders and the chest are similar to spheres, while the arms are like cylinders. Of course, they are irregular versions, but when you are examining the fall of the folds for items of clothing you can apply the rules for these shapes. This is easiest for a shirt covering an outstretched arm hanging downward. The shoulder can be compared to a sphere, and this shape can easily be suggested by the contours of the blouse. Farther down the blouse forms tapering folds. If the model bends her arm, the material gathers in folds above her elbow, becoming thicker where the arm is bent, and thinner elsewhere.

The fall of the folds between the knees on a long skirt follow the rules that apply to drapery hung from two points. At the knees the folds form according to the rules for material resting on a sphere. Around these two supports the folds converge, before running away from each other again.

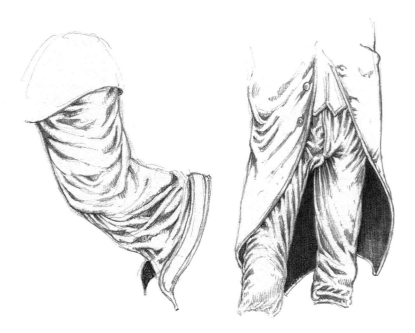

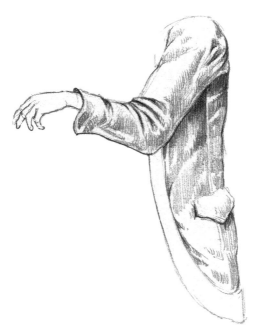

The fall of the folds and the drape of different textiles not only tell us about their material, but also about the movement or motionlessness of the model. The folds amplify the sense of movement.

The folds of the sleeve around the elbow and the slightly diagonal, loose folds running down from the shoulder show that the wearer of the coat is slim. In such cases the drawing should follow the rules for hung drapery.

The wearer's body is almost lost in this unusual shirt. However, the posture, movements, and girth of the wearer can still be made out due to the fall of the folds and the folds that correspond to the rules of hung drapery.

As this shirt with rolled-up sleeves is a little too big for the model, it forms thick folds, which fan out toward the shoulder and elbow.

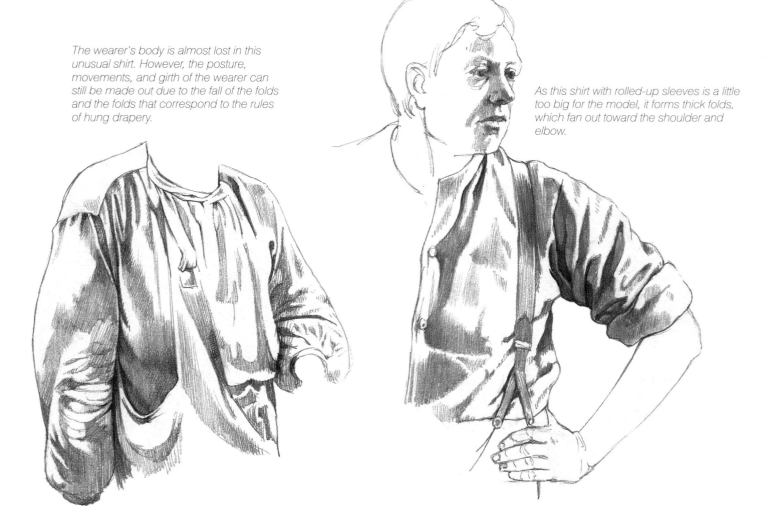

You have to know something about the anatomy of the human body if you are to understand the way that different clothes fall. Under thin materials it is easy to see the structure of the body.

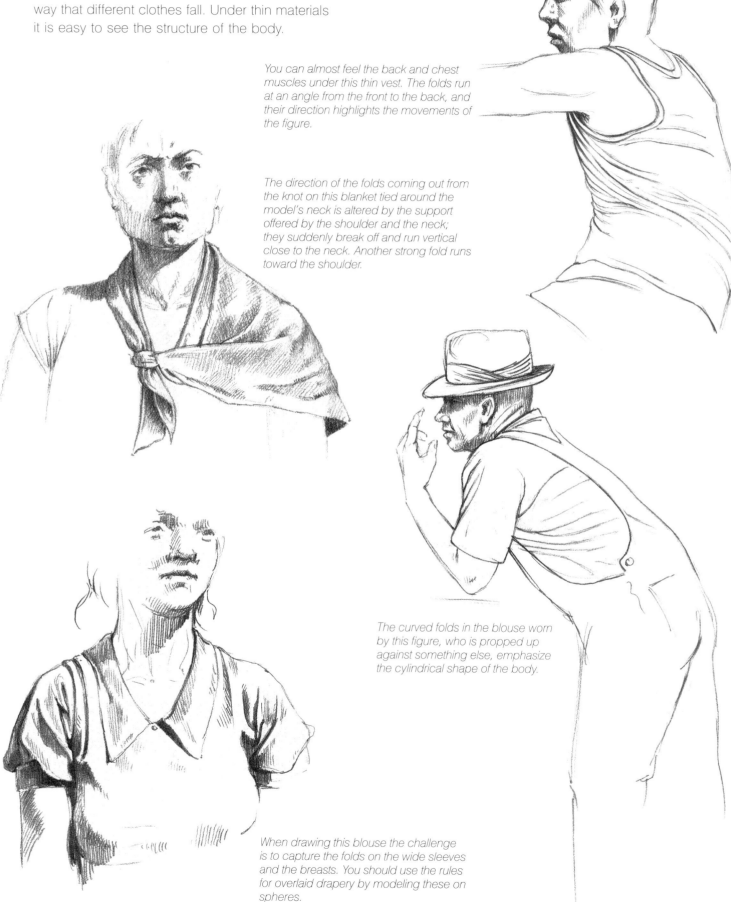

You can almost feel the back and chest muscles under this thin vest. The folds run at an angle from the front to the back, and their direction highlights the movements of the figure.

The direction of the folds coming out from the knot on this blanket tied around the model's neck is altered by the support offered by the shoulder and the neck; they suddenly break off and run vertical close to the neck. Another strong fold runs toward the shoulder.

The curved folds in the blouse worn by this figure, who is propped up against something else, emphasize the cylindrical shape of the body.

When drawing this blouse the challenge is to capture the folds on the wide sleeves and the breasts. You should use the rules for overlaid drapery by modeling these on spheres.

Unlike thin materials, which cling to the body and thus enhance the impression of its shape, drawing the fall of heavier and rougher cloth is more difficult.

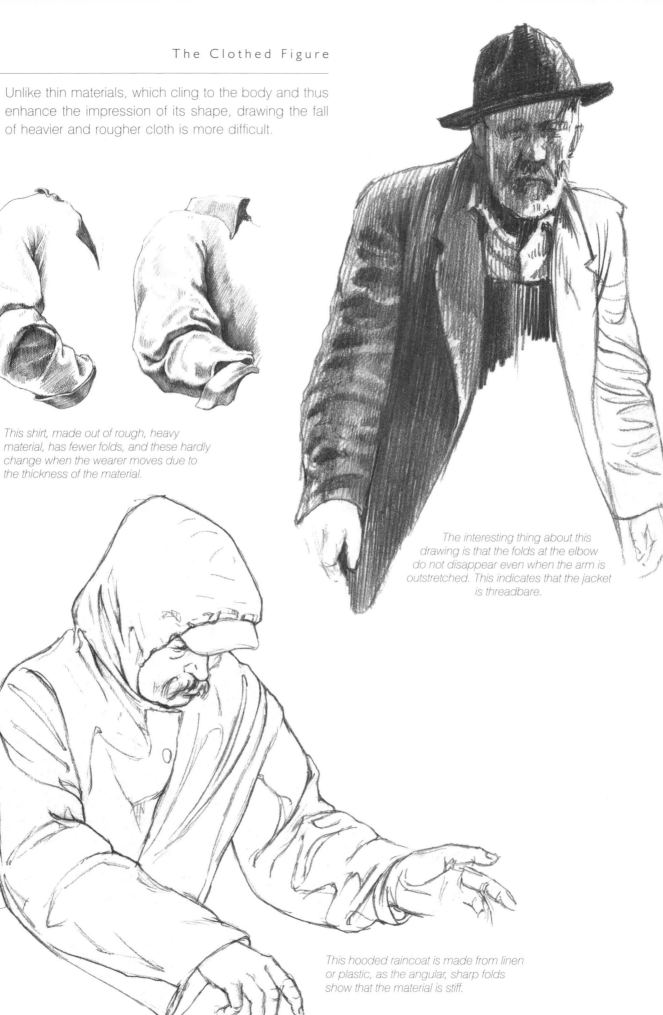

This shirt, made out of rough, heavy material, has fewer folds, and these hardly change when the wearer moves due to the thickness of the material.

The interesting thing about this drawing is that the folds at the elbow do not disappear even when the arm is outstretched. This indicates that the jacket is threadbare.

This hooded raincoat is made from linen or plastic, as the angular, sharp folds show that the material is stiff.

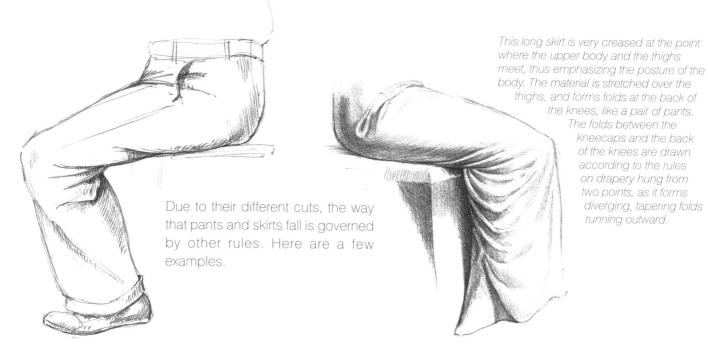

This long skirt is very creased at the point where the upper body and the thighs meet, thus emphasizing the posture of the body. The material is stretched over the thighs, and forms folds at the back of the knees, like a pair of pants. The folds between the kneecaps and the back of the knees are drawn according to the rules on drapery hung from two points, as it forms diverging, tapering folds running outward.

Due to their different cuts, the way that pants and skirts fall is governed by other rules. Here are a few examples.

The delicate material of this narrow dress forms curved folds between the thigh of the bent leg and the thigh of the standing leg. On the outer side of the thighs the folds all but disappear, thus emphasizing their shape.

The pants worn by this seated figure form numerous folds which run from the lap to the knee. The knee is a supporting point from which the material forms tapering folds. The folds almost cut across the back of the knee, and the upper folds end here.

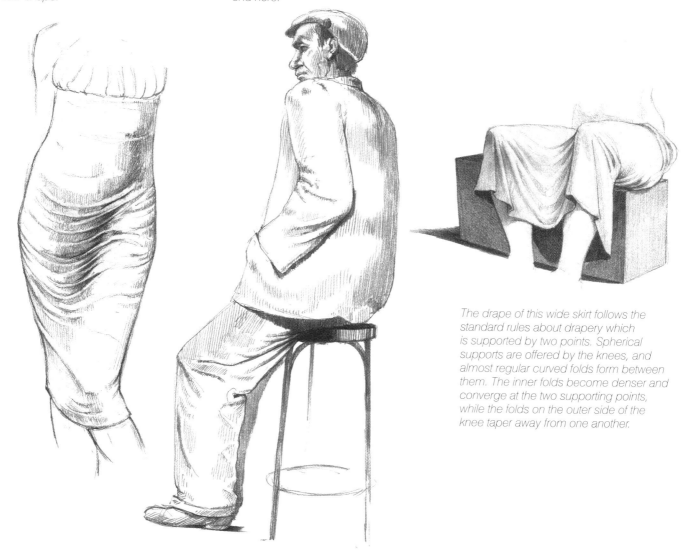

The drape of this wide skirt follows the standard rules about drapery which is supported by two points. Spherical supports are offered by the knees, and almost regular curved folds form between them. The inner folds become denser and converge at the two supporting points, while the folds on the outer side of the knee taper away from one another.

Certain rules have been laid out over the previous pages, but obviously certain poses can create effects that are completely different from the ones that have been described here. In such cases you should try to split what you see into simpler shapes. The following drawings show some examples in which I have given a few tips. However, you will only really build up your skills by trying them out for yourself. Happy practising!

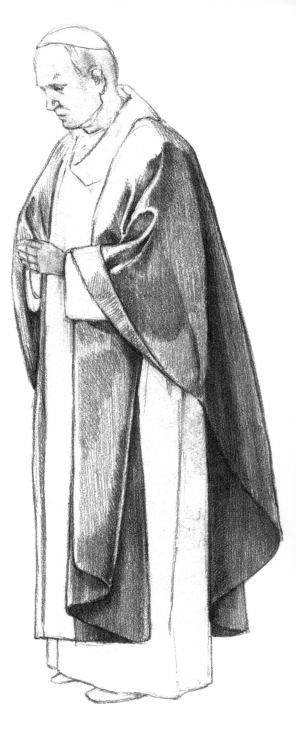

Drawing exotic items of clothing worn by other cultures or the many folds of a gathered robe can be a challenge, as the fall of the folds is determined by the way in which the cloth is twisted or knotted, which is largely a matter of chance.

The turban is a special head covering. If you want to draw it you will have to plan the folds carefully in order to capture the way in which the cloth has been twisted. The long shirt follows rules that have already been explained here—which of them apply in this case?

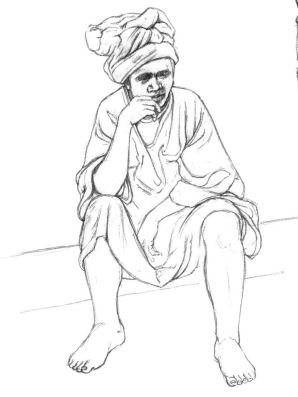

These priestly robes mainly create vertical folds, as they are loose and the material is heavy. Denser folds form around the elbow of the bent arm.

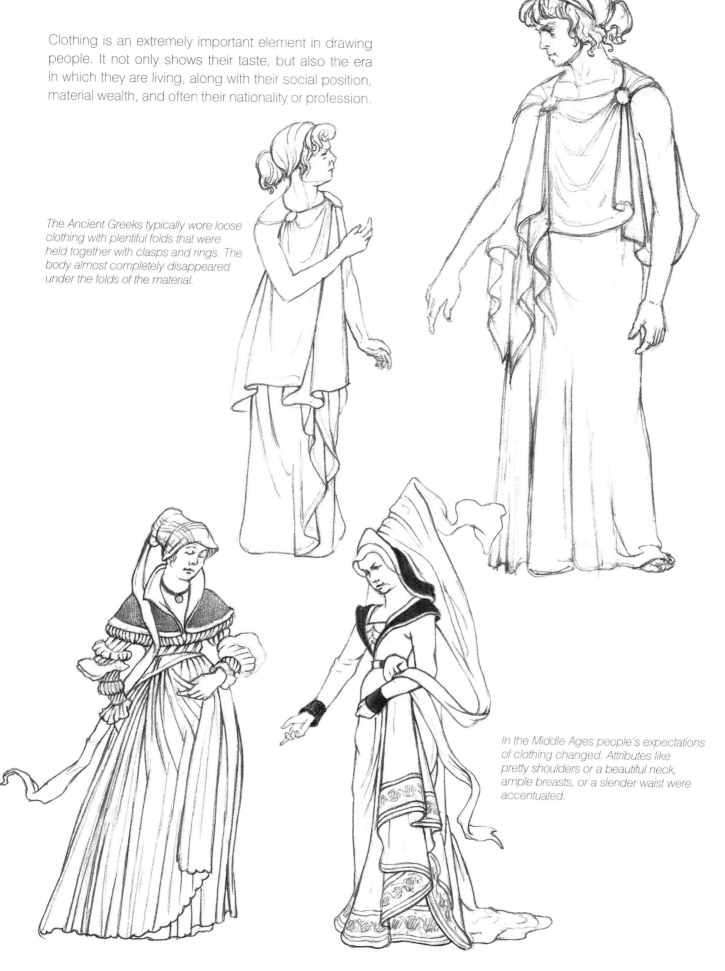

Clothing is an extremely important element in drawing people. It not only shows their taste, but also the era in which they are living, along with their social position, material wealth, and often their nationality or profession.

The Ancient Greeks typically wore loose clothing with plentiful folds that were held together with clasps and rings. The body almost completely disappeared under the folds of the material.

In the Middle Ages people's expectations of clothing changed. Attributes like pretty shoulders or a beautiful neck, ample breasts, or a slender waist were accentuated.

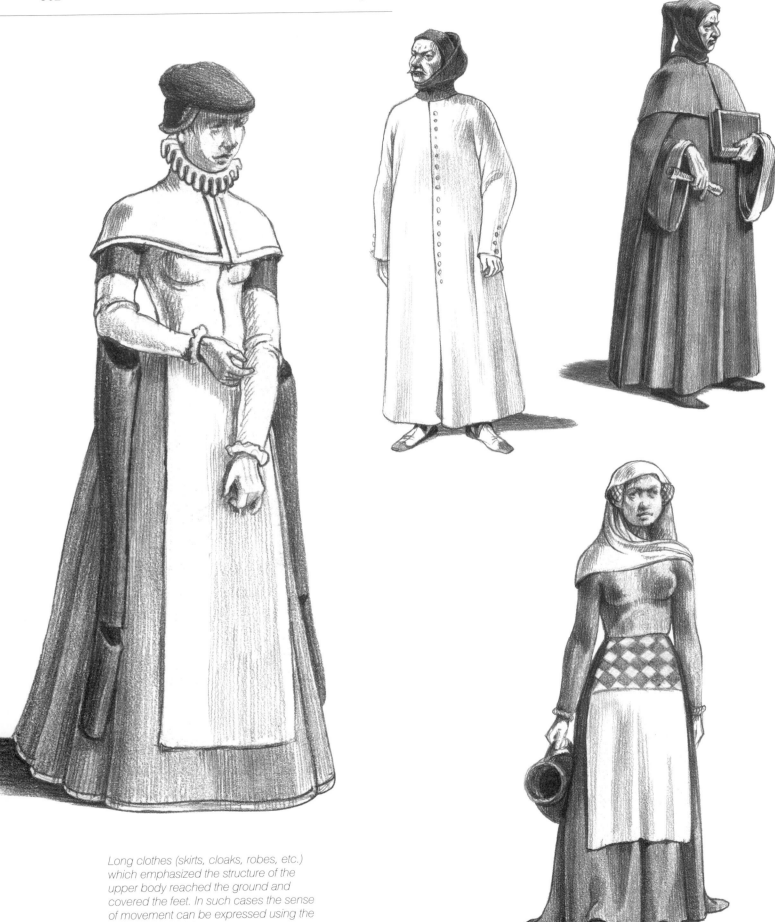

Long clothes (skirts, cloaks, robes, etc.) which emphasized the structure of the upper body reached the ground and covered the feet. In such cases the sense of movement can be expressed using the fall of the material.

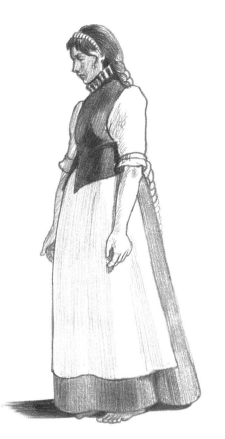

This is a typical example of the way in which clothing and accessories can also tell us about the profession of the wearer.

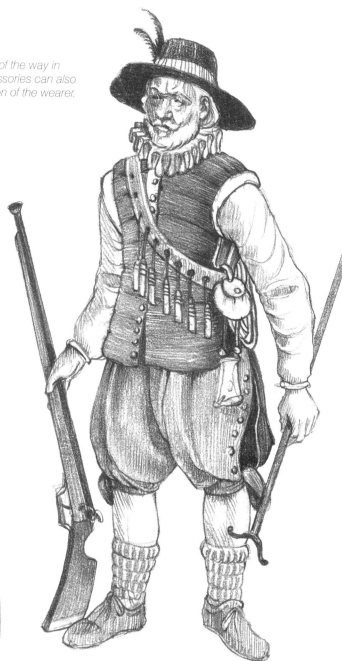

Headdresses can also tell us a lot about the wearer.

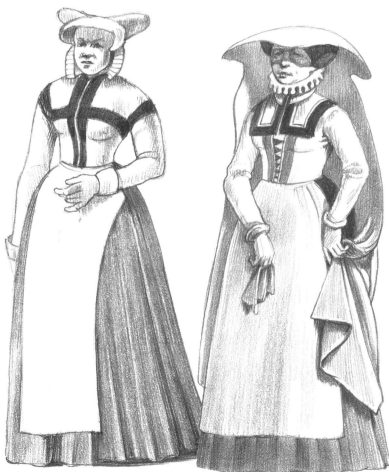

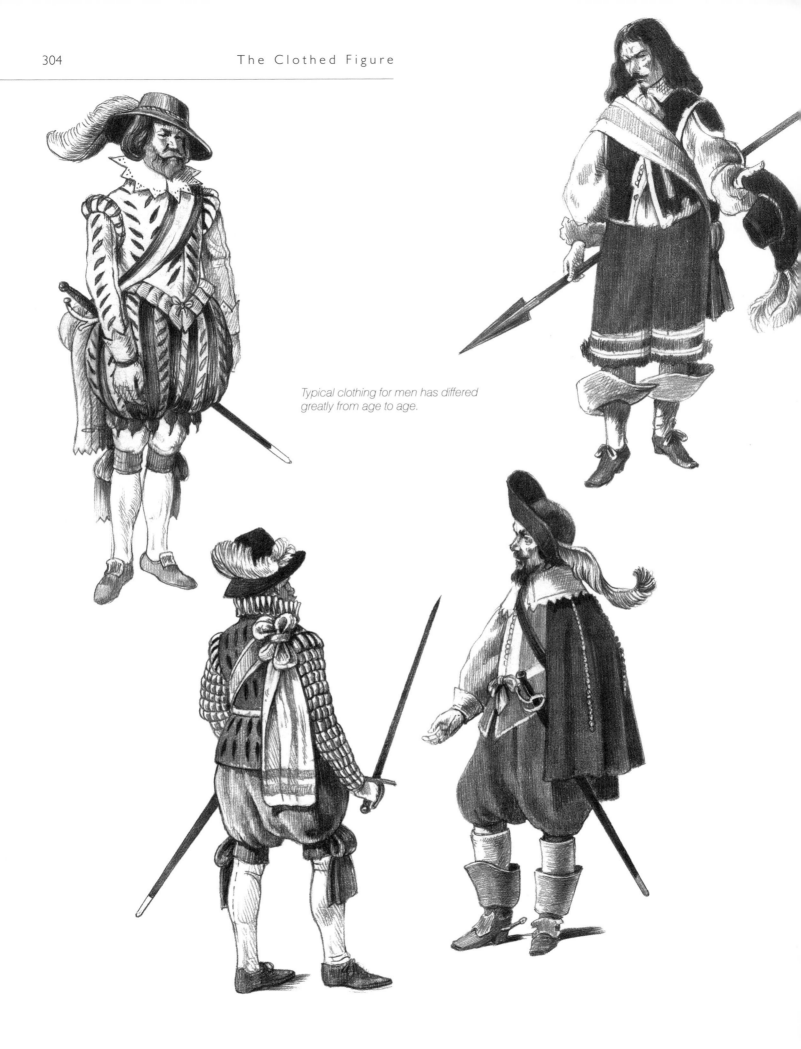

Typical clothing for men has differed greatly from age to age.

Mammals

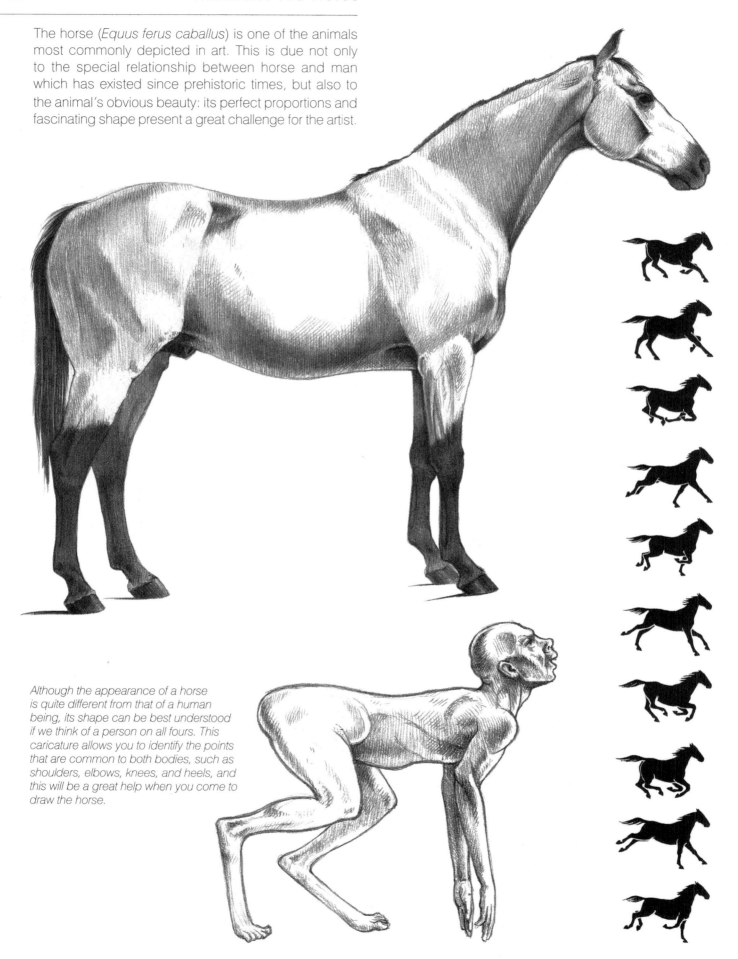

The horse (*Equus ferus caballus*) is one of the animals most commonly depicted in art. This is due not only to the special relationship between horse and man which has existed since prehistoric times, but also to the animal's obvious beauty: its perfect proportions and fascinating shape present a great challenge for the artist.

Although the appearance of a horse is quite different from that of a human being, its shape can be best understood if we think of a person on all fours. This caricature allows you to identify the points that are common to both bodies, such as shoulders, elbows, knees, and heels, and this will be a great help when you come to draw the horse.

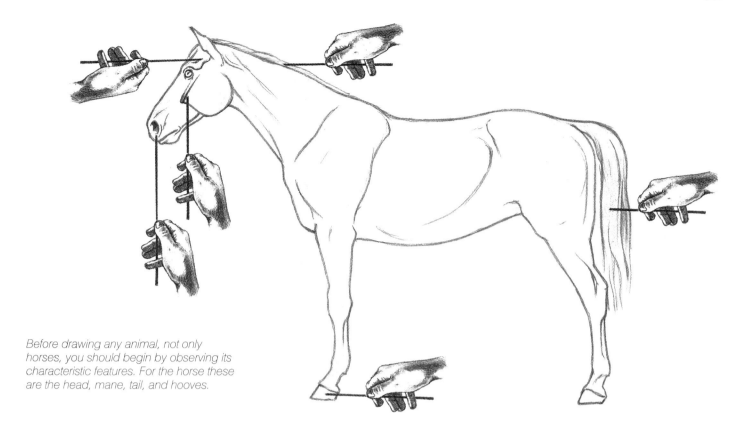

Before drawing any animal, not only horses, you should begin by observing its characteristic features. For the horse these are the head, mane, tail, and hooves.

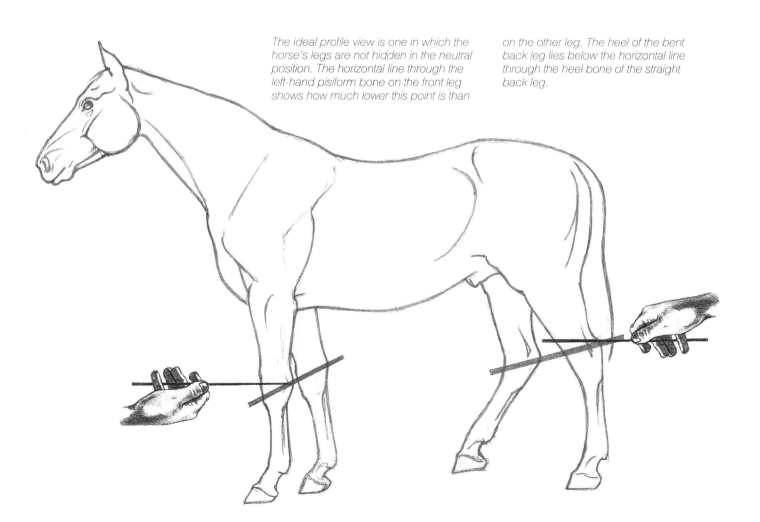

The ideal profile view is one in which the horse's legs are not hidden in the neutral position. The horizontal line through the left-hand pisiform bone on the front leg shows how much lower this point is than on the other leg. The heel of the bent back leg lies below the horizontal line through the heel bone of the straight back leg.

Unfortunately, there is no set system for drawing a horse. Many theories have been put forward, but all of them have proved impractical. The most important thing is to study every detail of the horse's body carefully. I have given some tips to help you with this over the following pages. You will be pleased to learn that there are also a few rules that you can follow.

One important characteristic of the horse is its symmetry. The axis of symmetry runs lengthways through the whole body, from the head to the tail. Of course, if the horse moves you will have to watch out for distortions in terms of perspective, and apply the rules accordingly: if the horse turns its head, it should be smaller on the drawing.

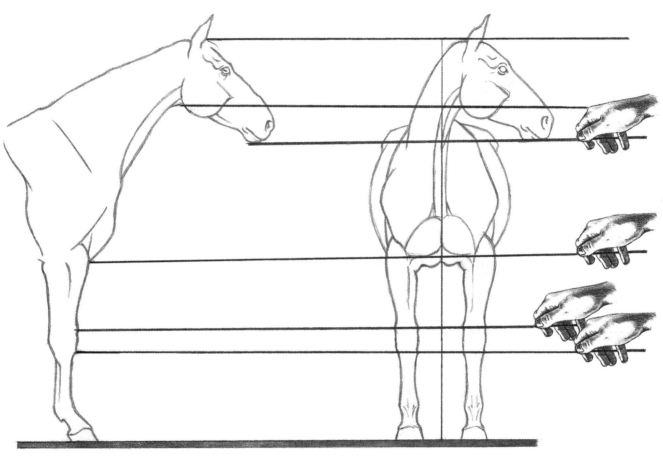

Many theories about the proportions of the horse have been devised, but no one has yet come up with an absolute rule. Those which have a practical use include the square theory proposed by the zoologist Settegast, according to which the body of a horse—minus its neck and head—fits into a square.

The flaw in this theory is that there are many different types of horse, and each has different characteristic features, so that their bodies do not always fit into the square.

In order to draw the head, whether in profile or head-on, the first step is to mark out its rhombus-shaped outline.

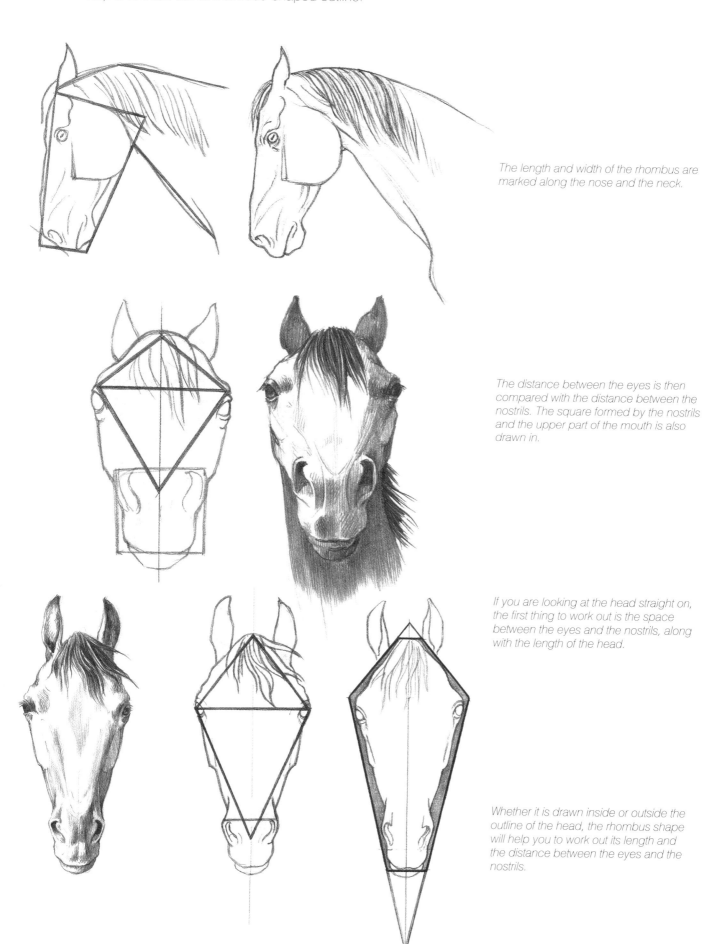

The length and width of the rhombus are marked along the nose and the neck.

The distance between the eyes is then compared with the distance between the nostrils. The square formed by the nostrils and the upper part of the mouth is also drawn in.

If you are looking at the head straight on, the first thing to work out is the space between the eyes and the nostrils, along with the length of the head.

Whether it is drawn inside or outside the outline of the head, the rhombus shape will help you to work out its length and the distance between the eyes and the nostrils.

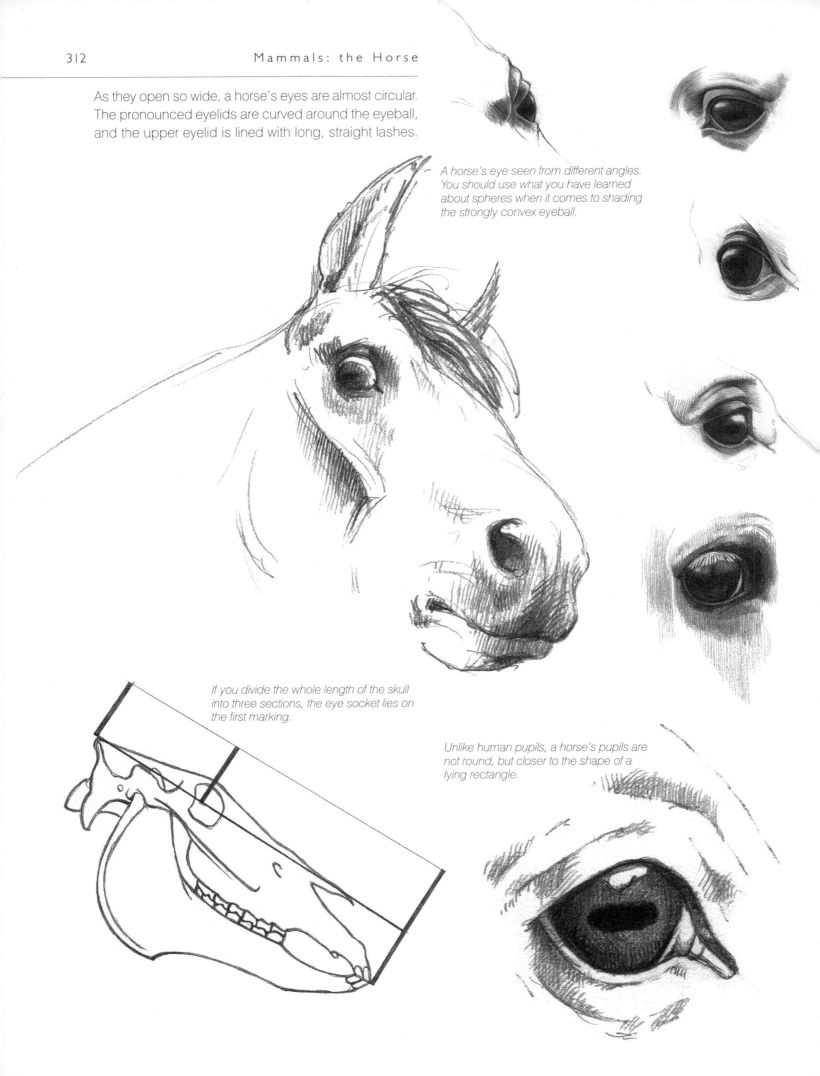

As they open so wide, a horse's eyes are almost circular. The pronounced eyelids are curved around the eyeball, and the upper eyelid is lined with long, straight lashes.

A horse's eye seen from different angles. You should use what you have learned about spheres when it comes to shading the strongly convex eyeball.

If you divide the whole length of the skull into three sections, the eye socket lies on the first marking.

Unlike human pupils, a horse's pupils are not round, but closer to the shape of a lying rectangle.

One distinctive detail of the horse's head is the ridge of its cheekbone, or zygomatic arch. This prominent, elongated, three-cornered formation of bones is clearly drawn as an extension of the cheekbone on the skull. The semicircular outer masticatory muscle appears on this ridge, giving the horse head a lifelike appearance.

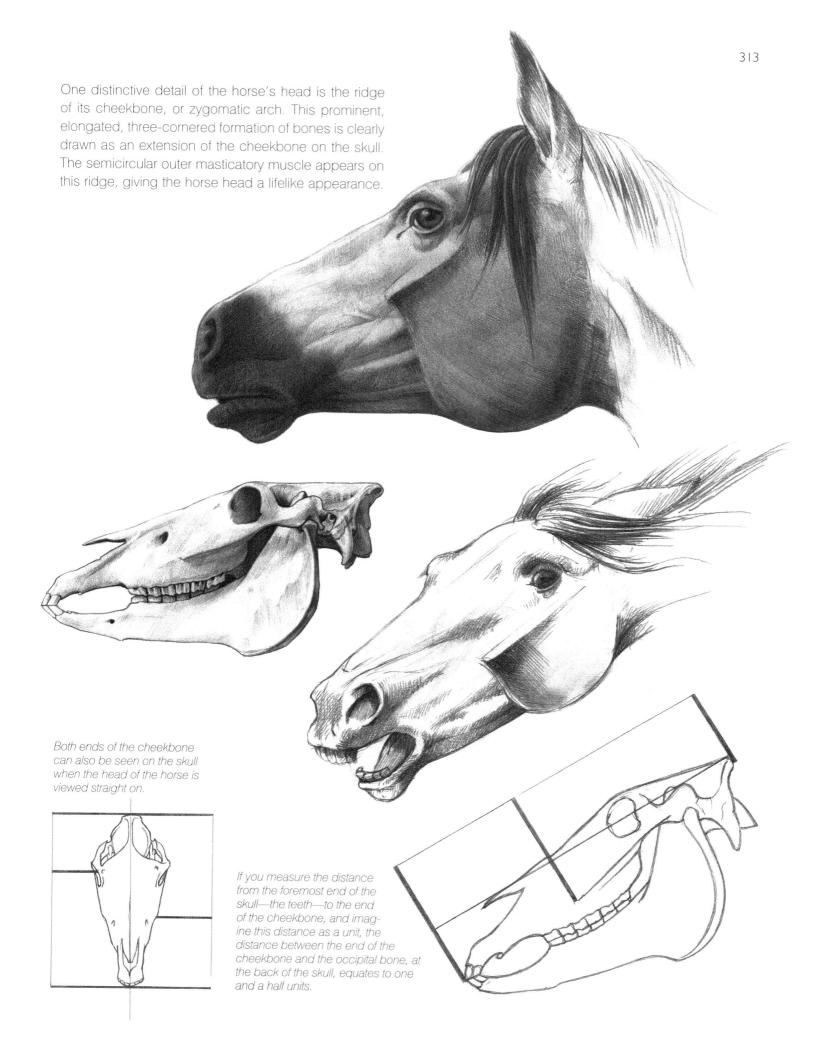

Both ends of the cheekbone can also be seen on the skull when the head of the horse is viewed straight on.

If you measure the distance from the foremost end of the skull—the teeth—to the end of the cheekbone, and imagine this distance as a unit, the distance between the end of the cheekbone and the occipital bone, at the back of the skull, equates to one and a half units.

When drawing the nostrils and the mouth, you will find that it helps to refer back to the rhombus shapes covered on p.105. The muscles of this part of the nose allow the expression of feelings and mean that you can produce a more lifelike drawing. Ideally, you should make as many preliminary sketches as possible, identifying and checking the proportions with a plotting grid or measuring stick.

Imagining a human profile rotated so that it is horizontal will help you to work out the relationship between the opening of the mouth and the nostrils.

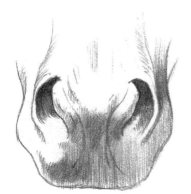

From the front, you can see two facing, roughly crescent-shaped openings. The outer curve arches slightly over the inner curve.

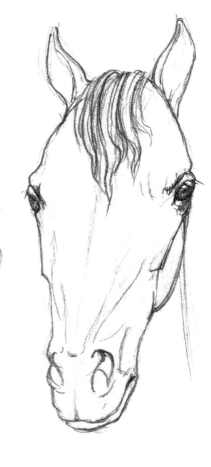

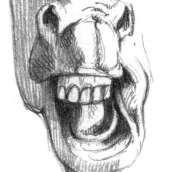

The nostrils may be flared or narrowed; both express the mood of the horse.

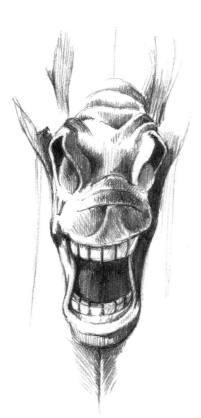

One of the muscles, the levator for the upper lip, can also pull the upper lip back. This makes the horse look as though it is laughing.

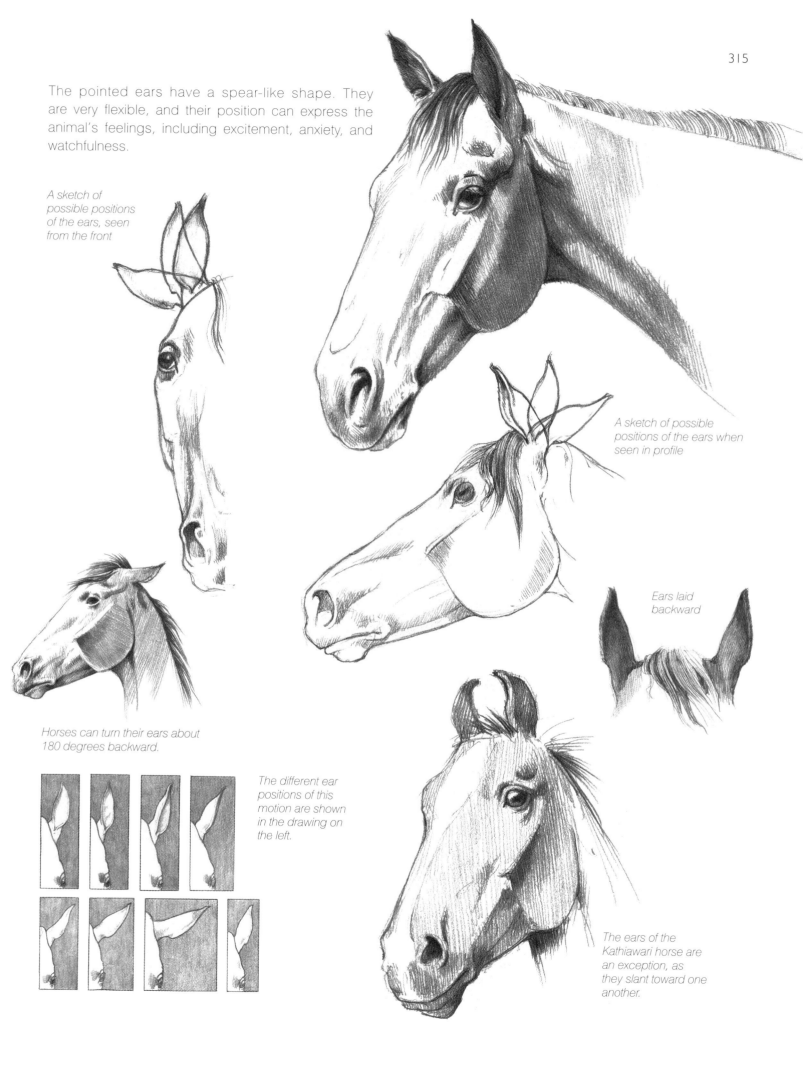

The pointed ears have a spear-like shape. They are very flexible, and their position can express the animal's feelings, including excitement, anxiety, and watchfulness.

A sketch of possible positions of the ears, seen from the front

A sketch of possible positions of the ears when seen in profile

Ears laid backward

Horses can turn their ears about 180 degrees backward.

The different ear positions of this motion are shown in the drawing on the left.

The ears of the Kathiawari horse are an exception, as they slant toward one another.

Horses have a distinctive mass of hair, their mane, along
the top of their neck. This hair follows the shape of the
neck and becomes longer as it moves down toward
the body. If the mane is drawn well, it will bring a sense
of life to the drawing by capturing either movement or
motionlessness and calm.

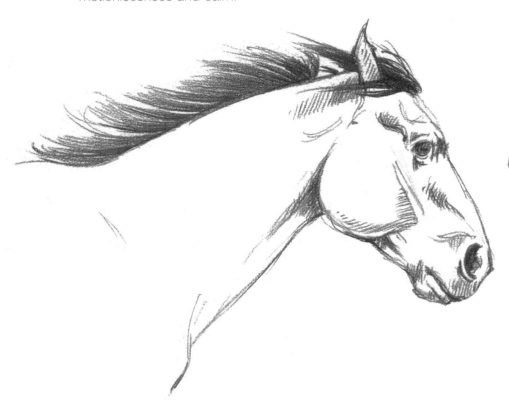

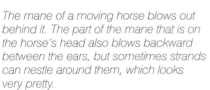

*The mane of a moving horse blows out
behind it. The part of the mane that is on
the horse's head also blows backward
between the ears, but sometimes strands
can nestle around them, which looks
very pretty.*

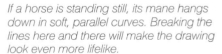

*If a horse is standing still, its mane hangs
down in soft, parallel curves. Breaking the
lines here and there will make the drawing
look even more lifelike.*

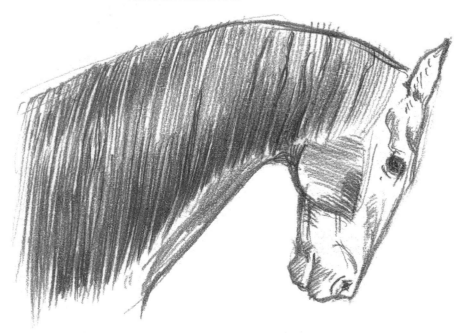

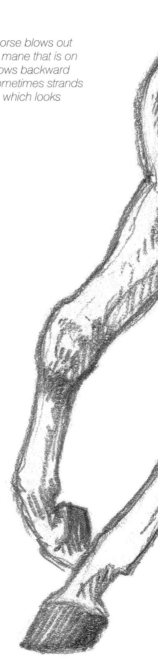

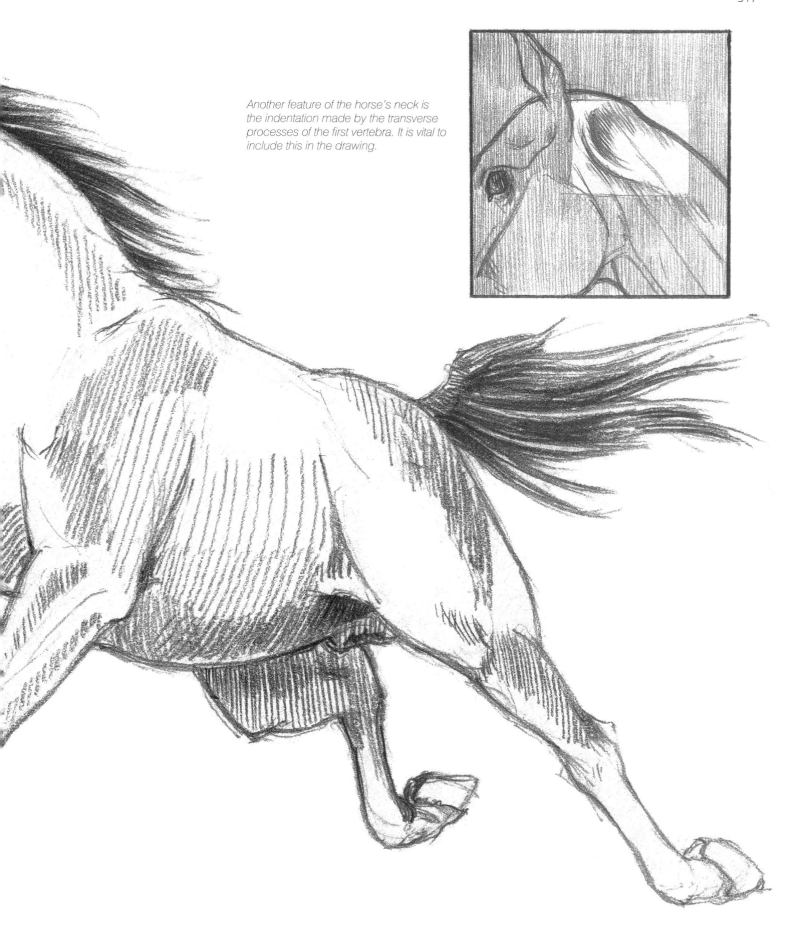

Another feature of the horse's neck is the indentation made by the transverse processes of the first vertebra. It is vital to include this in the drawing.

Making precise measurements with a plotting grid or measuring stick is vital when you come to draw the front legs.

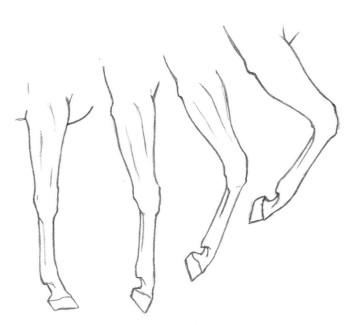

You can study the movement of the front legs on the drawing above. In the starting position the leg is vertical, with the fetlock forming a 45-degree angle with the hoof. If the horse lifts its foot from the ground, it flexes it to the height of the fetlock, and the hoof obviously follows this movement. When drawing this you should again check the different angles using a plotting grid.

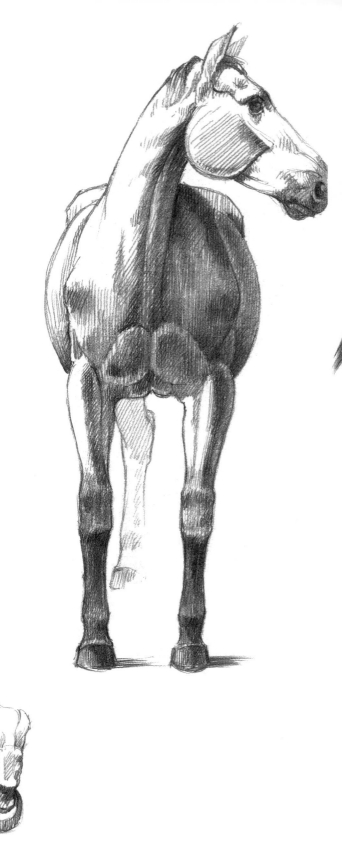

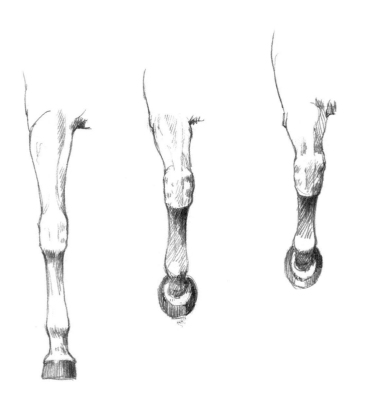

The movement of the front leg, as seen straight on. How high the horse lifts its leg depends on what kind of movement it is making: walking and galloping are markedly different from one another. However, in both cases the metatarsus becomes shorter, according to the rules of perspective. Since the fetlock is also bent, the outline of the hoof appears as an elliptical curve. The more the leg is bent, the shorter this metatarsus appears. When the leg is bent to its farthest extent, almost all that can be seen of it is the knee, fetlock, and hoof.

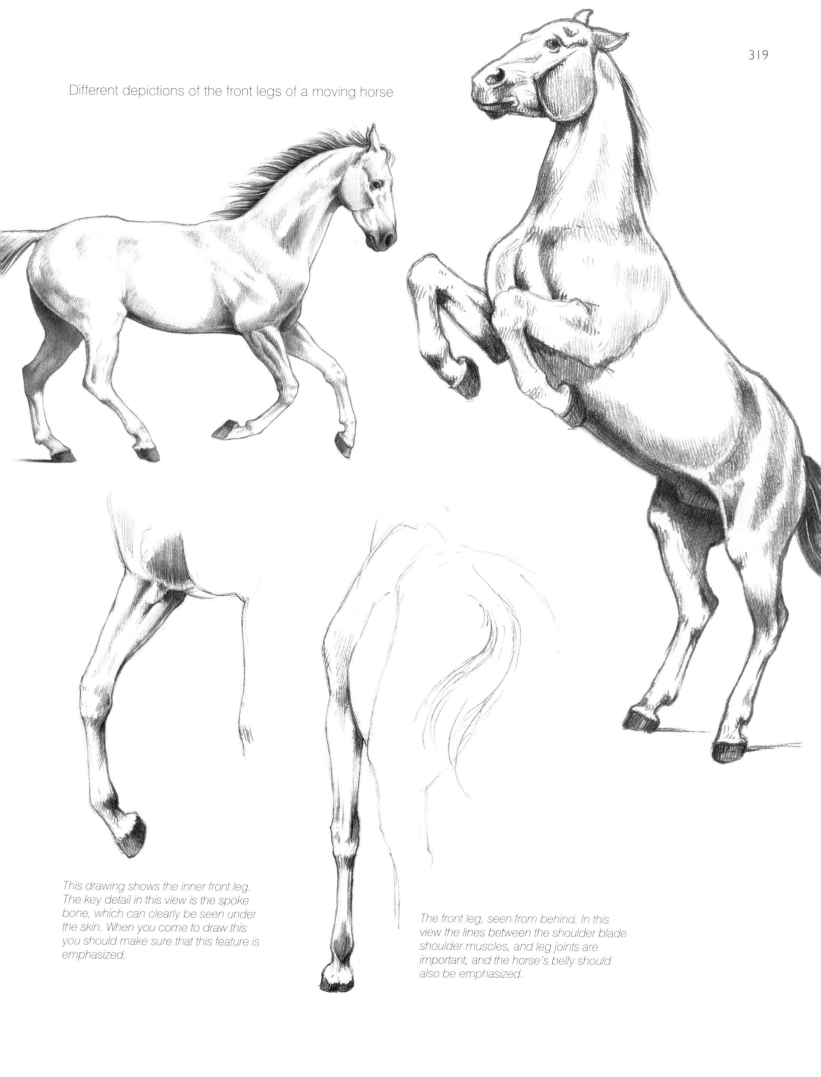

Different depictions of the front legs of a moving horse

This drawing shows the inner front leg. The key detail in this view is the spoke bone, which can clearly be seen under the skin. When you come to draw this you should make sure that this feature is emphasized.

The front leg, seen from behind. In this view the lines between the shoulder blade shoulder muscles, and leg joints are important, and the horse's belly should also be emphasized.

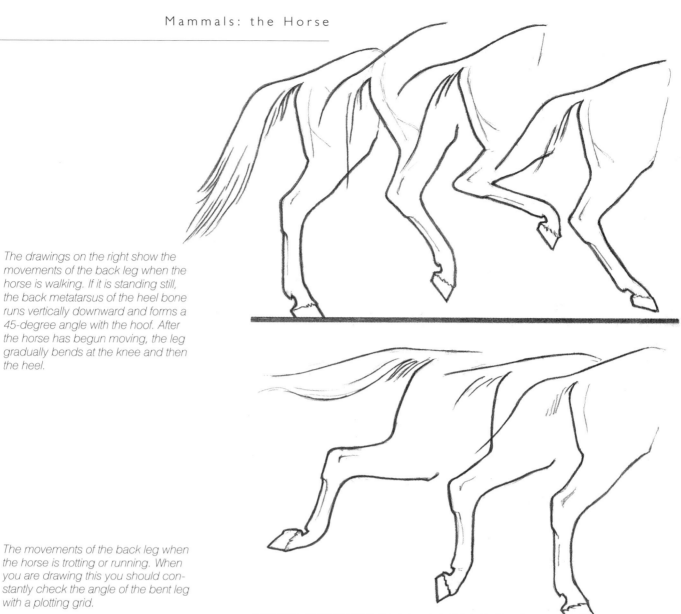

The drawings on the right show the movements of the back leg when the horse is walking. If it is standing still, the back metatarsus of the heel bone runs vertically downward and forms a 45-degree angle with the hoof. After the horse has begun moving, the leg gradually bends at the knee and then the heel.

The movements of the back leg when the horse is trotting or running. When you are drawing this you should constantly check the angle of the bent leg with a plotting grid.

When drawing the leg you should pay attention to the marked indentation below the Achilles tendon, as well as the line that runs almost parallel to the outline of the upper leg at the spot where the biceps femoris muscle and the semitendinosus muscle meet. The latter is important in giving the tail of the horse a three-dimensional appearance.

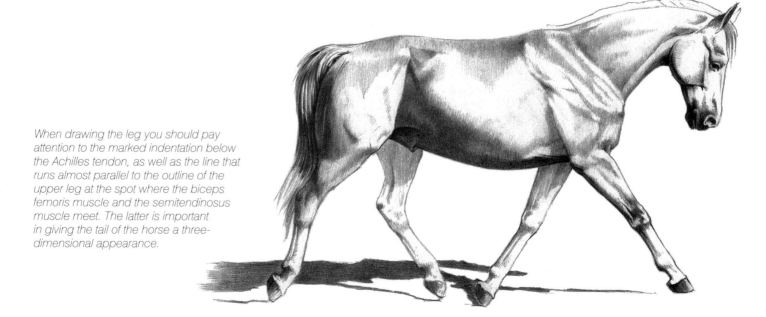

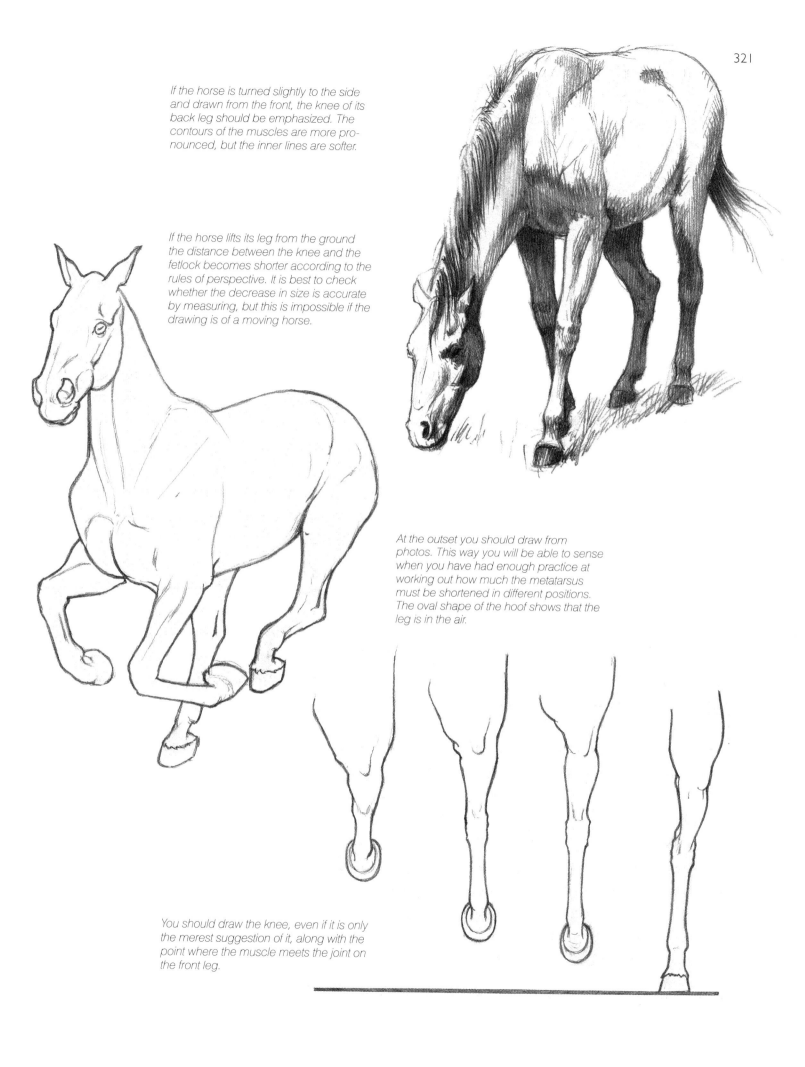

If the horse is turned slightly to the side and drawn from the front, the knee of its back leg should be emphasized. The contours of the muscles are more pronounced, but the inner lines are softer.

If the horse lifts its leg from the ground the distance between the knee and the fetlock becomes shorter according to the rules of perspective. It is best to check whether the decrease in size is accurate by measuring, but this is impossible if the drawing is of a moving horse.

At the outset you should draw from photos. This way you will be able to sense when you have had enough practice at working out how much the metatarsus must be shortened in different positions. The oval shape of the hoof shows that the leg is in the air.

You should draw the knee, even if it is only the merest suggestion of it, along with the point where the muscle meets the joint on the front leg.

You can capture the movements of the back legs by shortening them. When drawing the legs from behind, the important features are the heel bone and the gemellus muscle attached to this on the lower leg, along with the prominent Achilles tendon and the indentation that appears beneath it. Note that the gemellus muscle increases in size when the leg is lifted, becoming wider than it is when the leg is idle.

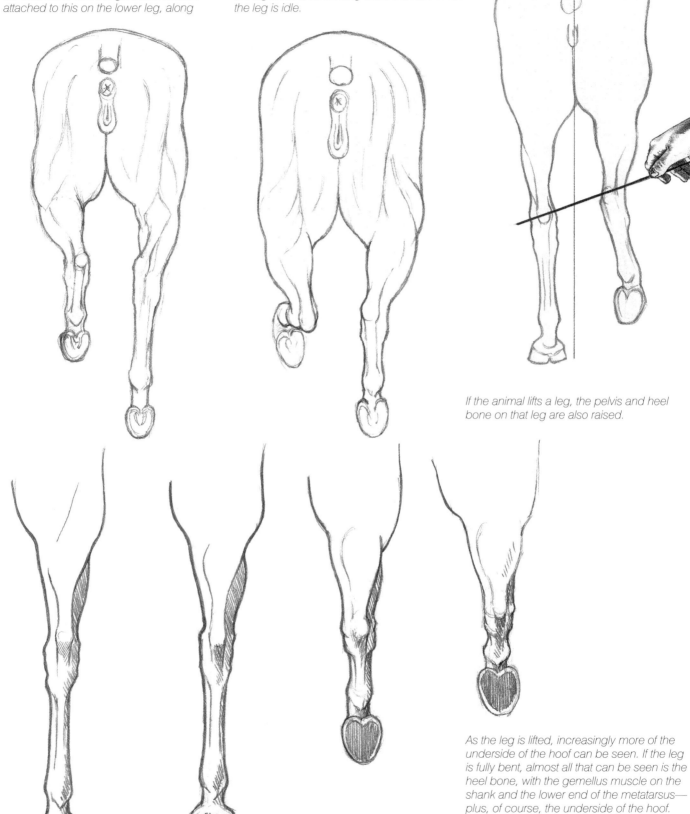

If the animal lifts a leg, the pelvis and heel bone on that leg are also raised.

As the leg is lifted, increasingly more of the underside of the hoof can be seen. If the leg is fully bent, almost all that can be seen is the heel bone, with the gemellus muscle on the shank and the lower end of the metatarsus—plus, of course, the underside of the hoof.

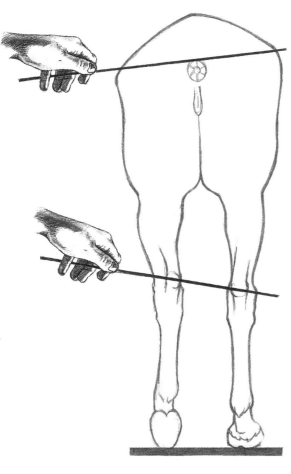

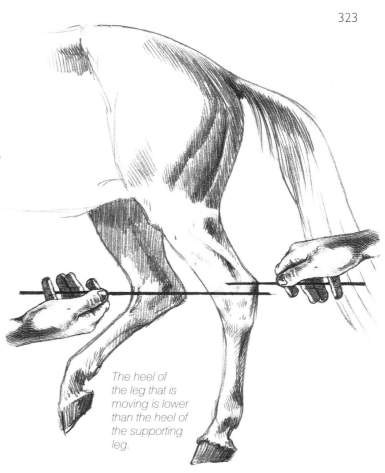

A common poise: the horse is bending a leg so that it is supported only by the edge of the hoof. When it does this the heel bone of the bent leg is higher, while the pelvis slips downward.

The heel of the leg that is moving is lower than the heel of the supporting leg.

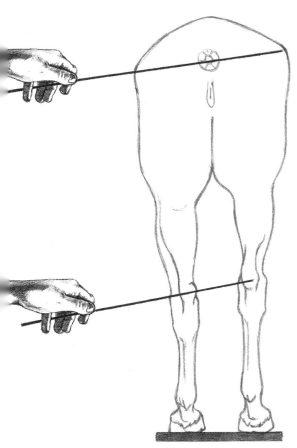

When the horse is walking, the heel bone of the leg that is put forward sinks with the pelvis.

The fetlocks always form a 45-degree angle with the vertical part of the leg.

The leg bends as it moves.

You can capture the movement or motionlessness of a horse very effectively with the position of the tail. When the horse is standing still, the hairs of its tail hang downward, undulating slightly. They reach to about halfway down the metatarsus, but may be longer or shorter than this. The tail is formed of shorter hairs above longer ones.

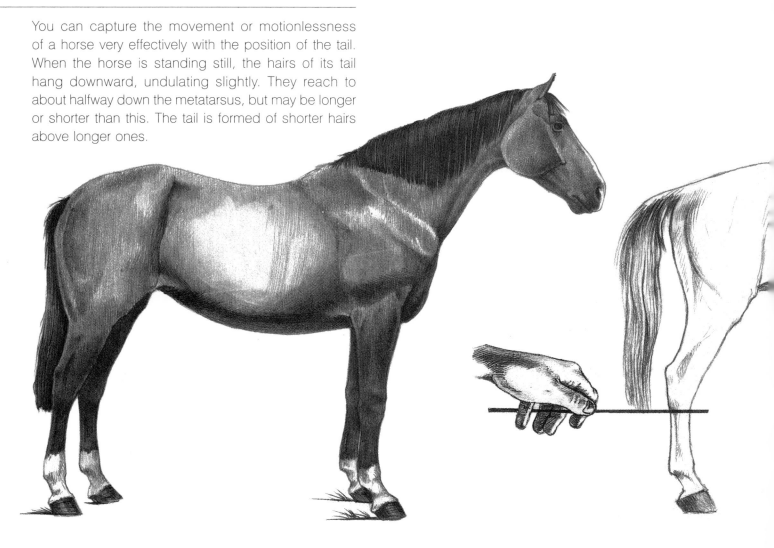

You should plan the ripples of the tail hair before you begin to draw it. The following drawings show a few mistakes, plus one good depiction. Drawing lots of even, parallel lines will not work here.

One common mistake is to draw the tail using lines that run in the same direction, at a 45-degree angle. This may be fine when you are sketching the horse, but it is not correct when you are trying to capture the nuances of the shading. You can produce a lifelike drawing by depicting the fine ripples of the hair with lines that curve in toward the body.

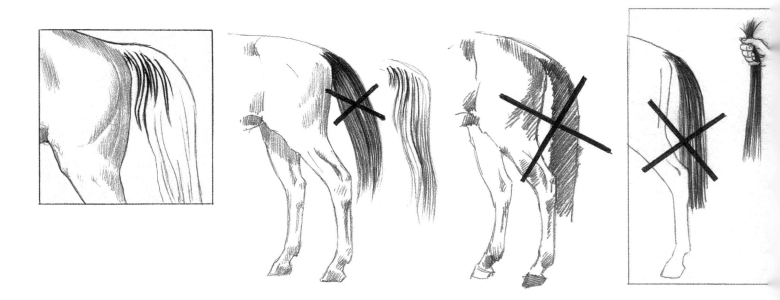

If the horse's tail is raised, the ripples in the hair become more pronounced toward the bottom of the tail, as it curves in toward the body. It is easy to work out the position of the lower end of the tail by holding a pencil or measuring stick horizontally against it.

The raised tail has a rhombus-shaped outline.

The picture is incorrect if the lines are not drawn with the same pressure, and if the tail is drawn only with parallel slanting lines, so that the shading is made up of lines running in the same direction, or if the tail appears as a surface consisting of simple wavy lines running parallel to one another.

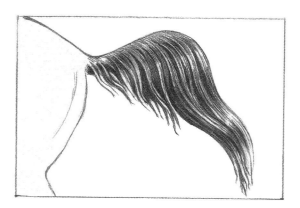

If the tail hair is light, the background must be made darker.

The muscular and well-proportioned body of the lion (*Panthera leo*) is the epitome of strength and majesty. Its muscles are well developed and can be clearly seen beneath its skin. Its relatively short legs are muscular, and its claws large. Its haunches are comparatively narrow. Its tail is long and ends in a tassel.

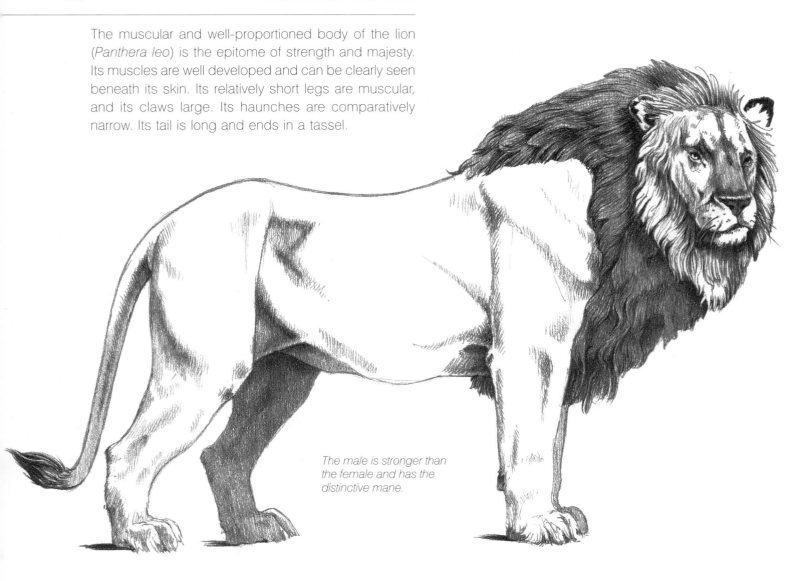

The male is stronger than the female and has the distinctive mane.

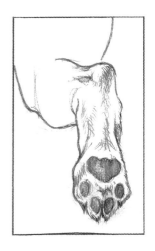

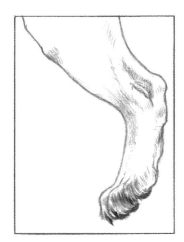

The mane presents a great challenge for the artist. First and foremost, this superb mass of hair is a separate entity and has a very specific sense of three-dimensionality, which can be captured using different areas of shading. The patterns and waves of the hair can then be planned and drawn. Individual strands are drawn using parallel lines, while tufts of hair alongside them should be drawn using lines running in a slightly different direction.

The back paw has a heart-shaped pad on the ball of the foot, while the toe pads are oval.

There is a marked indentation below the Achilles tendon, while the upper end of the heel bone is rounded.

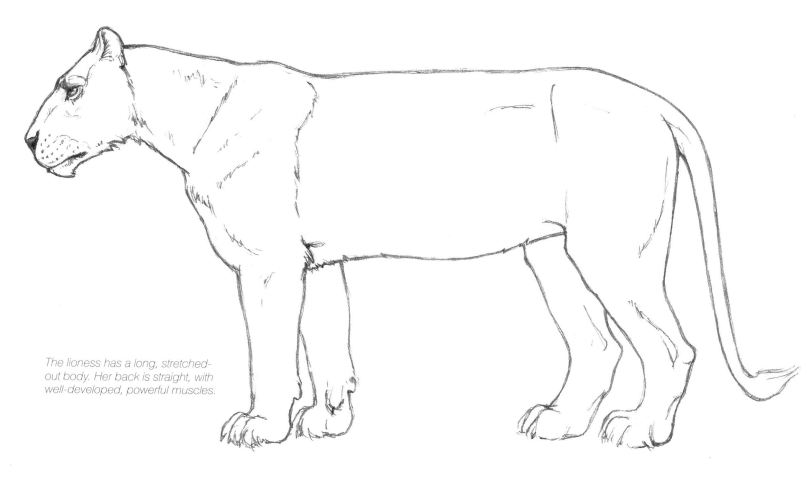

The lioness has a long, stretched-out body. Her back is straight, with well-developed, powerful muscles.

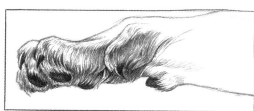

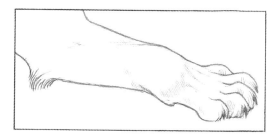

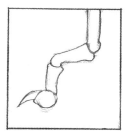

The lion is a digitigrade (an animal that stands or walks on its toes). Its legs are very strong, and it also uses its front legs to strike its prey. The five toes on each of its front and back legs are fully defined.

When drawing the feet it is not enough simply to hint at the paws by sketching a semicircular shape, as there are bones and sinews under the skin and hair. You must capture both the outline and the three-dimensional nature of the toes precisely.

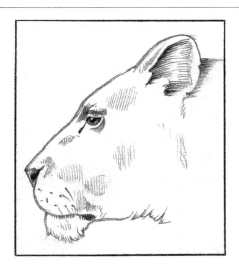

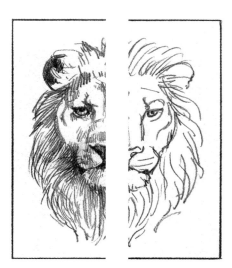

The ears are round and covered with longer and thicker hair on top.

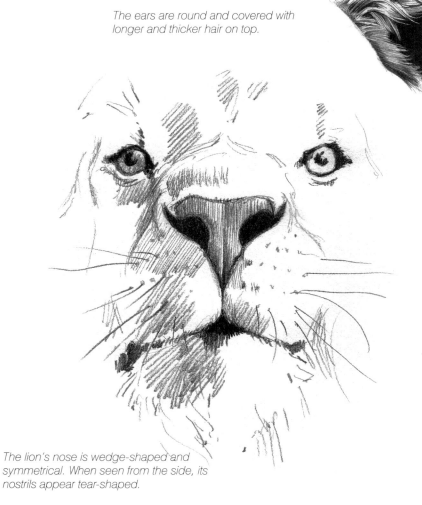

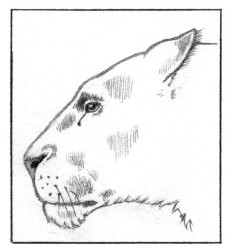

The lion's nose is wedge-shaped and symmetrical. When seen from the side, its nostrils appear tear-shaped.

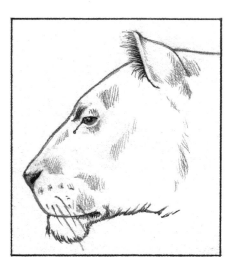

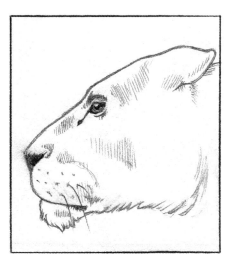

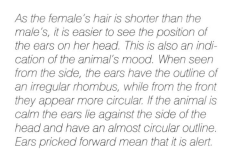

As the female's hair is shorter than the male's, it is easier to see the position of the ears on her head. This is also an indication of the animal's mood. When seen from the side, the ears have the outline of an irregular rhombus, while from the front they appear more circular. If the animal is calm the ears lie against the side of the head and have an almost circular outline. Ears pricked forward mean that it is alert.

Hunting lions that are nearing their prey press their ears backward, so that their outline resembles a triangle.

The mane is the distinguishing feature of male lions. When you are drawing this it is vital to show the outer contours of the ears and the hair.

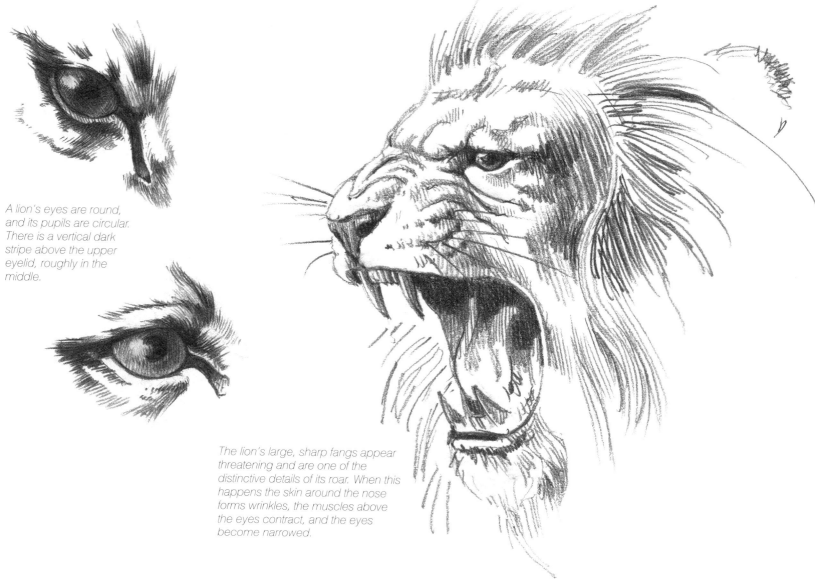

A lion's eyes are round, and its pupils are circular. There is a vertical dark stripe above the upper eyelid, roughly in the middle.

The lion's large, sharp fangs appear threatening and are one of the distinctive details of its roar. When this happens the skin around the nose forms wrinkles, the muscles above the eyes contract, and the eyes become narrowed.

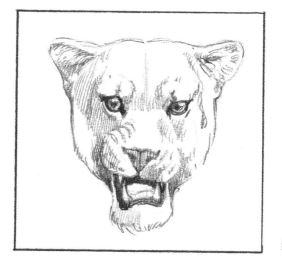

The mouth of an irritable lion

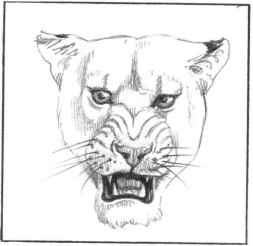

The mouth of an aggressive lion

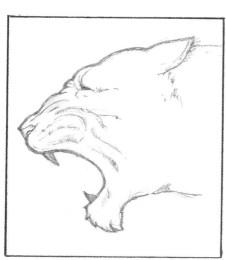

A roaring lion in profile. The ears are laid backward against the head, the nose is puckered, and the eyes are narrowed. The small beard makes the head even more distinctive.

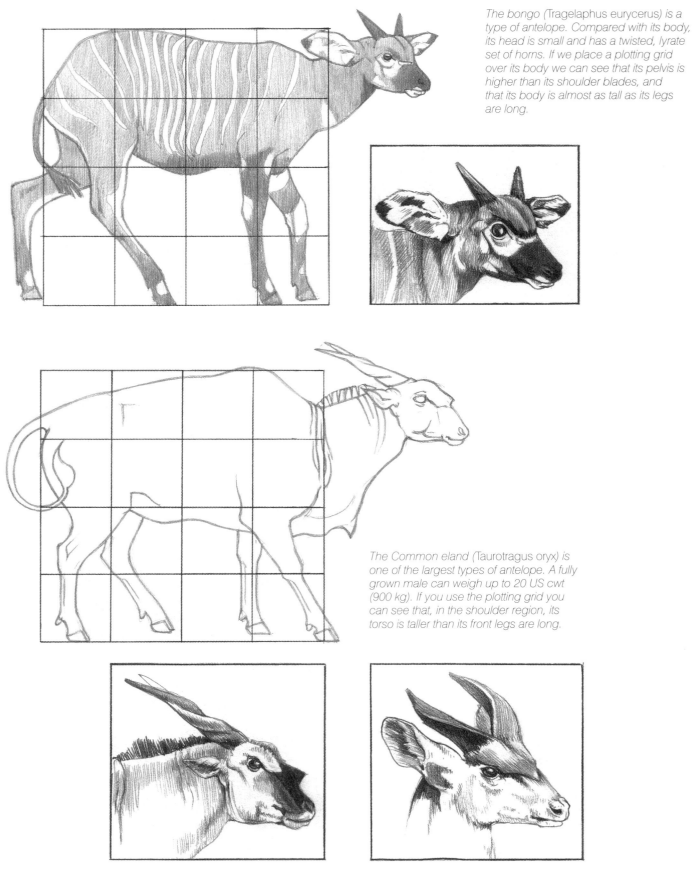

The bongo (Tragelaphus eurycerus) is a type of antelope. Compared with its body, its head is small and has a twisted, lyrate set of horns. If we place a plotting grid over its body we can see that its pelvis is higher than its shoulder blades, and that its body is almost as tall as its legs are long.

The Common eland (Taurotragus oryx) is one of the largest types of antelope. A fully grown male can weigh up to 20 US cwt (900 kg). If you use the plotting grid you can see that, in the shoulder region, its torso is taller than its front legs are long.

The Common eland's horns are short and twisted; the female's horns are shorter.

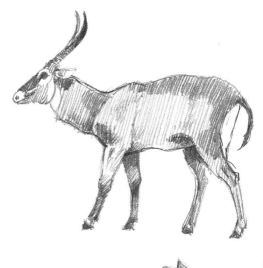

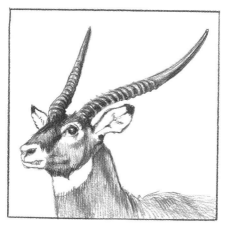

On a waterbuck (Kobus ellipsiprymnus) the ends of the horns are pointed forward. It has white patches around its eyes, nose, and tail. Its body is slightly squat, and its short legs are strong and muscular.

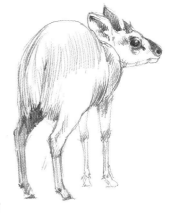

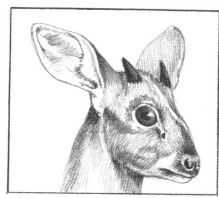

Sharpe's grysbok (Raphicerus sharpei) is a dwarf antelope. Its body is an interesting shape: its backbone slopes from the middle of its back to its hind legs. It has long hair, which means that its tail looks short and is almost invisible under its hide. Its legs are short. Its eyes and ears are very large in comparison to its head, and it has short, stumpy horns.

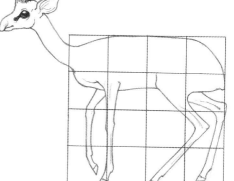

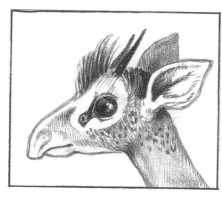

Kirk's dik-dik (Madoqua kirki) is a small, graceful species of antelope which is barely taller than a large male hare. Its legs are very long and thin compared with the length of its body. Its rump slopes sharply, and its pelvis is lower than its shoulder blades. Both its enormous eyes and its trunk-like, elongated nose are immediately noticeable when it comes to the head. The hair on its forehead is almost as long as its slender horns. When drawing this animal you should make sure that you draw this hair so that it is not quite parallel and sticks out backward at the ends.

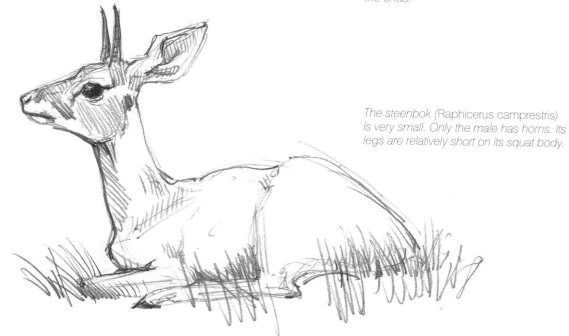

The steenbok (Raphicerus camprestris) is very small. Only the male has horns. Its legs are relatively short on its squat body.

Horns or spikes are horn-covered structures, with concave plating over bony studs on the frontal bone. The root diameter and length of the horns changes constantly over the course of the animal's life. They do not branch out, but may twist. Many horns have very beautiful shapes. When you are drawing them you should emphasize their surface texture, and when shading you should capture their tapering cylindrical shape and the play of light and shading upon them. It is also crucial that the surface of the horns is rendered differently to the hirsute body.

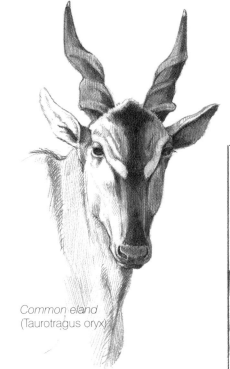

Common eland
(Taurotragus oryx)

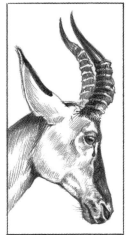

Topi (Damaliscus jimela)

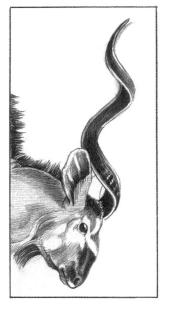

Greater kudu
(Tragelaphus strepsiceros)

Puku
(Kobus vardonii)

Kongoni or Coke's hartebeest
(Alcelaphus buselaphus cokii)

Sitatunga
(Tragelaphus spekii)

Southern or Common reedbuck
(Redunca arundinum)

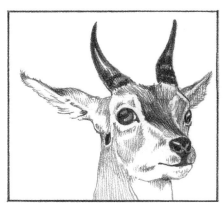

Nilgai antelope
(Boselaphus tragocamelus)

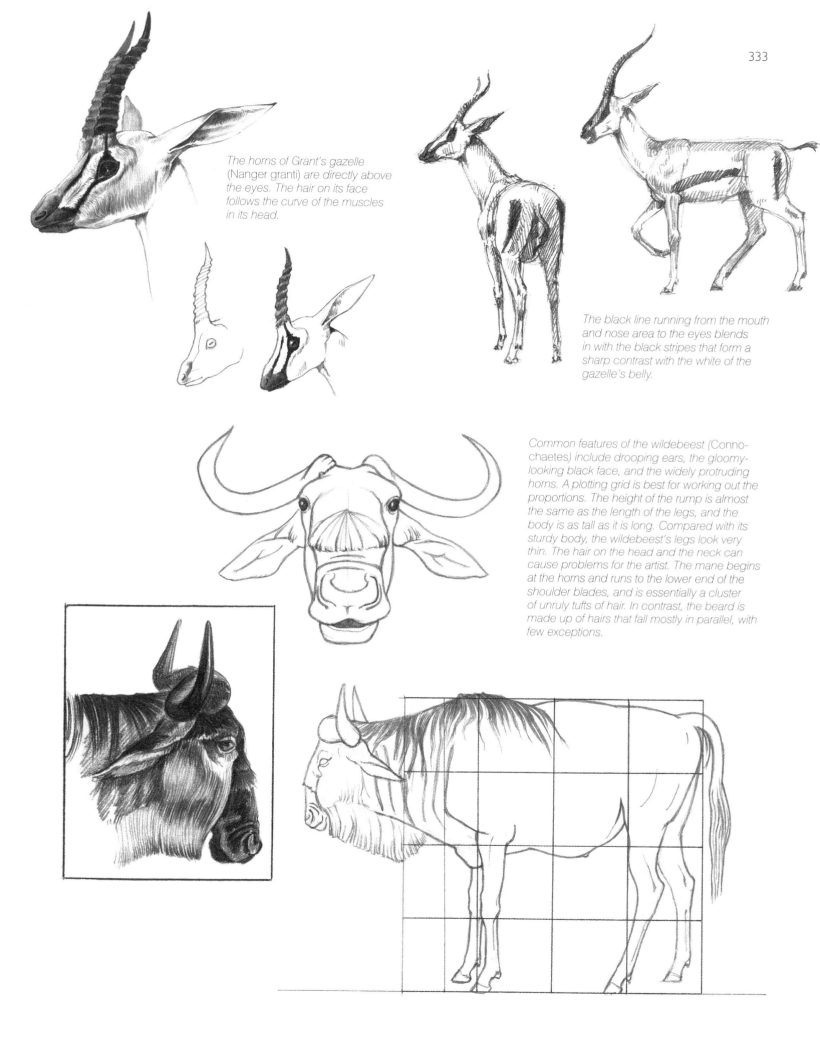

The horns of Grant's gazelle (Nanger granti) are directly above the eyes. The hair on its face follows the curve of the muscles in its head.

The black line running from the mouth and nose area to the eyes blends in with the black stripes that form a sharp contrast with the white of the gazelle's belly.

Common features of the wildebeest (Connochaetes) include drooping ears, the gloomy-looking black face, and the widely protruding horns. A plotting grid is best for working out the proportions. The height of the rump is almost the same as the length of the legs, and the body is as tall as it is long. Compared with its sturdy body, the wildebeest's legs look very thin. The hair on the head and the neck can cause problems for the artist. The mane begins at the horns and runs to the lower end of the shoulder blades, and is essentially a cluster of unruly tufts of hair. In contrast, the beard is made up of hairs that fall mostly in parallel, with few exceptions.

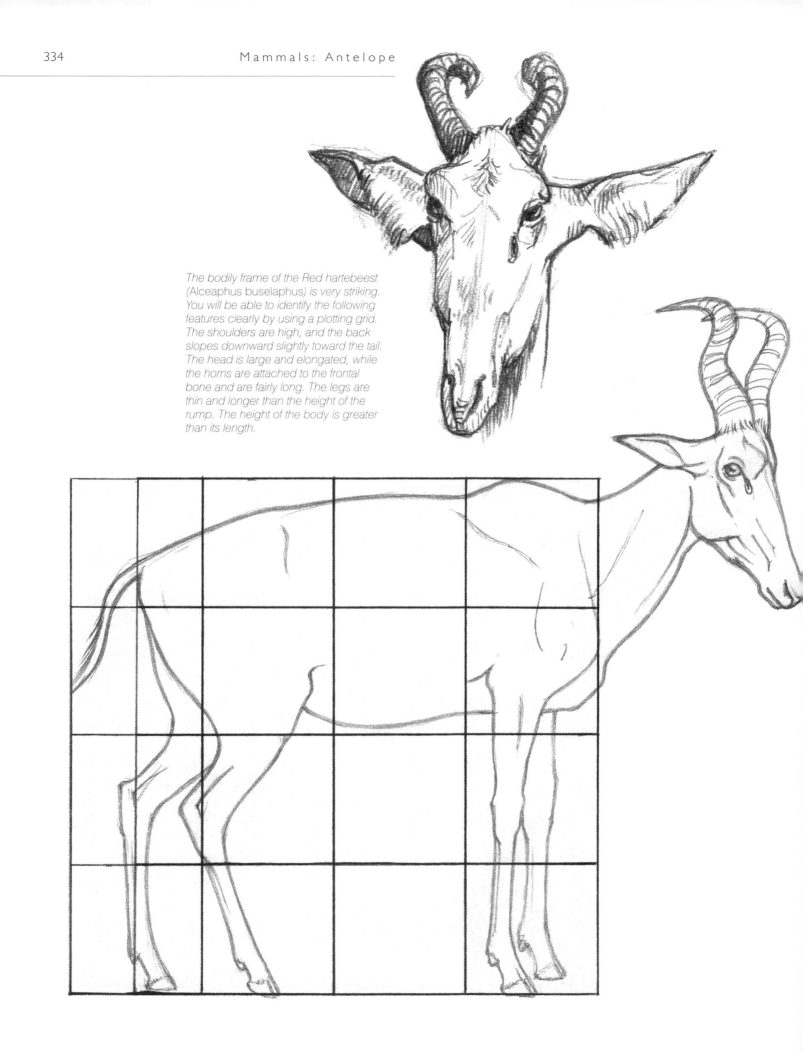

The bodily frame of the Red hartebeest (Alceaphus buselaphus) is very striking. You will be able to identify the following features clearly by using a plotting grid. The shoulders are high, and the back slopes downward slightly toward the tail. The head is large and elongated, while the horns are attached to the frontal bone and are fairly long. The legs are thin and longer than the height of the rump. The height of the body is greater than its length.

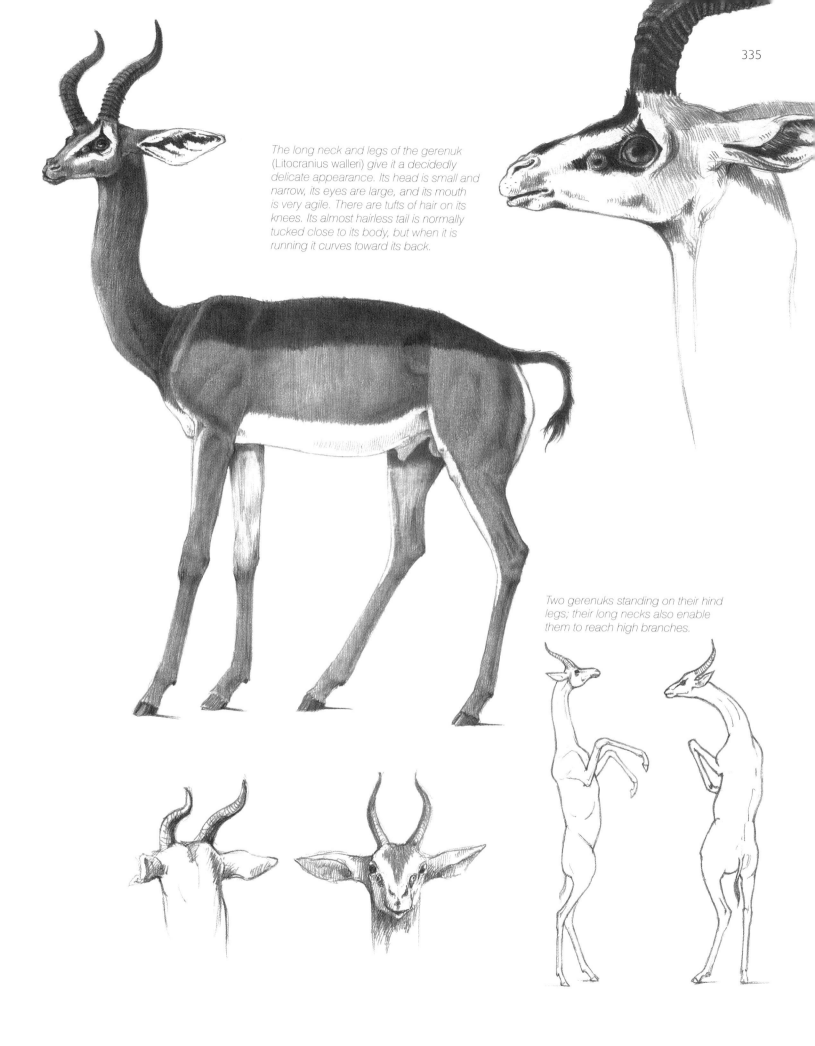

The long neck and legs of the gerenuk (Litocranius walleri) give it a decidedly delicate appearance. Its head is small and narrow, its eyes are large, and its mouth is very agile. There are tufts of hair on its knees. Its almost hairless tail is normally tucked close to its body, but when it is running it curves toward its back.

Two gerenuks standing on their hind legs; their long necks also enable them to reach high branches.

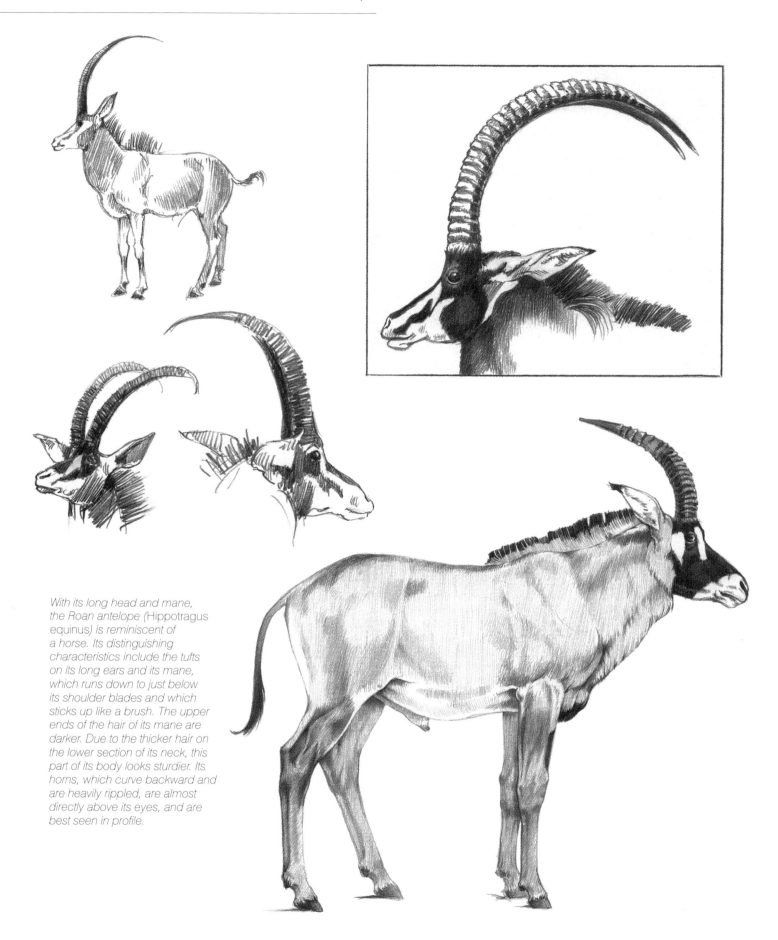

With its long head and mane, the Roan antelope (Hippotragus equinus) is reminiscent of a horse. Its distinguishing characteristics include the tufts on its long ears and its mane, which runs down to just below its shoulder blades and which sticks up like a brush. The upper ends of the hair of its mane are darker. Due to the thicker hair on the lower section of its neck, this part of its body looks sturdier. Its horns, which curve backward and are heavily rippled, are almost directly above its eyes, and are best seen in profile.

337

The head of the southern subspecies of the Lesser kudu (Tragelaphus imberbis australis) is highly distinctive: its screw-like horns and long ears are immediately eye-catching. Diagonal stripes cover its whole body. Using the plotting grid it is easy to see that its legs are longer than its body is tall.

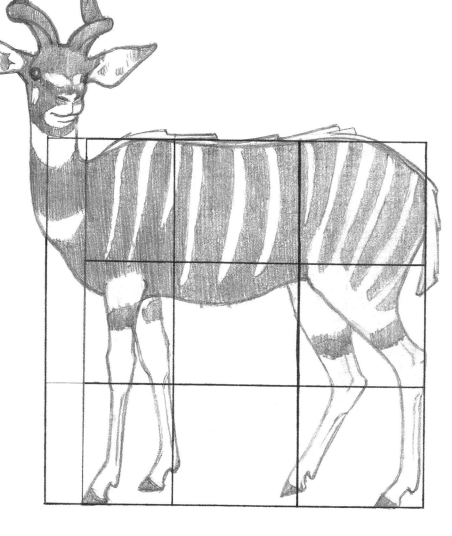

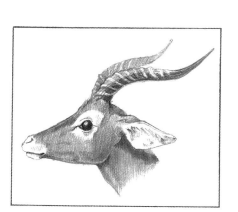

The impala (Aepyceros melampus) is one of the most famous African animals. Its horns have a double curve and are rippled in spirals. In this picture of a running impala my intention is to show that you can also depict movement in a sketch made up of only a few lines. This effect is created by the legs stretched far out in front, the muscles of the shoulders, which appear to be taut from the movement, and the blowing tail.

Deer are slender, long-legged animals. Their most striking characteristic is the antlers of the male, which are shed at the end of each winter, grow back in summer, and are at their most splendid in the fall.

The moose (Alces alces) is the largest type of deer. Its distinguishing features are its wide, drooping upper lip and the hanging lappet on its neck. The bull has massive, shovel-like, multi-branched antlers. Its body is about a third longer than its height.

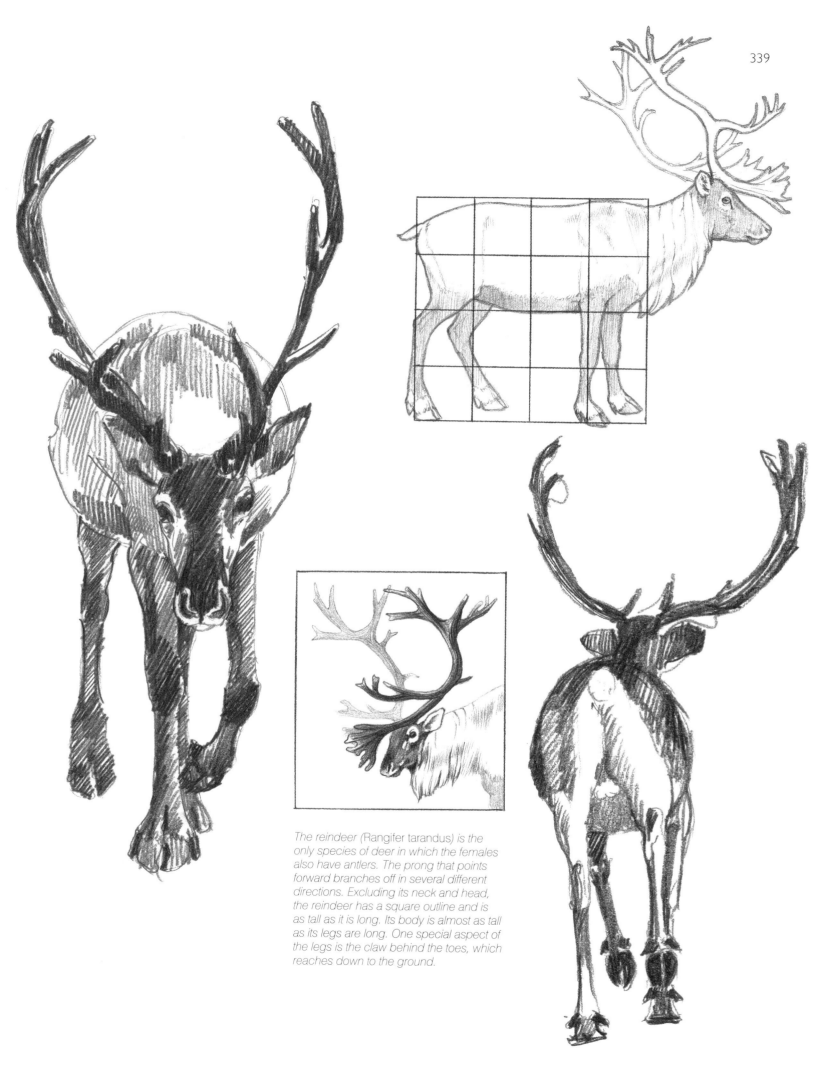

The reindeer (Rangifer tarandus) *is the only species of deer in which the females also have antlers. The prong that points forward branches off in several different directions. Excluding its neck and head, the reindeer has a square outline and is as tall as it is long. Its body is almost as tall as its legs are long. One special aspect of the legs is the claw behind the toes, which reaches down to the ground.*

The Roe deer (Cervus capreolus) is the smallest European species of deer. The surface of its antlers, which have three branches at most, is textured. It is a delicate animal with thin legs. If you look at it through a plotting grid, you will see that it is roughly as long as it is tall, and that its legs are slightly longer than the height of the torso. There is a marked indentation under the Achilles tendon. In the back view you can see that the heels of the back legs point toward one another slightly; this is also true for the other types of deer.

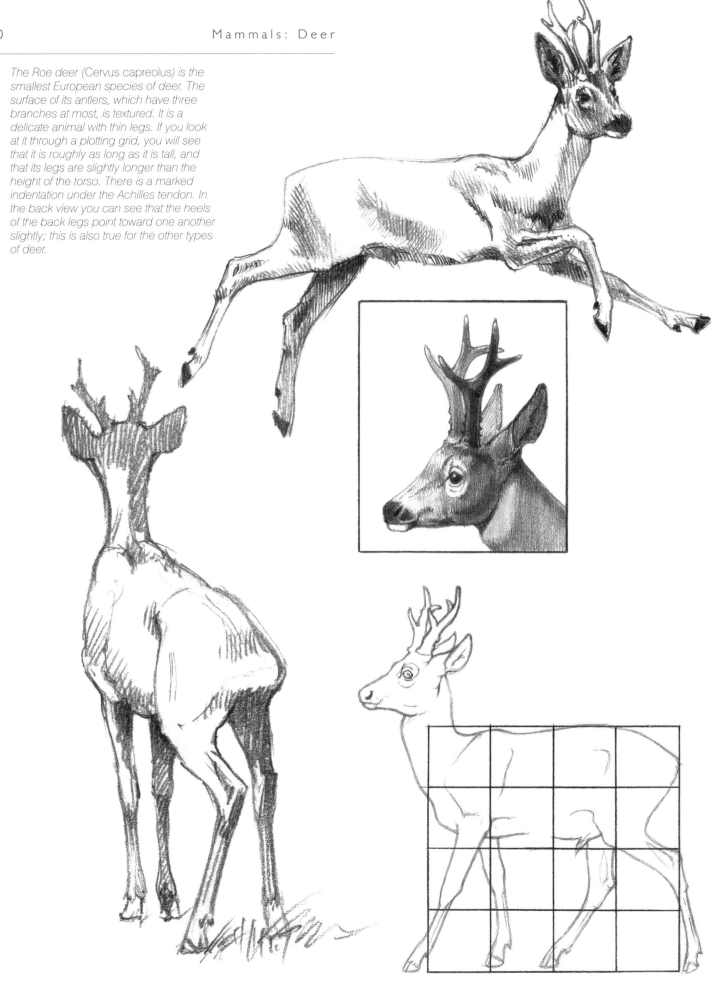

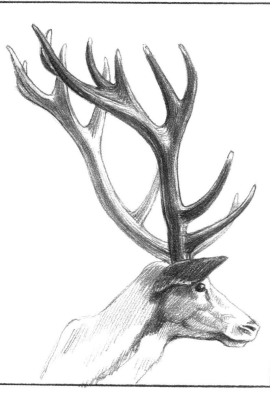

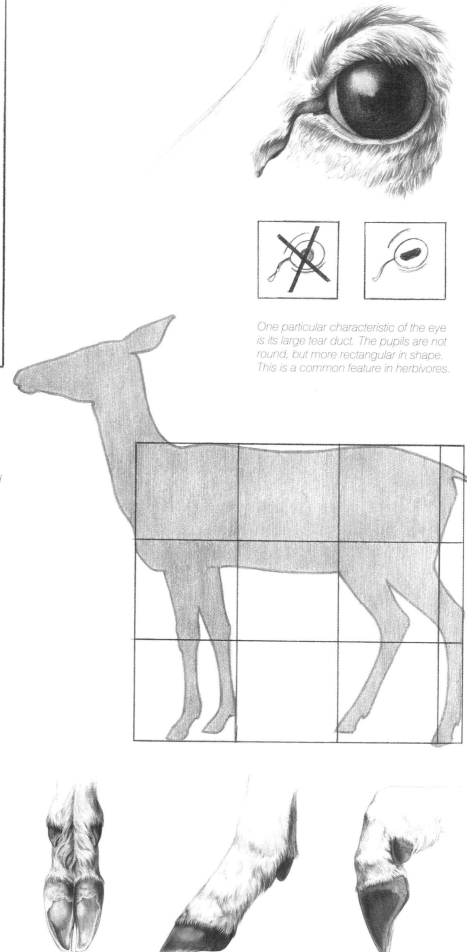

One particular characteristic of the eye is its large tear duct. The pupils are not round, but more rectangular in shape. This is a common feature in herbivores.

The proportions of the Red deer (Cervus elaphus) can be read accurately using a plotting grid: its length is the same as its height. The delicate legs are 1 $\frac{2}{3}$ squares long, while the body is only 1 $\frac{1}{3}$ squares high. The length of the head is 1 $\frac{1}{4}$ squares. Only the bucks have antlers, and they also grow a mane-like coat of hair on their neck in the fall and winter.

A hoof seen from different angles. The hoof forms a 45-degree angle with the leg, if the red deer is standing upright.

Deer have antlers; their shape depends on the particular species. These drawings show some typical shapes.

One of the main antler branches on Père David's deer points backward, while the other, which branches out farther, points forward.

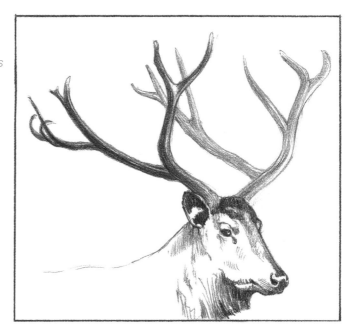

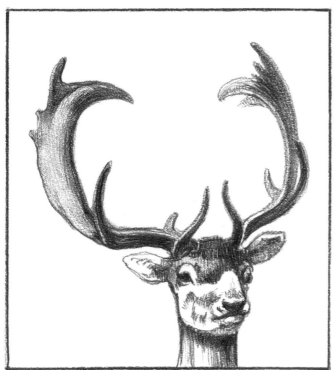

Small branches come off the main prongs of the fallow deer's antlers.

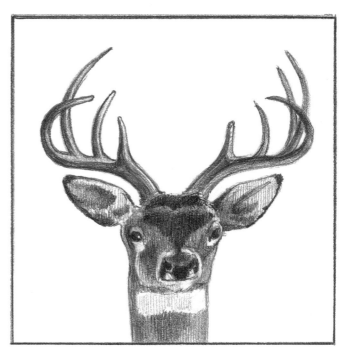

The antlers of the White-tailed deer (Odocoileus virginianus) are smaller and more delicate, with many branches.

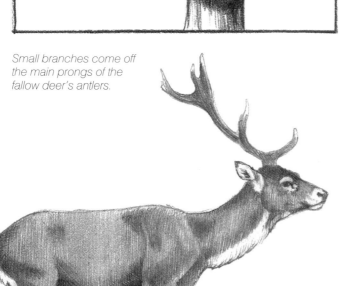

The massive antlers of the Red deer stag can weigh up to 28 lbs (12 kg).

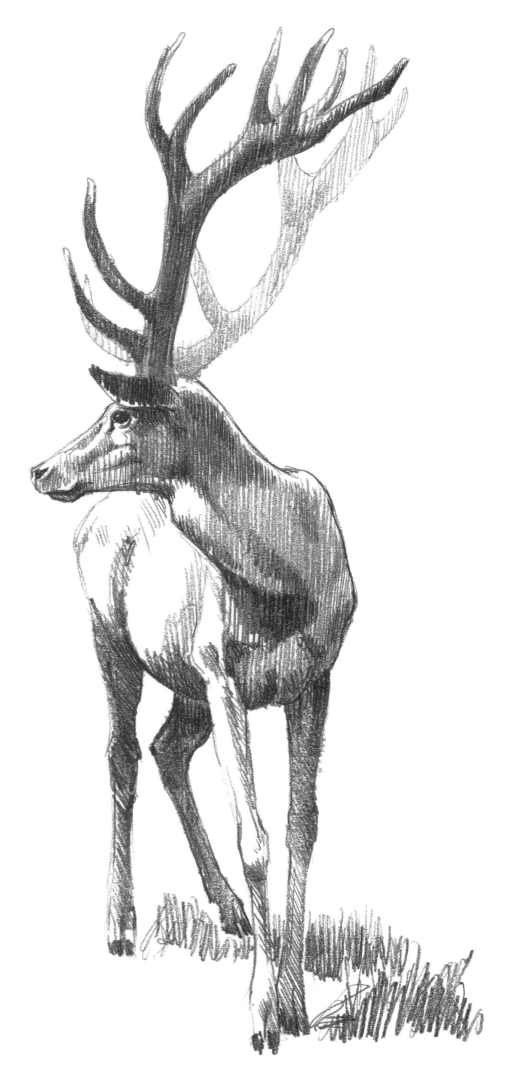

The elephant is the largest land mammal on Earth. Africa and Asia have different species—the African elephant *(Loxodonta africana)*, and the Asian or Indian elephant *(Elephas maximus)*. The elephant's most distinctive fea- ture is its trunk, which it uses to drink and reach, while its extremely flexible snout allows it to pick up food and protect itself. When you come to draw it, it is also vital to capture its tusks, gigantic ears, and pillar-like legs.

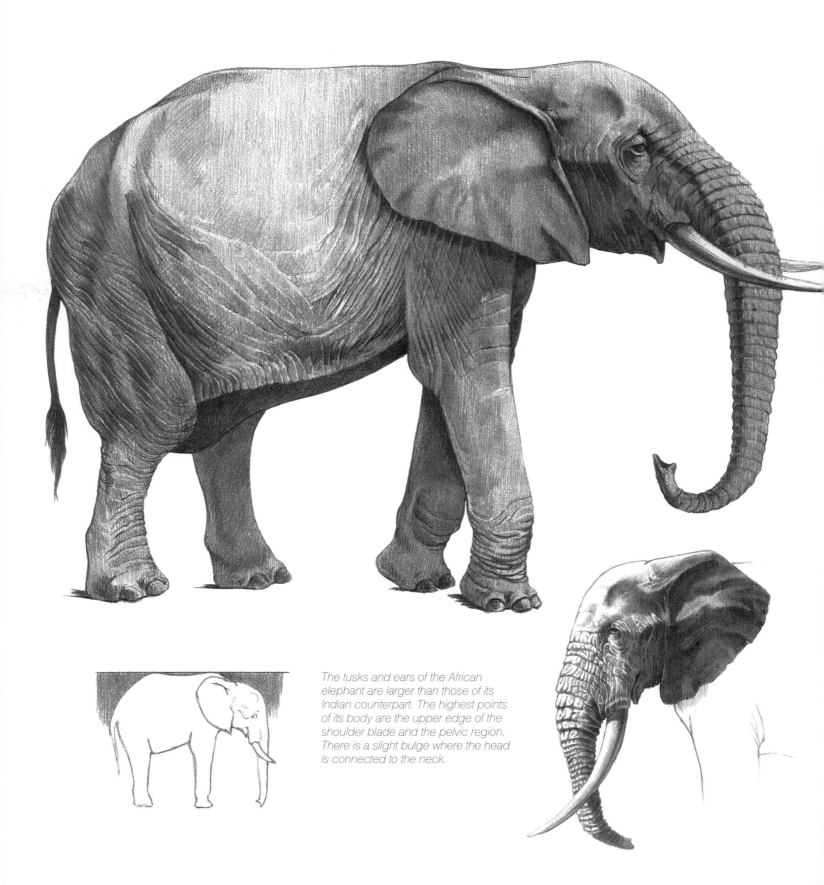

The tusks and ears of the African elephant are larger than those of its Indian counterpart. The highest points of its body are the upper edge of the shoulder blade and the pelvic region. There is a slight bulge where the head is connected to the neck.

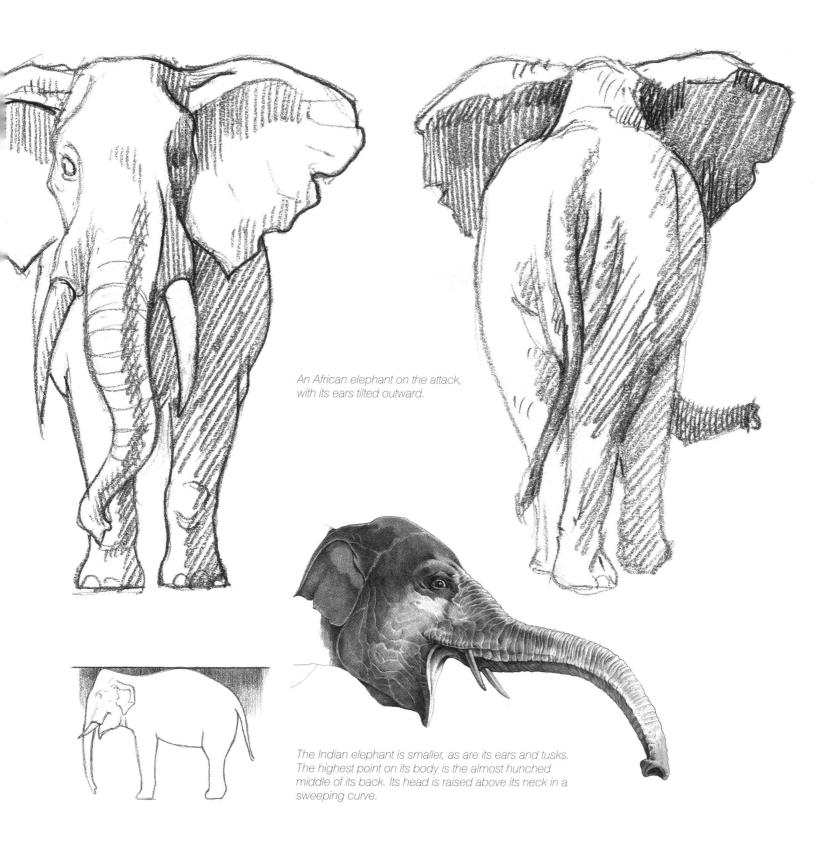

An African elephant on the attack, with its ears tilted outward.

The Indian elephant is smaller, as are its ears and tusks. The highest point on its body is the almost hunched middle of its back. Its head is raised above its neck in a sweeping curve.

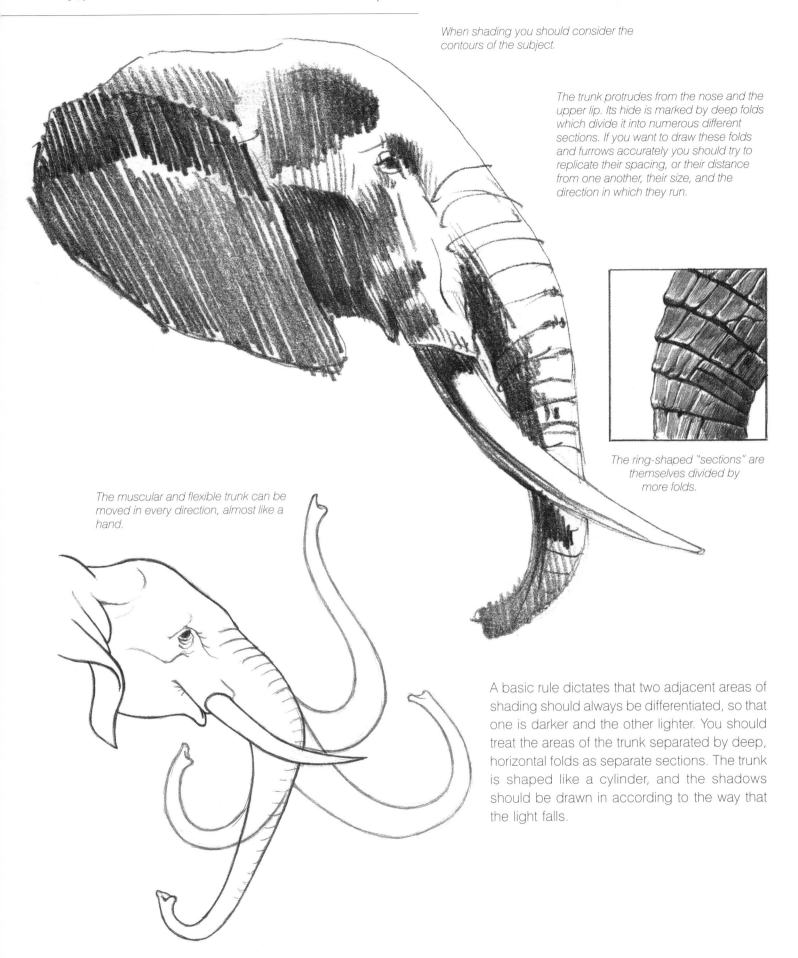

When shading you should consider the contours of the subject.

The trunk protrudes from the nose and the upper lip. Its hide is marked by deep folds which divide it into numerous different sections. If you want to draw these folds and furrows accurately you should try to replicate their spacing, or their distance from one another, their size, and the direction in which they run.

The ring-shaped "sections" are themselves divided by more folds.

The muscular and flexible trunk can be moved in every direction, almost like a hand.

A basic rule dictates that two adjacent areas of shading should always be differentiated, so that one is darker and the other lighter. You should treat the areas of the trunk separated by deep, horizontal folds as separate sections. The trunk is shaped like a cylinder, and the shadows should be drawn in according to the way that the light falls.

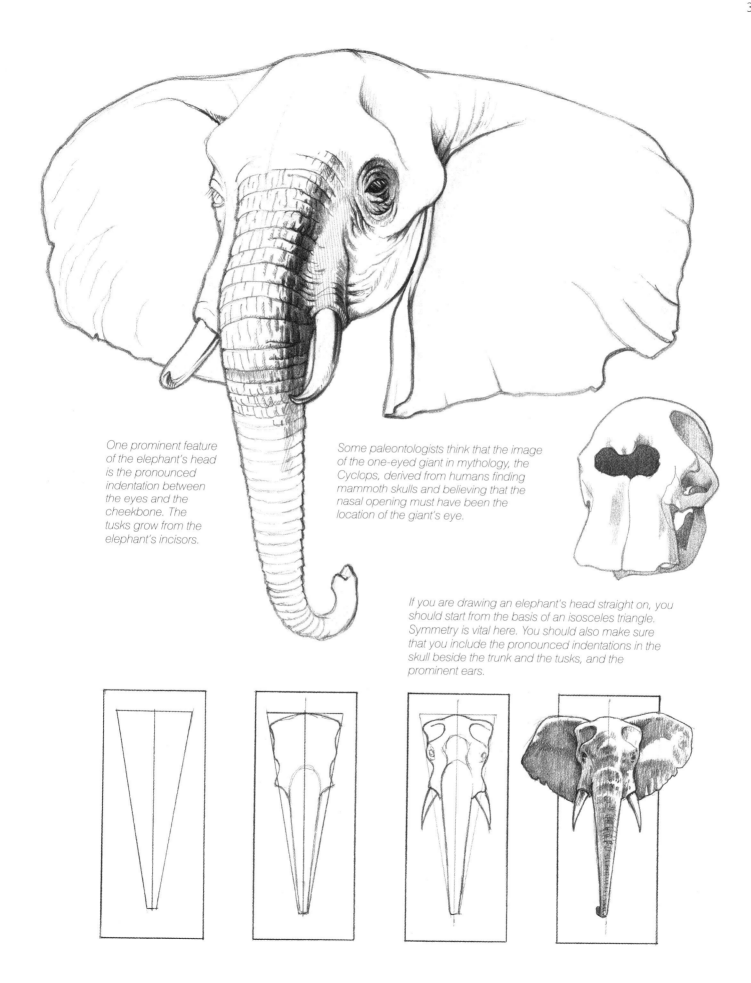

One prominent feature of the elephant's head is the pronounced indentation between the eyes and the cheekbone. The tusks grow from the elephant's incisors.

Some paleontologists think that the image of the one-eyed giant in mythology, the Cyclops, derived from humans finding mammoth skulls and believing that the nasal opening must have been the location of the giant's eye.

If you are drawing an elephant's head straight on, you should start from the basis of an isosceles triangle. Symmetry is vital here. You should also make sure that you include the pronounced indentations in the skull beside the trunk and the tusks, and the prominent ears.

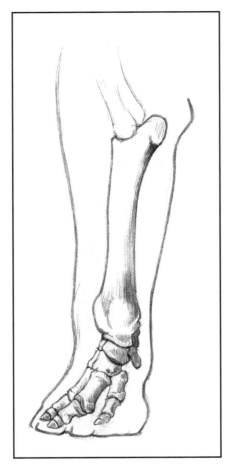

The shin bone of the front leg is long, but the space between the bones and the sole of the foot is relatively small.

The heels of the back legs are also close to the ground.

The tail hangs relatively low down in comparison to the back legs. With the tassel of hair at the end, it almost reaches the ground.

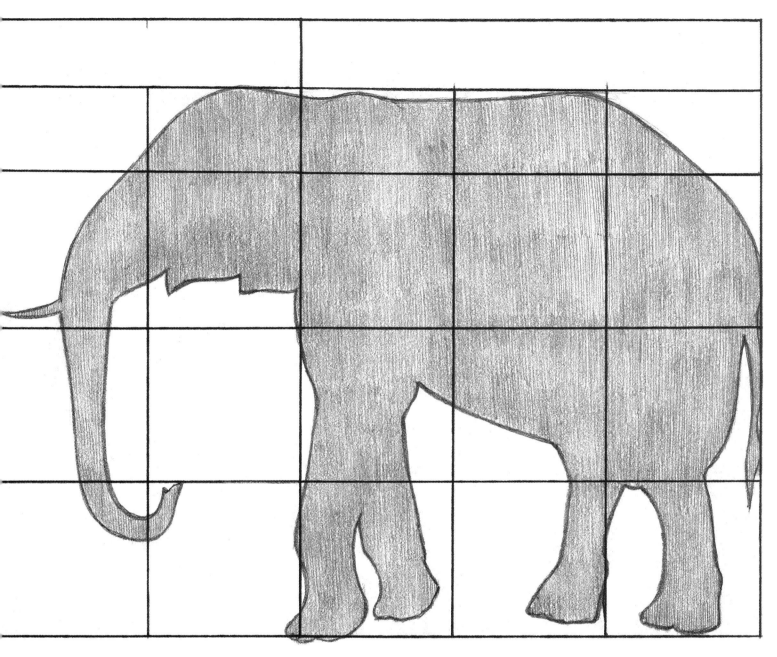

You can work out the proportions of the African elephant by using a plotting grid. Its length equates to four and a half squares, and its height to three and a half squares. Its thick legs are roughly half a square wide.

The front of the body is about two squares high, and the back about three. The trunk is three squares long, while the ears take up one and a half squares.

Motion studies

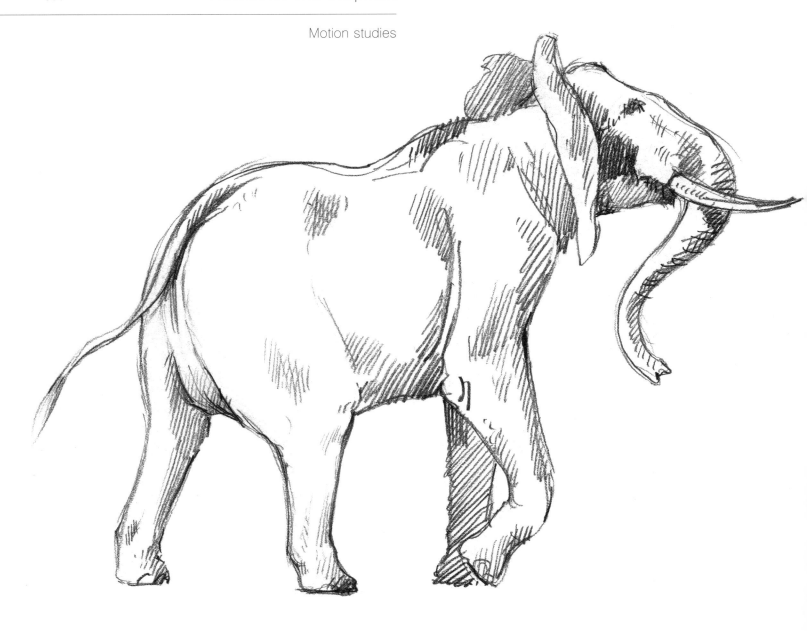

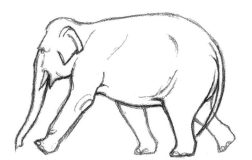 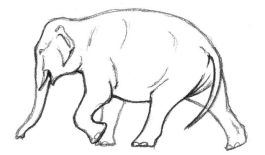 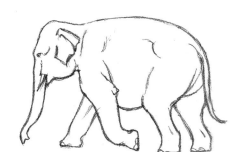

*An Indian elephant walking, showing the
movement of each of the legs.*

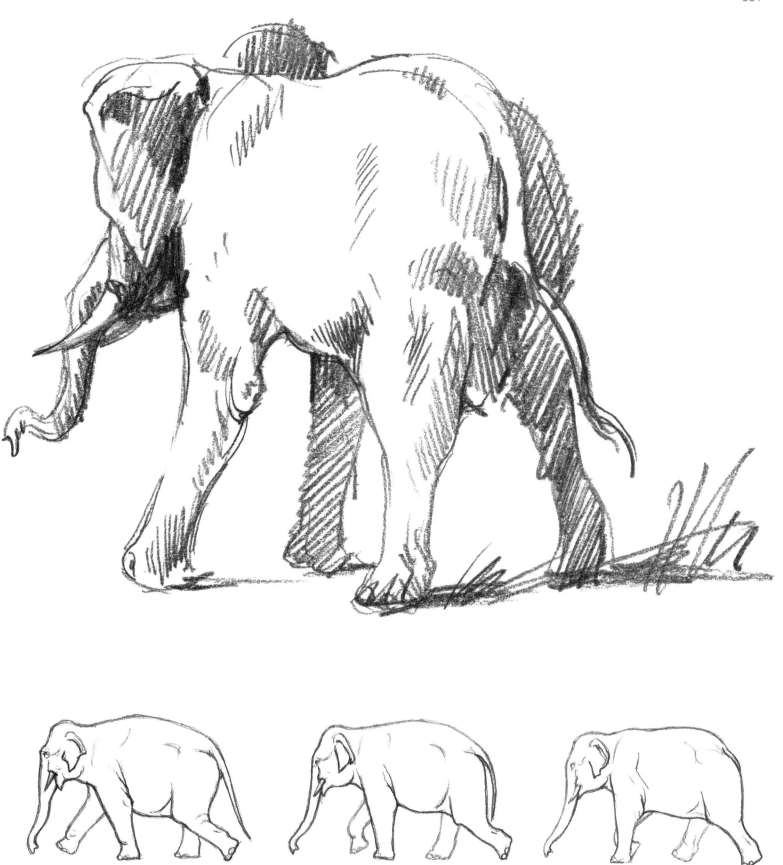

Different species of dog (*Canis lupus familiaris*) can differ greatly in terms of their shape, size, proportions, shape of the head, hair, and so forth, although their anatomical make-up is obviously the same. When you set about drawing a dog it is best to begin with a sketch so that you can work out its proportions. A plotting grid works well for doing this, as it makes it easy to read off the length of the head, the body, or the legs, and their relationship with one another or the distance between them. There can be vast differences in bodily frame between individual breeds of dogs.

Certain poises are typical for specific breeds. At dog shows, for instance, it is deemed ideal if both front paws are side by side, while one back paw is placed slightly behind the other.

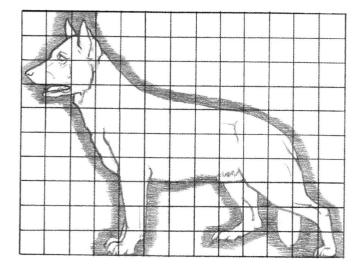

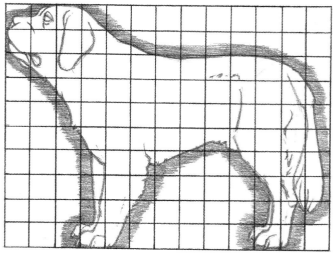

The proportions of a German shepherd. The front legs are somewhat longer than the head. Toward the back the body slants downward. The dog's tail is long, its back legs are powerful, and there is a marked indentation under the Achilles heel. Its hair is long and mottled, while its ears are short and pointed.

For Saint Bernard dogs, the head looks large in comparison to the body. This is one of the largest breeds of dog, and it has a powerful build and muscular legs. If you use a plotting grid you will instantly see that the length of the head is a quarter of the length of the body. The front legs are scarcely longer than the head, but the back legs are, by half a square. The tail is almost twice as long as the head.

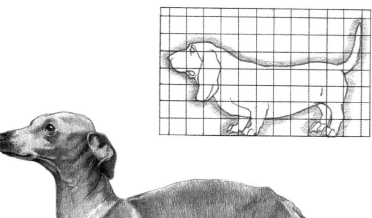

The characteristic features of the Basset hound are its very short legs, its large, long-eared head, and its long body. Using a plotting grid will allow you to work out the proportions more accurately. The body is four times as long as the head; even the ears are longer than the head. The skin covering the legs droops a little. The dog's legs are extremely short: the front legs are only a third of the length of the head, while the back legs are twice as long as the front legs. The tail may be up to twice as long as the head. Its coat is short and mottled.

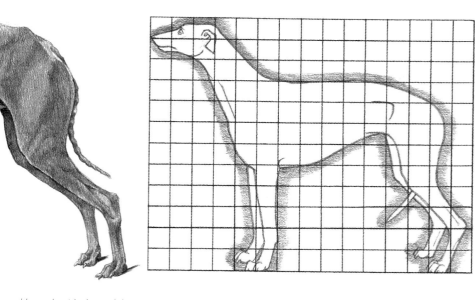

The Italian greyhound has short hair, and the texture and muscles of its back legs can be clearly seen. You can work out the approximate position of the femur and the point at which it is joined to the pelvis. There is a marked indentation under the Achilles tendon. The arrangement of the toe bones is also clearly visible.

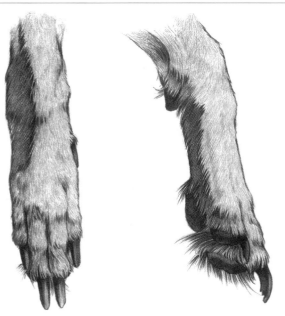
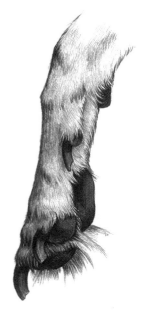
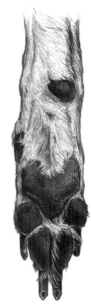

The paws of the front legs in profile, from an inside and outside view, and from the front and behind. When you are drawing this you should pay attention to the shape of the outline, and carry out the shading accordingly. The legs are cylindrical, while the

balls of the feet, when the dog is standing on them, resemble spheres divided by the toes into "segments." Four toes rest symmetrically on the ground, while the fifth is stunted and sits markedly higher, on the inside of the foot. The balls of the feet are

smooth, curved surfaces segmented by small clefts. Their texture is very different from that of the parts of the body, which are covered in hair, and the claws, and you must make sure that you capture this when you come to shade your drawing.

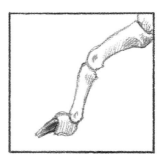
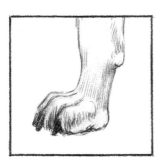

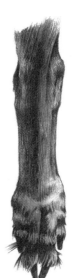
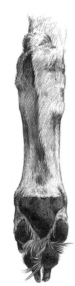
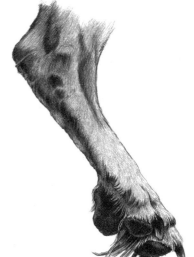
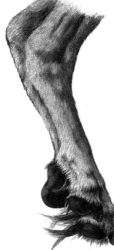

The back legs have a different shape from the front legs. There is a noticeable indentation below the Achilles tendon, and

the point where the tendon is connected to the heel bone appears roughly round.

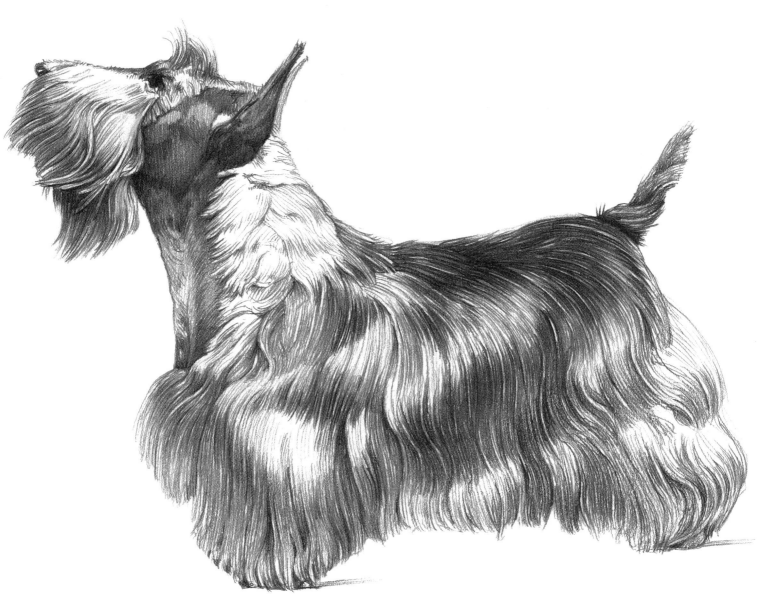

On a Scottish terrier, the vague shape of the legs can only be glimpsed through the waves in the hair—as though it were wearing a floor-length skirt. When you are shading this you should be aware that this is a three-dimensional subject, meaning that one part is lighter, while the other side is darker, as it is turned away from the light. At the outset you should simply roughly sketch the wavy lines for the hair.

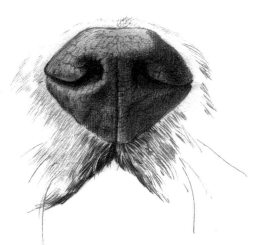

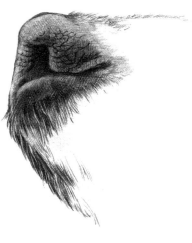

Individual breeds of dog may have very different faces. There is massive variation in the distance between the eyes and the nose, and the relative size of these facial features, to say nothing of the array of shapes, from protruding to flat. What they have in common is that the nose is symmetrical in the front view, with the nostrils showing, and a narrow opening running off to the side. The texture of the nose is very different from the hairy part of the face, and you should bear this in mind when you come to shade your drawing.

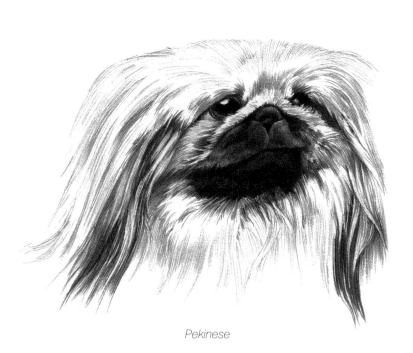

Pekinese

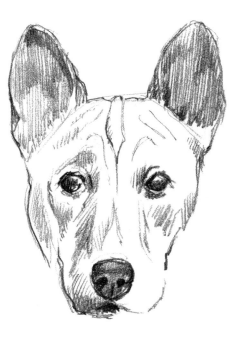

Basenji

Shar Pei

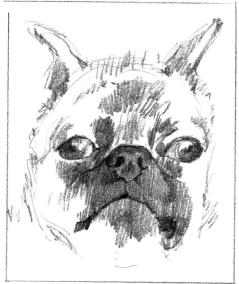

Brabant Griffon

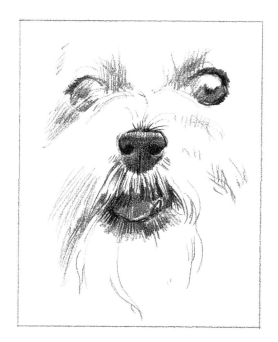

Maltese terrier

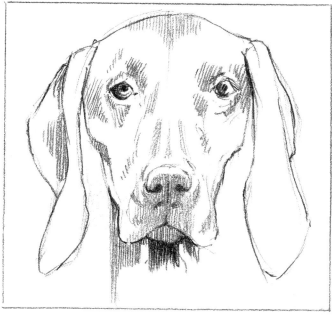

Magyar Vizsla

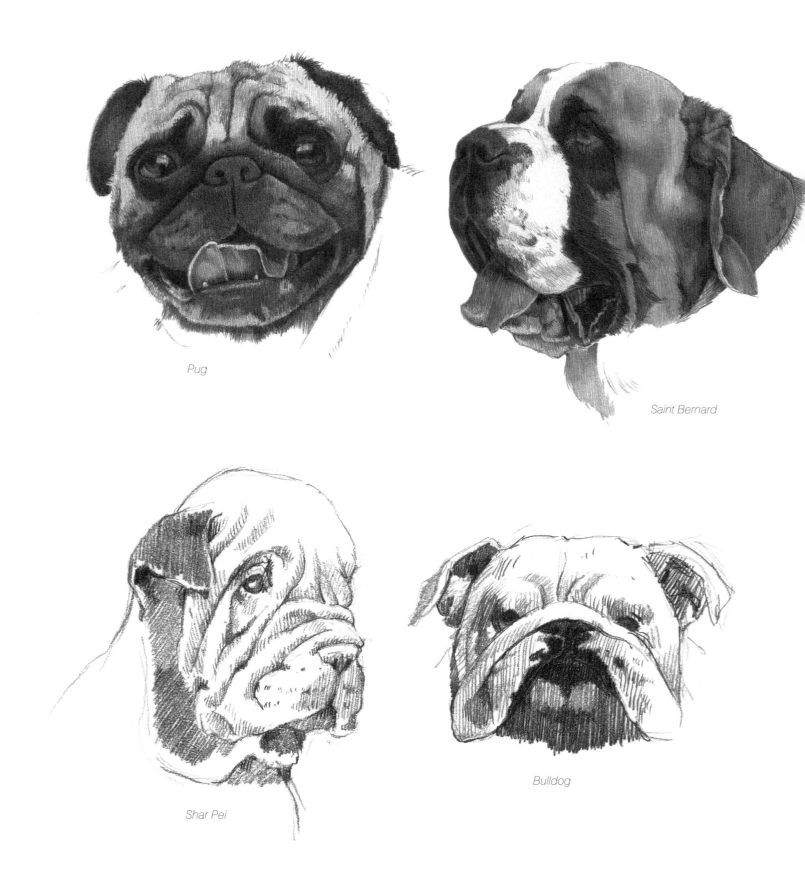

Pug

Saint Bernard

Shar Pei

Bulldog

There is also great variety in the shape and size of the ears. Most have a triangular outline, albeit in many different proportions, and there are also a great number of curved ears.

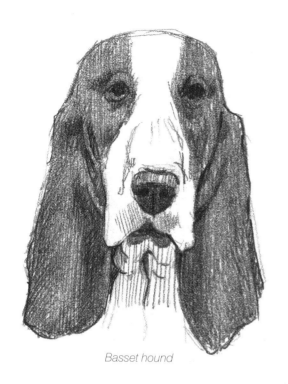

Basset hound

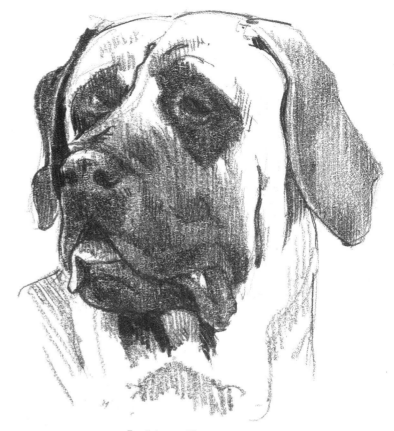

English mastiff

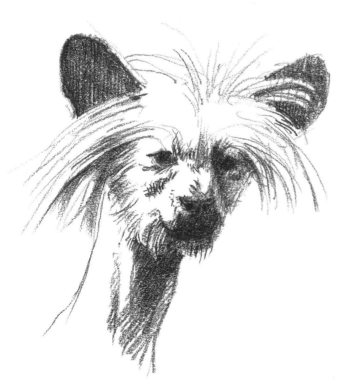

Mexican hairless dog

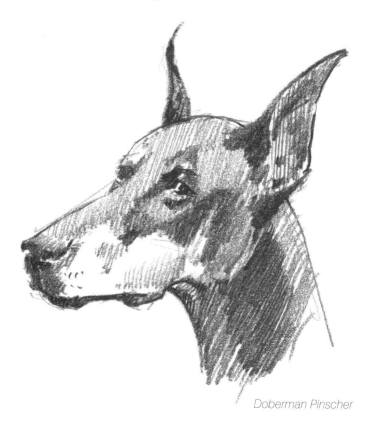

Doberman Pinscher

Alertness

Happiness

Anxiety

The tail of the dog reflects its breed, and its position indicates its mood.

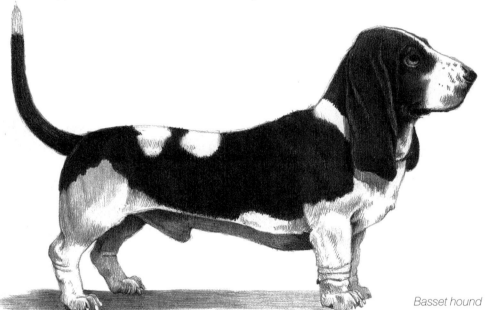

Basset hound

West Siberian Laika

Akita Inu

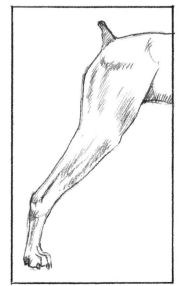

Boxer

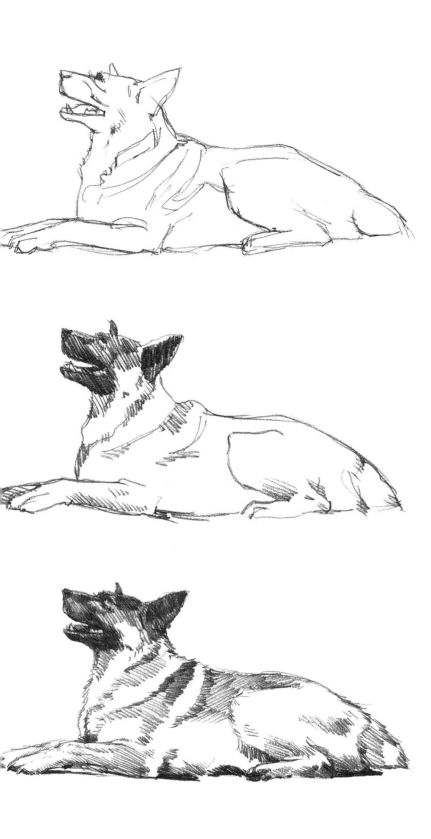

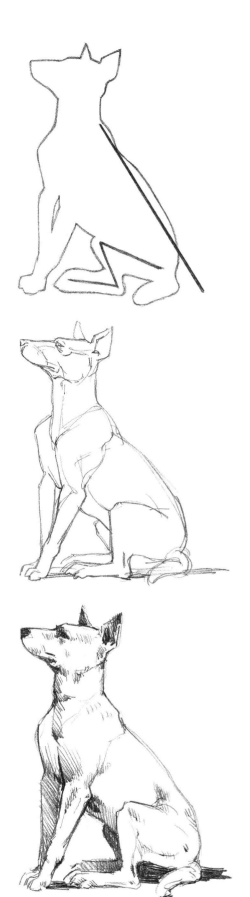

The steps for drawing a lying German shepherd. The first stage is a simple sketch with swift, firm lines, marking on the positions of all the parts of the body. The drawing can then be improved by adding in shading. On the finished drawing, the suggested lines and patches have been fully developed. The length and positioning of the front and back legs are particularly important, as is the distance between the outermost point of the head and the end of the front legs. You should also check where the back legs are joined to the body, and how high they reach.

The quality of this drawing of a sitting dog largely depends on whether the slant of the back and the angle that it forms with the floor is accurate. The direction and angle of the back legs are also important.

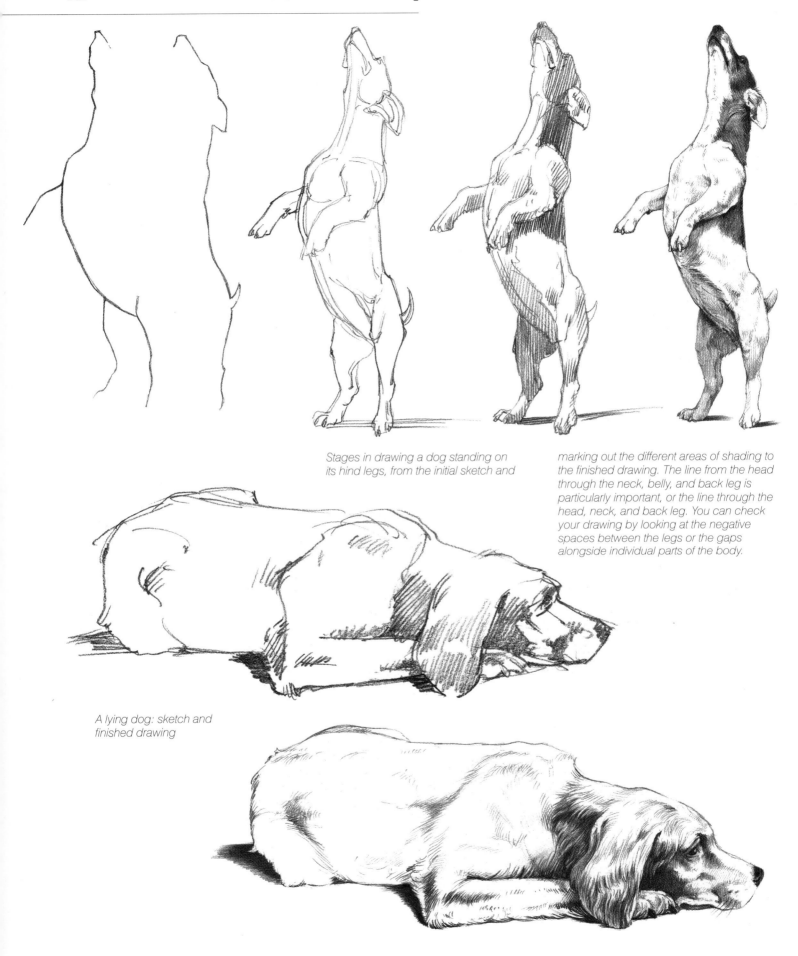

Stages in drawing a dog standing on its hind legs, from the initial sketch and marking out the different areas of shading to the finished drawing. The line from the head through the neck, belly, and back leg is particularly important, or the line through the head, neck, and back leg. You can check your drawing by looking at the negative spaces between the legs or the gaps alongside individual parts of the body.

A lying dog: sketch and finished drawing

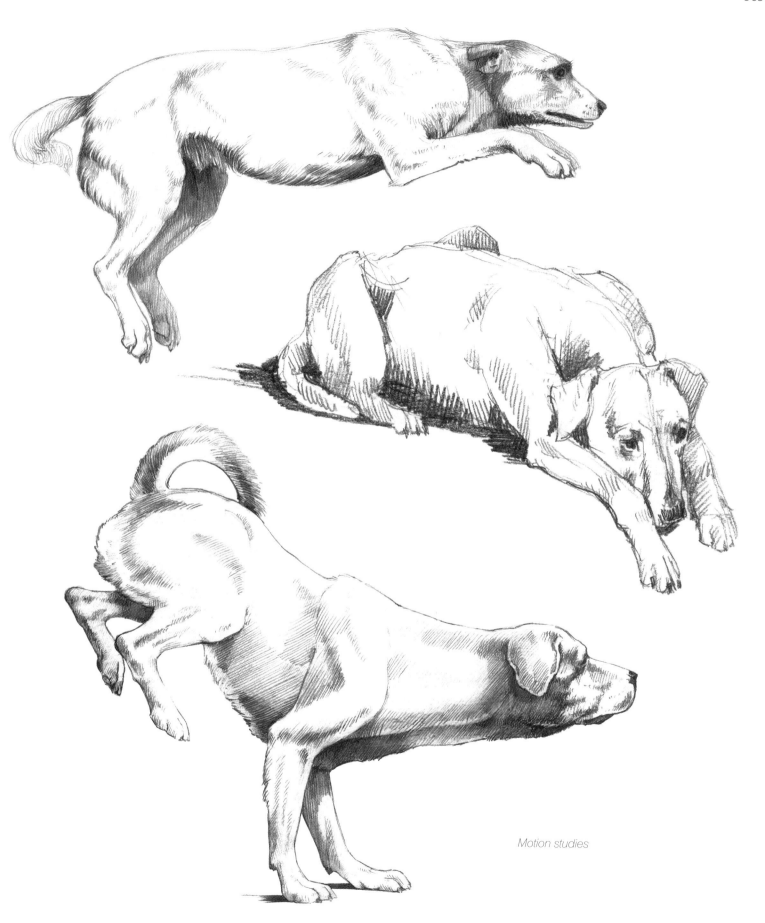

Motion studies

The giraffe (*Giraffa camelopardalis*) is the tallest land mammal. Its two most distinctive features are its long neck and its patterned hide. The structure of its body and the position of its muscles can be clearly seen under its short-haired hide. Its legs are remarkably long and slender, and its feet end in hooves. Its long tail has a tassel at the end.

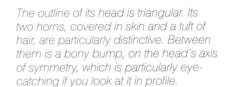

The outline of its head is triangular. Its two horns, covered in skin and a tuft of hair, are particularly distinctive. Between them is a bony bump, on the head's axis of symmetry, which is particularly eye-catching if you look at it in profile.

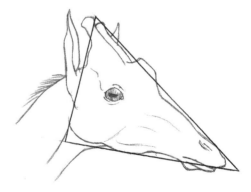

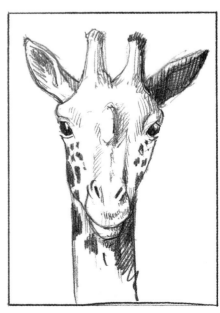

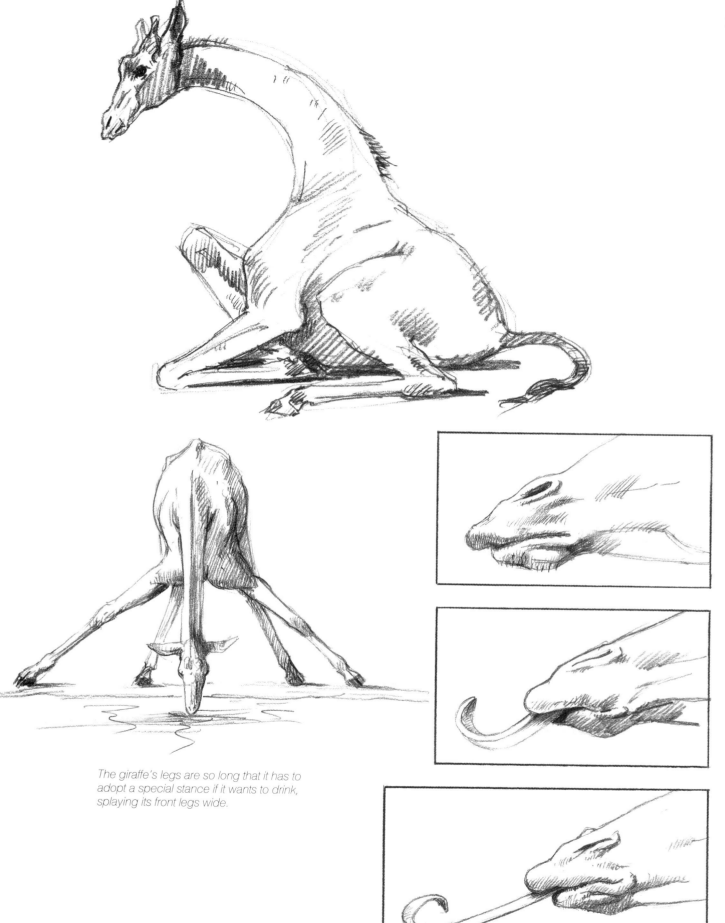

The giraffe's legs are so long that it has to adopt a special stance if it wants to drink, splaying its front legs wide.

The giraffe's lips and the long tongue are very flexible, which is important for eating.

Both Africa and Asia are home to the rhinoceros (*Rhinocerotidae*). Two species live in Africa—the White rhinoceros and the Black rhinoceros. The Great One-horned rhinoceros, the Sumatran rhinoceros, and the

Javan rhinoceros also belong to this family. The massive head of the rhino is immediately striking, and its most distinctive feature are the horns on its nose—it may have one or two, depending on the species.

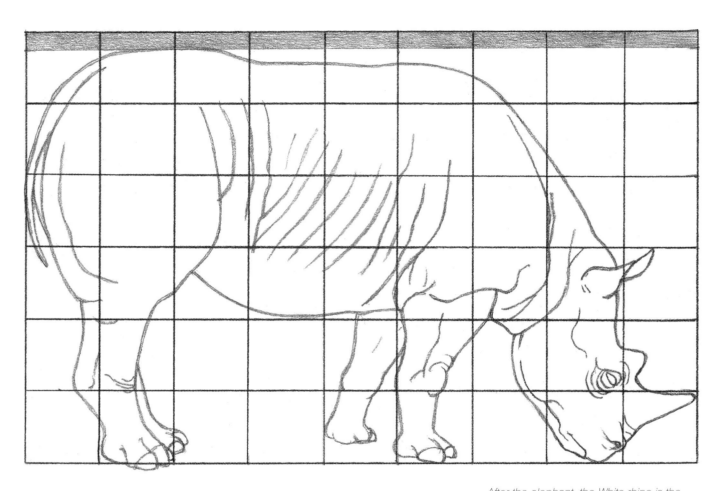

After the elephant, the White rhino is the heaviest land animal. You can see the proportions of its body clearly if you use a plotting grid: its head is almost three squares long—about a third of the length and half the height of its body. From the soles of its feet to its belly, its front legs are just over two squares long, while its back legs are two and a half squares long. When its body is in a normal posture, the distance between the front and back legs is about the length of its head. The powerful muscles can barely be seen under the thick hide, but the ribs can easily be made out due to the heavy folds that they create on the skin.

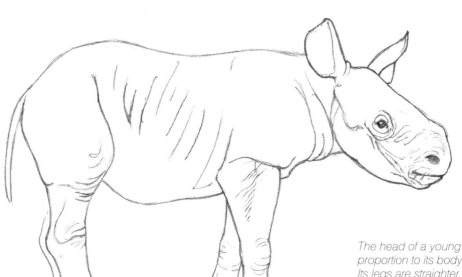

The head of a young rhino is larger in proportion to its body—about half as long. Its legs are straighter, and its toes and soles are relatively wide.

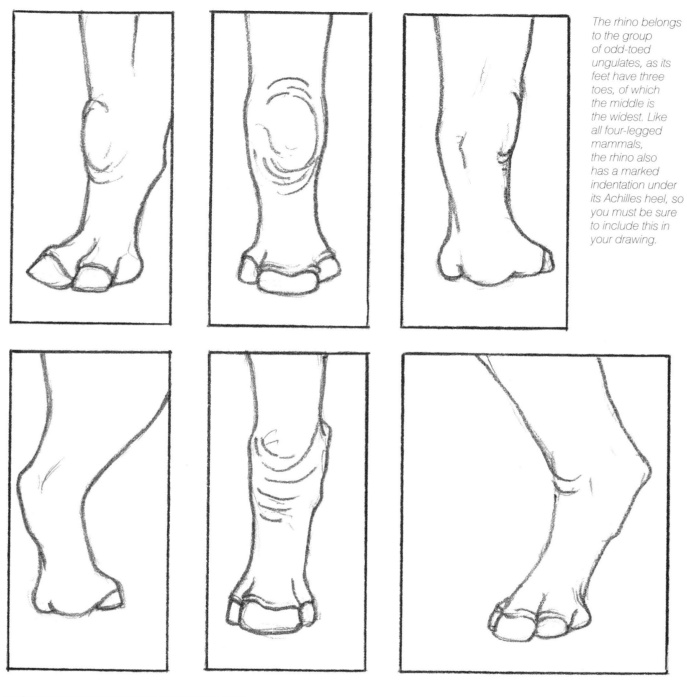

The rhino belongs to the group of odd-toed ungulates, as its feet have three toes, of which the middle is the widest. Like all four-legged mammals, the rhino also has a marked indentation under its Achilles heel, so you must be sure to include this in your drawing.

The nose and pointy upper lip of the Black rhinoceros are very flexible, allowing it to tear leaves and twigs from bushes easily.

The One-humped camel or dromedary (*Camelus dromedarius*) is a domesticated animal. It is an even-toed ungulate, as each of its feet has two toes, which broaden out to the sides and form flat, flexible pads. The way in which the toes are splayed out also allows it to move easily in the loose desert sand.

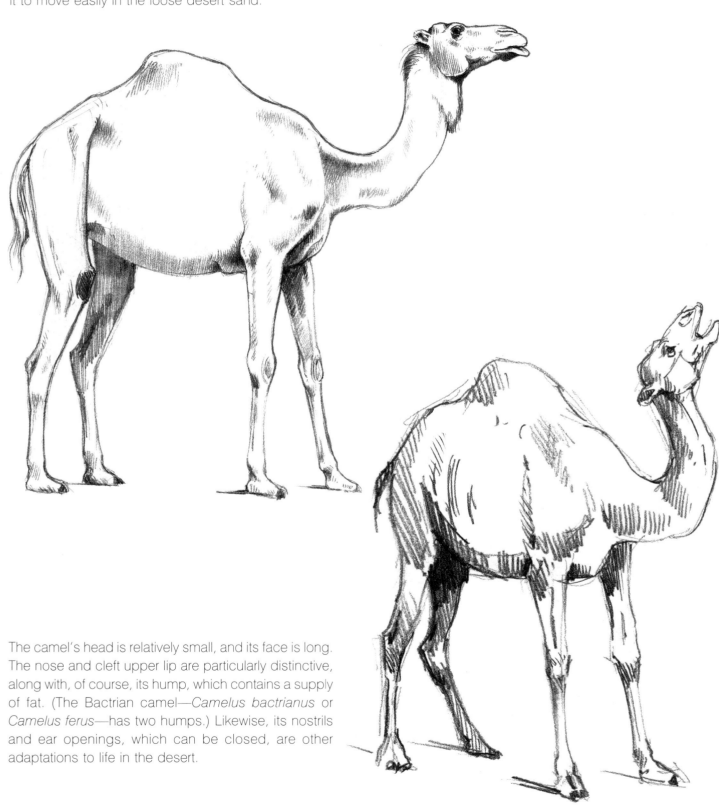

The camel's head is relatively small, and its face is long. The nose and cleft upper lip are particularly distinctive, along with, of course, its hump, which contains a supply of fat. (The Bactrian camel—*Camelus bactrianus* or *Camelus ferus*—has two humps.) Likewise, its nostrils and ear openings, which can be closed, are other adaptations to life in the desert.

A thick, horny skin covers the dromedary's leg joints. More callused skin can be seen on its underside, next to its front legs. This roughness protects the animal from the hot desert sand when it lies down.

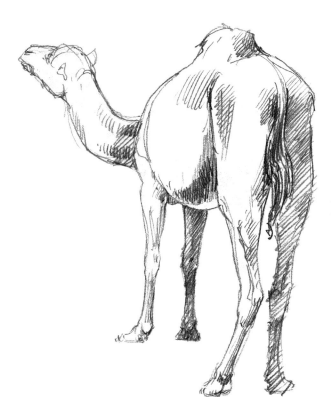

The long hairs of the camel's tail hang down between its slender back legs.

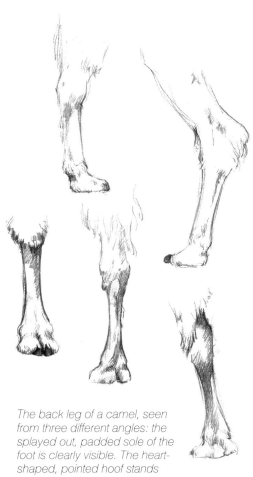

The back leg of a camel, seen from three different angles: the splayed out, padded sole of the foot is clearly visible. The heart-shaped, pointed hoof stands out in both drawings of the front leg. From behind you can see the way in which it is segmented along the axis of symmetry.

The shape of the hyena (*Hyaenidae*) is similar to that of a dog, although it is more closely related to feline species. The front section of its body is stronger than the back. Its body is somewhat squat, and it has one of the strongest bites of all mammals. Hyenas are scavengers, but they also hunt in packs.

The Spotted hyena is the largest species. Its legs are slender, its back slants downward, its tail ends in a tassel, and it has a short mane on the nape of its neck. Its coat is covered in irregular dark spots. It has oval-shaped ears which widen around the ear hole.

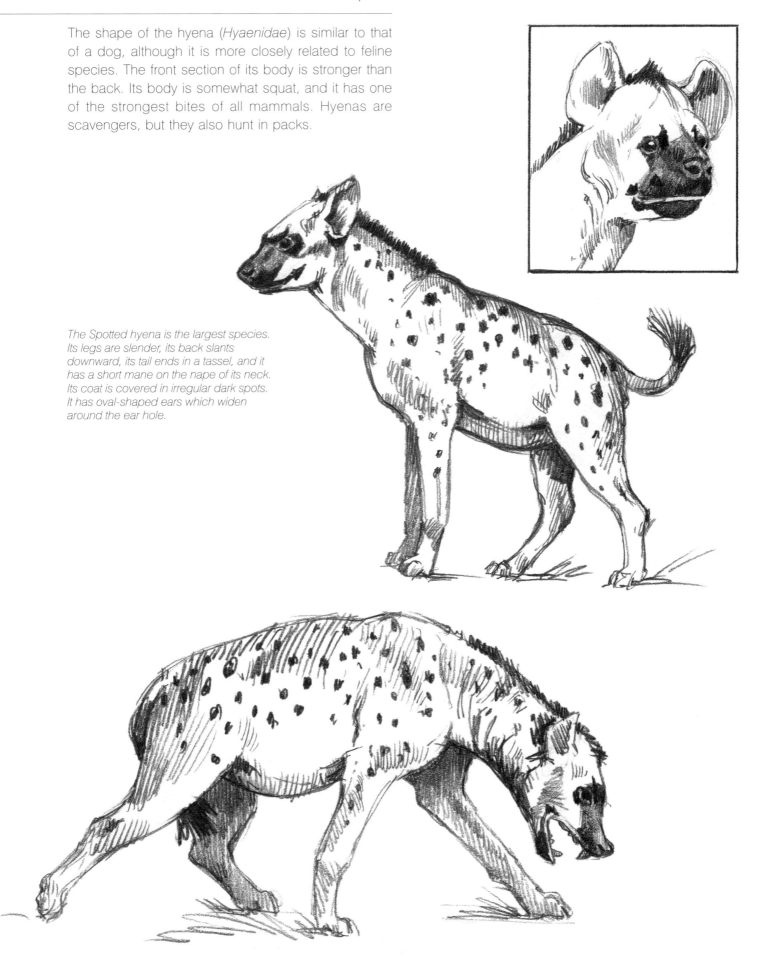

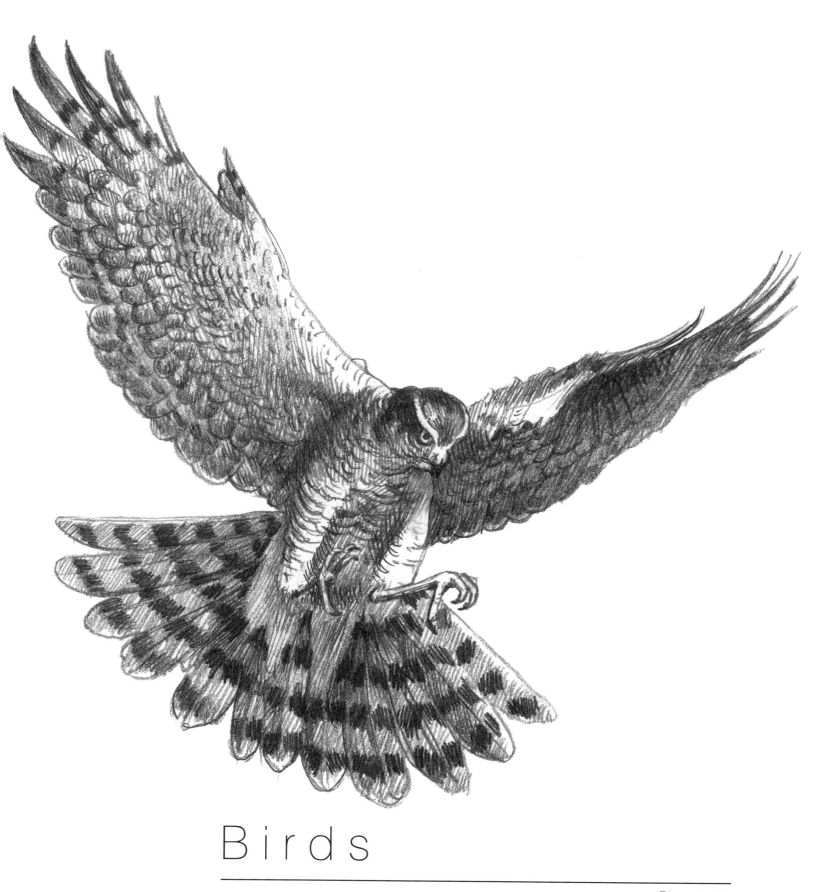

Birds

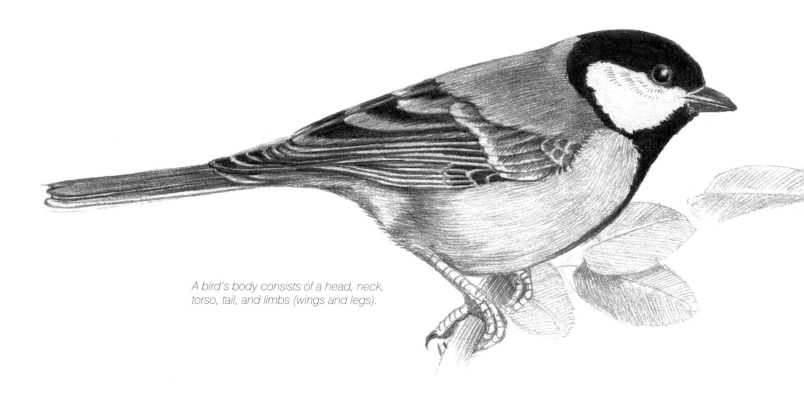

A bird's body consists of a head, neck, torso, tail, and limbs (wings and legs).

The most important parts of the body

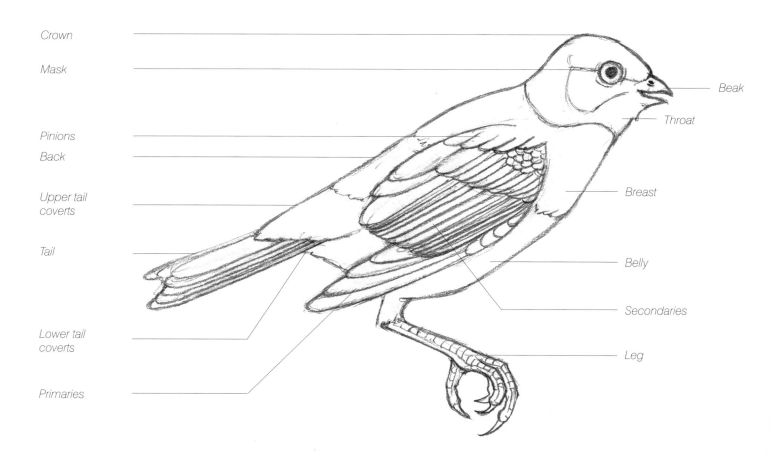

Crown

Mask

Pinions

Back

Upper tail coverts

Tail

Lower tail coverts

Primaries

Beak

Throat

Breast

Belly

Secondaries

Leg

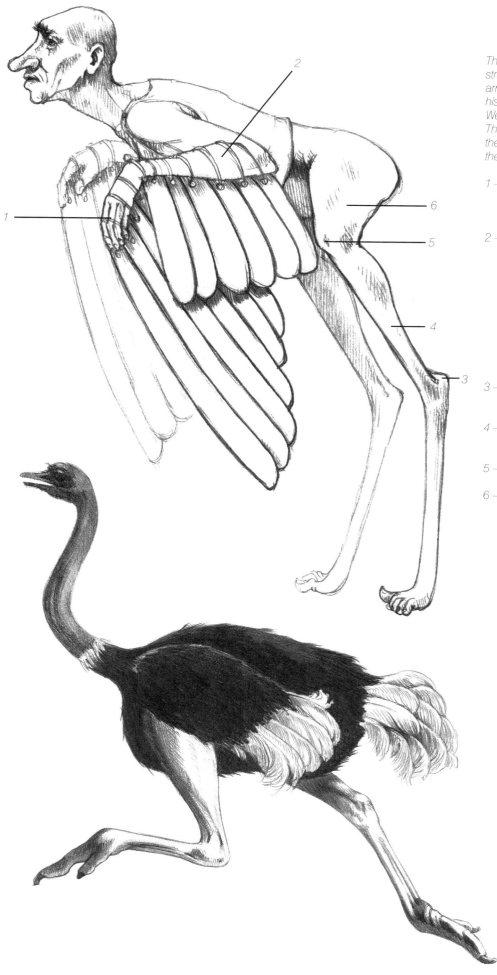

This cartoon will help you understand the structure of the bird's body. The man's arms correspond to the bird's wings, and his legs correspond to the legs of the bird. We can imagine the wings as bent arms. The cartoon picture shows the position of the essential rectrices (flight feathers) on the wings.

1 – The primaries are on the part of the wing that corresponds to the man's hand.

2 – The secondaries are on the part of the wing that corresponds with the human forearm. The shape of the man's legs is also different from the bird's legs, but there are some sections that can be compared. Depending on its way of life, the legs of birds differ greatly, but if you compare the bare legs of the ostrich with those of the man, you will spot the similarities immediately.

3 – The human heel corresponds to this part of the bird.

4 – The human lower leg corresponds to this part of the bird.

5 – Knee

6 – Upper leg

Depending on their way of life the legs of individual types of birds differ greatly, but the legs of birds that are similar, such as songbirds, have similar functions. The outline of the body and head of the birds on this page are spherical. The conical beak, the slender, cylindrical legs, the tips of the wings, and the tail feathers all jut out.

Three toes point forward and one backward. The middle toe is the longest one pointing forward. The toes end in powerful talons.

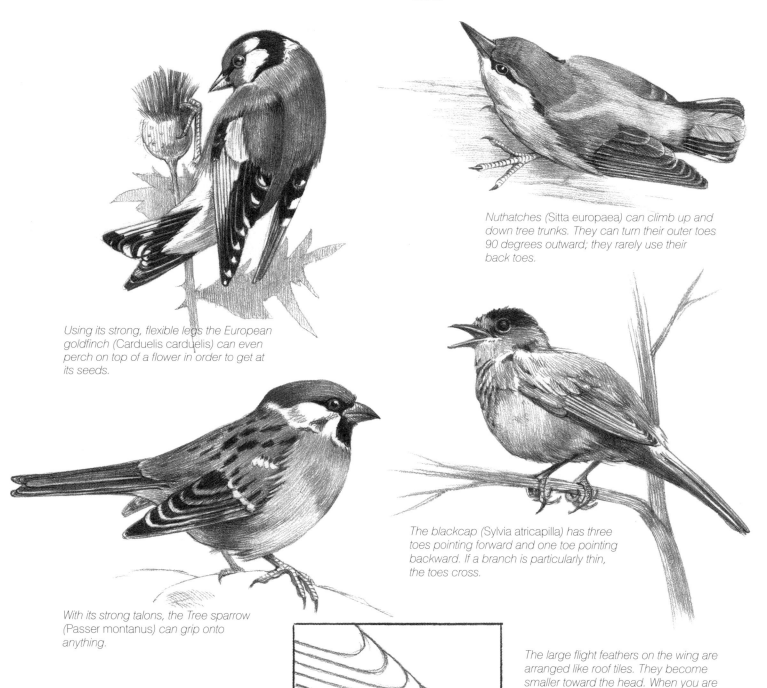

Using its strong, flexible legs the European goldfinch (Carduelis carduelis) can even perch on top of a flower in order to get at its seeds.

Nuthatches (Sitta europaea) can climb up and down tree trunks. They can turn their outer toes 90 degrees outward; they rarely use their back toes.

With its strong talons, the Tree sparrow (Passer montanus) can grip onto anything.

The blackcap (Sylvia atricapilla) has three toes pointing forward and one toe pointing backward. If a branch is particularly thin, the toes cross.

The large flight feathers on the wing are arranged like roof tiles. They become smaller toward the head. When you are drawing them it is important to make individual feathers stand out by outlining them.

The birds on this page belong to the pelican family, which have adapted to living on the water very successfully.

The wing feathers are arranged like small roof tiles. When you are drawing them it is important to separate individual feathers from one another, thus rendering the texture by drawing their outlines. You should only make the flight feathers at the ends of the wings a little livelier. The strict alignment of the feathers can be relaxed by allowing individual feathers to deviate slightly from the general direction.

When swimming, the Brown pelican (Pelicanus occidentalis) paddles with its short, webbed feet. If it wants to raise itself into the air, it walks on the water. The outline of its head is like an acute-angled triangle. One of the pelican's most distinctive features is the throat pouch positioned between its lower beak and neck. This skin is extremely stretchy, and its natural position can be drawn after marking on its outline using parallel lines between its starting point at the tip of the beak and the neck.

White pelican (Pelecanus onocrotalus)

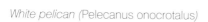

The feet of water birds are superbly adapted to their habitat. Their webbing has a very different texture from the toes, and this must be shown in any drawing. The taut skin can be drawn with short, parallel lines, and given a three-dimensional effect by adding the shadows of the toes. The toes have ring-like scales, while the scales on the legs look like plates. When you are drawing the feet you should apply what you have learned about the shadows on a cylinder.

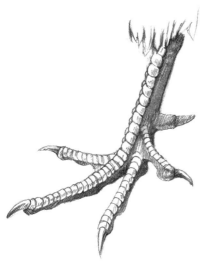

By way of comparison, a chicken's feet are used for scratching and running, so they are markedly different from those of the water birds. They are covered in thick, scaly skin. The flat scales are very close together, and when you are drawing them you should pay attention to their alignment. You should also pay attention to the curve of the sharp talons.

The size of birds of prey varies greatly, but common features include a hooked, downward-curving beak and wide, rounded wings. Their toes are splayed, and end in strongly curved talons with which they seize their prey.

With its outspread wings and tail feathers fanned out for landing, this Eurasian (or Northern) sparrowhawk (Accipiter nisus) makes an imposing sight. The drawing captures the moment that it swoops down on its prey, as also shown by the position of its feet.

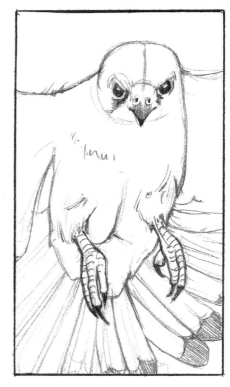

When drawing a bird of prey you should also begin by sketching its distinctive outline. In this view, the head and the large eyes resemble spheres, while the body looks like a compact and round, yet more open shape. The outspread wings and tail feathers must always be adjusted according to the size of the head and the body—it is easy to make mistakes with proportions.

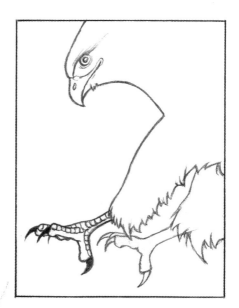

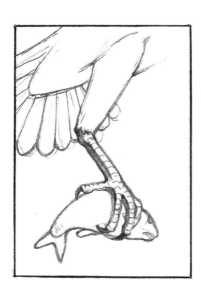

The talons of birds of prey are large and sharp and the undersides of the feet have raised calluses—these features all allow the bird to get a firm grip on its prey.

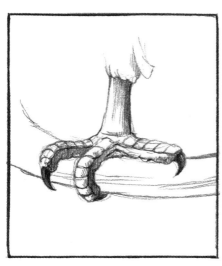

The most distinctive parts of a bird's body—and thus important elements in the drawing—are the wings. You should therefore exercise particular care when drawing them. Another caricature will help you to understand their structure, as the bones of the wings can be likened to the man's arm bones. You will need to be familiar with the alignment and roots of the plumage in order to draw it successfully. In order to fly, birds need a relatively large and wide wing surface. The flight feathers are the biggest feathers. The outer edge of the feathers curves slightly outward, while the inner edge curves slightly inward.

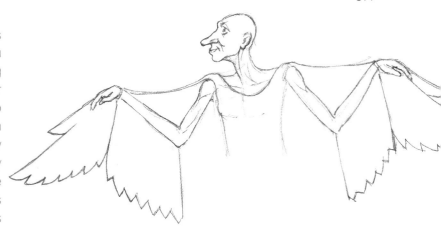

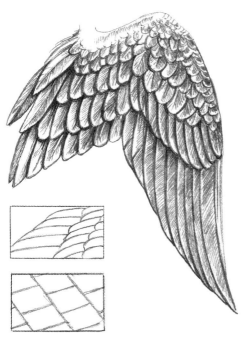

This caricature makes the structure of the wing easier to understand. The wing bones are arranged like the arm of the cartoon figure—the arm is bent. In order to fly, the flight feathers are absolutely essential. These are positioned on the lower edge of the hand and the forearm.

The outer surface of the wing
1 – Primary flight feathers
2 – Secondary flight feathers
3 – Large tail coverts
4 – Primary coverts
5 – Shoulder feathers

You can study the structure of the fanned-out wing using these drawings. The feathers in the area which corresponds to the hand are the longest, and lie right at the bottom. Above them are the feathers in the area corresponding to the forearm, plus the remaining coverts.

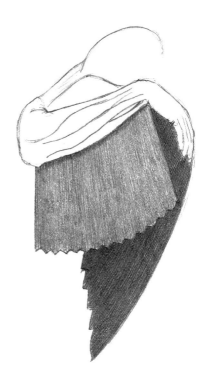

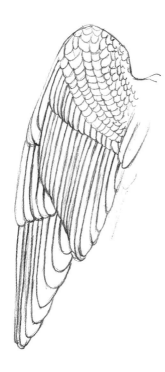

You can make the wing feathers look lifelike by delineating the secondaries and primaries, which form neat rows, becoming shorter toward the base of the wing. The feathers are closely joined together like roof tiles.

Birds capable of flying – example drawings

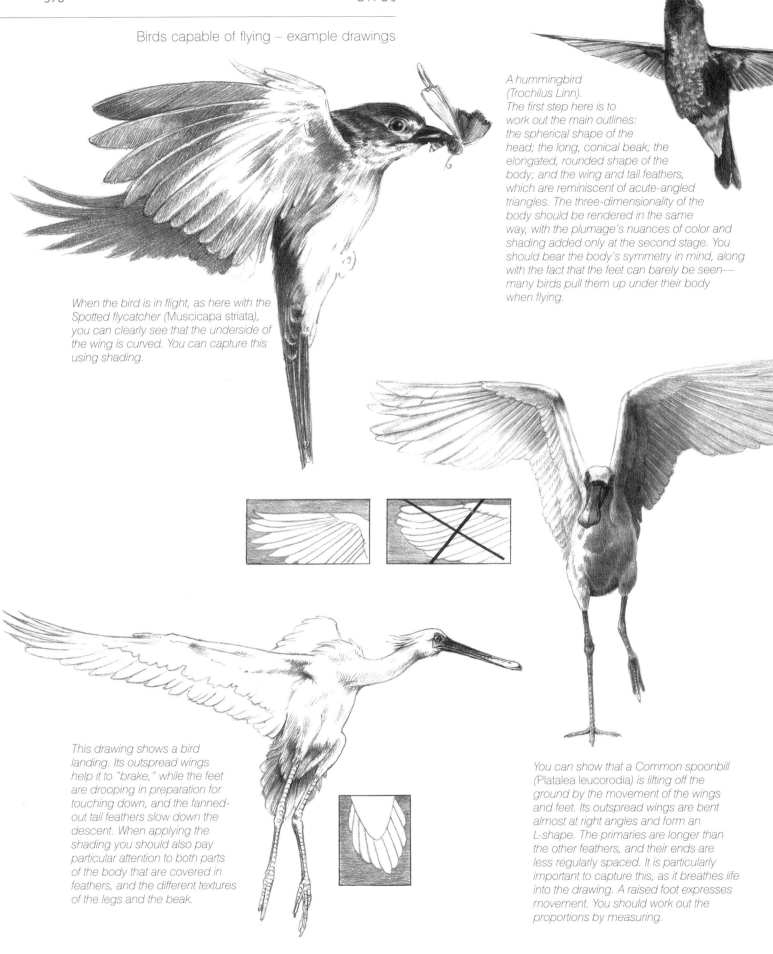

When the bird is in flight, as here with the Spotted flycatcher (Muscicapa striata), you can clearly see that the underside of the wing is curved. You can capture this using shading.

A hummingbird (Trochilus Linn). The first step here is to work out the main outlines: the spherical shape of the head; the long, conical beak; the elongated, rounded shape of the body; and the wing and tail feathers, which are reminiscent of acute-angled triangles. The three-dimensionality of the body should be rendered in the same way, with the plumage's nuances of color and shading added only at the second stage. You should bear the body's symmetry in mind, along with the fact that the feet can barely be seen—many birds pull them up under their body when flying.

This drawing shows a bird landing. Its outspread wings help it to "brake," while the feet are drooping in preparation for touching down, and the fanned-out tail feathers slow down the descent. When applying the shading you should also pay particular attention to both parts of the body that are covered in feathers, and the different textures of the legs and the beak.

You can show that a Common spoonbill (Platalea leucorodia) is lifting off the ground by the movement of the wings and feet. Its outspread wings are bent almost at right angles and form an L-shape. The primaries are longer than the other feathers, and their ends are less regularly spaced. It is particularly important to capture this, as it breathes life into the drawing. A raised foot expresses movement. You should work out the proportions by measuring.

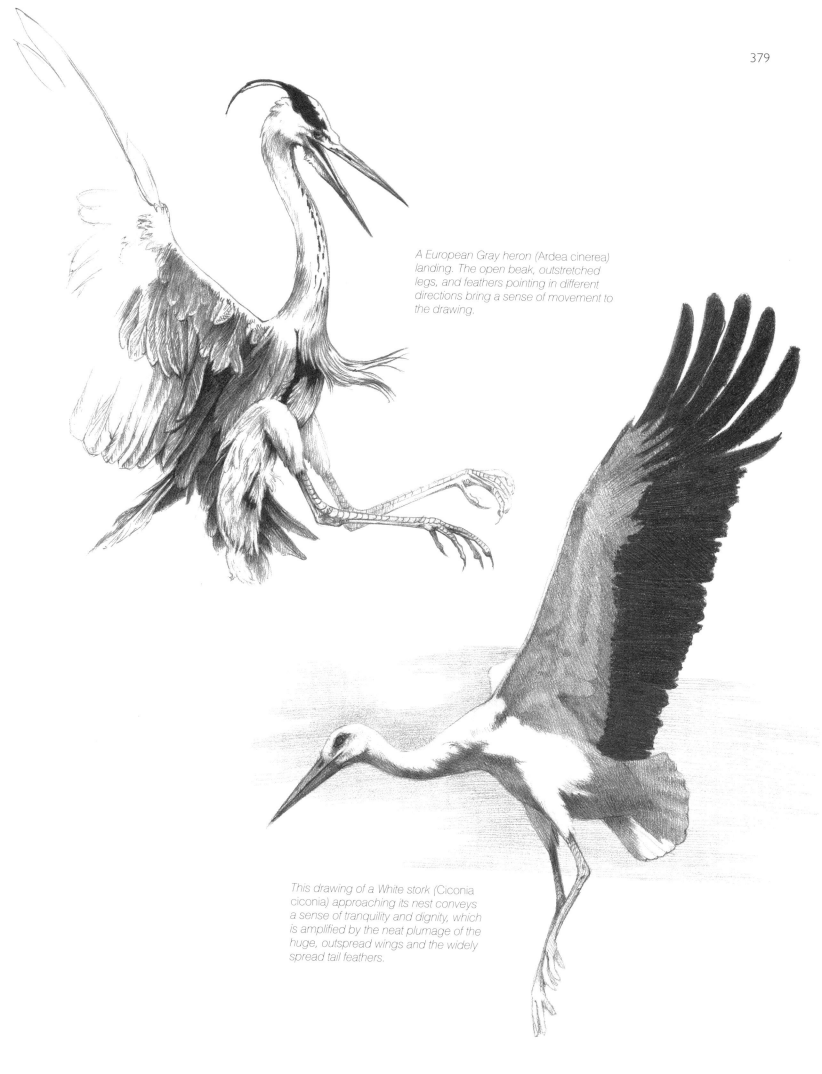

A European Gray heron (Ardea cinerea) landing. The open beak, outstretched legs, and feathers pointing in different directions bring a sense of movement to the drawing.

This drawing of a White stork (Ciconia ciconia) approaching its nest conveys a sense of tranquility and dignity, which is amplified by the neat plumage of the huge, outspread wings and the widely spread tail feathers.

Like the legs, the beak comes in many different forms, and its shape is suited to the way in which the bird feeds itself.

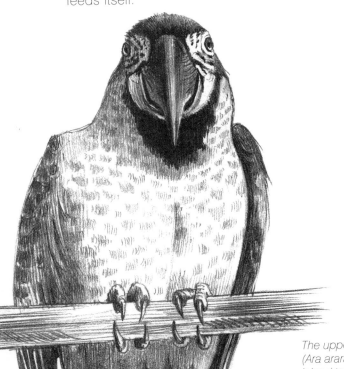

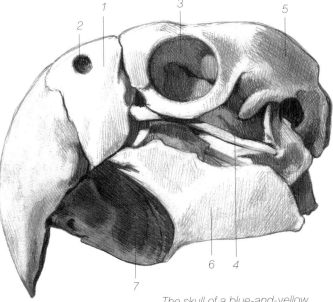

The skull of a blue-and-yellow macaw

1 – incisive bone

2 – nasal opening

3 – eye socket

4 – zygomatic arch

5 – neurocranium

6 – jawbone

7 – horn-like coating over the jawbone

The upper beak of the Blue-and-yellow macaw (Ara ararauna) is strongly curved and loosely joined to the head. This bird feeds on fruit, berries, and insects. It needs its powerful beak to open hard, tropical seeds, but it also uses it for gripping onto things. When seen from the front, the beak gets narrower as it goes downward, and has the outline of an acute-angled triangle. It should be shaded according to the rules for a cylinder. In the bottom view, the tail feathers form two symmetrically aligned columns, and gradually increase in size. Two toes point forward, and the other two back.

If you look closely at a feather you will notice that it has parallel "streaks," which can be drawn with short parallel lines. The shaft stands out from the gently curved feather; you can show this by using denser or darker shading.

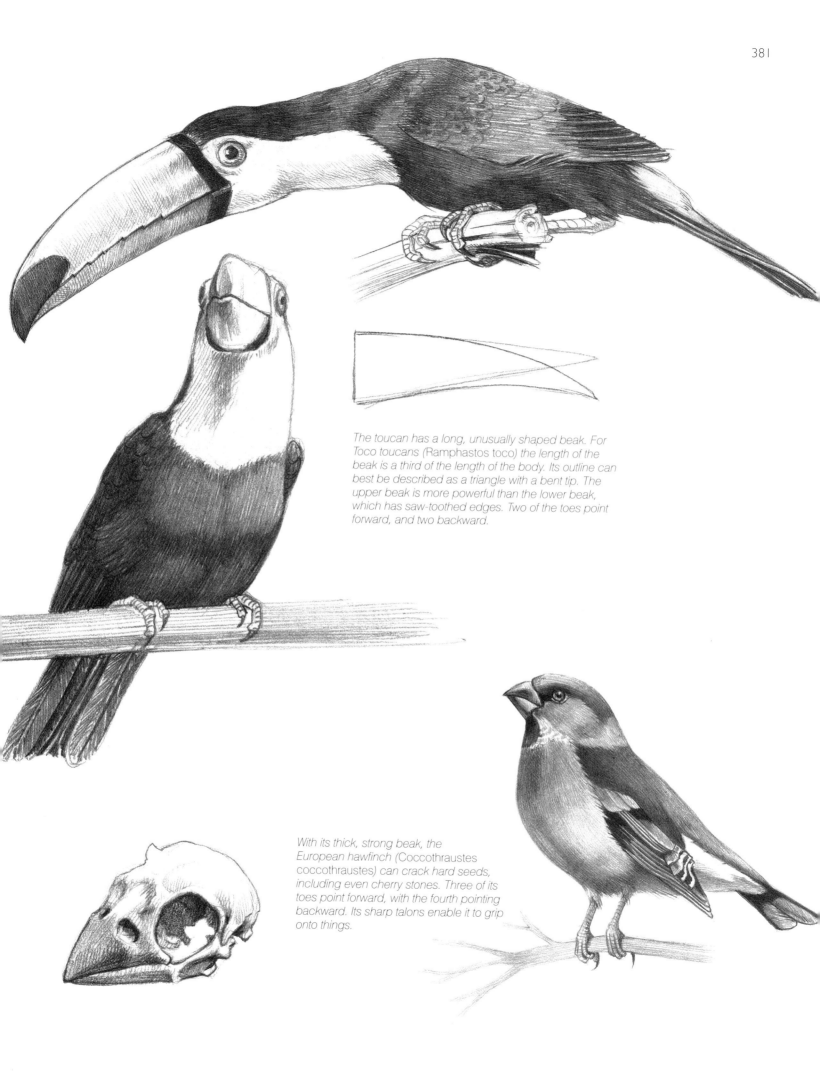

The toucan has a long, unusually shaped beak. For Toco toucans (Ramphastos toco) the length of the beak is a third of the length of the body. Its outline can best be described as a triangle with a bent tip. The upper beak is more powerful than the lower beak, which has saw-toothed edges. Two of the toes point forward, and two backward.

With its thick, strong beak, the European hawfinch (Coccothraustes coccothraustes) can crack hard seeds, including even cherry stones. Three of its toes point forward, with the fourth pointing backward. Its sharp talons enable it to grip onto things.

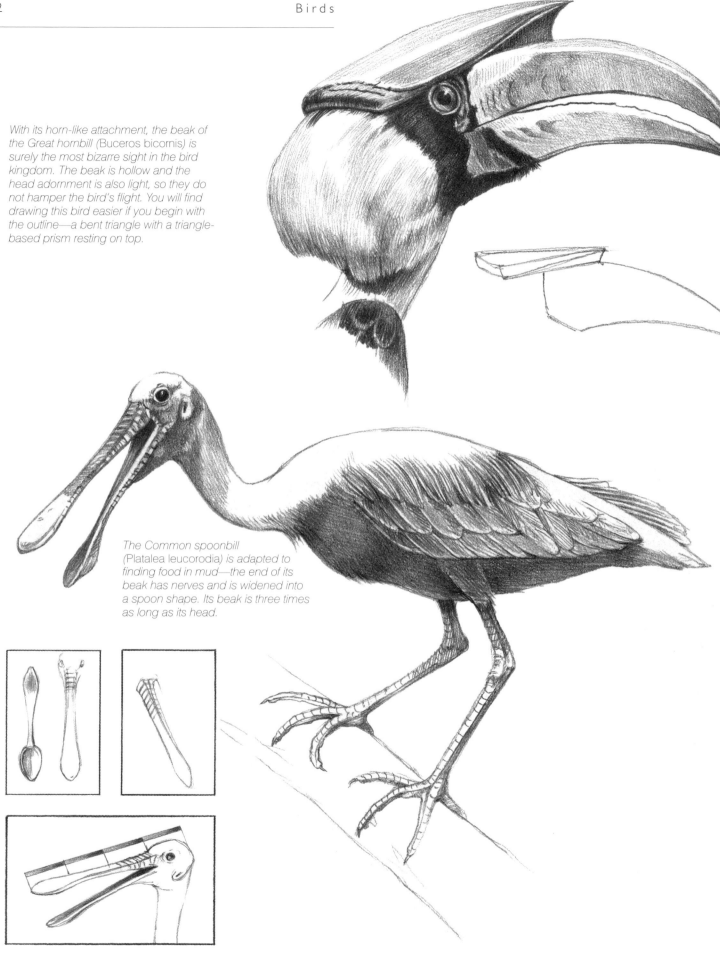

With its horn-like attachment, the beak of
the Great hornbill (Buceros bicornis) is
surely the most bizarre sight in the bird
kingdom. The beak is hollow and the
head adornment is also light, so they do
not hamper the bird's flight. You will find
drawing this bird easier if you begin with
the outline—a bent triangle with a triangle-
based prism resting on top.

The Common spoonbill
(Platalea leucorodia) is adapted to
finding food in mud—the end of its
beak has nerves and is widened into
a spoon shape. Its beak is three times
as long as its head.

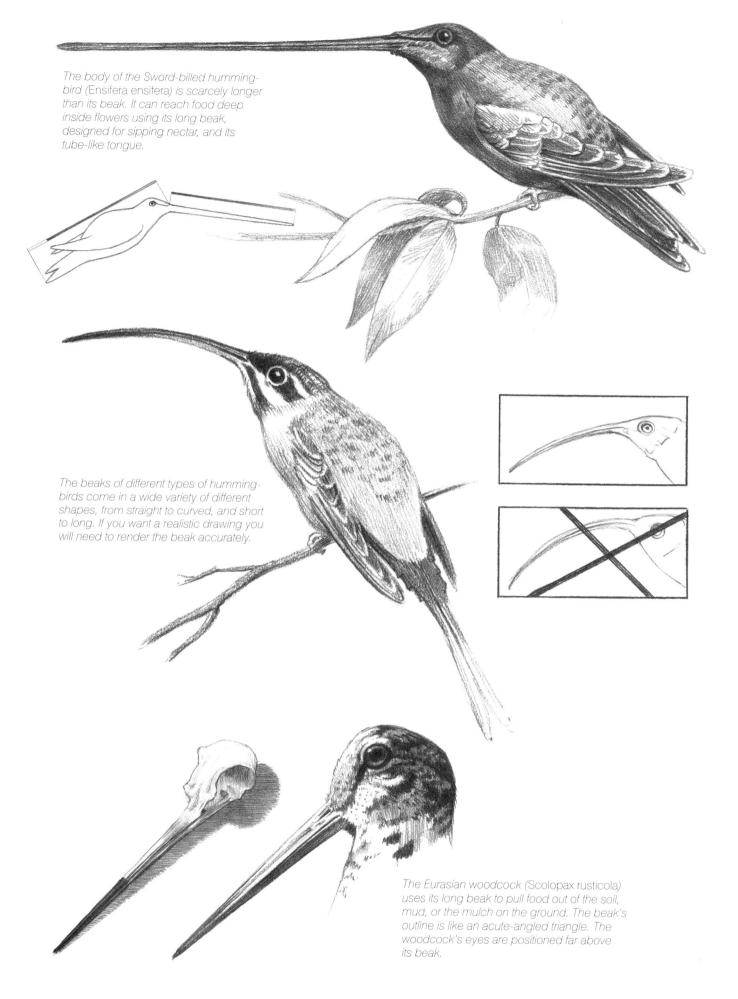

The body of the Sword-billed humming-bird (Ensifera ensifera) is scarcely longer than its beak. It can reach food deep inside flowers using its long beak, designed for sipping nectar, and its tube-like tongue.

The beaks of different types of humming-birds come in a wide variety of different shapes, from straight to curved, and short to long. If you want a realistic drawing you will need to render the beak accurately.

The Eurasian woodcock (Scolopax rusticola) uses its long beak to pull food out of the soil, mud, or the mulch on the ground. The beak's outline is like an acute-angled triangle. The woodcock's eyes are positioned far above its beak.

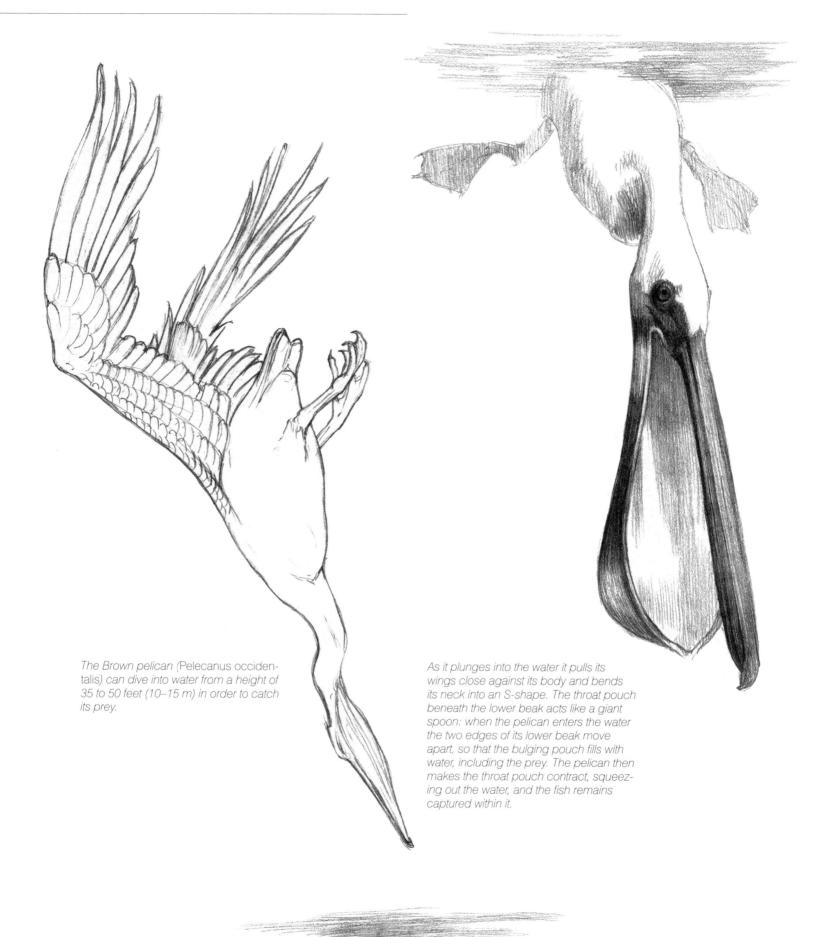

The Brown pelican (Pelecanus occiden-
talis) can dive into water from a height of
35 to 50 feet (10–15 m) in order to catch
its prey.

As it plunges into the water it pulls its
wings close against its body and bends
its neck into an S-shape. The throat pouch
beneath the lower beak acts like a giant
spoon: when the pelican enters the water
the two edges of its lower beak move
apart, so that the bulging pouch fills with
water, including the prey. The pelican then
makes the throat pouch contract, squeez-
ing out the water, and the fish remains
captured within it.

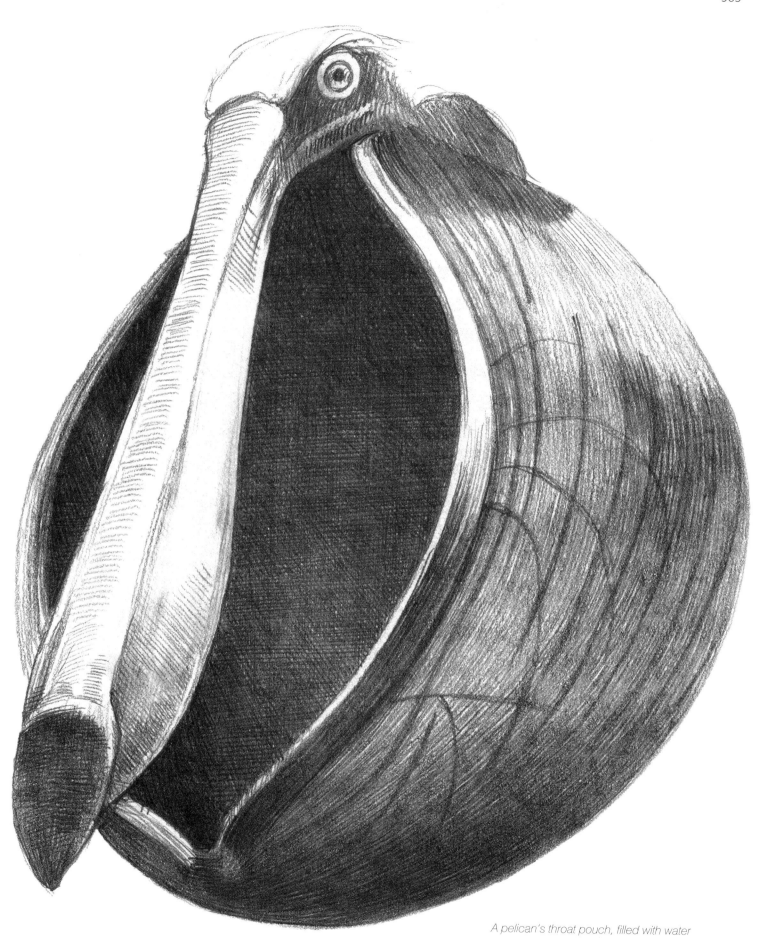

A pelican's throat pouch, filled with water

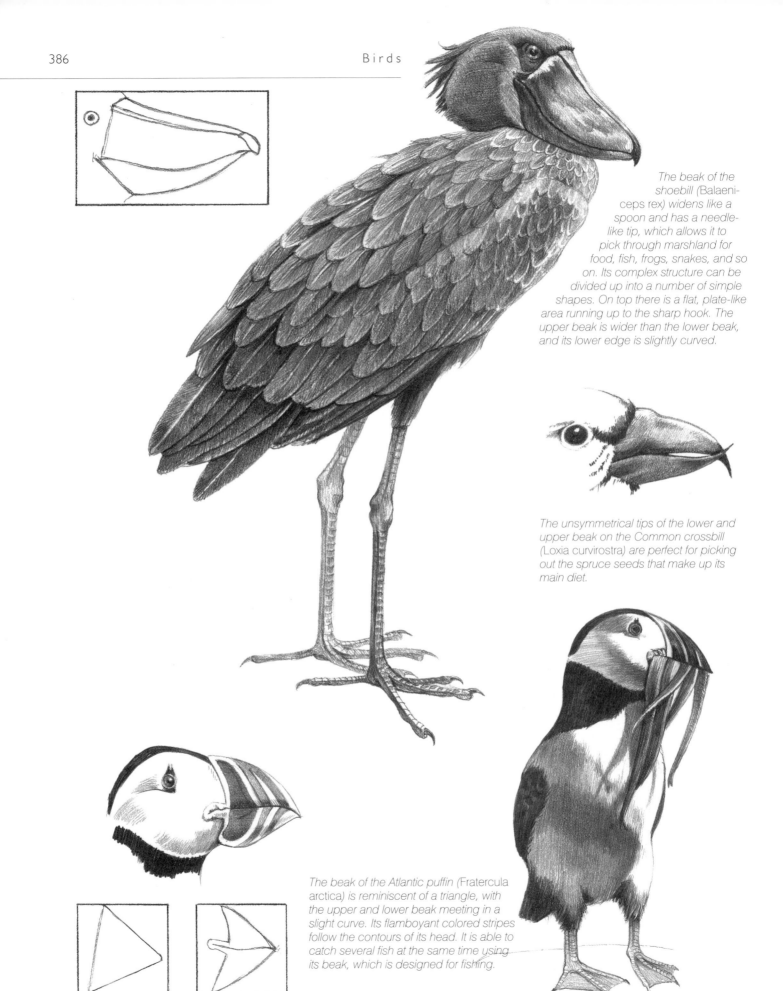

The beak of the shoebill (Balaeniceps rex) widens like a spoon and has a needle-like tip, which allows it to pick through marshland for food, fish, frogs, snakes, and so on. Its complex structure can be divided up into a number of simple shapes. On top there is a flat, plate-like area running up to the sharp hook. The upper beak is wider than the lower beak, and its lower edge is slightly curved.

The unsymmetrical tips of the lower and upper beak on the Common crossbill (Loxia curvirostra) are perfect for picking out the spruce seeds that make up its main diet.

The beak of the Atlantic puffin (Fratercula arctica) is reminiscent of a triangle, with the upper and lower beak meeting in a slight curve. Its flamboyant colored stripes follow the contours of its head. It is able to catch several fish at the same time using its beak, which is designed for fishing.

Other types of feathers and adornments

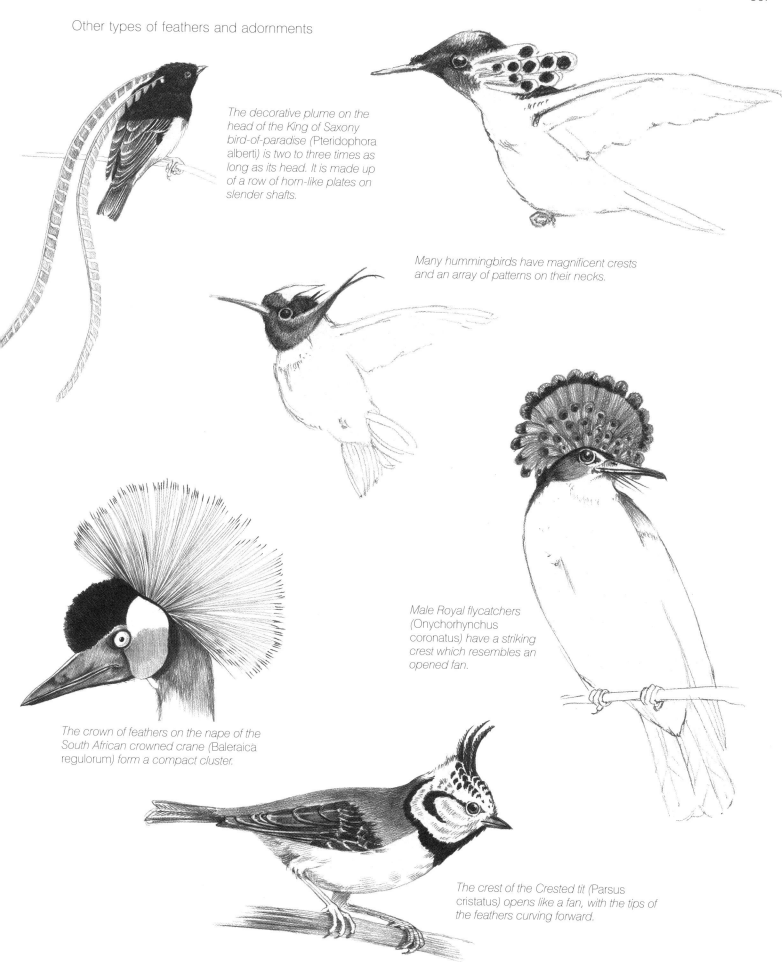

The decorative plume on the head of the King of Saxony bird-of-paradise (Pteridophora alberti) is two to three times as long as its head. It is made up of a row of horn-like plates on slender shafts.

Many hummingbirds have magnificent crests and an array of patterns on their necks.

The crown of feathers on the nape of the South African crowned crane (Baleraica regulorum) form a compact cluster.

Male Royal flycatchers (Onychorhynchus coronatus) have a striking crest which resembles an opened fan.

The crest of the Crested tit (Parsus cristatus) opens like a fan, with the tips of the feathers curving forward.

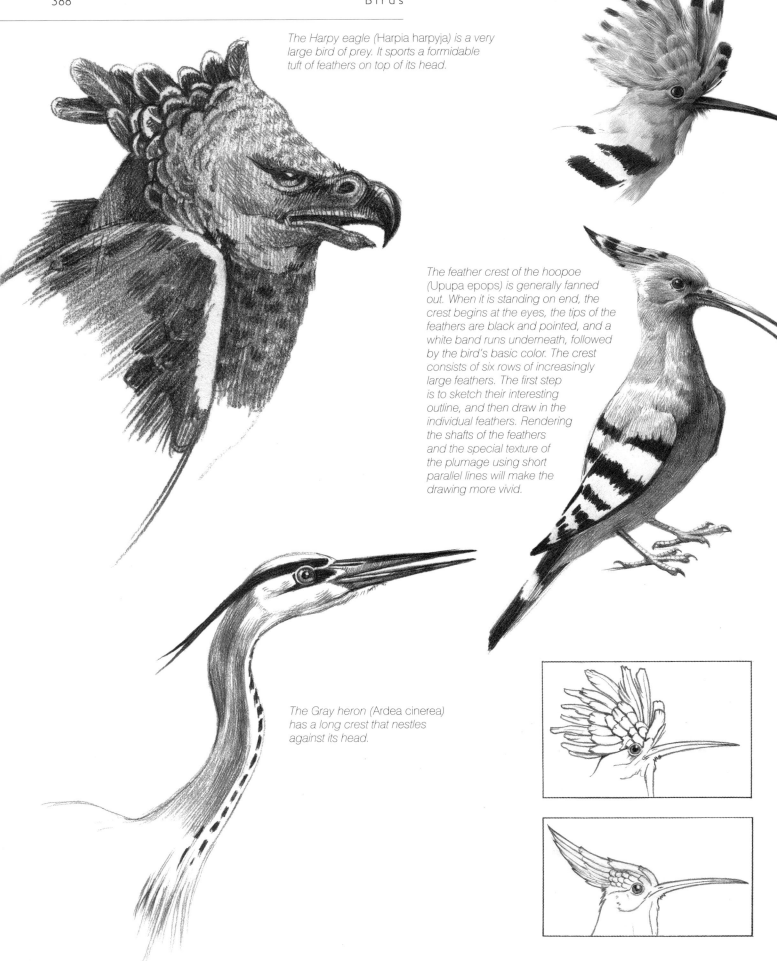

The Harpy eagle (Harpia harpyja) is a very large bird of prey. It sports a formidable tuft of feathers on top of its head.

The feather crest of the hoopoe (Upupa epops) is generally fanned out. When it is standing on end, the crest begins at the eyes, the tips of the feathers are black and pointed, and a white band runs underneath, followed by the bird's basic color. The crest consists of six rows of increasingly large feathers. The first step is to sketch their interesting outline, and then draw in the individual feathers. Rendering the shafts of the feathers and the special texture of the plumage using short parallel lines will make the drawing more vivid.

The Gray heron (Ardea cinerea) has a long crest that nestles against its head.

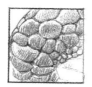

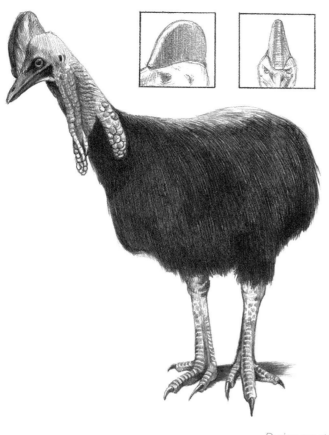

The Southern cassowary (Casuarius casuarius) has a semicircular, horn tissue-covered shape on a patch of spongy bone tissue on top of its head. When seen from the front it is narrow and looks like an inverted V. At its throat it has a wattle of skin with a wart-like texture. These flat warts are smaller around the beak and become gradually larger farther down, with no particular pattern and a wide variety of shapes, from round to oblong. When drawing this it is important to render a realistic depiction of the warts, as well as giving them consistent shading; the flat disks are slightly raised, and their texture is not completely smooth.

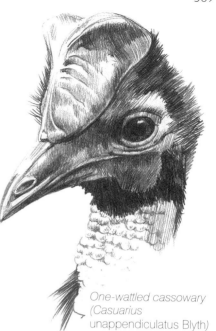

One-wattled cassowary (Casuarius unappendiculatus Blyth)

During courtship displays, the male Magnificent frigatebird (Fregata magnificens) puffs up his throat pouch in order to attract the female's attention.

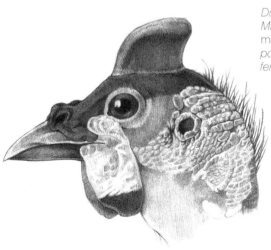

The Helmeted guineafowl (Numida meleagris domestica) also has a helmet made of horn tissue, and a wattle on either side of its beak.

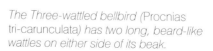

The Three-wattled bellbird (Procnias tri-carunculata) has two long, beard-like wattles on either side of its beak.

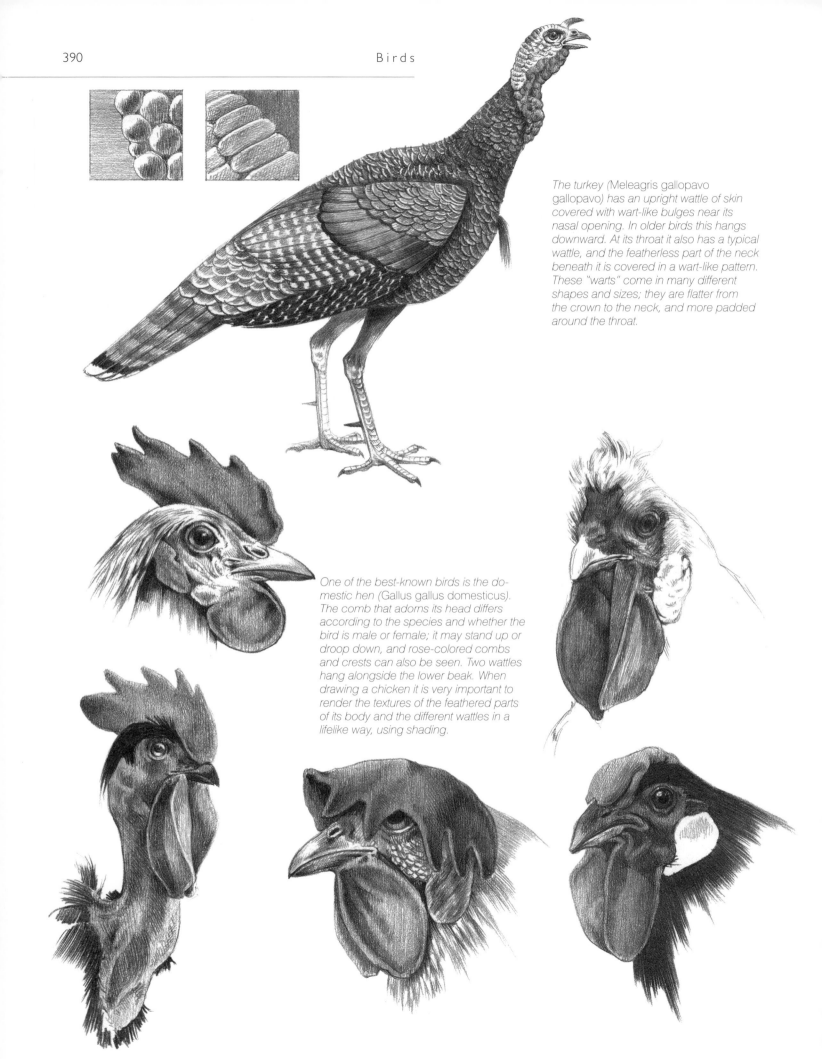

The turkey (Meleagris gallopavo gallopavo) has an upright wattle of skin covered with wart-like bulges near its nasal opening. In older birds this hangs downward. At its throat it also has a typical wattle, and the featherless part of the neck beneath it is covered in a wart-like pattern. These "warts" come in many different shapes and sizes; they are flatter from the crown to the neck, and more padded around the throat.

One of the best-known birds is the domestic hen (Gallus gallus domesticus). The comb that adorns its head differs according to the species and whether the bird is male or female; it may stand up or droop down, and rose-colored combs and crests can also be seen. Two wattles hang alongside the lower beak. When drawing a chicken it is very important to render the textures of the feathered parts of its body and the different wattles in a lifelike way, using shading.

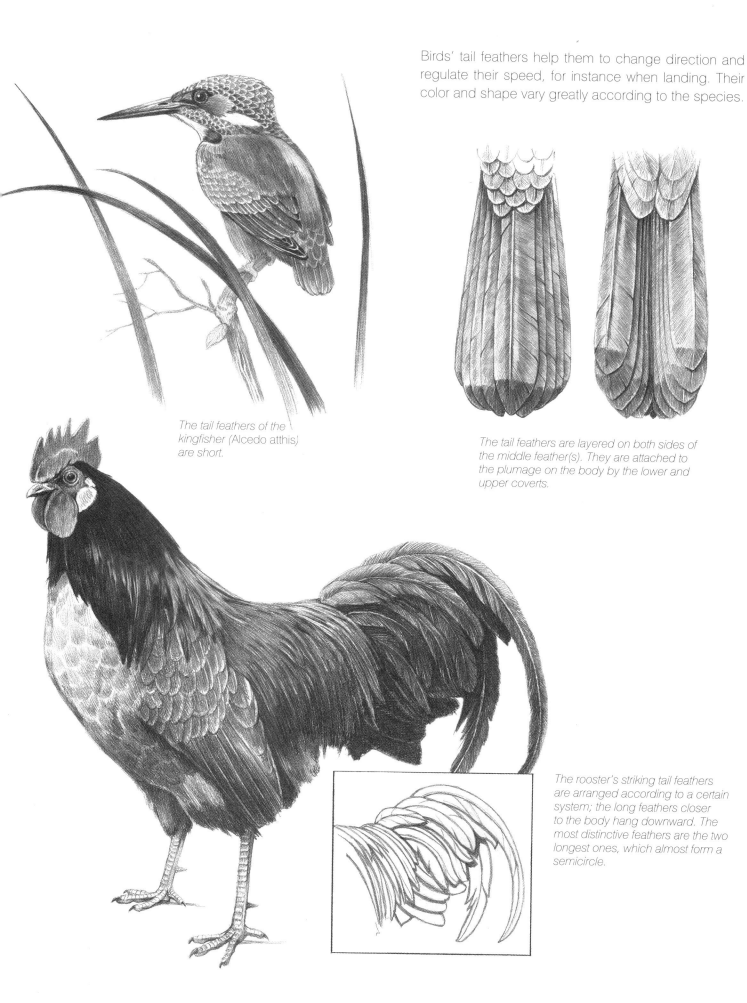

Birds' tail feathers help them to change direction and regulate their speed, for instance when landing. Their color and shape vary greatly according to the species.

The tail feathers of the kingfisher (Alcedo atthis) are short.

The tail feathers are layered on both sides of the middle feather(s). They are attached to the plumage on the body by the lower and upper coverts.

The rooster's striking tail feathers are arranged according to a certain system; the long feathers closer to the body hang downward. The most distinctive feathers are the two longest ones, which almost form a semicircle.

Tail feathers—example drawings

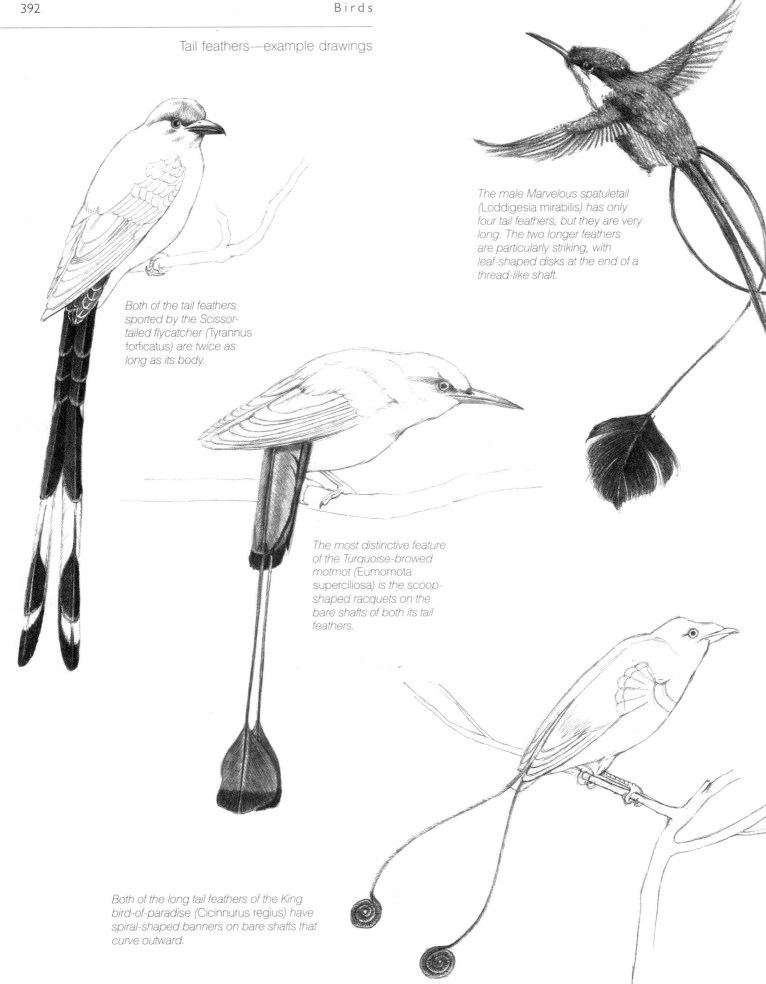

The male Marvelous spatuletail (Loddigesia mirabilis) has only four tail feathers, but they are very long. The two longer feathers are particularly striking, with leaf-shaped disks at the end of a thread-like shaft.

Both of the tail feathers sported by the Scissor-tailed flycatcher (Tyrannus forficatus) are twice as long as its body.

The most distinctive feature of the Turquoise-browed motmot (Eumomota superciliosa) is the scoop-shaped racquets on the bare shafts of both its tail feathers.

Both of the long tail feathers of the King bird-of-paradise (Cicinnurus regius) have spiral-shaped banners on bare shafts that curve outward.

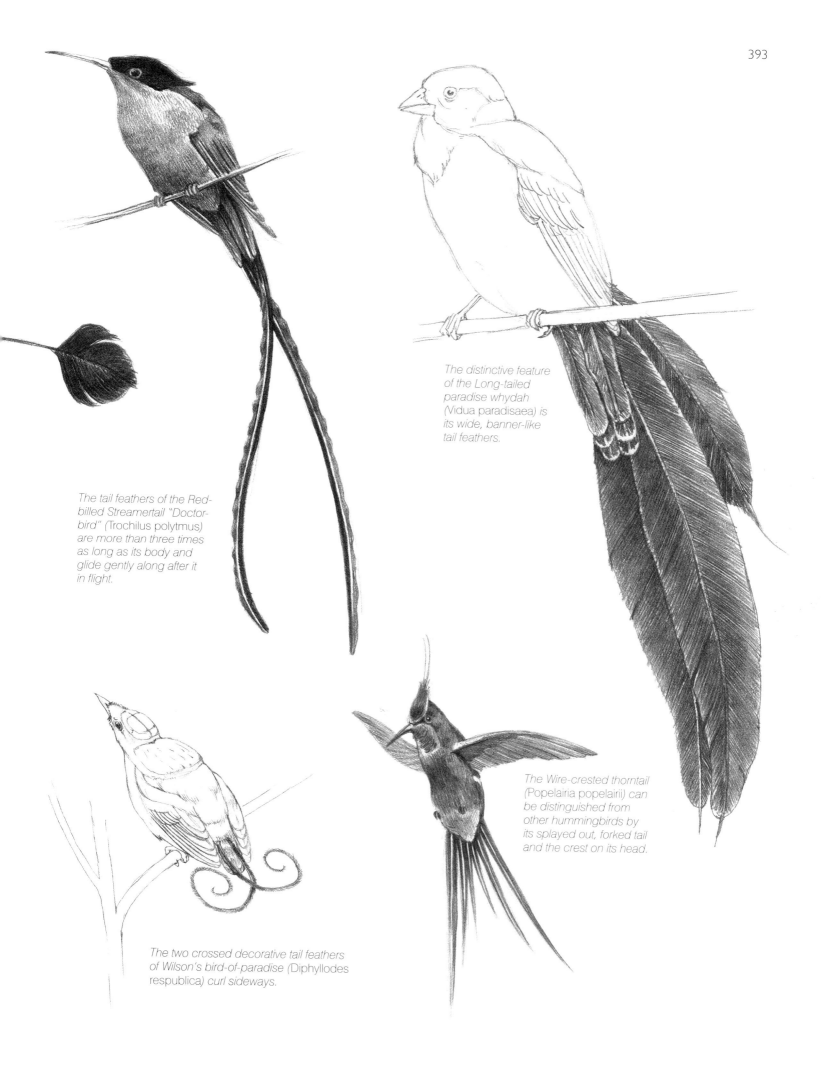

The distinctive feature of the Long-tailed paradise whydah (Vidua paradisaea) is its wide, banner-like tail feathers.

The tail feathers of the Red-billed Streamertail "Doctor-bird" (Trochilus polytmus) are more than three times as long as its body and glide gently along after it in flight.

The Wire-crested thorntail (Popelairia popelairii) can be distinguished from other hummingbirds by its splayed out, forked tail and the crest on its head.

The two crossed decorative tail feathers of Wilson's bird-of-paradise (Diphyllodes respublica) curl sideways.

You will only be able to produce a lifelike, accurate drawing if you know the proportions of your subject. You should ask questions such as: how long and tall is the bird; how big is its head; how does the size of its beak compare with the size of its head or the whole bird; and how long are its toes?

You should begin by doing a sketch with just a few lines, to give a general impression. You can use a plotting grid to check the proportions. The next step is to develop the lines and get to a stage where the drawing is almost completely correct. You can then add the shading, and only then should you refine the details, rendering the different textures in the picture.

Using a plotting grid, you will see that the Hooded crow (Corvus cornix) is approximately twice as long as it is tall, and that the largest space between its splayed toes is equivalent to half its body height.

*Puffin
(Fratercula arctica)*

*Common spoonbill
(Platalea
leucorodia)*

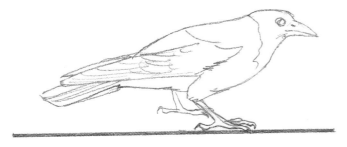

*Pied kingfisher
(Ceryle rudis)*

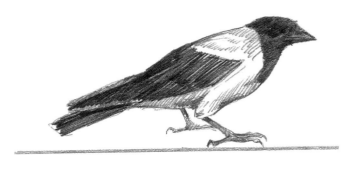

*Schematic drawing of tail feathers
splayed out like a fan.*

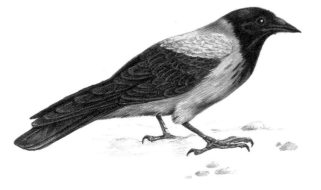

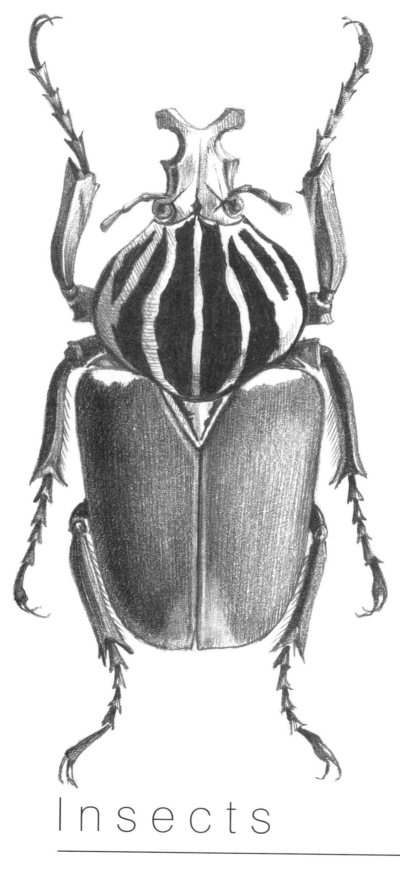

Insects

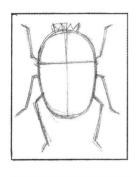

The most distinctive feature of the beetle is its exoskeleton, which protects it from outside interference. Like other insects, its body is divided into three distinct sections: the head, the chest (thorax), and the abdomen. The complex eyes, the antennae, and the mandibles are found on the head, and the mandibles have two pairs of feelers. The chest is made up of three sections: the prothorax, mesothorax, and metathorax. The legs are on the underside of the beetle; the wings are on the dorsal (back) side. Beetles have a pair of legs on every section of the thorax; those on the prothorax point forward, while those on the mesothorax and metathorax point backward. The legs are divided into femur, tibia, and foot (tarsus). A beetle's feet consist of several (three to five) tarsal joints, of which the last has claws. The chitin-plated forewings are located on the middle section of the thorax, with the thin, transparent, membranous wings, which are actually used for flying, on the back section. The forewings cover and protect the softer abdomen.

Common cockchafer
(Melolontha melolontha)

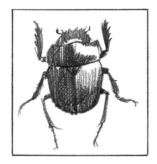

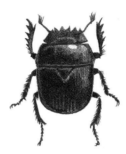

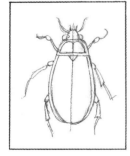

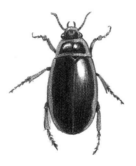

When drawing an Earth-boring dung beetle (Atechus pius L.), you should proceed according to the following steps. Firstly, sketch out the main outline, followed by the ovals of the body and the head, as well as the legs. The main areas of the body should be drawn on. The next step is to mark on the different areas of shading. As the beetle is black, the transitions between these areas are quite subtle. As you develop the drawing you can add a sense of three-dimensionality to the glossy exoskeleton and the structure of the legs. You should make sure that the body is made up of two symmetrical sections. The key feature, the hard forewings, are often smooth and glossy, but they can also be corrugated, as on the cockchafer. The rules of perspective should obviously be applied here, too. If you are not drawing the beetle from the front, straight lines become curved, and parallel lines converge as they move away from the viewer.

When you draw a Great diving beetle (Dytiscus marginalis L.) you should also begin by sketching the body and the legs. Its curved exoskeleton should be shaded as described in the section on rounded surfaces.

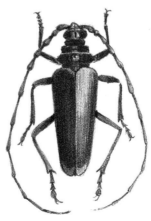

The antennae of the male Great Capricorn beetle (Cerambyx cerdo) are much longer than its body and consist of ever smaller drop-shaped links. The outline of the body here is also made up of different shapes, including several cylinders. Realizing this will make it easier to apply the shading and render the effect of light and shadow. The forewings taper toward the ends.

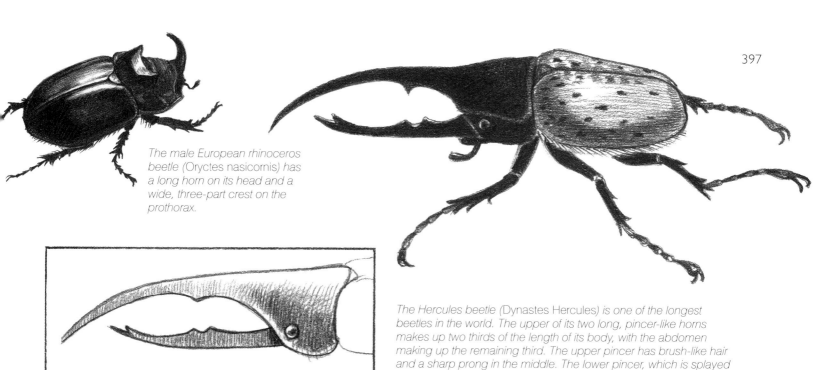

The male European rhinoceros beetle (Oryctes nasicornis) has a long horn on its head and a wide, three-part crest on the prothorax.

The Hercules beetle (Dynastes Hercules) is one of the longest beetles in the world. The upper of its two long, pincer-like horns makes up two thirds of the length of its body, with the abdomen making up the remaining third. The upper pincer has brush-like hair and a sharp prong in the middle. The lower pincer, which is splayed like a fork, has two prongs which help the beetle to grip onto things.

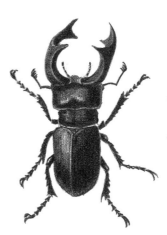

The male Stag beetle (Lucanus cervus) has powerful upper jaws that resemble branched antlers. With these terrifying upper jaws the head makes up roughly half the beetle's length.

The body of the Bee beetle (Trichius fasciatus) is covered in dense chitin hair, which can be seen on the button-like thorax as well as the forewings. It is also interesting to note that the thorax is circular, unlike the semicircular shape found in other beetles.

Butterflies come in a variety of different colors and shapes, but one common feature is that the wings that come out from their thorax are veined and covered in scales that are arranged like a pattern of bricks. In roughly the middle of the forewings and hindwings is a noose-like shape, from which the veins that subdivide the wings emanate.

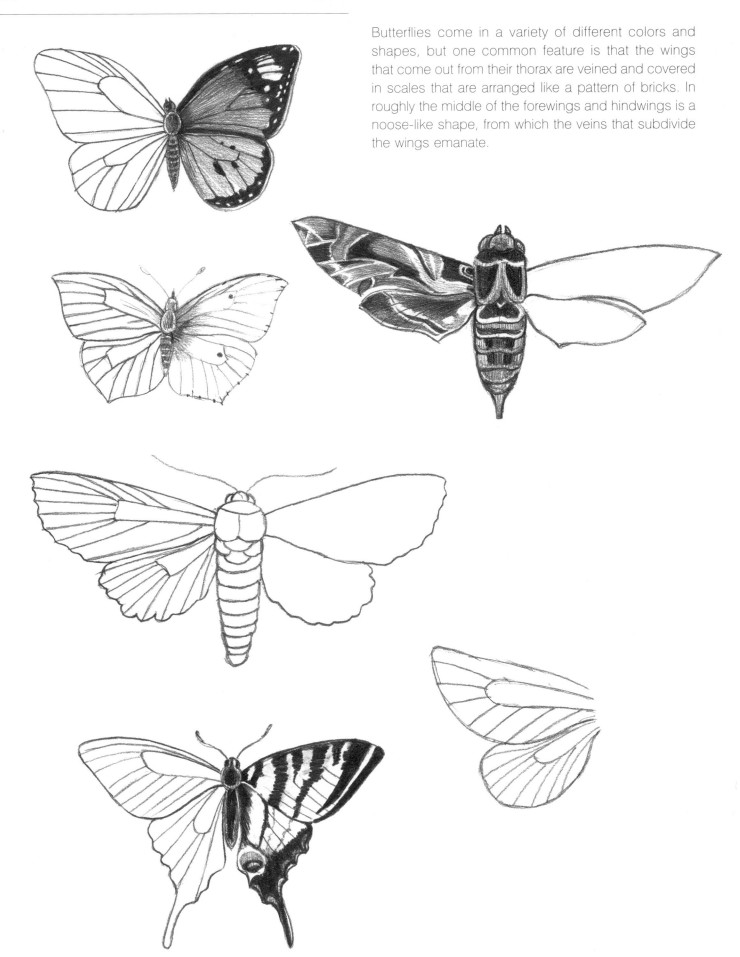

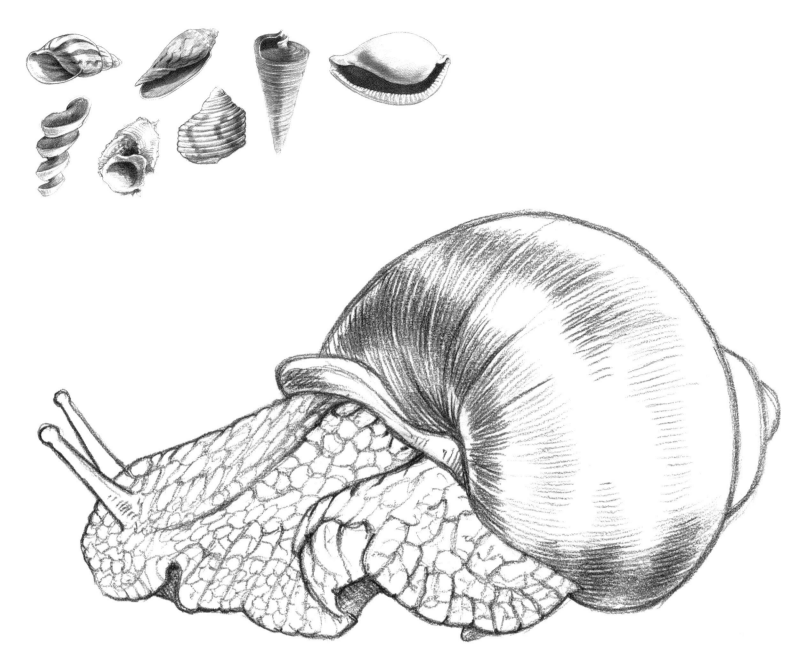

Snails

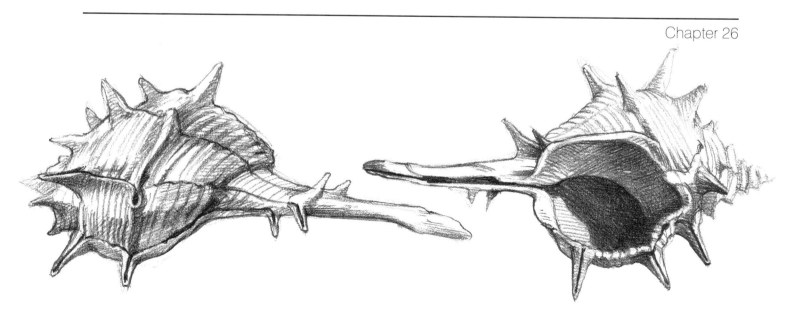

Drawing snails is an interesting exercise, as you will need to render very diverse textures and shapes in order to achieve a lifelike picture. You should use a plotting grid to find the proportions of the Roman snail (Helix pomatia). The snail shell is five squares long and four squares high. The body of the snail is 11 squares long and about one and a half squares high. Using the plotting grid makes it easier to work out the position and size of the spiral-shaped, broadening snail shell.

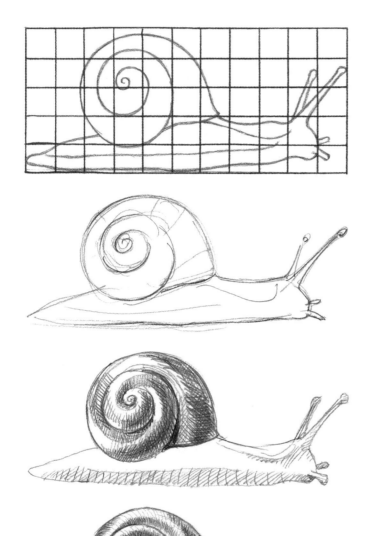

The snail shell looks as though it is made up of increasingly large rings. In addition to this you should also render the curvature of the surface. No matter what kind of snail shell you are drawing, and from what angle, your first step should be to determine where its point, the middle of the spiral, lies. Then you can compare the shell's height and width, and thus work out the shape of the outline—in this case, an acute-angled triangle. By measuring you can then easily proceed to work out the position of the coils, which become wider and wider as they move downward.

After determining the measurements, the first step is to make a quick sketch containing all the details in their correct position. By marking on the areas of shading you can also prepare to replicate the three-dimensional effect of the snail shell in the drawing. After doing this you should develop the texture, the color, and the pattern of the shell. The body needs to be given particular attention; the folds on the lower part of the body and along the lines that segment it are evenly spaced, and create a wart-like texture.

A typical spiral on a snail shell

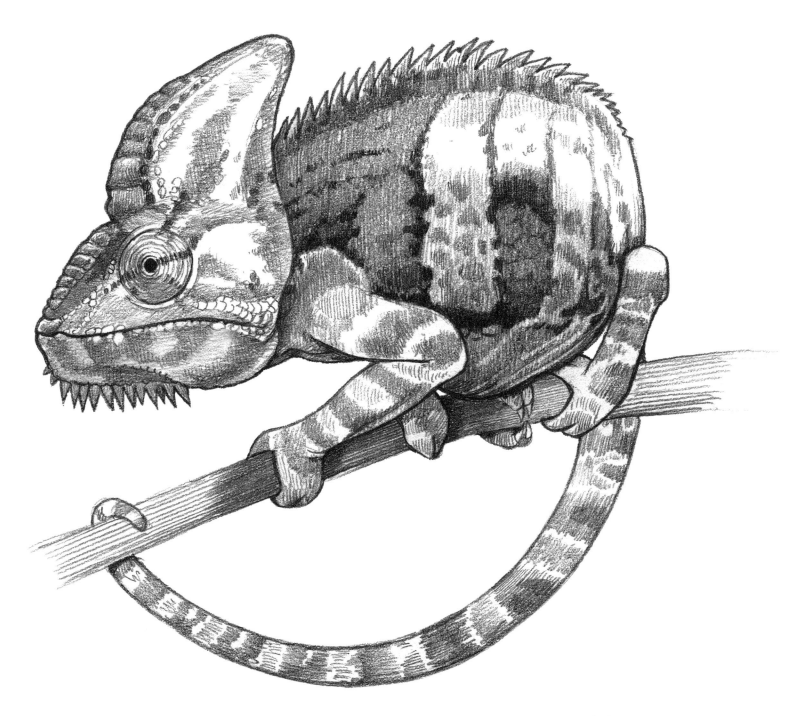

Amphibians and Reptiles

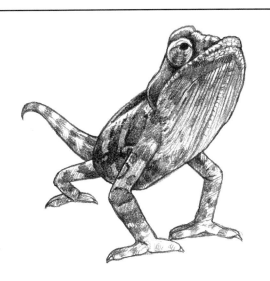

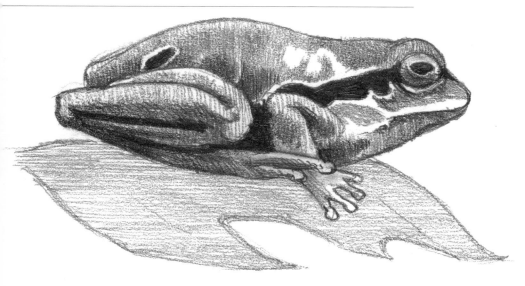

The European tree frog (Hyla arborea) is one of the best-known European amphibian species. Its most distinctive characteristics include its wide mouth and its protruding eyes on top of its head. The pupil of the eye differs according to the species. Its front legs are weaker and have four fingers with suckers at their tips. With five toes, the back legs are very muscular, and known as the cannon bone. The skin contains many glands, but in this species it is relatively smooth, unlike the warty skin of the toad. The tree frog can adjust the color of its skin to anything from light green to dark brown in order to blend in with its surroundings.

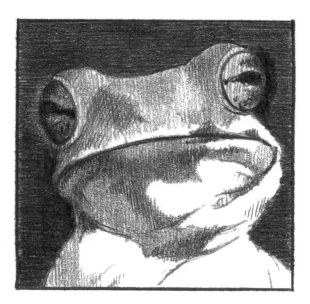

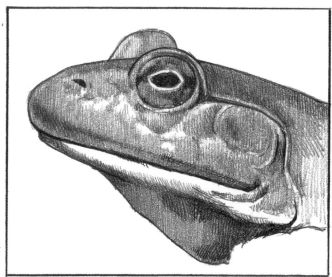

Drawing the frog's glossy, permeable, slippery skin presents a particular challenge for the artist. Narrowing your eyes when looking at the frog makes it easier to discern the correct shading.

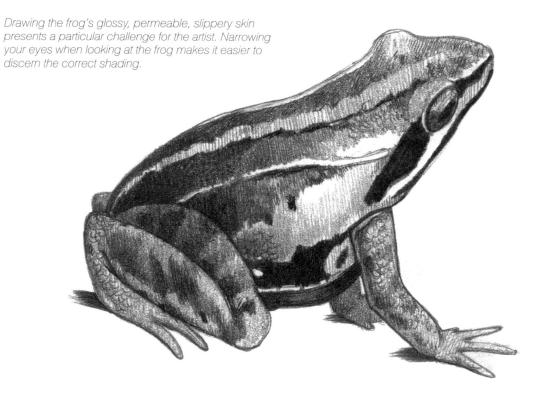

The bodily frame of lizards, which are classed as reptiles, is very similar: they can be divided into an elongated body, four limbs, and a long tail. Normally the limbs stick out from the body, and they generally

The tail is very long, and can grow up to five or six times the length of the body. Lizards' eyes vary greatly in size. Many species have very small eyes, but in others they are enormous and strongly protruding. Their eyelids are normally separate, so that they can blink. They have a wide mouth with lots of small, sharp teeth.

have five toes each, with sharp claws, allowing them to grasp even stones. Their bodies are covered in dry, horny scales. The torso is normally cylindrical, although it can also be flat.

Regularly spaced scales can be seen around the mouth of the lizard, separated from one another by a narrow indentation.

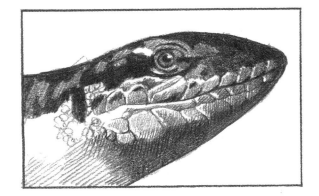

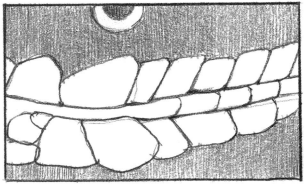

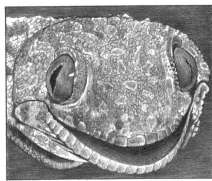

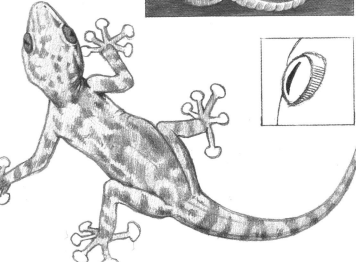

The special thing about geckos (Gekkonidae) is their prominent eyes which sit on either side of their wide heads, and look to the sides. They do not blink, as their eyelids are grown together and transparent. If you look closely at the eye area and divide it into simpler shapes, you will see two cylindrical shapes, with the hemispherical eye protruding out of them. During daylight the pupils contract; when it is dark they widen.

In profile, the gecko's head is elongated and wedge-shaped, and the opening of the ear lies very far back in relation to the nose and eyes. The tail makes up roughly two fifths of the whole length of the body. In situations of danger it breaks off easily and grows back again within a few months, but the new tail will have a different structure to the original one. Drawing the texture of the body is a difficult task; the belly is normally light and covered in smooth scales, but depending on the habitat and subspecies the upper side of the body can come in a wide variety of different colors, from yellowy gray to black, and may be striped or unpatterned.

Rows of scales may run parallel to the body's axis from the neck region downward. These scales, which cover the whole body, are flatter and more evenly spaced around the eyes and the mouth, while the rest have a hemispherical shape, being curved and unevenly spaced. You should start the drawing with the shading, and only then add the little details. The distinctive feature of the gecko's limbs is the complex gripping structures on the toes and soles, which allow it to hold onto even glass surfaces.

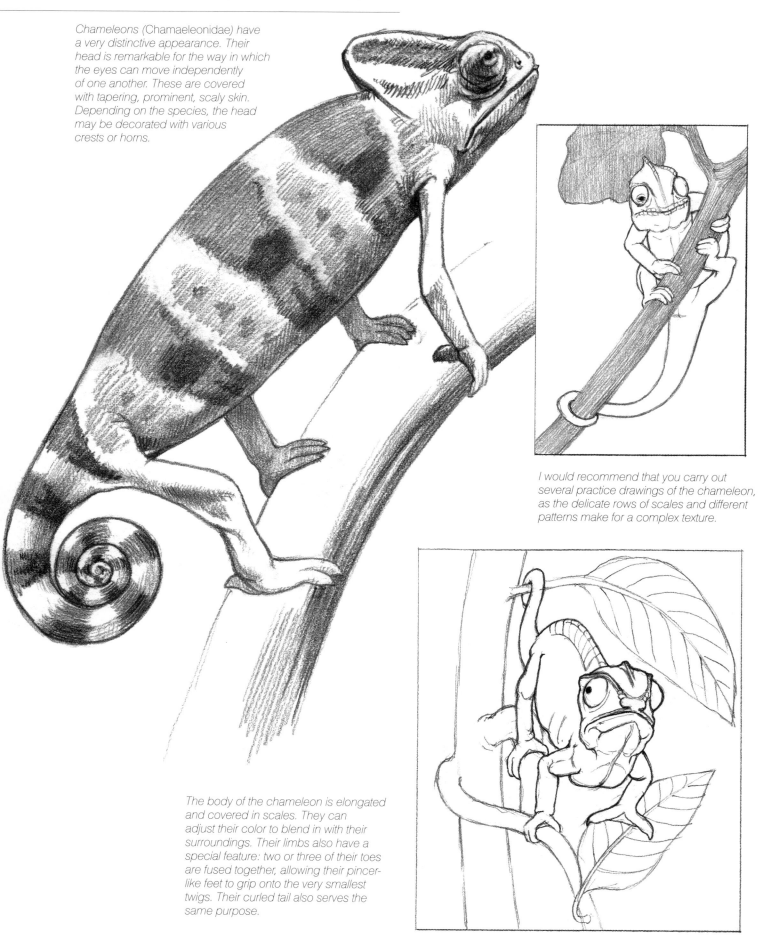

Chameleons (Chamaeleonidae) have a very distinctive appearance. Their head is remarkable for the way in which the eyes can move independently of one another. These are covered with tapering, prominent, scaly skin. Depending on the species, the head may be decorated with various crests or horns.

I would recommend that you carry out several practice drawings of the chameleon, as the delicate rows of scales and different patterns make for a complex texture.

The body of the chameleon is elongated and covered in scales. They can adjust their color to blend in with their surroundings. Their limbs also have a special feature: two or three of their toes are fused together, allowing their pincer-like feet to grip onto the very smallest twigs. Their curled tail also serves the same purpose.

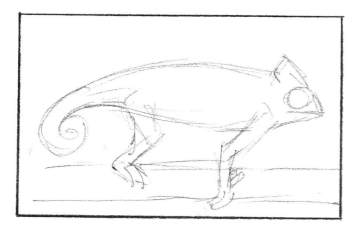

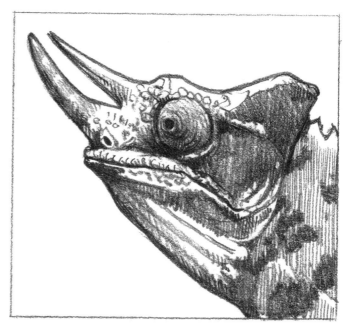

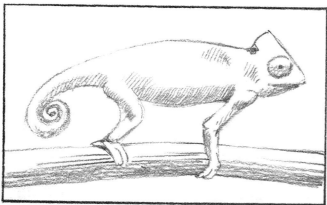

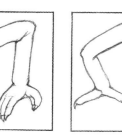

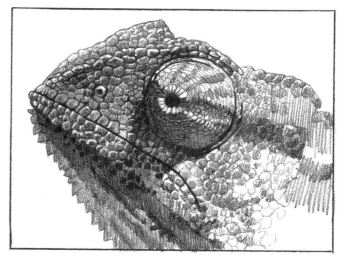

After you have completed the outline, you should mark on the most important areas of shading in order to render the three-dimensionality of the body. Then you can draw in the pattern of the skin, and finally its texture.

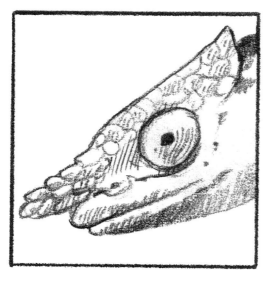

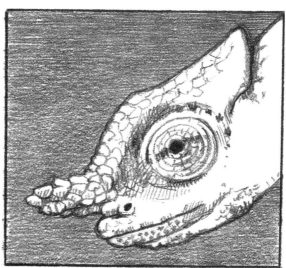

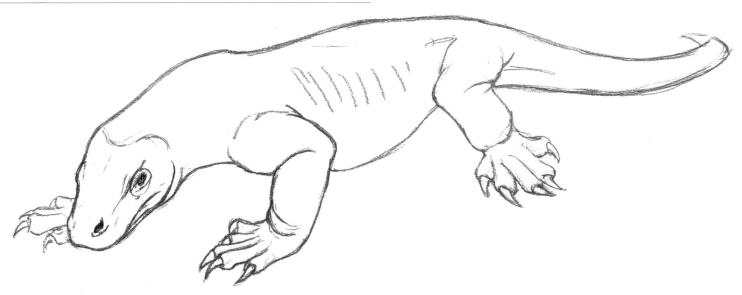

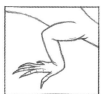

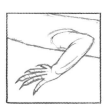

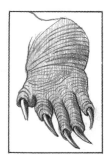

The Komodo dragon (Varanus komodoensis) *is the largest species of lizard. It can grow up to 8–10 feet long (2.5–3 m), and weigh up to 2 US cwt. (95 kg). It has a powerful, elongated body covered in thick, rounded, and uniformly charcoal or gray-brown scales. Like other lizards, it moves with a wave-like motion, due to its slanting legs. The skin on its legs has marked folds that you can capture by drawing several superimposed cylinder shells. Its toes end in sharp claws. The third and fourth toes are the longest. Its head is long and flat, and the wide mouth is surrounded by evenly spaced rows of scales. Its forked tongue is roughly 12 inches long (30 cm), and like the tongue of a snake, it allows the dragon to sense smells.*

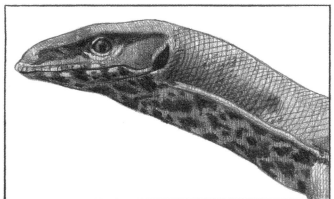

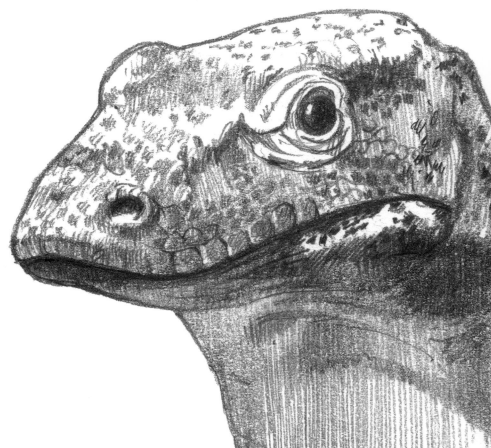

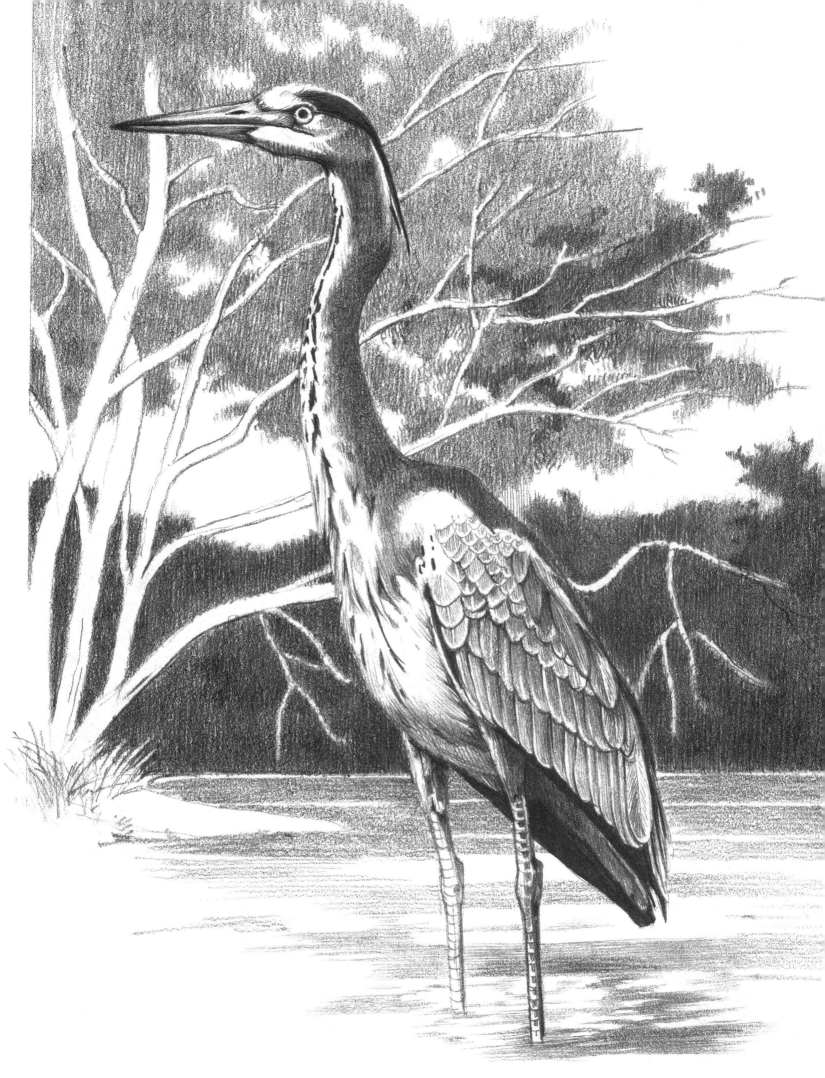